WILLIAM MORRIS
& his Palace of Art

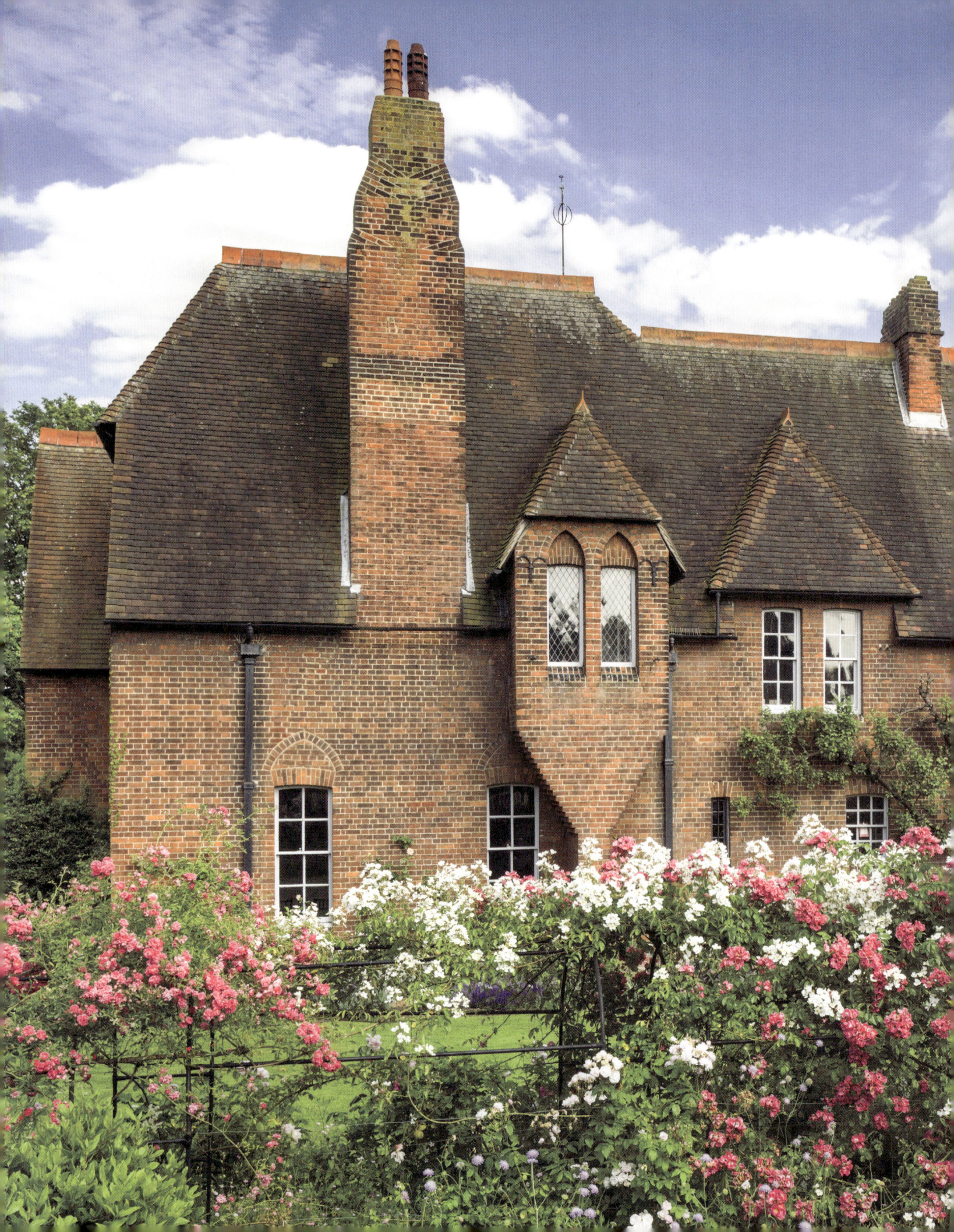

For Theo, Artemis & Honor
Fidelis in Parvo

Published in 2018 by Philip Wilson Publishers
an imprint of I.B.Tauris & Co. Ltd
London • New York

www.philip-wilson.co.uk

Copyright © 2018 Tessa Wild

The right of Tessa Wild to be identified as the author of this work has been asserted by the author
in accordance with the Copyright, Designs and Patents Act 1988.

All rights reserved.
Except for brief quotations in a review, this book, or any part thereof, may not be reproduced, stored in or
introduced into a retrieval system, or transmitted, in any form or by any means, electronic, mechanical,
photocopying, recording or otherwise, without the prior written permission of the publisher.

Every attempt has been made to gain permission for the use of the images in this book.
Any omissions will be rectified in future editions.

References to websites were correct at the time of writing.

ISBN: 978 1 78130 055 8

A full CIP record for this book is available from the British Library
A full CIP record is available from the Library of Congress
Library of Congress Catalog Card Number: available

Designed and typeset in Golden Type and Scala by E&P Design

Printed and bound in China by 1010 Printing

Contents

1. 'Si je puis': 'If I can' .. 7

2. Before Red House: Oxford and London 13

3. Designing and building Red House 29

4. Decorating and furnishing the house 53

5. The garden .. 195

6. The Firm ... 215

7. Relinquishing Red House .. 233

8. Red House after Morris .. 247

Notes ... 254

Select bibliography .. 264

Picture credits .. 266

A Red House colour chart .. 267

Acknowledgements ... 268

Index ... 269

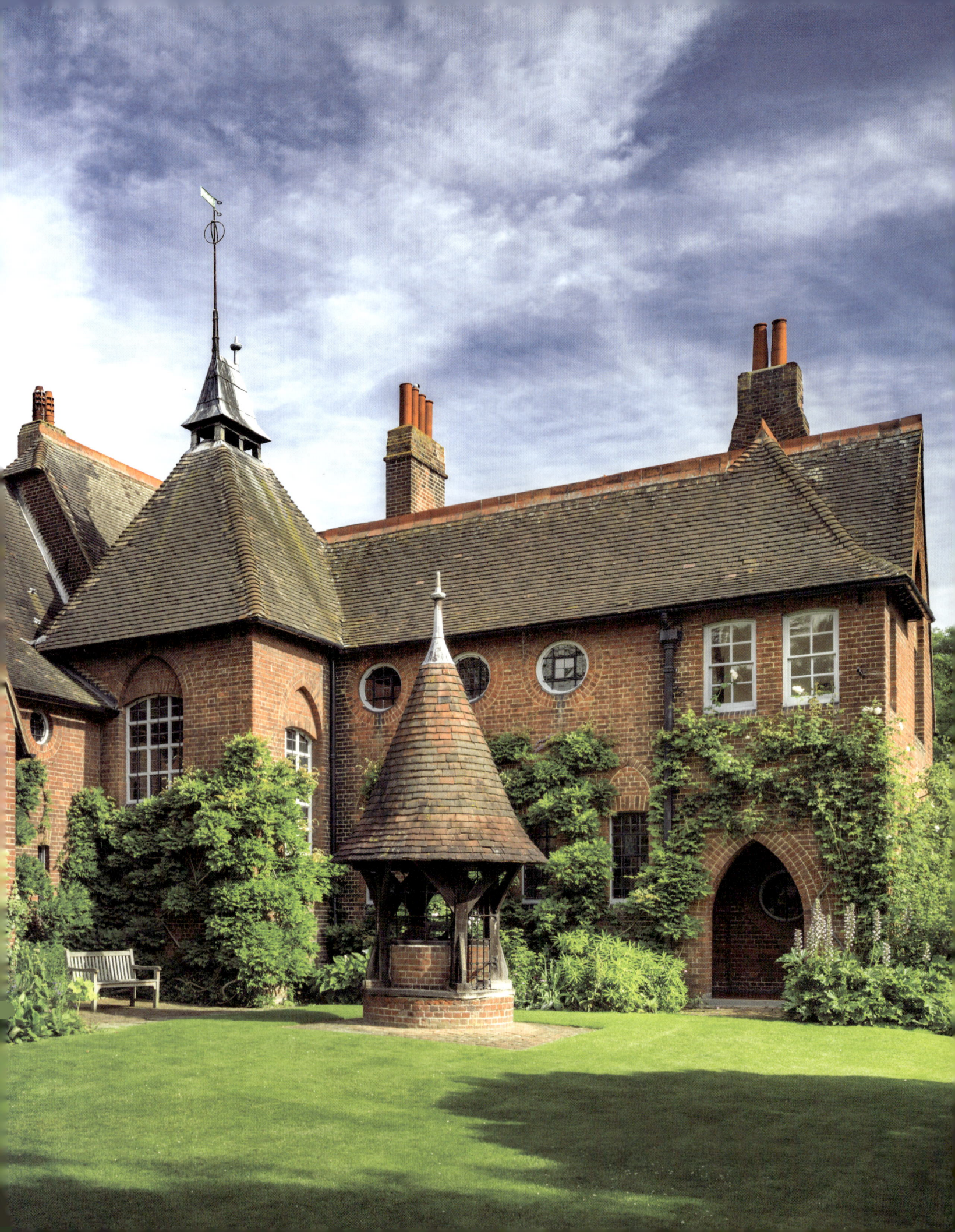

1
'SI JE PUIS': 'IF I CAN'

In emulation of Jan van Eyck, one of his great heroes, William Morris adopted for himself the painter's motto and incorporated it into the rich and complex decorative scheme at Red House.[1] 'Si je puis' appears on tiles in the garden porch and in the quarries of the stained glass window on the upper passage leading to Morris's studio. Just twenty-six in 1860, Morris was newly married, a published poet and an aspirant painter. His motto was a daily reminder both of what he strove to achieve and that the power to do so lay within himself and would come from his own effort. Morris was a man of prodigious energy, boundless enthusiasm and insatiable curiosity who threw himself with unstinting passion into every aspect of his life – his writing, his artistic work, his friendships, his marriage and the business he founded whilst at Red House. Never was a motto more aptly chosen.

Morris first expressed his hope for 'a Palace of Art of my own' in a letter of 1856, referring to Tennyson's poem *The Palace of Art*, where a man builds a 'lordly pleasure house' for his soul:

Full of great rooms and small the palace stood
All various, each a perfect whole,
From living Nature, fit for every mood
And change of my still soul.[2]

Red House was the realisation of his 'Palace of Art'. Designed as an artist's studio house for him by his friend and collaborator, the architect Philip Webb, it was the only house Morris ever commissioned and owned and was Webb's first independent work. It was a young man's house, the social and creative heart of his group of friends, and rapidly became a family home once Morris's two daughters, Jenny and May, were born there in 1861 and 1862.

Morris's dream of creating at Red House a deeply personal and highly expressive unified vision of house, contents, decoration and garden, was to

FIG. 1.1
Red House from the south.

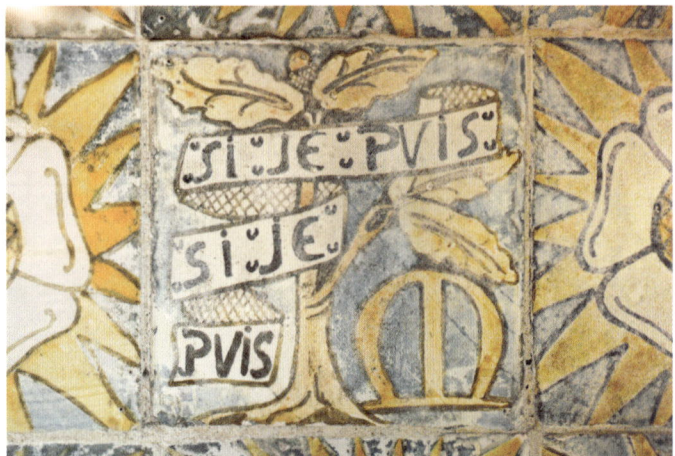

FIG. 1.2
'Si je puis' tile by William Morris, c.1860.

FIG. 1.3
William Morris, aged twenty-three, c.1853, photograph. William Morris Gallery.

come to fruition during the five short, but highly industrious and creatively charged, years that he spent living in the house. He worked collaboratively alongside his closest friends – artists and amateurs – to forge a place of extraordinary character which was redolent with meaning.

Red House was a place of experimentation and discovery, failure and success. This was the moment in the lives of the young friends – William and Jane Morris, Philip Webb, Georgiana and Edward Burne-Jones, Dante Gabriel Rossetti, Elizabeth Siddal, Charles Faulkner, Algernon Charles Swinburne – when they were establishing their own personal paths as artists, writers, architect, designer; it was also a time of youthful exuberance and opportunity, great personal happiness and devastating loss. Red House encapsulates these hopes and aspirations, for it was born of optimism and creativity and the desire of each member of the group to contribute his or her own artistry to the greater work of art and the happy home. It has a unique position in design history because it was shaped collaboratively by the creative forces of a highly talented group, each of whom went on to achieve fame and distinction in their individual spheres.

Red House acted as a crucible for what was to come. From the need to decorate and furnish the house came the impetus for the founding of Morris, Marshall, Faulkner & Co., in 1861, which would evolve to become the hugely important Morris & Co. (known by the group as 'the Firm'), revolutionising and influencing taste in Britain and abroad. Red House was the first direct expression of Morris's beliefs about the importance of art in everyday life

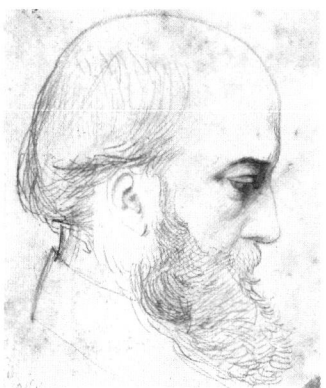

FIG. 1.4
Philip Webb by George Howard, c.1875, pencil on paper. Castle Howard Collection.

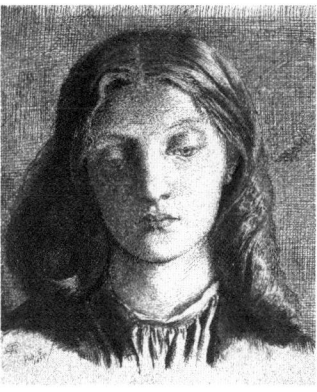

FIG. 1.5
Elizabeth Siddal by Dante Gabriel Rossetti, 1855, pencil on paper. Ashmolean Museum, University of Oxford.

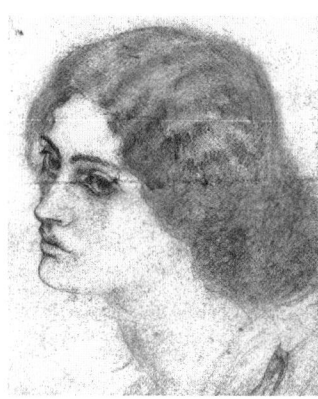

FIG. 1.6
Jane Burden by William Morris, 1858, photogravure of drawing made shortly before their marriage. William Morris Gallery.

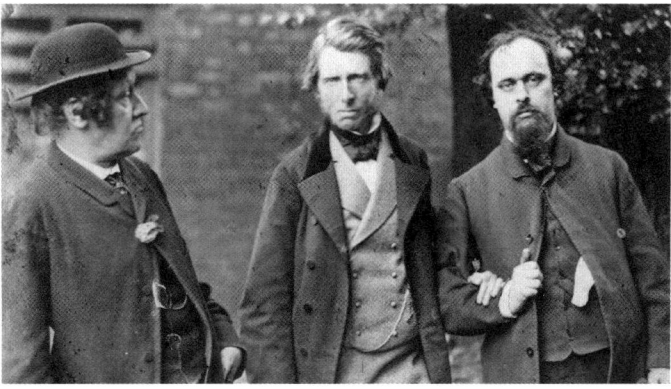

FIG. 1.7
Left to right: William Bell Scott, John Ruskin and Dante Gabriel Rossetti, 29 June 1863, photograph: W&D Downey. National Portrait Gallery.

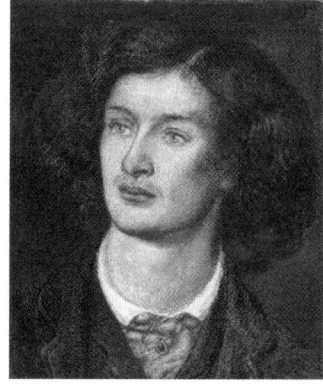

FIG. 1.8
Algernon Charles Swinburne by Dante Gabriel Rossetti, 1861, watercolour. The Fitzwilliam Museum, Cambridge.

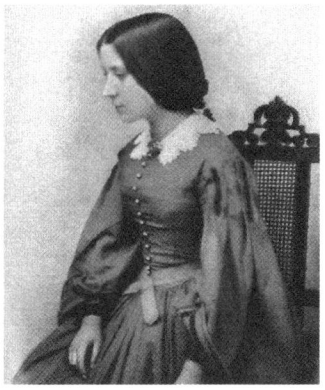

FIG. 1.9
Georgiana Macdonald, c.1856, photograph. Georgiana Burne-Jones, *Memorials of Edward Burne-Jones*.

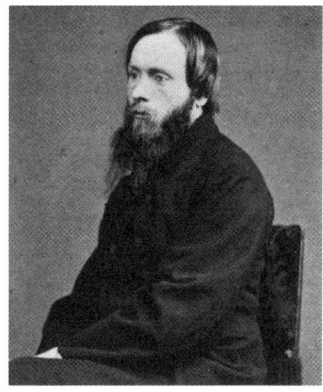

FIG. 1.10
Edward Burne-Jones aged thirty-one, in 1864, photograph. National Portrait Gallery.

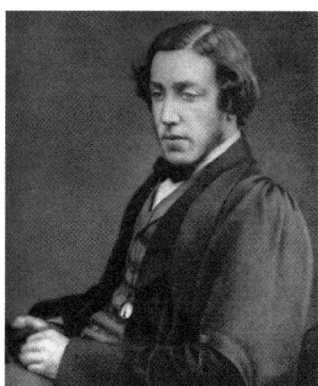

FIG. 1.11
Charles Faulkner, c.1860, photograph. Georgiana Burne-Jones, *Memorials of Edward Burne-Jones*.

and the joy to be derived from purposeful labour – ideas he was to develop throughout his career and which would deeply influence his later socialism and writing on art and society.

Morris's expectation was that he would live at Red House for a considerable time, perhaps forever, and conscious that he wished to create a 'brotherhood' there, Webb designed the house so that it could be readily extended to accommodate another family or group of like-minded friends. By 1865, with the interiors still unfinished and his vision not fully realised, it had become apparent that living out at Upton, near Bexley Heath, Kent, was no longer sustainable; the demands of the Firm necessitated Morris being in London on a near-daily basis and his hopes of moving the workshops of the Firm to a local site and extending the house for the Burne-Joneses were shattered after the death of their baby son. With a great sense of loss but with resolute pragmatism, Morris left Red House in 1865, never to return. Georgiana Burne-Jones understood Morris's choice not to see the house again but found that it left a lasting impression on her, taking on the character of an almost mythological dreamscape in the shared memories of the friends who had been part of its creation. She recollected: 'some of us saw it in our dreams for years afterwards as one does a house known in childhood'.[3]

More than one hundred and fifty years later, Red House is viewed as an iconic building. It has acquired great significance, not least for its association with Morris, as his star has waxed and waned, but also for its perceived role as a precursor to the Arts and Crafts Movement and for the importance of its architecture, which was hailed in the early twentieth century for its modernity and interpreted as a forerunner of the modern movement. Although its rural setting has gone and Red House now sits enveloped by suburbia as part of Greater London, the house and garden have survived remarkably intact. Webb's plan form has been very little altered; and whilst the garden has lost its intimate medieval character, the complete ensemble of wall, stable, house, garden and well is still readable. Inside the house, the taste of a succession of owners (many of whom were deeply respectful of the place) and the ravages of time have led to more significant changes and it has lost much of the colour and texture which was originally such an intrinsic part of its character. There have, however, been extraordinary survivals, both in terms of pieces of furniture designed for the house and in decorative schemes obscured from view for years by later layers of paint and wallpaper.

In January 2003, Red House was acquired by the National Trust and a detailed programme of research into the surviving physical evidence for its decorative schemes and an understanding of the layout and character of the garden began. This has been a voyage of discovery which has revealed 'lost'

wall paintings, surviving fragments of original patterns, wall colours and a wealth of new evidence about the furnishings and contents. A much richer knowledge of the interrelationship of house and garden has also been gained. Inevitably, there remain many unanswered questions and the fragmentary nature of evidence and lack of supporting documentary material means that there will always be an element of the unknown and of supposition in our understanding and appreciation of Morris's intentions and the communal achievements of the friends. Nonetheless, Red House stands as a fecund source for reinterpreting Morris, his romantic medievalism and his influences. The following chapters seek to bring this new evidence to the fore and to marry it with documentary sources and comparative examples to reassess the critical importance of Red House to the development of the artistic careers of Morris and his friends and to the early domestic and church commissions of the Firm for which it acted as a testing ground.

Heap cassia, sandal-buds and stripes
of labdanum, and aloe-balls,
smeared with dull nard an Indian wipes
from out her hair; such balsam falls
down sea-side mountain pedestals,
from summits where tired winds are fain,
spent with the vast and howling main,
to treasure half their island gain.

And strew faint sweetness from some old
Egyptian's fine worm-eaten shroud
which breaks to dust when once unrolled;
and shred dim perfume like a cloud
from chamber long to quiet vowed
with mothed and dropping arras hung,
mouldering the lute and books among
of queen long dead who lived there young.

2

BEFORE RED HOUSE: OXFORD AND LONDON

Beauty, which is what is meant by art, using the word in its widest sense, is, I contend, no mere accident to human life, which people can take or leave as they choose, but a positive necessity of life, if we are to live as nature meant us to; that is unless we are content to be less than men.[1]

Morris dedicated himself to the pursuit and promulgation of beauty, recognising that it is integral to life itself. He had a vital creative sensibility shaped by his experiences and strong emotional connections and was a voracious reader. He devoured works of classical mythology, medieval history and literature and contemporary novels, prose and poetry – including John Ruskin, Thomas Carlyle, Walter Scott, Alfred Tennyson, John Keats, Charles Kingsley, Robert Browning (fig. 2.1) and Charles Dickens. When he and Burne-Jones discovered Sir Thomas Malory's fifteenth-century text of *Morte d'Arthur*, it took a profound hold of their imaginations. 'Nothing', Burne-Jones wrote, 'was ever like *Morte d'Arthur* – I don't mean any book or any one poem – something that can never be written, I mean, and can never go out of the heart'.[2]

Morris recalled that when he first saw Canterbury Cathedral, aged eight, he 'felt the gates of Heaven had been opened to him'.[3] He connected with history as a creative dynamic force and saw the past as a place from which to draw inspiration for the present and the future, but he never simply sought to copy what had gone before. Burne-Jones aptly described his sentiment: 'All his life he hated the copying of ancient work as unfair to the old and stupid to the new.'[4] In the five years preceding the erection of Red House in 1860, Morris garnered significant knowledge, embraced new skills, chose a career for himself and followed his interconnected passions for art, friendship and, ultimately, love.

Thanks to his father's successful investment in the Devon Great Consols copper mine, Morris was able to indulge his interests with a degree of freedom;

FIG. 2.1
Two verses from Robert Browning's *Paracelsus* by William Morris, 1856–7. Ink, bodycolour and gilt: 17.5 x 15.2 cm. The Huntingdon Library, Art Collections and Botanical Garden.

BEFORE RED HOUSE: OXFORD AND LONDON

on his twenty-first birthday, he came into his inheritance and an annual income. Independent means also enabled Morris to indulge in his natural generosity to his friends, to fund his architectural training and to make important acquisitions – procuring books, notably Southey's edition of Malory's *Morte d'Arthur*, and purchasing works of art. Upon seeing Arthur Hughes's painting, *April Love*, at the Royal Academy exhibition and 'after brooding upon the subject for a few days made up his mind to possess it' (fig. 2.2).[5] Morris showed his emergent taste by acquiring the vividly coloured, romantic work, which Ruskin had admired and described as 'exquisite in every way; lovely in colour, most subtle in the quivering expression of the lips, and sweetness of the tender face'.[6]

In July 1855, Morris and his Oxford contemporaries, Edward Burne-Jones and William Fulford, made a three-week tour of Northern France, inspired by the writings of John Ruskin. Having taken to heart his chapter 'The Nature of Gothic', from *The Stones of Venice*, they visited nine cathedrals and at least twenty-four other churches that Ruskin had seen (fig. 2.3).[7] Morris was later to write that on first reading 'The Nature of Gothic', 'it seemed to point out a

FACING PAGE: **FIG. 2.2**
April Love by Arthur Hughes, 1855–6. Oil on canvas: 89 cm x 50 cm. On 17 May 1856, Morris wrote to Burne-Jones, 'do me a great favour, viz. go and nobble that picture called "April Love" as soon as possible lest anybody else should buy it'. Tate, London.

RIGHT: **FIG. 2.3**
West Porch of Rouen Cathedral, attributed to John Ruskin, unknown date. Pencil, sepia wash and watercolour on paper: 76.2 x 62.3 cm. William Morris Gallery.

FIG. 2.4
High Street, Oxford, 1860.

new road on which we should travel'.[8] It was to prove a momentous trip for both Morris and his closest friend Burne-Jones. Freed from the constraints of Oxford and struck by the awe-inspiring beauty and achievement of the medieval French craftsmen and master masons, they discussed their own intended future as clergymen and found it wanting. Morris's attraction to the liturgy of the High Church Anglican movement was waning and, whilst he had no dramatic loss of faith, he could no longer countenance a religious career.

At Oxford, Burne-Jones and Morris had established a deep rapport and formed a 'brotherhood' of like-minded souls, with a shared interest in poetry, literature, architecture, art, history and an increasing awareness of England's imbalanced society. In France, steeped in medieval history, they determined to turn their backs on careers in the church and to lead creative lives – Burne-Jones as an artist and Morris as an architect.

Morris was famed amongst his friends for his ebullience and, keen to forge ahead with his plan, he wrote with passionate zeal to his good friend Cormell Price: 'I MUST make haste, it would not do for me ... to be a lazy aimless, useless, dreaming body all my life long. I have wasted enough time already, God knows.'[9] After breaking the unwelcome news of his change of heart to his

mother, Morris wrote to her in November: 'You see I do not hope to be great at all in anything, but perhaps I may reasonably hope to be happy in my work, and sometimes when I am idle and doing nothing, pleasant visions go past me of what might be'.[10] He proposed to undertake his articles with George Edmund Street, the diocesan architect for Oxford, leading ecclesiologist and one of the foremost architects of the Gothic Revival. Although eager to embrace his new calling, and in the knowledge that his architectural training would take at least five years, Morris dutifully returned to Oxford that autumn, conscious of his mother's disquiet, and took his degree. His training with Street began in January 1856 and so too did a new and vital friendship with the young architect Philip Webb, who, as Street's chief assistant, was given charge of him in the office. Morris recounted that on meeting, they understood one another at once. Webb was twenty-five and Morris twenty-two and they had distinct but complementary characters. Together they shared high ideals of friendship and fellowship and held steadfast to their deep principles. They were bound by their love of nature and the English countryside, its vernacular buildings, ancient traditions and craftsmanship, and they strove to revive and uphold these things in an increasingly industrialised and socially riven age.

Oxford was important to them both. Webb was later to recall, 'I was born and bred in Oxford, and had no other teacher in art than the impressive objects of the old buildings there, the effect of which on my natural bent has never left me.'[11] Although Webb's first thought was to become an artist, he chose architecture over art, recognising it as a steadier career. After five formative years working on a variety of buildings, from banks to schools, domestic dwellings and churches in both the classical and gothic idiom, Webb moved to the practice of Bidlake and Lovatt in Wolverhampton. In stark contrast to the beauty of Oxford, the market town of Reading and the Thames Valley, Wolverhampton was a modern, industrialised town undergoing rapid expansion. Webb was horrified by it and left after only one month, taking a pay cut of half his previous weekly salary to work instead for Street. The memory of the deprivation and the grim buildings, the 'rows of infernal dog holes', he witnessed in Wolverhampton left a lasting impression.[12] As William Lethaby later succinctly put it: 'All Webb's future life was shaped by thought of this and that – of old and new – of Oxford and Wolverhampton.'[13]

Whilst the friendship between Webb and Morris deepened, it became quickly apparent to Webb that his charge was temperamentally unsuited to the life of a trainee architect. Street controlled every aspect of his designs, believing that 'three-fifths of the poetry of a building lay in its minor details, so he designed every part of his buildings himself; his assistants merely finished his pencil drawings in ink'.[14] Morris accordingly spent a large proportion of

his time copying and inking in Street's work and his strong creative instincts must have baulked at the repetitive nature of the tasks allotted to him and the lack of freedom for his own invention. The mundane nature of office life was broken only by site visits and the occasion when Street chose Morris to accompany him on an important visit to Lille. Street had entered a design for the new cathedral there and he and Morris studied the entries together. Street's was placed second, the winning design being the work of William Burges and Henry Clutton. Their drawings included 'an elaborately painted organ case which was Burges's first design for a piece of painted furniture' and which Clive Wainwright has argued prompted 'Morris's interest in a radical new departure just beginning in furniture design'.[15] Street, following the pioneering lead of A.W.N. Pugin, was alive to the interdependency and connectedness of architecture and the decorative arts and, as the architect of a building, he took on the role of devising its decoration and furnishing (fig. 2.5). Street believed that the architect himself should be a maker and that he should have a first-hand understanding of the properties of materials and be able to mould, sculpt and embroider. With Street's encouragement, Morris undertook clay modelling, carving, illuminating, stained glass design and wood engraving. Whilst his talent for architecture was unrealised, his aptitude for these traditional art forms was evident and Morris particularly enjoyed embroidery, illuminating and wood engraving. In 1848, Street had published an important work, *Ecclesiastical Embroidery*, and he nurtured Morris's instinctive and growing interest in the subject.[16]

Street moved his practice from Oxford to London in August 1856 and

FIG. 2.5
Table designed by George Edmund Street, *c.*1854. Oak: 66 x 98 cm diameter. Victoria and Albert Museum.

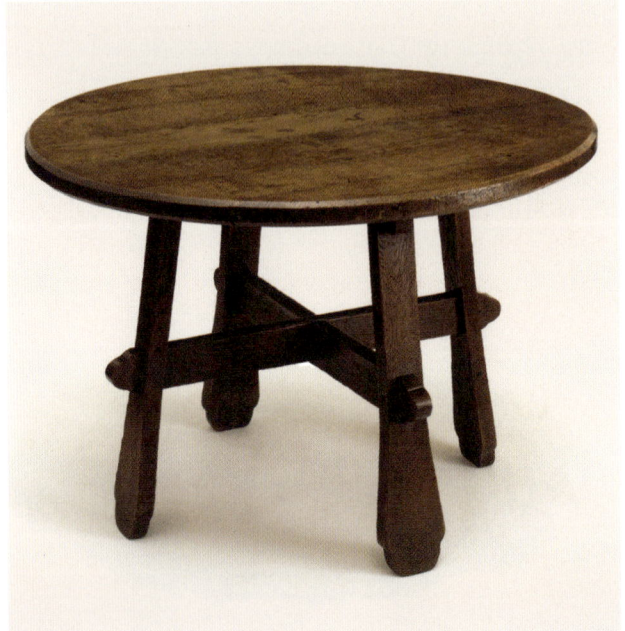

BEFORE RED HOUSE: OXFORD AND LONDON

Webb and Morris moved with him. After a few weeks, Morris took lodgings at 17, Red Lion Square with Burne-Jones, who, already in London and pursuing his artistic ambitions, had been taken up by the artist and poet Dante Gabriel Rossetti, one of the founders of the Pre-Raphaelite Brotherhood. Burne-Jones and Morris had first read about the Pre-Raphaelites in Ruskin's Edinburgh Lectures of 1854, and had then seen their work, in Oxford and later in Paris, admiring their choice of subject matter, their vivid colour palette and their sense of immediacy and naturalism.[17] Whilst still at Oxford, attracted by the artistic quest of the Pre-Raphaelites, and to their version of the longed-for 'brotherhood', Morris had started *The Oxford and Cambridge Magazine*, in emulation of their short-lived periodical *The Germ, thoughts towards nature in art and literature*. Burne-Jones rapidly became Rossetti's disciple and attended his drawing classes and worked in his studio. Morris was drawn into this avant-garde artistic milieu, and the charismatic Rossetti, already aware of Morris's facility as a poet, exerted his influence and pressed him to abandon architecture for art. With strong echoes of his letter of less than a year earlier, Morris wrote again to Cormell Price, 'Rossetti says I ought to paint, he says I shall be able; now as he is a very great man, and speaks with authority and not as the scribes, I must try. I don't hope much, I must say, yet will try my best'.[18] Morris valiantly combined his work with Street with evenings spent studying drawing, but he was ultimately to give in to Rossetti's urging and declared his intention of becoming a painter. Having witnessed and understood his friend's frustrations with architecture, Webb was to tell Lethaby that Morris gave it up because 'he found he could not get into contact with it; it had to be done at second hand'.[19] Morris needed to make a connection between design and execution; perhaps, as his skill in the traditional arts grew, it became apparent to him that he wanted to make what he designed and that architecture did not have the tangible quality he craved.

Number 17, Red Lion Square was an unfurnished set of three rooms, the largest of which was used as a studio and living space. Together, Burne-Jones and Morris lived in a state of bachelor disorder, relieved by the good offices of their maid Mary Nicholson (known familiarly as Red Lion Mary). She had the additional distinction of being a fine needlewoman and of working on the embroidery designs that Morris devised after the 'If I Can' hanging, which he designed and stitched himself (fig. 4.106).[20] Whilst he and Burne-Jones worked at painting and drawing, Burne-Jones made a caricature of himself in the room (fig. 4.108) surrounded by a plethora of objects – armour, brass rubbings, easels, candlesticks, artistic props – and dominated by several robust pieces of furniture. These were seminal items, the first steps taken by Morris in commissioning objects of his own choosing to serve both functionally as

tables, chairs and dressers and to be the repository of collaboratively produced decorative painting and figurative schemes. Although the later Red House pieces were to be designed in the main by Webb, Morris's own design work here is critical. Perhaps informed by Webb's attuned eye, the strongly medieval forms prepared his way for the much greater levels of artistic expression achieved in the commissioning, decoration and furnishing of Red House. It is likely that in conceiving this furniture – to be made by a workshop in Hatton Garden – Morris also had in mind the memory of Burges's design for his extraordinary painted organ case for Lille Cathedral. Rossetti was to describe Morris's massive, somewhat crude, pieces as 'intensely mediaeval furniture ... tables and chairs like incubi and succubi'; with Morris and Burne-Jones, he was involved in decorating them with narrative and poetic subjects, and geometric and flat patterns.[21] Rossetti worked with Morris on the decoration of the two chairs known as *The Arming of a Knight* (fig. 2.6), and *Glorious Guendolen's Golden Hair* (fig. 2.7), taking as their subject matter two of Morris's poems. Burne-Jones wrote of a cabinet, 'when we have painted designs of knights and ladies upon them they will be perfect marvels'.[22] The furniture stood as functional canvases awaiting the artist's impression; each item was a distinct vehicle for self-expression and homage to the stories and period which transfixed them. When the settle (later refashioned for the drawing room at Red House) arrived at Red Lion Square, it was so monumental in scale it caused 'a scene'. Burne-Jones's memory was still vivid when he recounted, 'I think the measurements had perhaps been given a little wrongly, and that it was bigger altogether than had ever been meant, but set up eventually it was and our studio was one-third less in size. Rossetti came. This was always a terrifying moment to the very last. He laughed, but approved.'[23] Rossetti's approval was critically important to the two younger men. All were enthused, emotionally connected and took pleasure in their joint creative endeavour. This was their first true collaboration; it opened up a world of possibilities for all three and seemed naturally to lead to their first 'professional' project, the decoration of the Debating Hall of the Oxford Union building, and in turn to Red House.

The newly completed Gothic Revival Oxford Union building was designed by Benjamin Woodward, the architect of the nearby University Museum. The commission for its decoration came through Rossetti, who was fired up by the contemporary interest in fresco- and mural-painting that two high-profile commissions, underway in 1857, demonstrated. These were William Dyce's series of history paintings, executed in fresco, for the Queen's Robing Room in the Houses of Parliament, and which depicted the chivalric virtues through the story of the *Legend of King Arthur*; and George Frederick Watts's

BEFORE RED HOUSE: OXFORD AND LONDON

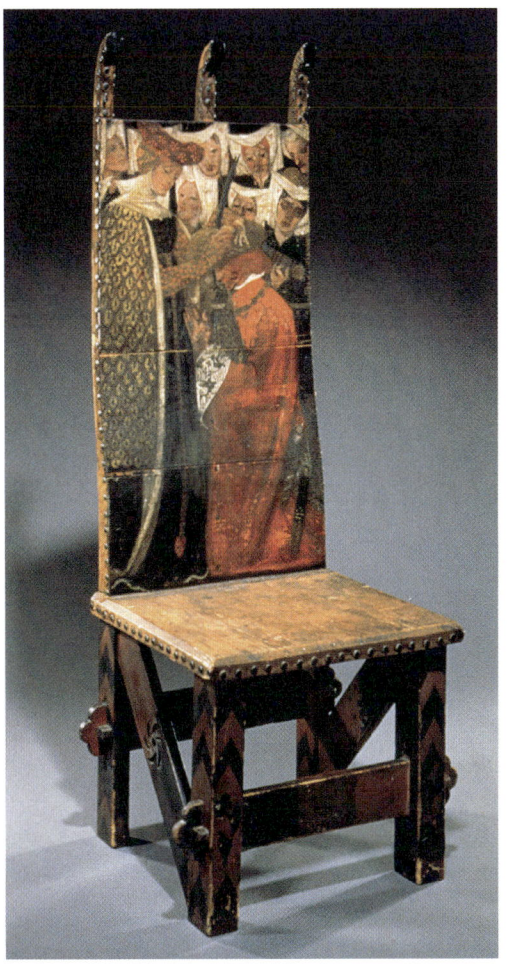 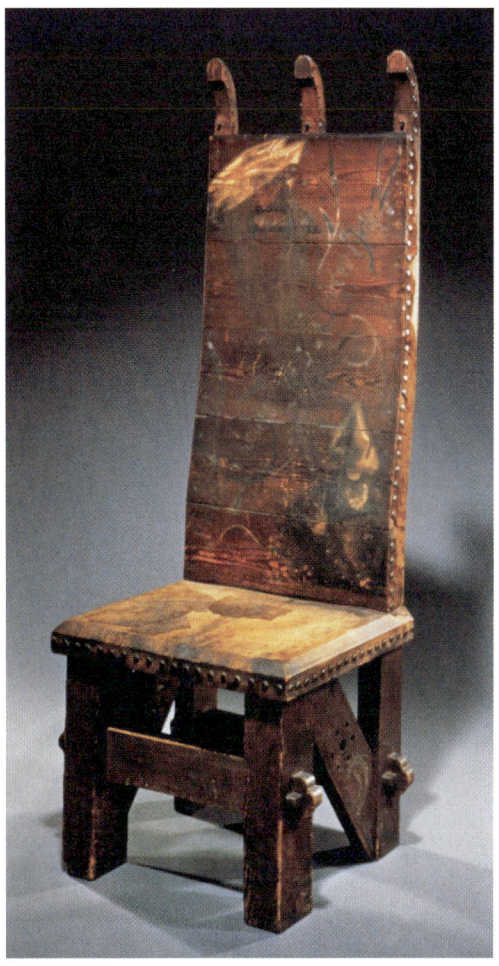

FIG. 2.6
The Arming of a Knight, chair designed by William Morris and painted by Morris and Dante Gabriel Rossetti, c.1857–8. Painted deal, leather and nails: 141.3 x 49.5 x 47.6 cm. On this and the companion chair, Morris is credited with the painted chevrons and patterns to the legs and Rossetti with the figurative scenes. Delaware Art Museum.

FIG. 2.7
Glorious Guendolen's Golden Hair, chair designed by William Morris and painted by Morris and Dante Gabriel Rossetti, 1856–7. Painted deal, leather and nails: 141.3 × 43.2 × 43.2 cm. Delaware Art Museum.

commission to paint a monumental fresco of *Justice, A Hemicycle of Lawgivers* for the Great Hall of Lincoln's Inn. These ambitious works roused Rossetti's enthusiasm for 'a new school of muralists in England'.[24] In the Oxford Union Debating Hall, he saw an opportunity for himself and for the followers of the Pre-Raphaelites to showcase the rediscovered medium on a grand scale. Rossetti unsuccessfully tried to induce Ford Madox Brown to take part in the scheme but was ultimately to recruit an eclectic collection of artists: Arthur Hughes, John Hungerford Pollen, John Roddam Spencer Stanhope, the much less experienced Burne-Jones and Morris, and the wholly inexperienced Valentine Prinsep. They began work in the summer of 1857.[25]

Morris had already purchased Hughes's picture, *April Love* (fig. 2.2) and greatly admired Pollen's ceiling decoration undertaken in Merton College Chapel in 1850, so he must have been delighted to find himself in such good artistic company.

The spirit of the endeavour was characterised as a 'jovial campaign', a sally in an artistic crusade, with work punctuated by much jollity and high spirits. No payment was made and the artists undertook the work on the promise of their board and lodging and an unlimited supply of soda water. Morris's training in Street's office and his local connections meant that he took on much of the organisation of the scaffolding and equipment and the supply of paints. J.W. Mackail described the hall as 'a long building with apsidal ends. A narrow gallery fitted with bookshelves ran completely around it, and above the shelves was a broad belt of wall divided into ten bays, pierced by twenty six-foil circular windows, and surmounted by an open timber roof'.[26] Rossetti had agreed that 'the ten bays and the whole of the ceiling should be covered with painting in tempera' and the subject of the whole would be the *Morte d'Arthur*, with floriated decoration to the ceiling.[27] Each artist chose to portray an individual scene from the legend, giving pictorial form to the chivalric narrative which so resonated with them (fig. 2.8). Morris took as his subject 'How Sir Palomydes loved La Belle Iseult with exceeding great love out of measure, and how she loved not him again but rather Sir Tristram' (fig. 2.9). J.W. Mackail observed that the 'subject was one for which he felt a singular almost morbid attraction, that of the unsuccessful man and despised lover'.[28] Morris approached it with passionate intensity and, determined to give full force to his depiction, commissioned a sword, a 'an ancient kind of helmet called a basinet, and ... a great surcoat of ringed mail' from a forge near Oxford Castle as props. Burne-Jones recorded that he ended up with his head stuck in the basinet as 'the visor, for some reason, would not lift, and I saw Morris embedded in iron, dancing with rage and roaring inside' (fig. 2.10).[29]

Morris was the first to start and the first to finish, but the whole scheme was beset by problems, for the plaster on the newly built walls was damp and the artists' understanding of fresco-painting was limited. The windows that pierced the bays broke up the flow of the composition and sat uncomfortably against the Arthurian figures, whilst the natural light made it difficult to view the pictures clearly from below. The design of the ceiling decoration was taken on by Morris as the others still laboured over their unfinished works. He is recorded as having completed the drawn design in a single day and with it 'surprised all the rest of the painters by its singular beauty and fitness'.[30] He was to execute the majority of the floriate design himself, with welcome assistance from his Oxford friends Charles Faulkner, Cormell Price

BEFORE RED HOUSE: OXFORD AND LONDON

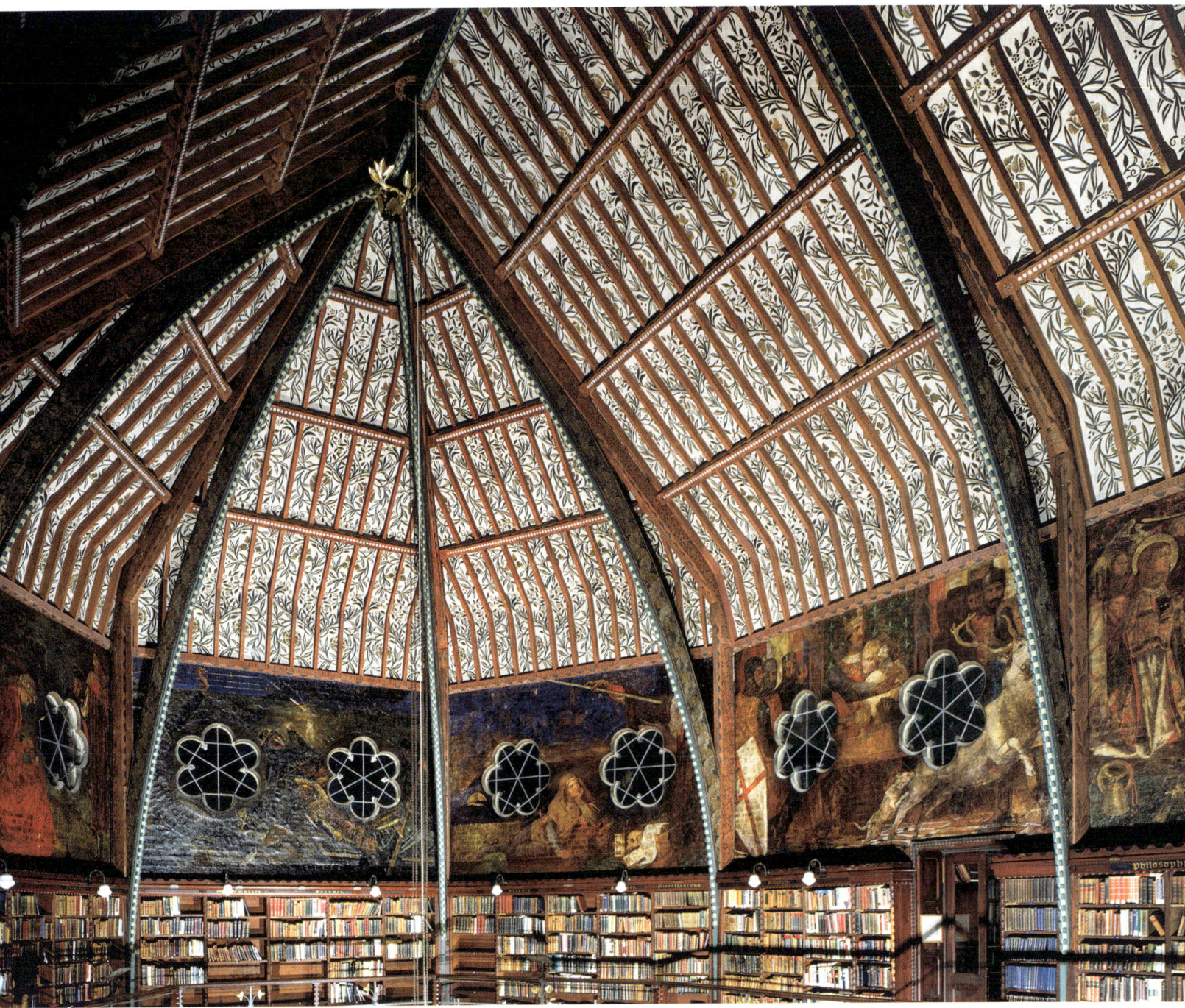

FIG. 2.8
The Debating Hall, the Oxford Union with (left to right) paintings by John Roddam Spencer Stanhope; Arthur Hughes; William & Briton Riviere (two consecutive works). Sir Lancelot's Vision of the San Grail by Dante Gabriel Rossetti, 1857, is part-visible on the far right. The ceiling decoration was designed by Morris c.1875, and replaced his original richly-coloured and densely patterned painting of 1857. The Oxford Union Society.

WILLIAM MORRIS & HIS PALACE OF ART

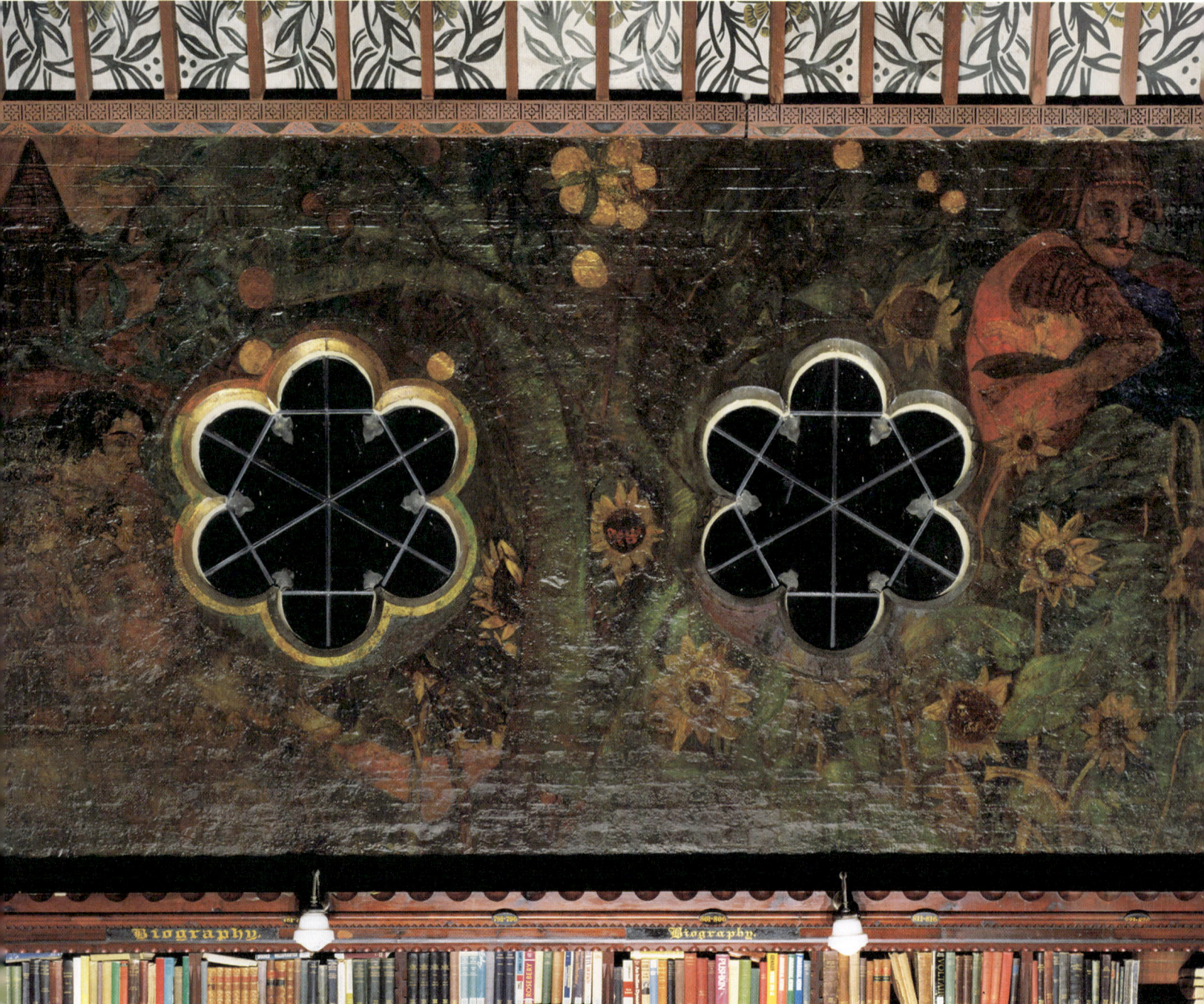

FIG. 2.9
How Sir Palomydes loved La Belle Iseult with exceeding great love out of measure, and how she loved not him again, but rather Sir Tristram by William Morris, 1857. Tempera on plaster. Sir Palomydes is depicted watching Tristram and Iseult embrace. The Oxford Union Society.

BEFORE RED HOUSE: OXFORD AND LONDON

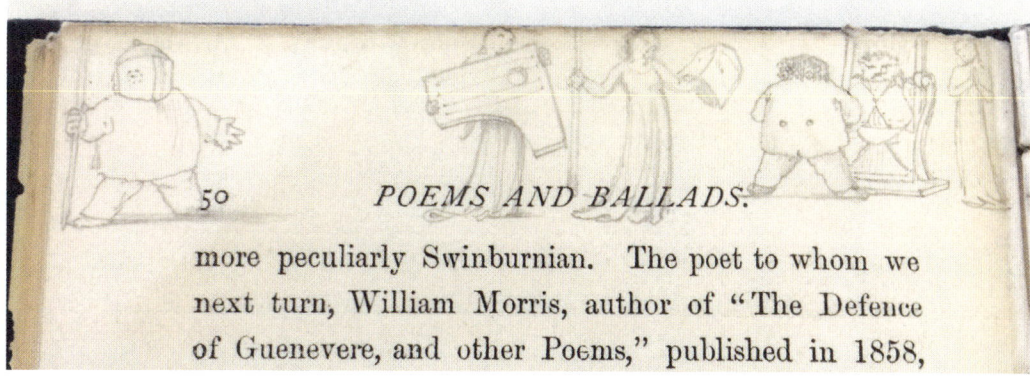

FIG. 2.10
Caricature of Morris in his suit of armour by Edward Burne-Jones, after 1866, drawn on page 50 of *Swinburne's Poems and Ballads: A Criticism*, William M. Rossetti, 1866. Pencil on paper. Burne-Jones was recalling the infamous incident when Morris became trapped inside the bassinet (helmet) he had made as a prop during the painting of the Oxford Union Debating Hall in 1857. National Trust, Wimpole Hall.

and Richard Dixon, all of whom added to the jollity of the enterprise and appear to have made valuable contributions.[31] Webb too 'gave some little help on the roof decoration during week-end visits'.[32] This coming together of amateur friends and more skilled artists was the unwitting dress rehearsal for the yet undreamt of Red House. It did not go unremembered by Morris when he welcomed his friends to work alongside him once again, on his own 'jovial campaign'. Although the mural paintings quickly flattened and faded, Coventry Patmore, who visited in late 1857, described the richness of the colours as 'so brilliant as to make the walls look like the margin of a highly-illuminated manuscript'.[33] This undoubtedly struck a chord with Morris.

Decorating the Oxford Union Debating Hall gave Morris a tangible sense of the pleasure that might be found in devising and executing painted schemes derived from literary sources and drawn from nature. He learnt the practicalities of how to build up colour and to form patterns, as he did of the level of skill and energy needed to complete successfully such tasks to the satisfaction of his own critical eye. He was later to write of his work, 'I believe it has some merits as to colour, but I must confess I should feel more comfortable if it had disappeared from the wall, as I'm conscious of its being extremely ludicrous in many ways ... I should say that the whole affair was begun and carried out in too piecemeal and unorganized a manner to be a real success'.[34] Nonetheless, it was undertaken with passion at a formative moment in Morris's artistic education and from it he developed a surer practical skill, and a profound sense of the joy of shared labour and a desire to emulate the spirit of the enterprise, if not the rather haphazard and incomplete results.

Whilst working on the Oxford Union, Rossetti's chance sighting of an eighteen-year-old 'stunner' at the theatre introduced Jane Burden into their artistic circle and to Morris. Rossetti admired her distinctive looks, which were strikingly different to the prevailing fashion of beauty, and persuaded Jane, the elder daughter of an Oxford stablehand to model for him as Queen Guinevere. Morris, with his romantic nature and his head full of chivalric stories, fell in love with the young woman and determined to marry her, notwithstanding the protestations made by his family and friends about the unequal nature of such a match. Jane modelled for Morris as he focused on his artistic career, and in 1858 Morris completed *La Belle Iseult* (fig. 2.11). It depicts Iseult mourning Tristram's exile from King Mark's court and explicitly conveys Morris's romanticism. Iseult is portrayed in a richly furnished chamber that stands as a detailed essay in Morris's own developing taste in decoration. The picture features the roughly embroidered 'If I Can' hanging, a painted chest, textiles and a brass pitcher, which subsequently appeared in the wall painting of *The Wedding Feast* in the drawing room at Red House. For Morris, the picture became a labour of love; he found defining figures and capturing a true likeness difficult and all the more challenging in this instance because of his burgeoning feelings for Jane. He was to inscribe the back of the picture with words born of great feeling and frustration, 'I cannot paint you but I love you.'[35]

'Red Lion Square was not very brilliant in 1858', recalled Georgiana Burne-Jones; 'a sense of change was in the air, and so as early as Easter they began to consider whether it was worthwhile to keep the rooms on ... At the beginning of the summer Morris told Edward of his engagement to Miss Burden, and they both realized that the old ways were now at an end and that a new order of things had begun.'[36]

With Morris's engagement, as J.W. Mackail so fluently observed of this time, 'A new kind of life opened out vaguely before him, in which that "small Palace of Art of my own," long ago recognised by him as one of his besetting dreams, was now peopled with the forms of wife and children, and contracted to the limits of some actual home, in which life and its central purposes need not be thwarted by any baseness or ugliness of immediate surroundings: an undertaking for a lifetime'.[37]

BEFORE RED HOUSE: OXFORD AND LONDON

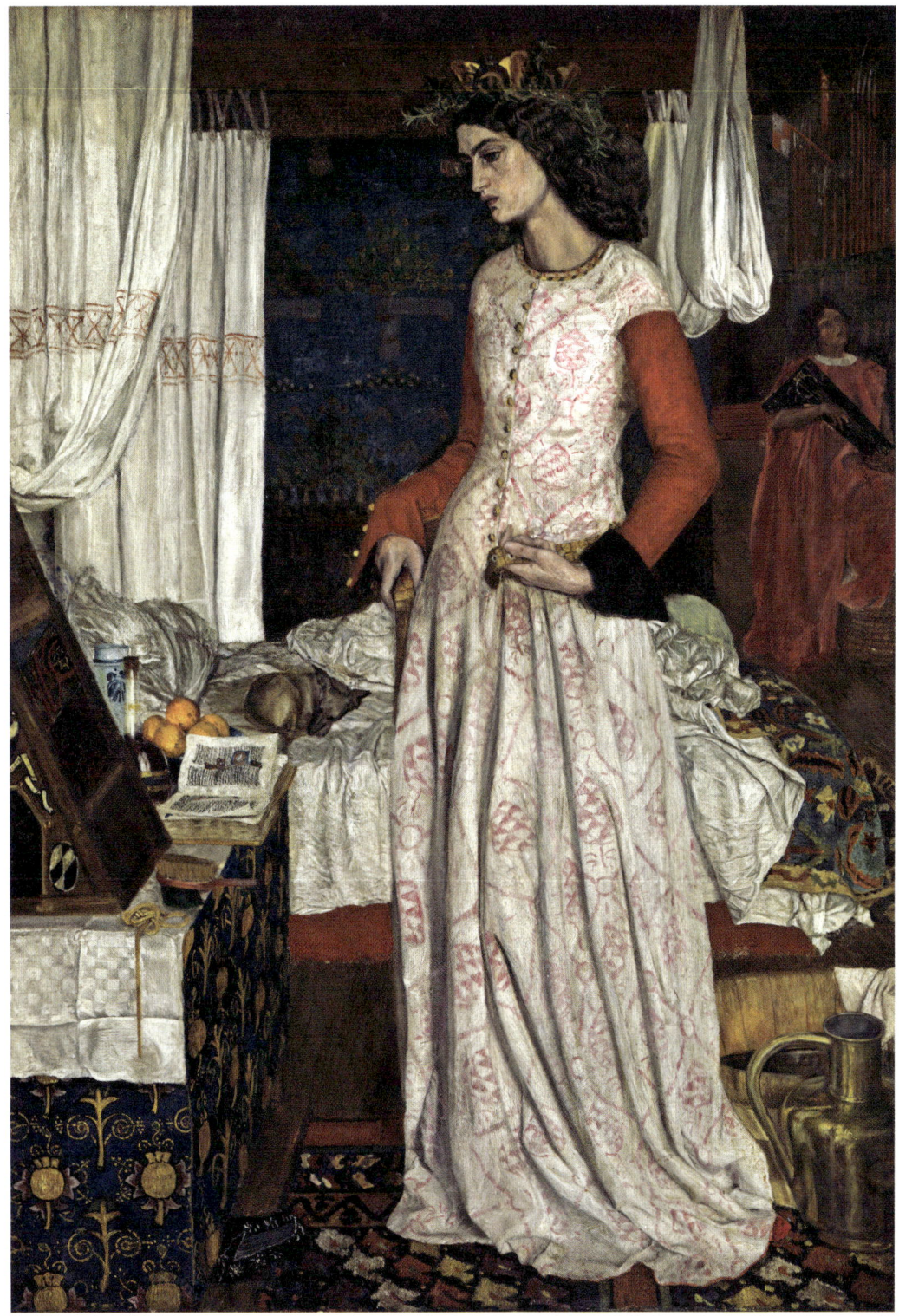

FIG. 2.11
La Belle Iseult by William Morris, 1858. Oil on canvas: 71.8 x 50.2 cm. Tate, London.

27

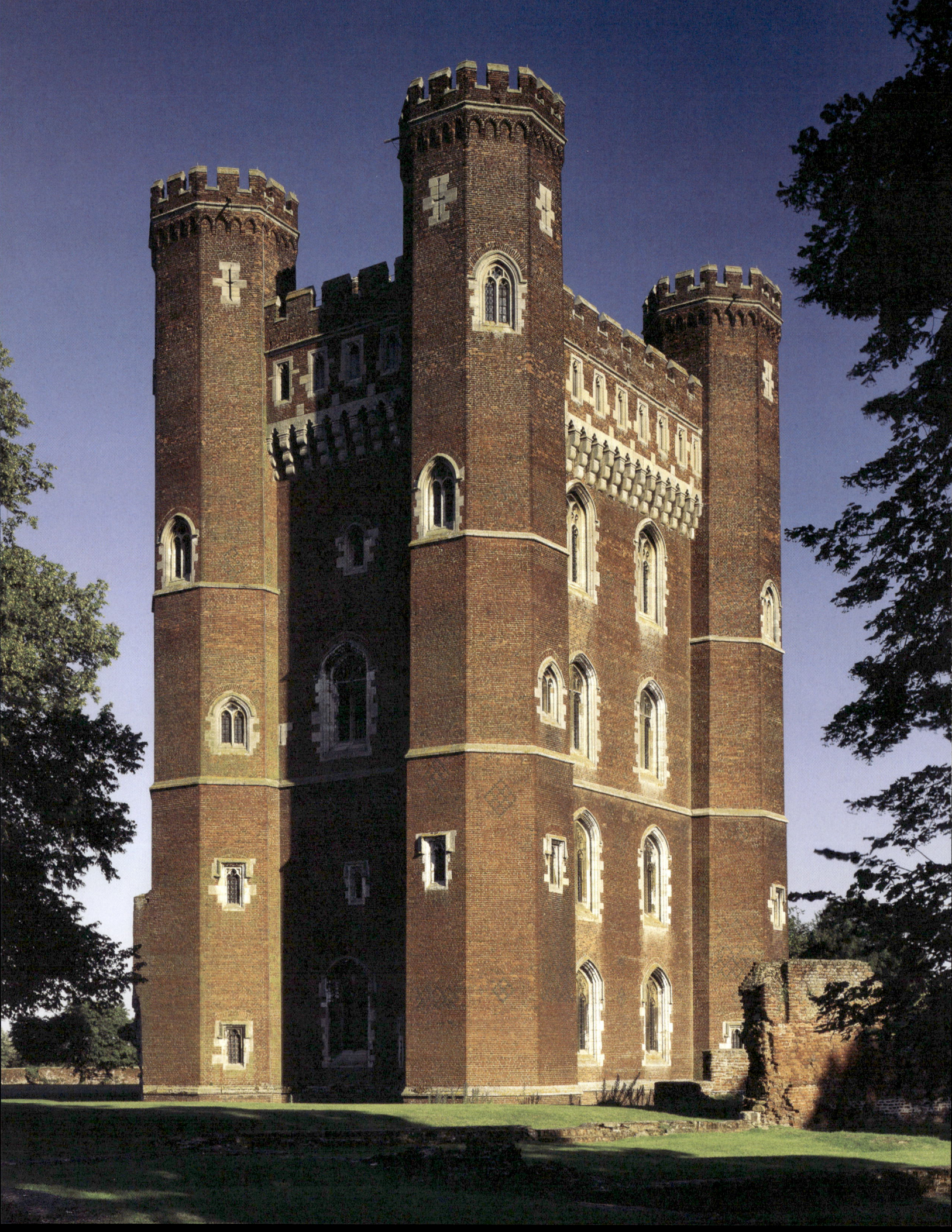

3

DESIGNING AND BUILDING RED HOUSE

My home is where I meet people with whom I sympathise, whom I love.[1]

The house fitted him exactly; there is nothing faintly pompous or pretentious about it; it is honourable, straightforward, and solidly built, but at the same time it is steeped and soaked in romanticism.[2]

Morris, Webb and Faulkner spent the summer of 1858 in France exploring medieval towns, churches and cathedrals; looking intently, responding emotionally and passionately discussing and sketching what caught their imagination. They travelled to Abbeville, Amiens, Beauvais and Chartres before adventurously rowing and sailing down the Seine from Paris in a boat that Morris had arranged to be sent over from Oxford. On this leg of their tour, they visited Poissy, Pontoise (on the tributary river Oise), Mantes-la-Jolie, Rouen and other, smaller towns en route (fig. 3.2). Morris had made several earlier trips to France, but his interest was unwavering and he was eager to share his enthusiasm with Faulkner and Webb. Having spent his previous holidays on sketching tours of England and Scotland, it was Webb's first venture abroad, and a sense of excitement and shared discovery permeated the expedition, living on in his sketches and memory. In 1905, Webb was to recall of Mantes-la-Jolie: 'I hardly think any building seen by me in France on my visits gave me more pleasure mingled with interest in its singularly impressive qualities, unhelped by what might be called ornament, than the big church at Mantes. (Our boat was leaking and had to be tarred, which hung us up for Sunday.) Its wide-embracing characteristic, and general appearance of gaunt amplitude (making it look like a veritable Noah's Ark) touched our imagination.'[3]

For Morris, the thought of his impending marriage and his long-held desire to have his own house must also have been much on his mind.[3] There does not appear to have been any question as to whom he would choose as his

FIG. 3.1
Tattershall Castle, Lincolnshire, fifteenth century. Webb greatly admired Tattershall and sketched it in 1857.

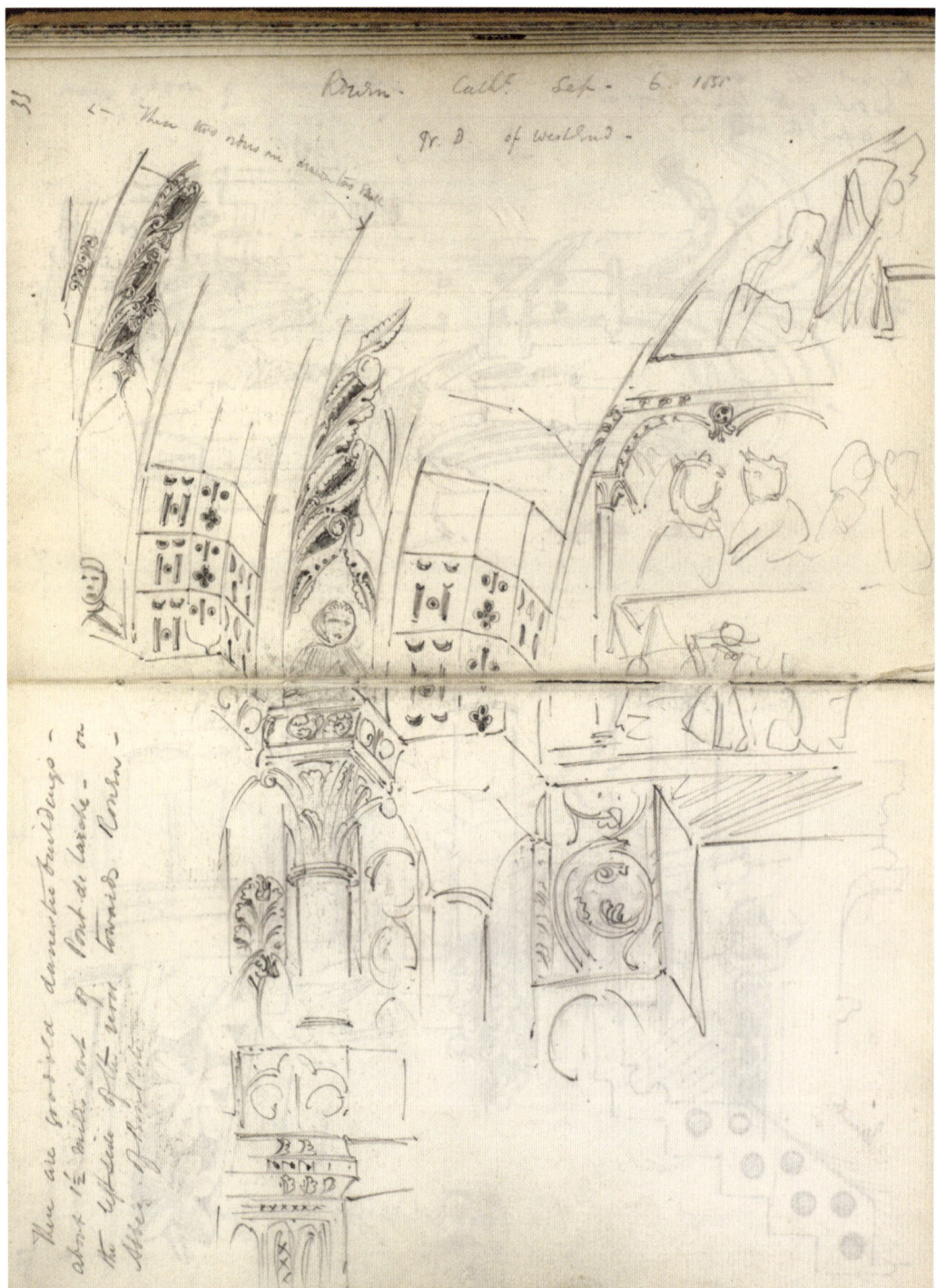

FIG. 3.2
Sketch of the west end of Rouen Cathedral by Philip Webb, 1858. Pencil on paper. Webb, Morris and Charles Faulkner arrived in Rouen on 2 September 1858 and Webb made this sketch on 6 September. It is inscribed with the note 'There are good old domestic buildings – about 1½ miles out of Pont de L'arche – on the left side of the river towards Rouen'. In between drawing and the rapt contemplation of medieval craftsmanship, they battled with soda siphons and were left stranded in a lock by an irate lock keeper. RIBA British Architectural Library Drawings and Archive Collections, Victoria and Albert Museum.

DESIGNING AND BUILDING RED HOUSE

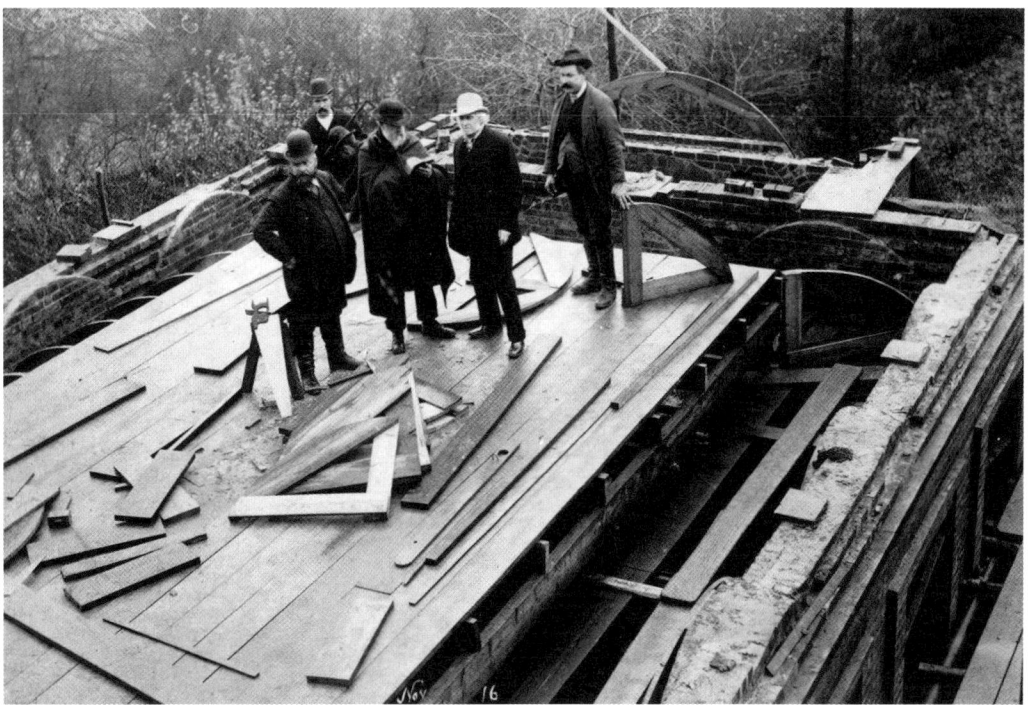

FIG. 3.3
Webb (in black bowler hat and cape) on the scaffolding at Joldwynds with his client Sir William Bowman (in pale hat), and the builder/clerk of works and other workmen, 16 November 1891. Webb disliked having his picture taken and this is the only known photograph of him at work. Although unrecorded, similar scenes with Morris and the builder William Kent, must have taken place on the Red House scaffold. RIBA British Architectural Library Drawings and Archive Collections, Victoria and Albert Museum.

architect. Webb, whom he was later to describe as 'the best man that he had ever known' was the ideal and only candidate (fig. 3.3).[4] Morris must already have broached the subject of a new house with him, for it was in France that Webb made 'a hurried sketch ... of the staircase tower ... rising to two finials ... the first idea for the staircase projection at Red House' on the back of a map in Morris's copy of Murray's *Guide to France*.[5]

With rich images of the textures, materials, craftsmanship and beauty of medieval French buildings still uppermost in their minds, Webb and Morris spent the autumn and winter searching for a site for the new house before eventually settling on an acre in the hamlet of Upton near Bexley Heath, Kent. Georgiana Burne-Jones was to recall, 'Needs must it be in the country to please them both, and in the midst of apple-trees; and such a place was found at Upton ... a roadside orchard surrounded by meadows' (fig. 3.4).[6] The deeds record that Morris paid £280 for the conveyance of a piece of land at Upton from 'T.L. Attreed Esq. to Willm Morris Esq. on 24 March 1859', just over a month before his marriage to Jane Burden in Oxford on 26 April.[7] The gentle Kentish landscape with its 'rose-hung lanes' and the historical and Chaucerian resonances of nearby Watling Street – the road medieval

31

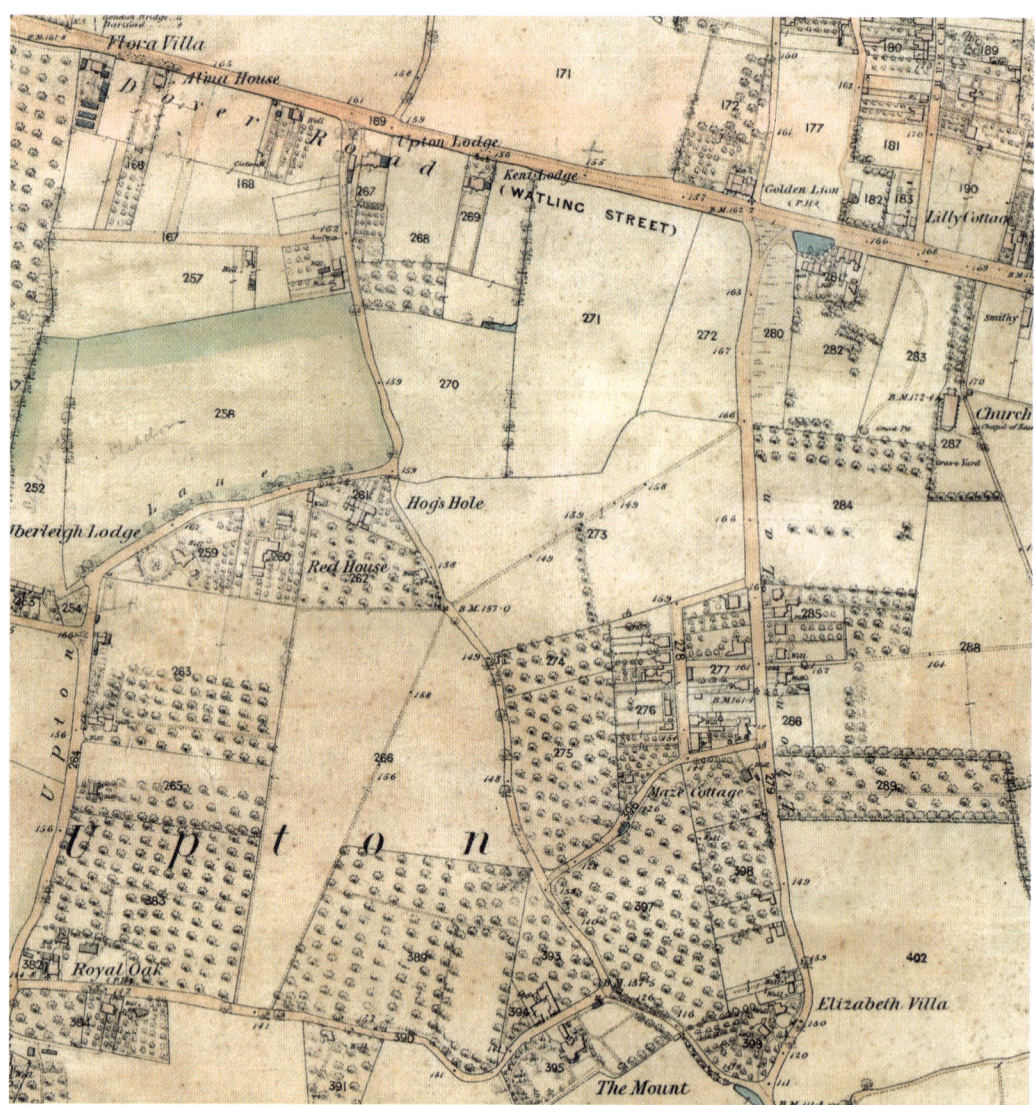

FIG. 3.4
The Ordnance Survey of 1865 shows Red House, Aberleigh Lodge and the Providence Row cottages at Hog's Hole, surrounded by orchards and fields. Watling Street, the Chapel-of-Ease and the Royal Oak were all within walking distance of the house. Bexley Local Studies and Archive Centre.

pilgrims walked on their way to Canterbury Cathedral – had the attraction of being both rural and yet within reach of London from the North Kent line station of Abbey Wood, three miles away (fig. 3.5).[8]

Upton comprised a scattering of detached villas, farmhouses, cottages, the Royal Oak public house, the Providence Row cottages at Hog's Hole and the newly built brick villa of Aberleigh Lodge, erected on a plot adjoining the land purchased by Morris (fig. 3.6). Within easy walking distance were the Danson House estate, with its neo-Palladian villa of 1755, designed by Sir Robert Taylor and the Chapel-of-Ease erected in 1835.

DESIGNING AND BUILDING RED HOUSE

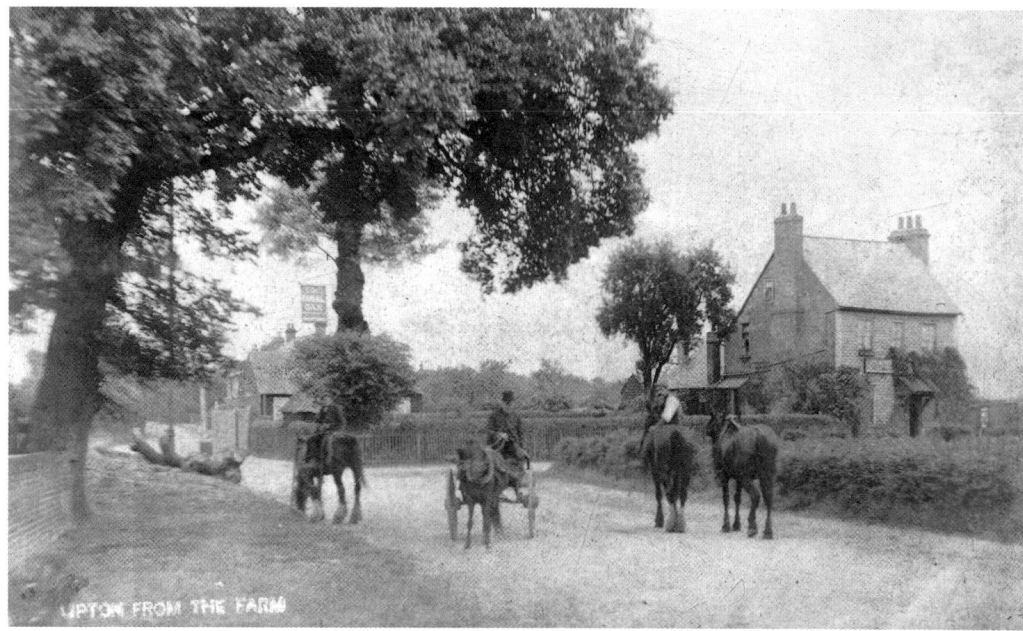

FIG. 3.5
'Upton From the Farm', the corner of Upton Lane (now Alers Road) and Mount Road *c*.1900. The farm was probably Home Farm, situated to the left of this view. The Royal Oak public house, which was in existence when Red House was built further along Upton Lane, is the building on the right. This part of the hamlet of Upton appears to have been little altered from the rural settlement that Webb and Morris alighted on when searching for a site for Morris's house in late 1858–early 1859. Bexley Local Studies and Archive Centre.

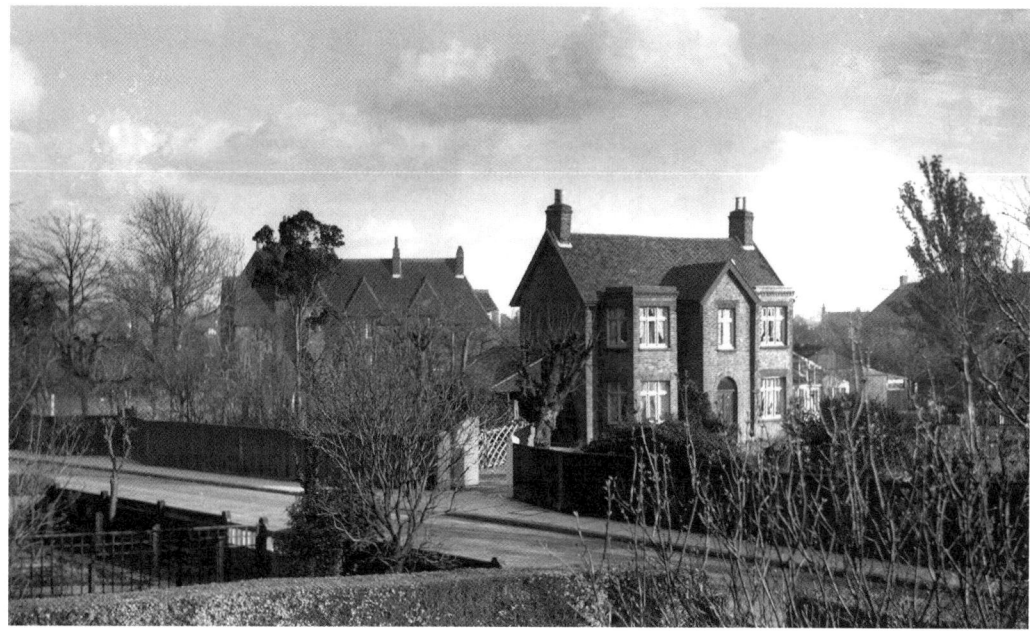

FIG. 3.6
Aberleigh Lodge from Upton Lane (now Red House Lane). Built *c*.1858–9 and lived in by the Morrises during the early summer of 1860, whilst they waited for Red House to be completed. This view shows how close Aberleigh Lodge was to Red House and that it lay on the view line west from the drawing room and bedroom windows. Bexley Local Studies and Archive Centre.

By April 1859, Webb had drawn up the first four sheets of his designs for the house: the ground and first floor plans (figs 3.9 and 3.10), north and south elevations (fig. 3.7), west and east elevations, together with the building contract, dated 16 May 1859. Webb, buoyed by the opportunity to design his first independent work, undertook this considerable task whilst still chief assistant in Street's office. He also devoted time to considering and contemplating the site, noting the approximate positions of the orchard trees and devising a scheme that placed the house centrally so as to preserve the majority of the trees. From the outset, he envisaged the house as integral to its setting and sought to ameliorate any rawness in the new building by specifying espaliered fruit trees and climbing plants against the walls, so that the garden clothed the house. He looked at local buildings as exemplars for materials and stylistic details and was to specify that 'the whole of the facing and other exposed brickwork in walls etc. to be done with bricks of the quality and color [sic] of those in the adjoining Danson Farm House ... on the south side (these bricks are supposed to be made of the ordinary clay of the neighbourhood as they are more or less used for common purposes in the whole district)'.[9] Webb left Street's practice on 27 May and executed three further designs for the stable, entrance gates (fig. 3.8) and well (fig. 3.11) by July. Morris and Jane spent the six weeks following their marriage visiting Bruges and the Low Countries, returning in June to be consulted by Webb on the final designs and to take up temporary residence in furnished rooms near him on Great Ormond Street. At the age of twenty-seven, with the commission for Red House, Webb had established his own practice. His account book reveals though that he had no income during his first two years in practice. Morris would undoubtedly have offered to pay for Webb's professional services and must have been refused on a point of principle. For Webb, designing Red House was an act of friendship and a tremendous opportunity to give expression to his own architectural voice for the closest of friends and most creative of clients. His aim was to realise Morris's desire for a house 'very mediaeval in spirit' and to achieve his own ambition to create a functional family home of great beauty, well built from traditional materials, where Morris could work as a poet and painter and effect his ideal of living.[10]

His designs for the house, stable, gate, retaining wall and well-head reveal the strong influences of vernacular buildings and of architects whose work he admired. They are imbued with his own great skill as a designer, his sure understanding of Morris's character, deep knowledge of vernacular traditions and rightness of materials (fig. 3.12). Webb gave expression to Morris's romantic medievalism, looking to the functional potential of gothic architecture and the reunification of the decorative arts with architecture that

FIG. 3.7
Detail of section 'c–d' and south elevation from contract drawing by Philip Webb, 1859. Pencil, pen and ink and watercolour. Victoria and Albert Museum.

FIG. 3.8
Contract drawing showing a detail of the entrance gates by Philip Webb, 1859. Pencil, pen and ink and watercolour. Victoria and Albert Museum.

DESIGNING AND BUILDING RED HOUSE

FIG. 3.9–3.10
Contract drawings showing the cellar, ground and first floor plans by Philip Webb, 1859. Inscribed 'Cellar Plan Ground Plan Upstairs Plan ... House to be built at Upton near Bexley Heath for W. Morris Esq ... No. 1 / This is one of the Plans referred to in the agreement signed by me this 16th day of May – 1859 – Witness P. Webb / William Kent'. The built house followed this exact plan. Pencil lines sketched in the reception rooms and bedrooms show potential locations for fixed and moveable pieces of furniture. The red tinted areas denote tiled or brick floors and the yellow timber floors. Pencil, pen and ink and watercolour. Victoria and Albert Museum.

FIG. 3.11
Contract drawing of the well by Philip Webb, 1859. Inscribed 'Philip Webb, No. 7 ... House to be built at Upton. Detail of covering to well ... This is one of the Plans referred to in the agreement signed by me this 19th day of Oct 1859 – Witness P. Webb / William Kent'. Pencil, pen and ink and watercolour. Victoria and Albert Museum.

FIG. 3.12
Streatley Mill at Sunset by George Price Boyce, 1859. Watercolour. This atmospheric depiction of vernacular buildings at Streatley in the Thames Valley, which appear to have grown organically in the landscape, reflects Webb and Morris's own fondness for local materials and the traditional, commonplace buildings of the countryside. Boyce, a friend of Rossetti, Webb and Morris, was to commission a studio house – West House, Glebe Place, Chelsea – from Webb in 1868–70. Private collection.

had first been championed by A.W.N. Pugin in the 1830s. The contemporary buildings he most admired by the Gothic architects G.E. Street and William Butterfield, who both referenced and adapted foreign precedents in their work, exerted a significant influence on him. Webb drew Butterfield's school and master's house at Great Bookham, Surrey (1856–8) in around 1858 and included his rectory at Alvechurch, Worcestershire (1855–6) and the estate houses, cottages, school and church at Baldersby St James, Yorkshire (1855–8) in the 'county lists' he drew up for himself of significant buildings in the late 1850s (figs 3.13 and 3.14).[11] Street's influential writings on art and architecture and the correlation he identified between the art of the Pre-Raphaelites – with their focus on pictorial realism, strong, bright colours, close study of nature and the inspiration they drew from the Middle Ages – and the progressive gothic architecture he practised affected both Webb's and Morris's thinking. Street argued that 'what Pre-Raphaelites are doing for painting must be done for architecture'.[12]

FIG. 3.13
Sketch of William Butterfield's school and master's house (1856–8) at Great Bookham, Surrey by Philip Webb, c.1858. Pencil on paper. The overall form of the design, which incorporates vernacular elements including steeply pitched tile roofs, prominent chimneystacks and dormers with gothic arches to windows, anticipates Red House. RIBA British Architectural Library Drawings and Archive Collections, Victoria and Albert Museum.

FIG. 3.14
Cottages, c.1855–8, with the spire of St James, 1855–7, Baldersby St James, North Yorkshire, both designed by William Butterfield. Webb's design for Red House undoubtedly draws on Butterfield's cottages, which are derived in part from vernacular models and feature many of the architectural motifs he adapted for Red House, including red brick, hipped and steep roofs, dormers and prominent chimneystacks. Webb however, purposefully differed from Butterfield by choosing not to incorporate details such as stone banding and stone mullions to windows.

DESIGNING AND BUILDING RED HOUSE

FIG. 3.15
Laverstoke Parsonage, Hampshire, G.E. Street, 1858. Designed whilst Webb was still Street's chief assistant, it is built of local materials and shares a varied roofline, tall chimneystacks and a tower with Red House.
Martin Charles/RIBA Collections.

Webb had an intimate knowledge of the designs he had worked on in Street's office, most notably the diocesan theological college at Cuddesdon, Oxfordshire, designed in 1852, and a series of churches, schools and rectories, including Laverstoke Parsonage in the 1850s (fig. 3.15). Not surprisingly, Street's influence is evident in Webb's first independent work. As Nicholas Cooper has observed, 'in its bold and simple massing of forms of ultimately medieval inspiration Red House has close affinities with Street's domestic work'.[13] The striking architectural form of the oriel window supported by a buttress, which lights the first-floor drawing room at Red House, has been identified by Michael Hall as a direct reference to 'the use of this motif in G.E. Street's Cuddesdon College', with the original source possibly being 'an English model in a much-admired medieval house, Great Chalfield Manor, Wiltshire' or more likely 'the Altes Rathaus at Regensburg', which Butterfield may well have known from visits to South Germany from 1849.[14] In similar vein, Webb refashioned the precedent of the clerestory windows of the

collegiate church at Mantes to create the run of circular windows lighting the first-floor passages overlooking the well-court. The influence of English medieval buildings, which he had first seen on his extensive tour in 1857, is another discernible element in Webb's personal architectural language. He was moved to inscribe his sketch of the fifteenth-century Tattershall Castle, Lincolnshire, with the words 'The keep is of solid and beautifully built brickwork ... bricks of a beautiful red' (fig. 3.1).[15] This might literally translate into a line from his building specification, for Tattershall's form, fine craftsmanship, deep colour and brickwork laid in English bond were all qualities that he was determined Red House should embody (fig. 3.16).

Webb's designs for Red House are marked by coherence and restraint and a pragmatic marrying of medieval and modern in a fluent whole. The tenets of medieval building are blended with contemporary practicality in the form of revealed construction and are distinguished by the conscious choice to employ modern over medieval construction techniques. Webb purposefully avoided the introduction of polychromy and stone detailing, ensuring that the plainness of the brick elevations executed in English bond possessed the unadorned quality he so much admired. He brought movement and vitality into the whole composition and to the individual elevations through the sweeping tile-hung roofs, stair tower and interplay of gothic-headed sash, lancet and casement windows. The internal and external treatment is unified by a consistency of detailing in his pared-back gothic style and a clearly expressed hierarchical distinction of spaces and functions within.

✤

Webb chose to orientate the house so that the main entrance faces north and is approached directly from the lane but shielded from it by the high redbrick wall he specified to extend along the northern boundary. Towards its western end is the entrance gateway, flanked by massive red-brick piers which originally supported a single-width carriage gate with a separate pedestrian gate with overthrow. The enclosing of the garden and separation of the house from the lane by a brick wall represents an important element of Webb's overall design for the site. The house's orientation must in part have been dictated by the position of the trees, the desire to give the rooms on the east and west elevations the best views out into the garden and to make the most of the garden areas themselves. Webb may also have had the thought of Morris's ambitious decorative schemes in mind and surmised that rooms with both north and west light would best serve the interiors within. Georgiana Burne-Jones's memory was that: 'It was not to be a large house, but so designed that additions could be made without difficulty, and to this idea it owed part of its form; indeed architect and client had but one mind about the whole work, and the result was happy.'[16]

DESIGNING AND BUILDING RED HOUSE

FIG. 3.16
Red House, north elevation, showing the strong forms of the roofscape and projecting deep entrance porch. The windows and doors have been painted in the original colour of greyed-white and brown respectively.

The south front houses the entrance to the service quarters overlooking the small service yard. The family rooms are mainly on the west and overlook the bowling green, whilst the east front houses corridors, the staircase and Morris's studio (study). The house was designed to an L-shaped plan, with the two wings meeting in a well-lit central staircase hall topped by a soaring turret from which the wide principal passages radiate. To take full advantage of the light, the dramatic roofline and views out across the surrounding countryside, Webb placed the drawing room and the studio (study), in which he anticipated Morris would paint, on the first floor. Each wing is one room deep, with wide passages on both floors overlooking the well-court to the west and south. The ground-floor accommodation comprises the entrance porch, a wide hall with broad oak stair, dining room, waiting room, bedroom, a broad passage leading to the garden porch and a door at the rear of the hall separating the family accommodation from the service areas. The service passage leads to a cupboard for 'cloaks', the stairs to a cellar and wine cellar, the store closet, 'man's pantry' with 'china closet', a water closet, the kitchen, larder, pantry, scullery, service stair and rear door opening onto the enclosed yard with a small range comprising 'dust', the servants' water closet, 'knives and boots' (a room for cleaning) and the storage of 'coals'.

FIG. 3.17
Extract from the building contract by Philip Webb, 1859. Pencil, pen and ink. This shows Webb's sketch of fireplaces for the dining, drawing and bedrooms set within the specification of works for the various craftsmen. National Trust, Red House.

The oak stair rises through three sides of a square, with the second half-landing giving onto a passage leading to two west-facing bedrooms and the water closet reserved for the use of female family members and guests. Beyond this lay the upper floor of the servants' quarters, a servants' bedroom for three staff and a small room for the housekeeper with stairs down. At the head of the oak stair lay the drawing room, landing, principal bedroom with adjoining dressing room, upper passage and studio (study).

❧

The building contract, between the builder William Kent of 8 Paulin Street, Bermondsey and Morris, is dated 16 May 1859 and comprises an agreement, the specification of works, and conditions. The price agreed for construction was £1,997 and work was to be completed in precisely six months, by 16 November. This tight timetable proved to be a miscalculation on Webb's part. Although this was his first independent commission, he was not inexperienced on site, but, perhaps infected by Morris's eagerness, he let his judgement fall prey to a keen builder and an even keener client. The house took over a year to complete and, within a month, William Kent had incurred Webb's displeasure with his dilatoriness. The decided lack of progress on the part of the builder prompted Webb to issue him with an ultimatum in June. Webb wrote that he found the work to be 'proceeding in a most irregular and unsatisfactory manner' and directed Kent to 'send a competent general foreman of the works at once' or, failing this, to be 'continually on the ground,

to attend to the directions ... [and] see the building is done to my satisfaction'.[17] No further letters in this vein are recorded and Webb's words had the desired effect. Webb's detailed specification includes comprehensive instructions for the excavator and bricklayer, tiler, carpenter and joiner, plasterer, smith, plumber, glazier and painter. Set within the text are pen and ink sketches of fireplaces, ridge tiles, iron door straps, windows, bell pulls, hopper heads and construction details to elucidate his intentions.

Webb employed a distinct repertoire of details in the form of exposed red-brick fireplaces with brick patterns delineating overmantels, exposed lintels to doors, projecting arris beads with a plain chamfer to all door and window surrounds, a simple canted cornice detail to ground-floor ceilings and sloping high ceilings to the first-floor rooms which gives the interior a unified character. The principal rooms had wooden-boarded floors in either yellow deal (dining and drawing rooms) or white deal; twelve-inch red paving tiles were specified for all the ground-floor circulating spaces, with the 'Scullery, Pantry, Larder, Cellars and Yard Offices ... to be paved with building bricks laid flat in sand and jointed with mortar' and the 'whole of the fireplaces in Sitting rooms and bedrooms to be built as the work proceeds with good red cutting and rubbing bricks set in cement, somewhat in the way of sketches' (fig. 3.17).[18]

One unusual element of the contract is the direction to the plasterer to 'provide stamps of 3 different patterns [to] stamp the ceilings with the Same where required'.[19] This was devised by Webb to give a grid of stamped holes, enabling three painted patterns of Morris's bold, repeating designs to be readily executed by him and his friends as the first phase of the interior decoration of the house. Morris's notebook shows tiny preliminary sketches of two patterns for stamped ceilings in the house, suggesting that his idea for the ceiling decoration was one of the earliest designs conceived for the interior (fig. 4.13). The stamping extended to the hall, dining room, staircase, the northern end of the service passage, the staircase (two designs), the studio (study), the principal bedroom, the upper and lower passages, the bedrooms on the west front and the servants' bedroom (with evidence of stamping surviving in the drawing room, although the painted decoration does not follow the stamped pattern). There may have been a medieval precedent for the stamped ceilings or they might have been entirely Webb's own invention, drawing on the related practice of pouncing for a cartoon for figurative painting to ceilings or a refashioning of the traditional art of pargetting, with which Morris would have been familiar in his native Essex.[20]

All of the interior woodwork, with the exception of the oak and deal stairs, was to be 'slightly stained of an approved color and twice varnished', and the

exterior wood and ironwork were to be given 'four coats of good oil color, to finish of the color directed'.[21] Anticipating Morris's painted interior of flat patterns and figurative schemes, Webb made provision for him to be provided with the necessary scaffolding to access the high ceilings and the stair tower in particular. The contractor is directed 'to leave such scaffolding standing in such position as the architect may require, for the use of the Decorators for three months after the completion of the works by the contractor free from all costs charges or expenses to the said William Morris'.[22] No doubt uncertain that all Morris planned could be achieved within this timescale, Webb added the further proviso that 'should such scaffolding be required for a longer period than said three months ... a proper sum to be fixed by the said architect shall be paid by the said William Morris'.[23]

The house also had to function on a domestic level, and Webb provides details for the fitting out of the water closets with 'best watercloset apparatus', the provision of a range in the kitchen and a copper (a water heater that produced hot water for bathing and washing clothes), iron grate and trivet in the scullery. He designed simple basket grates for all the fireplaces 'except the kitchen', and required the smith to 'Provide and fix to all the Sitting bed and dining rooms except Servants room and room adjoining numbered bells of varying tones hung to proper board in passage against Kitchen the bells to have the necessary springs pendulums, connections wires cranks etc. and the necessary preparation for ceiling pulls but no pulls to be provided only one will be required in each Room. Provide a heavier bell for front door with simple wrought iron pull in porch somewhat as sketch'.[24]

FIG. 3.18
The weathervane pierced with the intertwined initials W J M – for William and Jane Morris, the date 1859 and the head of a horse taken from the Morris family's coat of arms. Webb specified in the building contract that the vane and rod should be 'painted and gilded as required'.

DESIGNING AND BUILDING RED HOUSE

The roofs were to be tiled with 'good plain bright red tiles laid with oak pins to proper gauge on heart of oak laths' and a sketch of the profile of the ridge tile is provided by Webb. Amendments to this section for the proposed extension in 1864 state that the roof tiles should be 'from the same yard as the old (near Bromley)' with ridge tiles from 'Mr Cooper of Maidenhead'.[25] The fixings for the weathervane, designed by Webb, are specified in detail. The smith was to 'provide a wrought iron standard one and a half inches square and other ironwork shown to vane over stairs also provide and fix wrought copper vane to turn on steel pivot as shown with the necessary balance etc.', with 'the vane and rod to be painted and gilded where required'.[26] The celebratory weathervane is pierced with the initials 'W J M' for William and Jane Morris, the date 1859 and a detail of the horse's head from the Morris family coat of arms, which had been granted to Morris's father in 1843 (fig. 3.18).

The service yard and single-storey service range lie at the south end of the house and are contained by a red-brick wall to the east and a corresponding wall with a pedestrian gate to the west. Although encircled by the garden, the activities of the service yard were shielded from the garden and vice versa; although the servants might have been able to hear the fun as Morris and his friends threw apples and played bowls in the garden, they would not have been able to see it from within the yard or from the dormitory bedroom above.

❧

The rectangular stable block stands in the north-east corner of the garden and was built to accommodate two horses in a loose box and a stall and a waggonette, with a loft of two rooms: one for the storage of fodder and bedding and the other in which the groom is likely to have slept, as there was insufficient room for a male member of staff in the servants' rooms. It was the only element of Webb's design for the house and its ancillary buildings that was substantially altered in its execution on site. The drawing shows that the stable was planned to run east–west, parallel to the wall with Upton Lane, but that at the point of building, it was turned through 90 degrees to run north–south, with its entrance on the west for the stable element and on the south gable for the waggonette. The internal plan was reversed to accommodate this change in orientation. Nicholas Cooper has suggested that the 'alteration was made at the last minute without the need to revise the contract which is dated on the drawing 19 October 1859', although the reasons for this change of plan are uncertain.[27] It is built of red brick with a steeply pitched tiled roof, hipped at the north end and gabled at the south, with a small dormer on the west roof.[28] Georgiana Burne-Jones recorded that it possessed 'a kind of younger-brother look with regard to the house' (fig. 3.19).[29]

Webb chose, possibly on the grounds of economy, not to provide the house with a separate service entrance, so all traffic to the stable and goods to the

FIG. 3.19
The stable, which was the only one of Webb's designs to be significantly altered between the point of the contract drawing and its execution, when it was re-oriented. The deep roof houses a hayloft which must also have provided accommodation for the groom recorded at Red House in the 1861 census.

service yard had to pass across the front or along the west side of the house. Webb's first known sketch plan of the site, of about 1859, suggests that at this early stage in his deliberations he was considering a separate gateway to Upton Lane, close to the stable, but that this had been abandoned by the time that the contract drawings were produced.

The ornamental well-head, with its echoes of Kentish oast houses and lychgates, stands at the centre of the space created within the angle of the L-shaped house, overlooked by wings to the north and west. It has a steeply pitched conical tiled roof supported by a heavy timber framework, which in turn sits on a low brick plinth within a square apron of red-brick paving on the lawn. Morris's knowledge of water features depicted in medieval illustrations of herbers and other enclosed gardens may well have been the original source for the idea which Webb translated into three-dimensional form (fig. 3.20).

Webb designed a further functional and highly decorated element of the Red House ensemble: a horse-drawn waggonette, in which the Morrises drove

FIG. 3.20
The well with the Pilgrim's Rest porch and south-facing windows.

around the countryside and brought guests to the house from the station. May Morris conjures up a colourful image of the equipage and its impact as it passed through the local villages (fig. 3.22).

> *These dear young people and their wagonette! It was covered with a tilt like an old-fashioned market cart, made of American cloth lined with gay chintz hangings; the Morris arms were painted on the back. When it was finished, they used to go little jaunts with their friends, and their appearance caused much joy in the neighbourhood, where it was thought they were the advance-guard of a travelling-show. One day, the tilt was blown bodily off in a high wind.*[30]

The painted decoration of the family coat of arms depicting, in azure, a horse's head erased argent between three horseshoes (fig. 3.21), was the perfect heraldic device for such an equipage and visually tied the wagonette to the house through the shared use of imagery in the Pilgrim's Rest porch and on the weathervane. The waggonette was joined in the stable by a horse procured in Derbyshire:

> *My mother has told me about the buying of the horse at Clay Cross horse-fair. (Clay Cross was the home of my Father's eldest sister Emma: the chum of Marlborough school-days.) As she spoke the stillness of her face would be moved by smiles at recollection of the scene, recounted by Father on his return. Would that she could have given the very words! For it was all presented to her dramatically, dialogue and action: what the horse-dealer said to him and what he said to the horse-dealer, and 'it was very, very funny!' As you know, my Father always acted a story, and the climax would be led up to with art, and well done.*[31]

With 'Morris's dream dwelling ... the ultimate Pre-Raphaelite building' and its ancillary buildings erected and the wagonette designed, Red House was ready to be occupied and made into a home.[32]

DESIGNING AND BUILDING RED HOUSE

FIG. 3.21
Coat of arms tile, designed by William Morris, c.1859–60. Morris's tile design for the back of the bench seat in the Pilgrim's Rest porch shows the family coat of arms 'azure, a horse's head erased argent between three horse shoes' granted to his father in 1843. May Morris records that it was also painted on the back of the covered waggonette.

FIG. 3.22
A sketch from Webb's notebook, c.1858, showing a traditional wagon, which may have provided the model for the covered waggonette he designed for the Morrises. RIBA British Architectural Library Drawings and Archive Collections, Victoria and Albert Museum.

51

4

DECORATING AND FURNISHING THE HOUSE

If I were asked to say what is at once the most important production of Art and the thing most to be longed for I should answer A Beautiful House ...[1]

... when the shell of the house was completed, and stood clean and bare among the apple trees, everything or nearly everything, that was to furnish or decorate it had to be likewise designed and made. Only in a few isolated cases – such as Persian carpets, and blue china or delft for vessels of household use – was there anything then to be bought ready-made that Morris could be content with in his own house.[2]

In early summer 1860, as the building of Red House was close to completion, William and Jane Morris were living in the neighbouring villa Aberleigh Lodge and must have visited the house every day to check on progress, make plans and picture life together in their 'palace of Art'. Morris's sense of anticipation and excitement and his eagerness and impatience to take possession would have been palpable (fig. 4.1).

In his deliberations about the appearance of the house and the detailed narratives he wished to convey within it, Morris drew on the eclectic visual and literary memory he had amassed since childhood and refashioned and wove together individual elements to create a distinct and deeply personal series of interiors. The vast lexicon of influences from which he derived inspiration included Arthurian romances, interiors illustrated in illuminated manuscripts, Chaucer's tales, details of cathedrals and churches, the Bayeux Tapestry, Pre-Raphaelite art and medieval stained glass.[3]

Morris first saw and became mesmerised by textile hangings when he discovered the Tudor interior of Queen Elizabeth's Hunting Lodge in Epping Forest (fig. 4.2). As a boy, he had his own miniature suit of armour and rode in the medieval royal hunting forest which lay close to his home with his head full of chivalric tales of romance and knightly prowess, garnered

FIG. 4.1
The carefully orchestrated view through the entrance porch to the wide hall and oak stair beyond.

FIG. 4.2
Queen Elizabeth's Hunting Lodge in Epping Forest held great historical resonance and romance for Morris.

from the pages of Walter Scott's novels. The Lodge, originally built by Henry VIII as a hunt standing (grandstand) from which he could view the chase, exerted a powerful and lasting influence on Morris's imagination. Although the building had been altered, Morris was able to conjure up the atmosphere of the past and revel in the ancient spirit of the place. He recalled: 'How well I remember as a boy my first acquaintance with a room hung with faded greenery at Queen Elizabeth's Lodge … and the impression of romance that it made upon me'.[4] As Fiona MacCarthy has identified, 'Looking inward Morris saw the sort of room he loved immediately and always sought to emulate in one way or another. The bareness of its outline and the richness of its detail; space, strength and masculinity; the overtones of chivalry. Morris's ideal interiors are here.'[5]

The vivid colours given life in poetic form in his first published volume of poetry, *The Defence of Guenevere*, in 1858, are drawn from a rich palette held in his mind's eye from illuminated manuscripts, textiles, wall paintings, medieval glass and the intense colours of the Pre-Raphaelites. Lethaby was to reflect that 'Morris's colour-work glows from within' and Morris, already honing his skills, was arguably to become the most gifted colourist of his age.[6]

THE BLUE CLOSET[7]
Alice the Queen, and Louise the Queen,
Two damozels wearing purple and green,
Four lone ladies dwelling here
From day to day and year to year;
And there is none to let us go;
To break the locks of the doors below,
Or shovel away the heaped-up snow;
And when we die no man will know
That we are dead; but they give us leave,
Once every year on Christmas-eve,
To sing in the Closet Blue one song;
And we should be so long, so long,
If we dared, in singing; for dream on dream,
They float on in a happy stream;
Float from the gold strings, float from the keys,
Float from the open'd lips of Louise;
But, alas! the sea-salt oozes through
The chinks of the tiles of the Closet Blue

Morris's poem was inspired by Rossetti's intensely coloured, tightly composed watercolour of the same title (fig. 4.3). It is a subjective rather than a literal response, though it equally conveys a sense of the intensity of colour that Rossetti depicted in its allusions to broad swathes of 'purple, green, white, golden, scarlet, blue'.[8]

The study of illuminated manuscripts for their texts and their luminous illustrations had attracted Morris since his Oxford days, when he was known to spend hours in the Bodleian. This was to be an enduring passion which led him, under the aegis of G.E. Street, to attempt the mastery of the art of illumination for himself. On moving to London, he derived great pleasure and stimulus from studying the manuscripts at the British Museum. One example of Morris's earliest illuminations is a single sheet comprising two verses from Robert Browning's poem *Paracelsus*, which Morris made in 1856–7 (fig. 2.1). He admired Browning's poetry and was to become friendly with the poet through Rossetti. The text of the illumination is written in a gothic script with two historiated capitals set against gold blocks, curling foliate decoration in red and blue, and framed by two hybrid beasts with grotesque heads and wings. By this time, Morris had become acquainted with his hero Ruskin and was recommended by him to the keeper of manuscripts at the British Museum as a man of talent 'as great as any thirteenth-century

FIG. 4.3
The Blue Closet by Dante Gabriel Rossetti, dated 1857 but probably completed in 1856. Watercolour on paper: 35.4 x 26 cm. This is one of the intensely coloured, dramatic watercolours Morris commissioned directly from Rossetti. It inspired Morris's poem of the same name, published in *The Defence of Guenevere* in 1858. Although the subject of Rossetti's watercolour remains uncertain; the colours, form of the instrument and blue and white tiles depicted have a stylistic affinity to the furnishings and interiors Morris created at Red House. Tate, London.

draughtsman'.[9] Rossetti, too, was unstinting in his praise and wrote that 'in all illumination and work of that kind he is quite unrivalled by anything modern that I know'.[10] This work is revealing of Morris's understanding of the building up of colour to create the glowing illuminated image and his instinctive ability at pattern-making. It anticipates the detail of the similar foliate patterns found on a much larger scale in the background of his embroidery of Hippolyte and the foliate flat patterns on the Red House drawing room ceiling.

At Red House, he had his first unfettered opportunity to give expression to this artistic inheritance; to forge something new and imbue it with just such a romantic spirit and intimate atmosphere. Morris was to mastermind the overarching scheme for the interior. Though, by its very nature, it was an inherently shared endeavour, a collaborative enterprise which was discussed and debated amongst his close friends and brought to life by their shared sensibility, literary and visual landscapes, and with their own skill and creative force.

What did it look like and what was Morris's overall vision? It now takes a considerable effort of the imagination to visualise the interior of 1860–5. Recent research has centred on understanding what survives of Morris's striking interiors and the teasing out of myth from reality. Much of the surviving evidence in contemporary accounts is anecdotal or recalled after a considerable passage of time. Amongst the most revealing are letters by Rossetti and the artist William Bell Scott, and the recollections of Webb and Edward and Georgiana Burne-Jones. There are also Burne-Jones' drawings and studies for the wall paintings and sketches in Morris's notebook of ceiling patterns and the embroidery scheme for the dining room, but unfortunately no contemporary drawings, watercolours or photographs of the interiors are known and there is no detailed account by Morris of his intentions, frustrations or achievements at Red House.

Architectural paint analysis of the wall surfaces and study of the painted furniture has revealed that the original decorative finishes have survived to a surprising degree – providing tantalising glimpses of the rich, polychromatic interiors. This newly uncovered evidence demonstrates Morris's love of earthy colours, flat patterns and figurative painting, his burgeoning talent for design and pattern making and his great skill as a colourist, which was to come to the fore in his designs for the Firm that he founded from Red House in 1861. In uniting the known furnishings and contents of the rooms with this much better understanding of the decorative schemes, it has also been possible to identify an overarching theme which connects the figurative painted decoration and figurative embroidery scheme envisaged for the principal rooms of the house – the hall, the dining room, the drawing room and the principal bedroom. The theme of love in its many different guises is inherent to all these works and expresses Morris's preoccupation

with building his own house after his decision to make a romantic marriage. Red House stands as the embodiment of Morris's youth – art, friendship and love are its very heart.

❧

Red House has traditionally been seen as a house with a series of ambitious but disparate interior schemes. The image of Morris exuberantly starting each new scheme before completing the last, and the incomplete nature of the whole, have added to this idea of visual cacophony. The interiors appear, however, to have had a much more coherent, unified appearance than has previously been understood. The strong palette of colours – warm reds, yellows, greens, blues, browns – flows throughout the house, uniting the whole. So too do the stained glass in the windows, the tiles in fireplaces, the red floor tiles and wooden floorboards, and Webb's beautifully detailed exposed red-brick hearths. Rather than a series of discrete decorative schemes in each individual room, there was a carefully controlled fluency and strong visual movement between each space, with lighter, brighter passages leading into richly patterned, intensely coloured spaces with through-decoration in the form of repeated stylistic motifs and settings. The figurative schemes planned for the hall settle, dining room embroideries, drawing-room wall and settle paintings and principal bedroom wall painting, for instance, all feature figures in an outdoor or garden setting with shared characteristics. There is a quality to the interior, embodied in the use of exposed brick and timber elements, which is an essential part of Webb's architectural language and a celebration of the honesty of materials. A slightly rough character, which also engenders a sense of immediacy and urgency, permeates some of the decorative paintwork; there are drips of paint in evidence on the wall painting in the principal bedroom which could readily have been removed, and the lack of obvious polish to the finishes suggests either an amateur hand at work, or perhaps that the hand was called away and the final flourishes were left awaiting a moment which never presented itself. There is the strong sense that it was more important to capture the essential truth of a piece than to produce highly sophisticated works.

In late summer 1860, the long-planned 'jovial campaign' of decorating and furnishing the house and of making it a home began.[11] Almost immediately, the Burne-Joneses joined the Morrises for an extended stay of several months. Georgiana Burne-Jones recorded that 'Charles Faulkner came down a couple of days after we did, and helped to paint patterns on walls and ceilings, and played bowls in the alley, and in intervals between work joined in triangular bear-fights in the drawing room.'[12] Webb, Swinburne, Rossetti and Elizabeth Siddal all visited and contributed to the decoration as often as time would allow. At Red House, women were co-workers and

DECORATING AND FURNISHING THE HOUSE

Morris welcomed and encouraged their artistic aspirations and talents.[13] All hands were happily put to work on the great artistic enterprise and these earliest days at Red House were charged with good fellowship and a shared sense of purposeful creative endeavour as they embraced the opportunity to create a setting for the way they wanted to live. Intense periods of work were punctuated by forays into the surrounding countryside, hearty meals, games of bowls, apple fights and schoolboy pranks (fig. 4.4).

Faulkner and William and Jane Morris are all recorded working on the ceilings this summer. Faulkner reprised his role of ceiling painter from the Oxford Union. Webb had ensured they were ready for painting by specifying that two coats of whitewash were applied as a ground for their colourful, intricate pattern-making. Alongside the decoration, Morris was directing plans for the furnishing of the house. The furniture designed by Morris for Red Lion Square, which moved with him to Red House, *The Prioress's Tale* wardrobe designed by Philip Webb and painted by Burne-Jones, and the furniture wrought specifically for Red House by Philip Webb, were highly individual, hand-crafted, personal pieces. These pieces spoke of their designers' and makers' emergent ideas about art, beauty and fitness for purpose, and their shared love for beautifully made objects which looked to past traditions reinterpreted for their own time and which, in their decoration, fused references from art and literature. They reflected a growing interest in painted furniture which emerged in the 1850s in the flamboyant and strongly coloured work of William Burges. These, together with pieces by Millais and Holman Hunt, amongst others, were the antithesis of the mass-produced

FIG. 4.4
A lively piece of graffito hidden from view above an angled beam above the stair. Five strokes of a brush loaded with the same blue paint used on the slopes of the ceiling created a smiling face, which encapsulates the spirit of a house that resounded with cries of laughter and good fellowship.

FIG. 4.5
The Damsel of the Sanct Grael by Dante Gabriel Rossetti, 1857. Watercolour on paper: 34.9 x 12.7 cm. In this intimate work, commissioned by Morris, Rossetti depicts the damsel of the Holy Grail from Malory's *Morte d'Arthur*. The damsel, who is modelled on Elizabeth Siddal, symbolises purity and the dove the Holy Spirit. Tate, London.

FIG. 4.6
The Tune of Seven Towers by Dante Gabriel Rossetti, 1857. Watercolour on paper: 35.4 x 26 cm. Morris commissioned this watercolour directly from Rossetti and published a poem with the same title in *The Defence of Guenevere*, 1858. The richly coloured, crowded interior is densely furnished with bed hangings which are very close to the form of the tree in Morris's *If I Can* embroidered hanging of 1856 and his later *Qui bien aime tard oublie hanging*, c.1861. The canopied chair may have suggested the 'great painted chair' made to Morris's design which Georgiana Burne-Jones and May Morris record. Tate, London.

FIG. 4.7
The Chapel before the Lists by Dante Gabriel Rossetti, 1858. Watercolour on paper: 40 x 41.9 cm. Rossetti portrays a chivalric scene of an unknown lady and a knight before an alter in a chapel, which appears to be drawn from Arthurian legend. Tate, London.

furniture against which Morris railed.[14] The purposeful functionality of the furniture that Webb designed suggests that he may already have had a hand in designing furniture, or at least overseen its manufacture, whilst in G.E. Street's office. He may also have been consulted by Morris when he made his first furniture designs for Red Lion Square. Webb's earliest known piece of furniture is *The Prioress's Tale* wardrobe, which was designed with a simple hinged door spanning two-thirds of its width, giving a large flat expanse, admirably suited for painted figurative scenes. Morris's response to the wardrobe is unrecorded but as a gift fashioned for his marriage by his two closest friends, and decorated with one of the *Canterbury Tales*, he must have delighted in it.

The design of the wardrobe gave Webb a stylistic lexicon on which he drew for details throughout the house. The gothic detail of the crenellated banding on the wardrobe is deployed in similar form on the dining room dresser and the fixed wardrobe in the dressing room, whilst a variant is to be found on the crenellated newels to the stair and the notched door lintels. The wardrobe is a spectacular and seminal piece which, in its form, subject matter and the collaborative nature of its production, stands as a prelude to Red House – a miniature evocation of what was to come.

Burne-Jones recollected how the chairs and settle brought from Red Lion Square were supplemented by significant pieces commissioned for the house: 'There were the painted chairs and the great settle ... but these went only a little way. The walls were bare and the floors ... Webb had already designed some beautiful table glass ... metal candlesticks, and tables ... for the fireplaces I designed painted tiles ... the floors were covered with eastern carpets ... and it was a beautiful house'.[15] In October 1858, Morris had been in France 'to buy old manuscripts and armour and iron-work and enamel' that, along with his art collection, which included *April Love* by Arthur Hughes (fig. 2.2), five medievalising watercolours by Rossetti (*The Damsel of the Sanct Grael* (fig. 4.5); *The Tune of Seven Towers* (fig. 4.6); *The Blue Closet*; *The Death of Breuse Sans Pitie*; *The Chapel before the Lists* (fig. 4.7)), *The Hayfield* by Ford Madox Brown (fig. 4.8), engravings by Dürer, pen and ink drawings by Burne-Jones and his own painting of his wife as *La Belle Iseult* (fig. 2.11), all moved with him to Red House.[16]

Amongst the five painted chairs brought from Red Lion Square were two high backed, unwieldy, gloriously coloured and patterned pieces, described by Rossetti as 'such as Barbarossa might have sat in'. The first chair is inscribed 'The Arming of a Knight' (fig. 2.6) and is believed to draw on Morris's poem 'Sir Galahad: A Christmas Mystery'. The second chair is decorated with a scene depicting Guendolen in the tower with the prince below and is inspired by Morris's poem 'Rapunzel' and bears the painted inscription in Morris's hand 'Glorious Guendolen's Golden Hair' (fig. 2.7). Rossetti's painting shows a lady bestowing her favour on a kneeling knight, watched by seven women

FIG. 4.8
The Hayfield by Ford Madox Brown, 1855–6. Oil on mahogany panel: 24.1 x 33.3 cm. Morris bought this painting directly from the artist in 1856 for 40 guineas and was to return it to Madox Brown in late 1860 in exchange for 'work to be done at the Red House'. The work envisaged was possibly figurative painting on the walls, although it does not appear to have been undertaken, for in 1864 Madox Brown made a payment to Morris for the picture. Tate, London.

wearing identical white headdresses, some of whom play musical instruments. Two tub chairs and a throne-like chair were also transferred to Red House (fig. 4.9).[17]

Webb designed six pieces of built-in furniture for the house: the hall settle, the dining room dresser, the corner cupboard in the downstairs bedroom, the fixed wardrobe in the dressing room adjoining the principal bedroom, and fixed wardrobes in the two bedrooms on the west front. He also adapted the 'great settle' from Red Lion Square so that it suited the requirements of the drawing room. These pieces are marked on his floorplan with faint pencil lines indicating positions and, remarkably, all have survived in situ, and give a strong sense of the stylistic unity his pieces had with their bold forms and gothic-inspired detailing. In addition, Webb was responsible for much of the other furniture in the house, making designs for small oak tables and simple painted furniture for bedrooms and servants' quarters. It is interesting to note that after his bold foray into furniture design for Red Lion Square, Morris does not appear to have contributed to the design of furniture for Red House but rather entrusted this considerable task to Webb. Consequently, the

furniture with which the house was populated had a slightly sparer, more functional quality than the medieval chairs made to Morris's design. A few objects were acquired by Morris, with some everyday items coming from his mother in Essex to bolster the sparsity of furniture in the earliest days of the house. His mother may well have provided a half-tester bed for the principal bedroom, which was recorded by May Morris; although its present whereabouts are unknown.[18] A sofa is recalled by Georgiana Burne-Jones on the day of Jenny's christening on 21 February 1861, when 'Janey and I went together to look at the beds strewn about the drawing room for the men, Swinburne had a sofa; I think Marshall's was on the floor', but no record of its appearance has survived.[19] There are rooms for which it has not been possible to identify furniture, beyond knowing that there must have been a minimum of a bed and a chair for them to offer guests even a modicum of comfort. May Morris also recorded in 1926, an 'eastern' and a Turkey carpet at Kelmscott Manor, which had come from Red House, and one of these is likely to have been the 'Marsulipatam' carpet she mentions as having been in the drawing room.[20]

As the lives of the various friends evolved, with their own work taking precedence and family life holding sway, they were naturally not so often at Red House as in the first halcyon year. Contributions to the interior must have become much more episodic, with short bursts of activity as visits would allow. The founding of the Firm in 1861 drew Morris's attention away from the domestic sphere, and the unfinished nature of the house was probably at the time viewed as a temporary hiatus in the whirlwind of establishing a

FIG. 4.9
Chair by William Morris, c.1856. Ebonised and painted wood: 63 x 75 x 51.5 cm. The simple construction and medieval style of this chair suggests it was originally made for Red Lion Square. The curved back is enlivened by eight panels of rather naively painted stylised plant forms. William Morris Gallery.

business and forging a reputation. Burne-Jones's comment that Morris 'is slowly making Red House the Beautifullest place on earth' alludes to both the gentler pace and the charm of the result after 1862.[21] Rossetti, whose admiration was often tempered by jokes at Morris's expense, was equally drawn to the fluent, lyrical character of the place. He wrote to the American writer and academic, Charles Eliot Norton: 'I wish you could see the house that Morris has built for himself in Kent. It is a most noble work in every way, and more a poem than a house such as anything else could lead you to conceive, but an admirable place to live in too.'[22]

ENTRANCE PORCH

> **DOMINUS CUSTODIET EXITUM TUUM ET INTROITUM TUUM**
> *'The Lord shall preserve thy going out and thy coming in'*[23]

On seeing the painted Latin inscription in dark blue gothic script, every entrant was made aware that in passing through the entrance porch, the promise of good fellowship and a warm welcome lay within (fig. 4.10). With this quotation, Morris's inherent generosity and hospitality is etched on to Red House's physical form. Georgiana Burne-Jones was to recall that when she and Edward made their first visit to the house in late summer 1860, 'I think Morris must have brought us down from town himself, for I can see the tall figure of a girl standing alone in the porch to receive us'.[24] The deep porch offered shelter and twin oak benches on which to rest; it was the prelude to the expansive hall, hidden behind the brown arched door, partially glazed with panels of leaded bottle glass in emulation of a medieval precedent.[25]

HALL

An anonymous visitor, remembering his first visit in 1863, recalled 'the hall appeared to one accustomed to the narrow straight ugliness of the usual middle class residence of those days, as grand and severely simple. A solid oak table with tressle like legs stood in the middle of the red tiled floor ... and a hospitable fireplace gave a roomy look to this hall place.'[26]

Not every visitor was so taken with the interior of the house upon finding themselves in the hall. When Dr Furnivall, the founder of the Chaucer Society, complained about the colours, in particular the yellow and the 'London mud' colour, Morris is reported to have curtly dismissed him with the words 'Don't be a damned fool!'[27]

DECORATING AND FURNISHING THE HOUSE

FIG. 4.10
The Latin inscription above the entrance door reads: 'The Lord shall preserve thy going out and thy coming in'. The lower walls are believed to have had a green and red painted floral pattern. The present Morris & Co. wallpaper, *Apple*, was introduced in the twentieth-century.

WILLIAM MORRIS & HIS PALACE OF ART

FIG. 4.11
The stair today with Morris's decoration surviving on the ceiling. The walls were originally yellow.

Webb created a version of a medieval living hall, a distinct room heated by a red-brick fireplace lined with tiles, with his own settle placed on the opposite wall. The hall also served as a circulating space giving onto the oak stair, dining room, service passage, lower passage and waiting room. From the entrance, the eye is immediately drawn to the broad oak stair,[28] where, as Mark Girouard has observed, 'the huge pinnacle newel-posts rise like frozen bishops and carry the eye to the open and boldly patterned roof' (fig. 4.11).[29] The floors were laid with '12 inch red paving tiles' which echoed the deep red of the exterior brickwork and the hearth.[30] The walls possibly had a green and red floral pattern or a yellow distemper, edged with a dark red line around doors, window frames and skirting, in preparation for a figurative scheme of scenes from the Trojan Wars.[31] Burne-Jones conveys the passionate enthusiasm and high levels of ambition he and Morris shared, when he recounts: 'We schemed also subjects from Troy for the hall, and a great ship carrying Greek heroes for a larger space in the hall, but these remained only as schemes, none were designed except the ship'.[32] A study of Jane by Morris, which potentially portrays her as Helen of Troy preparing to board a ship (fig. 4.12),[33] may be a preparatory work for this great, unexecuted scheme which spoke of the enduring fascination for this subject shared by Morris and Burne-Jones.[34] In his notebook from the Red House period, Morris lists 'Judgement of Paris, Carrying off Helen, Battle, Death of Hector, [Death of] Achilles, Wooden Horse, Return of Greeks' and, on the opposite page, has made a rough sketch of what might be Greek or Trojan warriors.[35] Morris was working on his Trojan poem in blank verse, 'Scenes from the Fall of Troy' – which places Helen's love for the warring Menelaus and Paris at its heart – from 1857 onwards but left it unfinished in the early 1860s.[36] He purposefully derived his story from the later medieval retellings, rather than the earlier classical accounts of the siege of Troy. As A.P.M. Wright observes, in his poem, 'Morris has ... medievalised the physical and moral setting within which his characters act. From the walls of Troy, protected by lily-spangled moats, the Trojan ladies watch the battles of their lovers, who have sallied out to tilt past barriers like those in Froissart, some wearing, like medieval knights, those ladies' favours on their helmets.'[37] This suggests that had Morris and Burne-Jones executed their proposed scenes of Troy on the walls; they would have had a medieval character in keeping with the scheme of heroic women in the dining room, the panel painting on the hall settle and the Arthurian romance of *Sir Degrevaunt* in the drawing room.

A plain canted cornice rises from the head of the wall to the stamped ceiling, which was decorated in white and yellow after William and Jane moved in. A sketch for the stamped pattern of alternating blocks of colour survives in Morris's notebook (fig. 4.13). The inner face of the front door and the door to the dining room were painted a dark green, as was the glazed door screen which separates the hall from the passage.[38] Square-ended lintels 'to project

FIG. 4.12
Jane Morris in medieval costume by William Morris, c.1860. Pencil and ink on paper: 51 x 41 cm. The subject of this drawing is not definitively known and both Helen of Troy boarding a ship and Iseult leaving Ireland have been suggested. If the former, it is likely that it is a preparatory drawing for the unexecuted hall wall paintings. Willliam Morris Gallery.

DECORATING AND FURNISHING THE HOUSE

beyond the face of plaster and to be wrought where exposed to view' with three gouged notches are found above the internal doors, but all evidence of their original coloured finish was lost when they were returned to plain deal in the early 1950s.[39] The yellow walls with red details continued up the staircase, rising up to the springing of the ceiling, which soars high into the stair tower and forms a dramatic counterpoint to the solidity and simplicity of the stair. The ceiling is painted with two contrasting but allied repeating patterns: the flat is an alternating green and blue weave-like pattern on an off-white ground, and the angled sides have snaking green and blue flowerheads rising upwards to the roof (fig. 4.15). The decoration is at once strikingly bold in its apparent simplicity and evocative of medieval precedents. Paint analysis of the two ceiling planes has confirmed that this decoration is original and has never been painted out or covered over by later wallpapers, so has been on continuous view since around 1860–1. It has also revealed that there was a partial scheme in red and yellow which was quickly abandoned and painted out in favour of blue and green – in dramatic contrast to the walls (fig. 4.14). Although the ceiling design was planned well in advance of the painting, colours and details were critically judged by eye and adapted at will.

The exposed structural timbers of the stair tower, which presently reads as a uniform brown from the landing, were originally painted a warm black and dark brown; slightly different shades were applied at a similar point in time, perhaps mixed and applied by different hands. At the base of the four

FIG. 4.13
Detail from Morris's notebook *c.*1858–60 showing preliminary sketches of two patterns for stamped ceilings – the arcs found in the hall and geometric bands found on the flat of the staircase ceiling. A further sketch denotes clumps of flowers like the daisies in Froissart's Chronicles, from the fifteenth century, on which Morris based his daisy hangings for the principal bedroom. British Library.

FIG. 4.14
Detail of the stamped and painted decoration on the sloping ceiling of the stair. During conservation work, an incomplete first scheme of red and yellow was revealed at the top of the sloping ceiling above the stair This was quickly abandoned and overpainted in favour of the blue and green that survives from *c.*1860–1. Close study when the stair was scaffolded also revealed indented shapes made in the plaster when the small hand-held board with protruding spikes was pressed into the damp plaster to create the stamped pattern for the painters – amateur and professional – to follow.

OVERLEAF: **FIG. 4.15**
The sloping and flat staircase ceilings with their stamped patterns decorated in blue and green on a white ground.

vertical posts, banded decoration rising to a dentil detail (which relates to the crenellated detail found on the newel posts of the stair and on the dining room dresser) survives and has never been overpainted. The bands of colour rising from the horizontal supporting beam are black, followed by red-brown, yellow ochre, green, red-brown, green, yellow ochre and the red-brown dentil detail. They are of varying depths and, in most instances, the colour is layered over a red-brown basecoat. This is a subtle detail that would have drawn the eye and added definition and movement to the overall scheme for the stair tower (fig. 4.16). Hidden from view above an angled beam is a mischievous piece of graffito in the form of a smiley face (fig. 4.4). It is emblematic of the jokey rapport of the friends engaged in the task of painting the stair tower.

The settle

Aymer Vallance, the art and literary critic and Morris's first biographer, recalled in 1897, 'Immediately to the right as one enters the hall is a wooden structure, the lower part projecting to form a bench seat; the upper part being a press or cupboard, with unfinished colour designs. On the outside of the two doors of it are figure compositions, sketched in, and begun in oils, but left incomplete: while inside are some interesting experiments in diapering in black on a gold ground by Mr Morris's hand.'[40] This is the built-in settle designed for the hall by Webb. In its form, it reflects and responds to the architecture of the house. The tall sloping roof shares a similar profile with the drawing room fireplace and the detail of its construction is revealed, as is that of the neighbouring stair. The settle is relatively plain and was clearly designed to be decorated with flat patterns and figurative painting, whilst being inherently functional, with six cupboards and four drawers (figs 4.18 and 4.19). Evidence suggests that the drawers, the seat, upper cupboards and roof were originally painted

FIG. 4.16
Detail of the banded decoration surviving on the wooden braces supporting the stair tower.

FIG. 4.17
Detail of the hall settle in 1910. The pattern of rows of gold circles set within a geometric grid on a purple-pink background is just discernible on the two pull-down cupboards beneath the figurative painting. *Country Life*.

a single orange-red colour, whilst decorative patterns were painted on the sides, on the two fall-front cupboards beneath the figurative panel and on the inner face of the figurative panel doors, the latter being the 'experiments in diapering in black on a gold ground by Mr Morris's hand' to which Aymer Vallance refers. Just visible beneath later layers of paint are an incised grid with flowers painted in rows to the sides of the fall-front cupboards and the decoration of the cupboards themselves, which were painted a purple-pink with a pattern of gilded circles (fig. 4.17), echoing the design of the bottle glass in the front door. Above this are two doors painted in oils, with an incomplete scene of nine figures in medieval-style dress in a garden setting. The overall composition is believed to be Morris's work, with Rossetti's involvement in the execution of the faces and hands, the area where Morris displayed the least confidence.[41] Three of the faces were left blank, never benefitting from Rossetti's deft artistry. The friends portrayed are Mary Nicholson (Red Lion Mary), Morris (or possibly Charles Faulkner, attributions have been made to both men), Jane Morris, (three incomplete figures), Edward and Georgiana Burne-Jones and Elizabeth Siddal. Who might the blank figures of two women and one man have been? The strongest male contender is either Morris or Faulkner (Morris would surely have taken into account Webb's dislike of having his image portrayed) and at least one of the women may have been intended to be one of Faulkner's sisters, Lucy and Kate, both of whom are thought to have visited Red House and went on to work for the Firm. The subject of the scene is open to interpretation as there is no known documentary evidence assigning it a definitive source. It has been suggested that Morris envisaged the friends in the Arthurian setting of Lancelot's castle, Joyous Gard from Malory's *Morte d'Arthur* or that it may be a medievalising portrait, capturing the friends in the garden at Red House.[42] If Rossetti did paint all the faces, he must have completed that of his wife before her death in 1862 and perhaps this association is what prevented him from completing the last three faces. The unfinished picture has become a pictorial metaphor for the closeness of the friends and the collaborative but ultimately incomplete decoration of the whole house.

The anonymous visitor noted that 'a solid oak table with trestle-like legs stood in the middle of the red tiled floor' and William Bell Scott, in his slightly confused recollection, where he conflates the hall and drawing room into a single room, recalled 'a long table of oak reaching nearly from end to end'.[43] This table must have been the smaller of Webb's two oak dining tables although, on grounds of its size, this may have only been found on occasion in the hall.

Webb designed another table for the house, which May Morris describes as 'Red House the first made'.[44] This is believed to be the round oak table with crenellated bases to the legs (fig. 4.84), which are close in detail to the newel posts, and pierced openings to the sides, which echo the stair.

WILLIAM MORRIS & HIS PALACE OF ART

FIGS 4.18–4.19
Settle by Philip Webb, 1859–60. Decorated by William Morris and Dante Gabriel Rossetti c.1860. Painted wood: 300 x 163 x 88 cm. The figurative painting has never been painted over but the brown and green paint are later colours hiding the original orange-red of the roof, upper cupboards, drawers and bench. The fall-front brown doors were originally decorated with rows of gold circles on a purple-pink background.

The settle opened to reveal the interior spaces of Webb's highly practical composite piece of furniture. It is uncertain whether the black and gold decoration at the back of the left cupboard dates from 1860–5 or whether it is a later addition, possibly 1889–1903, in the spirit of Morris's work. The pattern depicted is the same as that of the dress worn by Iseult in *La Belle Iseult* (fig. 2.11) and on the sleeves of Georgiana's dress on the right-hand panel door. The ghostly pattern of the 'diapering in black on a gold ground by Mr Morris's hand' recorded by Vallance is just visible on the inner face of the right-hand door.

DINING ROOM

It was the most beautiful sight in the world, to see Morris coming up from the cellar before dinner, beaming with joy, with his hands full of bottles of wine and others tucked under his arms.[45]

This characterful image of Morris laden with wine from his well-stocked cellar symbolises the plentiful hospitality and good fellowship which abounded at Red House. 'How is he looking – I trust well and rosy with good wine', Webb was asked of Morris in 1866, and Burne-Jones made several deft caricatures showing him replete with food and drink (fig. 4.20).[46]

With Morris's munificent hospitality in mind, Webb created a generously proportioned room which runs parallel to the hall with views out to the garden with its enclosed herbers on the north and bowling green on the west side. Pencil sketches on the floorplan denote the intended position of the fixed dresser and the two moveable oak tables. The dresser is monumental in scale but is harmoniously balanced by the tall, red-brick fireplace with its pointed relieving arch and herringbone tympanum on the adjoining window wall. The blue and white Dutch picture and pattern tiles which line the reveals have replaced the original tiles which may have been traditional white blanks or painted tiles by Burne-Jones.[47]

The dresser is a sophisticated piece of furniture which derives its inspiration in part from gothic precedents, perhaps pieces Webb noted on his tour of France in 1858 (figs 4.22 and 4.23). An expansive oak shelf separates the upper section – which comprises a shelf with two runs of turned rods dividing up the space, and three gabled cupboards with open trefoil decoration which rise to the ceiling – from the lower section, made up of two rows of deep cupboards. The bold and deceptively simple form of the dresser is enhanced by the crenellated detail on the rods and horizontal band and the elegant flowing ironwork which would have glowed silver against the 'Dragon's blood red' finish of the dresser, and shimmered by candlelight. The dresser has always been a deep red and there appears to have been no intention of ever enlivening it with decorative patterns or figurative panel paintings because of the ambitious scheme of embroidered figures that Morris envisaged would adorn the walls to either side of it and around the rest of the room.

Panelling extends around the room following the line set by the oak shelf on the dresser and rises behind the upper section, visually anchoring it to the wall. This section was painted red to appear as part of the dresser, whilst the dado panelling, door and window shutters were painted a rich dark green.

The walls were a reddish-brown terracotta, which served as a foil to the embroidered hangings. The original ceiling has been replaced but it is known from a drawing by H.P. Clifford of about 1897 (fig. 4.24). This shows a pricked ceiling with the same repeating painted pattern that is found on the slope of

DECORATING AND FURNISHING THE HOUSE

FIG. 4.20
'Grace before meat, Disgrace after meat' by Edward Burne-Jones, c.1870. Pen and brown ink: 15 x 11.3 cm. Morris is depicted sequentially, standing at a trestle table laden with food and wine, and lying on the floor having consumed everything in sight. British Museum.

the staircase ceiling – though in two rather than the three colours found there, for Vallance records that the dining room ceiling was 'ornamented by hand in yellow on white'.[48]

Webb is known to have designed two dining tables for Red House, though the whereabouts and precise appearance of both tables was unknown until the smaller of the two was traced in 2017 (fig. 4.21).[49] Morris had this one in the dining room at Kelmscott House, his London home from 1878, and on his death in 1896, Jane gave it to the landowner, diplomat and poet, Wilfrid Scawen Blunt.[50]

Fortuitously, Webb gave a detailed description of the tables in a letter of 1898:

FIG. 4.21
Dining table by Philip Webb, 1859. Oak and iron: 71.5 x 260 x 71.5 cm. The smaller of the two oak trestle tables with iron banding which Webb designed to prevent Morris impatiently 'whittling away the edge'. Private collection.

77

DECORATING AND FURNISHING THE HOUSE

FIG. 4.22
The dresser by Philip Webb, 1859–60. Oak and painted wood: 321 x 257 x 81 cm. The light fitting was added after 1866 when the house was supplied with electricity.

FIG. 4.23
Detail of the drop-down cupboards, which could readily store quantities of table glass for use in the room. Webb's attention to detail is evident in the gentle mirroring of the arches to the upper shelf with the curved mechanism of the cupboard doors.

FIG. 4.24
Drawing by H.P. Clifford showing the stamped ceiling decoration, c.1897.

> *I find as to the oak table of Red House that it was made at the end of 1859. There were two of the kind – to match; one for the dining-room and the other for the hall, which could be put together at feast times in T fashion: the Gods at the cross end and tributaries along the shank. I think the one Mr. Blunt has must be that for the hall – the shorter of the two, which would be if I am right, 8' 6" long. Both tables were bound round the edge with scoured iron fixed with clout-headed nails, to keep the impatient from whittling away the edge if victuals lingered on the road.*
>
> *Doubtless the chill of the iron would be a reminder to hot hands that enough Beaune or Bordeaux had been turned over the thumb. What became of the longer table I have forgotten, or never knew.*[51]

Webb's account reveals his intimate understanding of the need to fashion robust tables which would withstand the explosive outbursts, fidgeting and impatient 'whittling' which were part of Morris's nature.[52] In 1863, with wry good humour, Faulkner reported of Morris, 'I grieve to say, he has only kicked one panel out of a door this twelve-month past.'[53] The two dining tables bear a close resemblance to the table that the furniture maker Henry Price records

making for Morris. Morris had commissioned several very distinctive pieces for Red Lion Square, from Tommy Baker of Christopher Street, Hatton Garden. Price was given the task of making what he described as 'very old fashioned furniture in the Mideavel [sic] Style' because 'the guvner knowing that I took great interest in such things put the job in to my Hands'. Price describes the table he made as 'a large Oak Table on tressels with a [sic] Iron Stretcher twisted and partly burnished The top in a bine [line?] with tressils was inlaid with various colours of wax to represent the heads of the bolts.'[54] It is plausible that this lost table thought to have been made to Morris's design around 1857–8 was, in fact, an early design by Webb and possibly the prototype for his tables for Red House. Webb designed a similar oak trestle table for the newly married Burne-Joneses in 1860, which is depicted in a watercolour of their dining room at The Grange, Fulham (fig. 4.25).[55]

Their table was made at the Industrial Home for Destitute Boys in Euston Road, where, amongst other trades, the apprentices were taught the skills to make simple furniture. The home was supported by Major Gillum, an important early patron of Webb's and member of the Hogarth Club, for whom Webb designed an estate cottage and furniture in 1860.[56] Morris's two tables and accompanying 'slim rush-seated "Sussex" chairs, painted black or red' were probably also made at Euston Road.[57]

Vallance records 'by the fireplace stood a moveable settle' (fig. 4.26).[58] This is Webb's distinctive curved-back settle of ebonised oak with three rows of embossed leather, each with three separate panels of painted and gilded decoration of roses and flower motifs on the front face and a single row of three panels with stylised floriate designs on the back, which was intended to be seen in the round. The settle has simple curved bench ends of a very similar profile to those found on the hall and drawing room settles. Webb is believed to have drawn inspiration for his design from traditional, vernacular settles and would also have had Morris's 'medieval' chairs in mind.

In a remembrance from infancy, May Morris conjures up an intimate snapshot of family life and refers to her father's 'great painted chair'. She recounted, 'In another picture of Red House, the babies are included: my Father is sitting in his great painted chair at the end of the long table, with a babe on each knee [fig. 4.27 has Morris and his children in a similar pose], and he is looking very amused and happy, cutting up a large rosy apple. Red House was built, you will remember, in an orchard: this apple, I hope, not to be given to the younger babe [May], who was certainly not of an apple-eating age.'[59] The 'great painted chair' is now lost but is likely to be the one designed by Morris for Red Lion Square, which Georgiana Burne-Jones described as 'a large one with a box overhead in which Gabriel suggested owls might be kept to advantage', and which Morris may have realised in three-dimensional form, from the extraordinary canopied chair Rossetti depicted in his 1857 watercolour *The Tune of Seven Towers* (fig. 4.6).[60] The canopy of

FIG. 4.25
Dining Room, The Grange by Thomas Matthews Rooke, c.1904. Watercolour on paper: 52 x 36 cm. This depiction of the Burne-Joneses slightly later but closely related interior gives a strong impression of the similar atmosphere of Red House – layers of colour, pattern and texture with stained glass panels, bottle glass windows, embroidered hangings, pictures, painted furniture, rush-seated chairs and a sturdy oak trestle table. National Trust, Bateman's.

FIG. 4.26
Settle by Philip Webb, *c.*1860. Ebonised oak with panels of embossed leather, painted and gilded: 209 x 194 x 56.5 cm. The painted floral patterns are also found on the rear face of the curved hood. Society of Antiquaries of London, Kelmscott Manor.

FIG. 4.27
Caricature by Edward Burne-Jones, *c.*1865 of Morris with his arms encircling Jenny and May. Pencil on paper. Private collection.

the chair inthe picture has a distinctive red flower-spiral motif found on two other painted chairs made for Red Lion Square. *The Arming of a Knight* and *Glorious Guendolen's Golden Hair* chairs (figs 2.6 and 2.7) may have stood in the dining or drawing room. The wooden floorboards were probably 'covered with eastern carpets' in rich, dark hues to accentuate the strong colours and glinting details of the gilded and silvery metal finishes to the furniture.[61]

In his utopian novel *News from Nowhere*, Morris's narrator, William Guest, finds himself transported into a future society based on common ownership and democratic freedom – where happiness prevails in a world free from class systems, exploitation, cities, industry and many of the perceived ills of the late nineteenth century. One morning, Guest describes the dining room in which he sits and through him we might glimpse Morris recalling Red House:

The glass, crockery and plate were very beautiful to my eyes, used to the study of mediaeval art; but a nineteenth-century club-haunter would, I dare-say, have found them rough and lacking in finish; the crockery being lead-glazed pot-ware, though beautifully ornamented; the only porcelain being here and there a piece of old oriental ware. The glass, again, though elegant and quaint, and very varied in form, was somewhat bubbled and hornier in texture than the commercial articles of the nineteenth century ... Withal, there was a total absence of what the nineteenth century calls 'comfort' – that is, stuffy inconvenience.[62]

Webb designed table glass in January 1860, which was made by James Powell & Sons, Whitefriars Glassworks, London. Each piece was an exquisite work of art. Webb's detailed drawing survives, illustrating a water jug, large drinking glass, water glass, goblet, large wine glass and small wine glass and listing the amounts required – four water jugs, six large drinking glasses, eight water glasses, one and a half dozen goblets, one and a half dozen large wine goblets, one and a half dozen small wine goblets, two grace cups, four decanters, four flower glasses (figs 4.28 and 4.29). Only one piece of this beautiful glass is known to have survived, a handsome goblet that May Morris bequeathed to Birmingham Museum in 1939 (fig. 4.30).

Both Webb and Morris were frequent visitors to the newly opened South Kensington Museum (now the Victoria and Albert Museum). It is thought that Webb drew inspiration for the form of his glassware from the Roman, seventeenth-century German and eighteenth-century English pieces and, for its decoration from Venetian examples he discovered there. His designs for a water jug and large drinking glass both feature exquisite enamelled decoration. On the neck of the jug alone, Webb delineates thin horizontal

Designs for Glass Vessels
for W. Morris &c.

plan at top of mouth.

Water Jug.

Large Drinking Glass.

DECORATING AND FURNISHING THE HOUSE

FIG. 4.28
Detail from a sheet of designs for table glass for Red House by Philip Webb, 1860. Pencil, pen and wash: 53 x 66 cm. Inscribed 'Designs for Glass Vessels for W. Morris Esq'. The glass was made by James Powell & Sons, Whitefriars Glassworks. Victoria and Albert Museum.

FIG. 4.29
Webb's design for a goblet (sheet as fig. 4.28).

FIG. 4.30
Goblet designed by Philip Webb, 1860; made by James Powell & Sons for Red House. Glass: 13 x 8 cm. Birmingham Museum and Art Gallery.

FIG. 4.31
Goblet, finger bowl and tumbler designed by Philip Webb for James Powell & Sons, c.1862. Part of a wider range of less elaborate table glass designed by Webb and sold by Morris, Marshall, Faulkner & Co. and probably in use at Red House. Victoria and Albert Museum.

bands of decoration of white spots, gold band, blue band, brown arcs, blue band, gold band and white spots with the body and handle featuring their own distinctive decoration in the same glistening colours. Jennifer Hawkins Opie identifies that the 'enamelled decoration may have appealed to Morris for its affinity with medieval illustrations in its minutely jewel-like gilding and preciousness, although it was in direct confrontation with Ruskin's influential principle of allowing undecorated glass to speak for itself'.[63] Webb's connection with the glass radiates from the page of the design and he must have relished the many opportunities he had to use the various glasses when dining with the Morrises.

'Blue china or delft for vessels of household use' were one of the few things 'then to be bought ready-made that Morris could be content with in his own house'.[64] Georgiana Burne-Jones recalled of the Madox Browns, where she was a guest in April 1860, 'At their table the standard of the common English willow-pattern plate was boldly raised'; Morris may well have followed suit by having the simple but beautiful Staffordshire stoneware at his table.[65]

※

Morris was to argue passionately in his 1882 lecture 'The Lesser Arts of Life' for the importance of textile hangings with patterns drawn from nature or figurative scenes. At Red House, his plans for the dining room hangings gave full expression to his later exhortation to the craftsmen he lectured:

> *To turn our chamber walls into the green woods of the leafy month of June, populous of bird and beast; or a summer garden with man and maid playing round a fountain, or a solemn procession of the mythical warriors and heroes of old; that surely was worth the trouble of doing.*[66]

Drawing on the invaluable experience he had gained from designing and executing the 'If I Can' embroidery, Morris devised two ambitious textile schemes, confident in the knowledge that Jane, whom Georgiana Burne-Jones acknowledged to be an 'exquisite needle-woman', had the skill to create beautiful works from his designs.[67] The first scheme was for the daisy hangings which lined the walls of the principal bedroom. By far the most ambitious scheme, though, was his design for the dining room. As Jane Morris recalled, the 'scheme for adorning the house was a series of tapestries for the dining-room of twelve large figures with a tree between each two, flowers at the feet and a pattern all over the background, seven of the figures were completed and some of them fixed to the background'.[68] The seven finished figures are St Catherine, Guenevere, Penelope, Aphrodite, Lucretia, Hippolyte and Helen of Troy (figs 4.34–4.37).[69]

The identity of the five unexecuted figures intended to complete the

scheme has been the subject of much debate and has not yet been conclusively determined. There is a surviving cartoon by Morris of Artemis, which May Morris illustrated as the frontispiece to volume IX of *The Collected Works of William Morris*, 1911, with the description 'Artemis: design by William Morris for one of the figures in the Red House embroidered hangings' and two sketches in Morris's notebook of a section of the overall scheme, with St Cecilia identified by a named banderole (figs 4.32 and 4.33).[70]

Julia Dudkiewicz has proposed that on stylistic grounds Morris's cartoon for Mary Magdalene also forms part of this scheme and that because of her romantic love for Christ, which links her to the leitmotif of love connecting all the figures, Morris intended to display it on the dining room walls.[71] The cartoon of Mary Magdalene was employed for a stained glass panel at All Saints Church, Langton Green in 1863 but, like so many of the designs produced at this point and in the earliest years of the Firm, they were often used in several different media.

The identity of the remaining two figures needed to complete the scheme of twelve is still elusive. There are other designs and unfinished embroideries of this period which may have been intended for this scheme or, more likely, created for two schemes of Chaucerian heroines, which Burne-Jones made for Ruskin in 1863 and for his own home, that were never completed (fig. 4.47).[72]

Although Jane Morris briefly describes the extent of the scheme and those involved, neither Morris nor Edward or Georgiana Burne-Jones gives a detailed account or a title to the embroideries. May Morris, who grew up with several of the embroideries, called it 'the series of renowned ladies that were being embroidered for the dining room at Red House'; Mackail writes of 'twelve figures with trees between and above them, and a belt of flowers, running below their feet'. It has also been described as a scheme based on Chaucer's poem *The Legend of Good Women* (1372–86) and 'illustrious women'.[73]

Chaucer's prologue to *The Legend of Good Women* opens with lines in praise of the daisy (following the established literary tradition of 'Marguerite' poems in French) and proceeds with a description of the criticism the sleeping Chaucer receives from the god of love because he has written disparagingly about women. Chaucer promises Alceste, the queen of love, that he will make amends by extolling the virtues of women who are celebrated for their faithfulness in love. The poem is unfinished but tells the stories of ten women – namely, Cleopatra, Thisbe, Dido, Hypsipyle and Medea, Lucrece, Ariadne, Philomena, Phyllis and Hypermnestra.

Lucrece/Lucretia is the only female figure known to occur in both Chaucer's poem and in Morris's embroidery scheme. Due to Morris's reverence for Chaucer and the associations he made between the proximity of Red House to Watling Street – the Roman road that pilgrims travelled along on their way

FIG. 4.32
Sketch of embroidery scheme for dining room by William Morris, *c.*1860. Pencil on paper. British Library.

to the shrine of St Thomas Becket in Canterbury Cathedral – it is arguable that, although Morris did not intend to faithfully recreate Chaucer's subjects, he was inspired by the Chaucerian precedent and paid a degree of homage to the poet.

Another striking influence on Morris's choice of appliqué figures and strong female characters is the dramatic and superbly wrought set of appliqué wall hangings of the 'Noble Women of the Ancient World'. Originally commissioned for the State Apartments at Chatsworth in the 1570s, Bess of Hardwick took them with her to Hardwick Hall, where four still hang.[74] Morris's favourite sister, Emma, married the Rev. Joseph Oldham in 1850 and lived at Clay Cross, near Hardwick, and Morris visited with Emma in 1855.[75] Bess of Hardwick's embroideries of strong female figures are believed to have been similarly influenced by Chaucer's *The Legend of Good Women*, and her scheme shares two figures in common with that devised by Morris three centuries later. Both schemes include Penelope (fig. 4.38) and Lucretia, whilst Bess of Hardwick's scheme also features Artemisia, Queen of Caria, a warrior-queen (named after the goddess Artemis).

Morris's study of illuminated manuscripts was a further rich seam of visual sources on which to model his female figures. At Oxford, he spent

DECORATING AND FURNISHING THE HOUSE

FIG. 4.33
Sketch of embroidery scheme for dining room by William Morris, c.1860. A more developed sketch than fig. 4.32, with the figure of St Cecelia identified; the figure on the right has the pose and style of dress of the completed embroidery of Guenevere. Pencil on paper. British Library.

hours poring over medieval manuscripts in the Bodleian and later in the British Museum and, drawing on his fascination, had experimented with making his own illuminated pages in 1856–7 (fig. 2.1).[76]

It is not hard to imagine Morris's careful deliberation over the choice of figures to be included. He may have debated their various merits with Burne-Jones and others, or it may have been a highly personal selection intended to convey dramatically the women from literature, history, mythology and the Bible who most inspired him, and whose characters spoke most eloquently of love in its many varied forms.[77] What is certain is that each of the figures held great resonance for Morris and was deemed deserving of its place in his female canon of embroidered portraits.

Embroideries

St Catherine: a Christian saint and virgin, who refused to recant and was martyred for her religion. She was condemned to an excruciating death on a breaking wheel (where the victim's limbs were threaded through the spokes and an executioner broke their bones with a metal rod), but on seeing the

wheel, she touched it and it miraculously shattered. She was subsequently beheaded. She is often depicted with a wooden wheel.

In the embroidery, she is shown reading a book (the Bible), symbolising her great learning, and holding the sword with which she was beheaded. Her red and gold underdress is decorated with a pattern of breaking wheels, as are the cuffs of her sleeves. The fine workmanship of this piece is attributed to Jane Morris. A shield with a breaking wheel set against a backdrop of stylised single flowerheads is suspended from the lemon tree that she stands beside. The two embroideries are mounted on a velvet panel which was used as an internal door curtain, or portière, by the Burne-Joneses at the Grange in Fulham. This suggests that on leaving Red House, Morris gave the embroideries to Georgiana Burne-Jones.

Guenevere: the wife of King Arthur in the *Morte d'Arthur*, who falls in love with his knight Lancelot and betrays Arthur, causing the breakup of the Round Table. She is saved from being burnt at the stake and lives out her life in a convent.

She is portrayed in the embroidery with her head slightly bowed, holding a drooping flower in her right hand. This has not been embroidered and is shown in outline only, but it may be a daisy, a symbol of innocence. Her appearance and pose are directly modelled on Morris's oil painting *La Belle Iseult*, 1858 (fig. 2.11), in which he portrayed Jane as Iseult. This embroidery is unfinished and has not been cut from its linen ground. Annotations of the intended colours of the areas still to be worked are visible in Morris's hand. The embroidery is attributed to Bessie Burden.

Penelope: the wife of Odysseus in Homer's *Odyssey*, known for her fidelity to Odysseus during his twenty-year absence fighting in the Trojan War, despite being besieged by suitors. Renowned as a weaver, she occupied herself with the creation of an intricate shroud for her father-in-law and promised her suitors she would choose between them on its completion but cunningly wove all day and unpicked her work in secret at night.

In the embroidery, she is depicted in a simple dress unadorned with pattern but she holds the shroud decorated with laurel wreaths draped over her right arm. This completed embroidery is attributed to Jane Morris and remained in the Morrises' ownership.

Lucretia: a heroine of ancient Rome, who was raped by the son of the Etruscan king and took her own life after extracting a promise of vengeance from her family. She appears in Canto IV of Dante's *Inferno* in the section of Limbo reserved for Roman nobles.

In the embroidery, she is depicted holding the sword with which she takes her life. Lucretia stands in a flowery mead replete with daisies, which is edged

FIG. 4.34
Unfinished embroidered panel of Guenevere designed by William Morris, *c.*1860 and attributed to Bessie Burden, *c.*1861. Linen with wool thread: 130 x 63 cm. Society of Antiquaries of London, Kelmscott Manor.

FIG. 4.35
Embroidered panel of St Catherine and a stylised lemon tree designed by William Morris, c.1860 and worked by Jane Morris c.1860–1. Linen, velvet with wool and silk threads: 179 x 140 cm. Society of Antiquaries of London, Kelmscott Manor.

FIG. 4.36
Embroidered panel of Penelope designed by William Morris, c.1860 and attributed to Jane Morris. Serge with wool threads: 111.5 x 51.5 cm. Society of Antiquaries of London, Kelmscott Manor.

DECORATING AND FURNISHING THE HOUSE

FIG. 4.37
Embroidered panels of Lucretia, Hippolyte and Helen designed by William Morris, *c.*1860 and worked by Bessie Burden, *c.*1861. Linen, wool with wool and silk threads: each panel 171.5 x 73.6 cm. The panels were made into a three-figure screen in 1888. Castle Howard Collection.

FIG. 4.38
Embroidered panel depicting Penelope flanked by Perseverans and Paciens, *c.*1573. Silk, cloth of gold and silver on linen: 277 x 350 cm. National Trust, Hardwick Hall.

by four rows of creamy grey brick. A terracotta band bound by flowers runs along the foot of the embroidery. The feature of the garden setting in which she stands is repeated with slightly different arrangements of flowers in the embroideries of Hippolyte and Helen, and shows Morris's intention for all the other embroideries with the probable exception of Aphrodite. The terracotta band is the same colour as that recently discovered surviving on the walls of the dining room and would have visually anchored the embroideries against the painted wall face. This completed embroidery is attributed to Bessie Burden.

Hippolyte: in Greek mythology, she was an Amazonian queen who was given a magical girdle by her father, the god of war. The girdle symbolises her authority over her people.

She is depicted wearing a suit of armour and chainmail beneath a flowing outer garment which is tied at the waist by a red and gold patterned belt. In her right hand, she clutches a lance, and in her left, a sword she has removed from the sheath at her waist. Hippolyte is appliquéd to a green woollen serge

ground which is embroidered with yellow and white flowers and green leaves. This completed embroidery is attributed to Bessie Burden.

Helen (Flamma Troiae): Queen of Laconia, wife of King Menelaus, abducted by Paris and held in Troy; known as the most beautiful woman in the world and sister of Aphrodite and Artemis. Morris had written of Helen in about 1857, with great intensity, in his unfinished series of poems on the Trojan War, and planned that the adjoining hall and staircase should be decorated with scenes from it.[78]

Here, Helen holds a flaming torch entwined by a banderole with the Latin inscription 'Flamma Troiae', which refers literally to the flaming torch she holds and the flames of passion her beauty excited. Helen is appliquéd to a green woollen serge ground with the same flowery backdrop as Hippolyte. This completed embroidery is attributed to Bessie Burden.

Aphrodite: the Greek goddess of love and sister of Artemis and Helen.

In the embroidery, she is shown naked except for a garland of flowers worn as a girdle across her hips and a more modest flower garland in her hair. The embroidery is complete but has not been cut from its linen ground. It is possible to discern that changes were made to the design as it was worked – painted tendrils of hair are left unstitched on the left side and the line of the hips has been slightly adjusted. The separately stitched girdle appears to be a second design, as there is evidence of an earlier design beneath, which has been painted over in white paint. Rough practice stitches, pencil sketches and painted details of two pink flowers, which relate to the flowers on the floral garlands, and a nose and lips are visible on the linen ground. The dark bluegreen outer edging of the halo is the same colour as that originally used on the dado panelling that the embroideries were designed to hang above.[79] Thought to have been lost, the embroidery was rediscovered at auction in 2007 and now hangs in the dining room at Red House. This piece is attributed to Jane Morris.[80]

Except for Guenevere, whose visible hair straying from her headdress has not been embroidered, all the embroidered figures share abundant hair in varying shades of red and all conform to the Pre-Raphaelite style of beauty that Rossetti characterised with the term 'stunner'.

Cartoons and sketches

Artemis: the Greek goddess of the hunt, forests and hills, and childbirth. Sister of Aphrodite and Helen.

She is depicted in Morris's cartoon extracting an arrow from her quiver with her right hand and holding a purposeful-looking bow.

FIG. 4.39
Unfinished embroidered panel of Aphrodite designed by William Morris, *c.*1860 and attributed to Jane Morris, *c.*1861. Linen with wool and silk thread: 118 x 39 cm. National Trust, Red House

FIG. 4.40
Venus (Aphrodite) attributed to William Morris and Edward Burne-Jones, *c.*1860–5. Oil on canvas: 132 x 62.5 cm. Society of Antiquaries of London, Kelmscott Manor.

FIG. 4.41
Cartoon of Artemis by
William Morris, c.1860.
Pencil on paper: 120 x
58.9 cm. Tullie House
Museum and Art Gallery.

FIG. 4.42
Cartoon of St Mary Magdalene by William Morris, c.1862. Wash, graphite and ink on paper: 121.9 x 43.8 cm. The Huntington Library, Art Collections and Botanical Garden.

FIG. 4.43
Embroidery of an orange tree by William Morris, c.1860 and attributed to Alice Macdonald c.1861. Linen with wool and silk threads: 183 x 104 cm. National Trust, Bateman's.

St Cecilia: made a vow of virginity but was married against her will to a pagan nobleman. She sang in her heart to God during her wedding ceremony and later explained to her husband both her vow of chastity and that she was protected by an angel. Her husband sought proof of the angel and, upon witnessing its heavenly form, was baptised on the Appian Way. Cecilia converted a significant number of people to Christianity and was condemned to death by fire. She miraculously survived, and the executioner was instructed to behead her. He struck three blows but could not decapitate her and she died after a further three days. She is the patron saint of musicians because she heard heavenly music in her heart.

In Morris's pencil sketch depicting St Cecilia, she is shown holding a long object with a box-shaped base. This most probably depicts organ-pipes, the organ being one of several instruments with which she is traditionally shown in works of art.

Mary Magdalene: the loyal follower of Jesus who washed and anointed his feet and who witnessed his crucifixion and his resurrection.

The surviving cartoon depicts her wearing a flowing gown with stylised floral decoration with a wavy stem and flowerhead which appears to closely replicate the painted decoration found on the drawing room ceiling that Morris painted in 1860. In her right hand, she holds a dome-topped ointment jar with banded decoration.

Trees

Lemon tree: completed and applied to a velvet backcloth alongside the figure of St Catherine. Attributed to Jane Morris (fig 4.35).

Orange tree: completed and later made into a curtain. Attributed to Alice Macdonald, sister of Georgiana Burne-Jones (fig. 4.43).

Pomegranate tree: an unfinished embroidery. Attributed to Jane Morris (fig. 4.44).

The figures were principally worked by Jane and her sister Bessie Burden. Both Jane and Bessie would have been taught to sew as children as it would have been a potential source of future income. Morris must also have imparted his knowledge of embroidery stitches and techniques to them, so as to enhance their skill and meet his ambitious expectations. Georgiana Burne-Jones was taught to lay stitches by Morris and, although she never achieved the expert skill of Jane or Bessie, she became an able embroiderer and con-

FIG. 4.44
Unfinished embroidered panel of a pomegranate tree by William Morris, c.1860, attributed to Jane Morris, c.1861. Linen with wool threads: 160.5 x 69.8 cm. Victoria and Albert Museum.

tributed to the Red House hangings. Georgiana recalled the fulfilling hours of industry and discovery: 'Oh how happy we were, Janey and I, busy in the morning with needlework or wood-engraving, and in the afternoon driving to explore the country round by the help of a map of Kent'.[81] Jane recorded Morris's impetus and involvement, and the key role she and Bessie played in embroidering the figures: 'All these things were set going by the one master spirit and carried out under the master eye, chiefly by myself and my sister.'[82] Linda Parry has identified the embroidery techniques they employed as being late medieval in origin. The designs were painted onto a fine linen ground (known as holland) and embroidered with woollen and silk threads in chain, long and short, brick and darning stitches and then cut out and appliquéd to a woollen serge panel.

Morris's ambitious scheme was a huge undertaking, especially when considered in the light of the concurrent decorations going on in other parts of the house, and may well have been disrupted by the births of Jenny in January 1861 and May in March 1862, as Jane Morris redirected her energies

DECORATING AND FURNISHING THE HOUSE

to sewing baby clothes and caring for her family.[83] Georgiana recorded:

One morning Janey and I sat sewing I saw in her basket a strange garment, fine, small, and shapeless – a little shirt for him or her – and looking at my friend's face I knew that she had been happy when she made it; but it was a sign of change, and the thought of any change made me sigh. We paid other visits to the Morrises after this, but none quite like it – how could they be?[84]

Had Morris's entire composition for the room been completed, all the figures and trees would have been appliquéd to woollen serge panels and enhanced by floral decoration in the manner of the Lucretia, Hippolyte and Helen panels worked by Bessie Burden. The one anomaly is the figure of Aphrodite. The oil painting of Venus (Aphrodite) of roughly 1860–5, is a painted version of the embroidered panel.[85] Inspired by Botticelli's painting, *The Birth of Venus* (c.1485), it portrays Venus stepping from the waves onto the seashore, suggesting that the Aphrodite embroidery would feature a sea setting rather than a flowery mead (fig. 4.40). Burne-Jones's description of the comparative scheme that he devised for John Ruskin in 1863 provides invaluable detail of

FIG. 4.45
Sketch for a wallpaper design by Dante Gabriel Rossetti, 1861. Pen and ink on paper. The Morgan Library and Museum.

FIG. 4.46
Sketch of a seated female figure holding an embroidery frame by William Morris, c.1861. Pencil on paper watermarked for 1861: 43.2 x 25.7 cm. This drawing would appear to be a spontaneous sketch and is likely to depict Jane Morris, Bessie Burden or Georgiana Burne-Jones embroidering at Red House. The Huntington Library, Art Collections and Botanical Garden.

FIG. 4.47
Sketch for an embroidery scheme by Edward Burne-Jones, 1863. Pencil on paper: 26.6 x 36.2 cm. Designed for John Ruskin and based on Chaucer's *The Legend of Good Women*. The composition is influenced by Morris's scheme for the dining room and, interestingly, shows the three figures bottom left and the upper right figure standing on the seashore, as the embroidered figure of Aphrodite may well have done had it been completed. Birmingham Museum and Art Gallery.

his proposed plan for the distinct treatment of figures standing on land and those on the seashore, and gives a good indication of Morris's intention. 'All the ground will be powdered with daisies' Burne-Jones recorded, 'only where Dido, Hypsiphile [sic], Medea and Ariadne come there will be sea instead of grass and shells instead of daisies'.[86]

The garden setting for the scheme of fruit trees and flowery meads is a theme which is found in figurative decoration on walls and furniture in the hall, drawing room and principal bedroom. Morris clearly intended the hanging of the embroideries in the dining room to create a strong visual link between the walls of the dining room and the flowery meads and orchard trees visible outside the windows. His art imitated nature and enhanced the sense of unity between the interior and the garden.

Many intriguing questions remain unanswered about the dining room and Morris's vision for the whole room. How were the embroideries to be hung? Would they have been suspended flat against the walls or loosely hung so that there was the suggestion of a gentle fold in the textile (as the painted 'hangings' are depicted in the drawing room above)? Would the placement of the figures in relation to one another, in paired groups separated by trees, have added to the iconographic message Morris wished to convey? Which other women had Morris chosen for the scheme? What were the other three trees? Would apple and cherry trees from the garden have featured in the scheme? Was the scheme abandoned or was it simply left incomplete due to the intensive nature of the skilled work and the lack of time available? Were the completed embroideries hung before 1865 in a partial scheme? What else may have been hung in their stead to decorate the room whilst the embroideries were being made? Did the 'If I Can' embroidery, worked for Red Lion Square, hang here temporarily? Where did Morris's picture collection hang? Might *April Love* by Arthur Hughes (fig. 2.2) have graced the walls of the dining room until the embroidered scheme was ready to be viewed in all its glory of twelve figures and six trees?

Though these questions may remain irresolvable, we do know that the finished embroideries were valued: the Burne-Jones's made St Catherine and the lemon tree into a door curtain for their dining room, perhaps making a direct connection with Red House; Bessie Burden kept her three embroideries until 1889, when they were sold to George Howard for £80 and made into a screen; and Guenevere, Penelope and Aphrodite all remained in Morris's ownership. The designs of various of the embroideries also played an important role in the works of the Firm. Several of the figure designs were reused in stained glass commissions and may have been in Morris's mind when he designed works such as the ceiling of Jesus College Chapel, Cambridge in 1866 and much later when he made his first figurative design for a tapestry of allegorical female figures in an orchard setting, *The Orchard* or *The Seasons* tapestry, 1890 (fig. 5.11).

FIG. 4.48
Queen Guenevere and Isoude of the White Hands by William Morris c.1862. Stained glass: 71 x 71.5 cm.
The embroidery design of Guenevere was reused for this stained glass panel commissioned by Walter Dunlop, a Bradford businessman, for Harden Grange, Yorkshire in 1862. The Guenevere figure is redeployed for Isoude, and a new design is created for Guenevere. This was an important secular commission when most of the Firm's early commissions for stained glass came from architects working on new churches. Bradford Art Galleries and Museums.

Morris's ambitious scheme demanded a great deal from him. Prior to this, he had painted the rather stiff picture of *Sir Palomydes* at the Oxford Union Debating Hall, made figure studies at Langham Chambers under Rossetti's tutelage, laboured over and completed *La Belle Iseult*, and possibly begun work on the painted version of *Venus* (Aphrodite). For the dining room, he made at least eight designs for figurative embroideries, which demonstrated his growing skill and inherent aptitude for the medium. With the designs for the embroideries and their placement within the overall room setting, Morris was in his element.

Although not fully realised, Morris's coherent and comprehensive vision for the room was one of visual splendour. Had the embroidered figures lined the walls, walking in to the dining room would have been like entering a three-dimensional illuminated scene. The patterns and textures of the striking figure embroideries hanging alongside the strong colours and patina of the walls and furniture would have created an opulent and arresting interior – one which would have sung in daylight and glowed by flickering candlelight in the evenings. Even without the full set of embroideries, the dining room must still have struck visitors with its rich scheme.

With the three artist friends, Morris, Burne-Jones and Rossetti, working in such close collaboration at this time, it is possible to trace cross-pollination in their wider work and most notably in their designs for their own domestic interiors. Burne-Jones's design for embroidered hangings (fig. 4.47) is a variation on the theme that Morris established in his dining room designs and concurrently Rossetti was engaged in creating a vivid scheme for himself and Elizabeth Siddal in their rented lodging in Chatham Place, London. The closeness of his sketch of a wallpaper design of fruit trees (fig. 4.45) to Morris's trees for the dining room (fig. 4.32) is immediately discernible and Rossetti's pre-occupation with enriching his rooms suggests that he found himself spurred on by Morris's realisation of his decorative ambitions. All must have discussed their intentions and shared inspiration, for indebtedness and friendly rivalry was an integral part of their relationship. Writing to William Allingham in January 1861, Rossetti recounts:

We have got our rooms quite jolly now. Our drawing-room is a beauty ... and on the first country trip we make we shall have it newly papered from a design of mine which I have an opportunity of getting made by a paper manufacturer somewhat as below. I shall have it printed on common brown packing paper and on blue grocer's paper, to try which is best. The trees are to stand the whole height of the room, so that the effect will be slighter and quieter than in the sketch where the tops look too large. Of course they will be wholly conventional. The stems & fruit will be Venetian Red – the leaves black. The fruit however will have a line of yellow to indicate roundness & distinguish it from the stem. The lines of the ground black. And the stars yellow with a white ring round them. The red & black will be made of the same key as the brown or blue ground so that the effect of the whole will be rather sombre but I think rich also. When we get the paper up we shall have the doors & wainscoting painted summer house green ... I should like you to see how nice the rooms are looking and how many nice things we have got in them.

However you have yet to see a real wonder of the age – viz: Topsy's [a nickname for Morris] house which baffles all description now?[87]

FIG. 4.49
The view from the Pilgrim's Rest porch through the glazed screen to the hall today. The passage was originally decorated in rich shades of green.

DECORATING AND FURNISHING THE HOUSE

FIG. 4.50
A stained glass panel of a cock crowing by Philip Webb, c.1859–60, probably made by James Powell & Sons. Painted and leaded glass: 15.5 x 13 cm.

FIG. 4.51
A stained glass panel of a goose by Philip Webb, c.1859–60, probably made by James Powell & Sons. Painted and leaded glass: 15.5 x 13 cm.

PASSAGE

The passage leading to the Pilgrim's Rest porch and the garden runs at right angles to the hall. It is divided from it by a part-glazed screen with two fixed outer panels and a pair of doors beneath seven glazed sections, which was originally painted dark green with a blue-green on the frame return (fig. 4.49). Although this is not indicated on Webb's ground plan and cuts across the stamped ceiling pattern, it is mentioned in the memoir of a visit in 1863. This suggests that it was added during the late stages of building work in 1860 or once the Morrises had moved in and realised the need to contain the heat in the hall of what must have been a very cold house in winter.

The passage was painted a warm green with darker green window reveals and lit by the glowing quarries of the four leaded stained glass windows. These are filled with alternating bird and stylised plant designs attributed to Webb and Morris. The deftly drawn birds, which are believed to have a fifteenth-century precedent, speak of Webb's study from nature. His early notebooks contain many quick sketches and detailed drawings of birds and animals, for whom he felt a natural empathy. The stylised birds – a cock (fig. 4.50), a duck, a goose (fig. 4.51) and a heron – are full of character and liveliness and sit comfortably alongside Morris's design of a daisy-like flowering plant. These windows pre-date the production of stained glass by the Firm and were probably made by James Powell & Sons, Whitefriars, in about 1859–60,

FIG. 4.52
Stained glass panel, *Fortune* by Edward Burne-Jones, *c.*1863–4, probably made by James Powell & Sons. Stained and painted glass: 33.5 x 20 cm. The figure of Fortune is shown blindfolded, clasping the wheel of fortune, a symbol of the mercurial nature of fate. Burne-Jones's richly coloured glass overlays quarries of stylised flowering plants designed by William Morris and beady-eyed birds designed by Philip Webb which are believed to have been part of the house's original decoration in 1860.

DECORATING AND FURNISHING THE HOUSE

FIG. 4.53
Stained glass panel, *Love* by Edward Burne-Jones, *c.*1863–4, probably made by James Powell & Sons. Stained and painted glass: 33 x 19 cm. The winged and crowned figure of Love, clutching his bow, stands on a flowery mead against a backdrop of the golden sun and a starlit sky.

who went on to produce them under the aegis of the Firm from 1861. Webb's birds were also translated into tile designs in blue overglaze on tin-glazed white tiles and sold from 1862. Overlaying the quarries in the two outermost windows are stained glass figure panels designed by Burne-Jones depicting *Fortune* and *Love*, c.1863–4 (figs 4.52 and 4.53). These are striking studies in the glowing, earthy reds, yellows, greens and blues of the fourteenth-century stained glass that Morris favoured and subtly reinterpreted in the Firm's earliest glass. Burne-Jones first made these two designs for the artist Myles Birket Foster's house, The Hill, Witley, Surrey, in 1863. Here the bedroom fireplace with the Cinderella overmantel had tiled reveals containing tiles of *Love* and *Fortune*. The two designs were then translated into stained glass panels and overlaid on the quarries in the ground-floor passage windows at Red House. Burne-Jones's figures of *Love* and *Fortune* share stylistic details with Morris's designs for the dining room embroideries and, given their date, may well have been inspired by them. Morris's female heroines are similarly portrayed wearing flowing robes and standing on grassy banks studded with flowers. The depiction of *Love* and *Fortune* in stained glass forms part of the broader theme of love – the subject that underpins and unites the figurative decoration throughout the house.

PILGRIM'S REST PORCH

The sheltered garden porch (fig. 4.55) has come down through history with the name of the 'Pilgrim's Rest' and it is tempting to attribute this to a romantic notion of Morris's, in which he weaves together the proximity of the medieval pilgrimage route to Canterbury with the character of his own house and garden. The porch overlooks the well-court on the south-east side of the house. It is furnished with a simple oak bench set into the wall, with a tiled

FIG. 4.54
Detail of the tiled back to the fixed oak bench in the Pilgrim's Rest porch, which shows two of the three tiles designed by Morris for this location – the rose in splendour and his motto 'si je puis'.

DECORATING AND FURNISHING THE HOUSE

FIG. 4.55
The Pilgrim's Rest porch leading from the house to the well-court. The circular window was added *c*.1926.

back comprising three distinct but linked designs. The blue, white and yellow tiles depict the coat of arms adopted by Morris's father in 1843 (details of which Webb adapted for the design of the weathervane), the medieval symbol of the rose in splendour (which Morris used in a similar style on his Chaucer tile, 1864) and Morris's motto 'si je puis' in the form of scrolling text around an oak sapling, which shelters the medieval form of the letter M (fig. 4.54). The tiles were fired to Morris's design in the kiln at the Firm's showroom at 8 Red Lion Square in about 1861 and are his earliest known tile designs. Georgiana Burne-Jones fondly recalled sitting in the 'small garden-room' at a red painted table and enjoying the garden.

WAITING ROOM

The waiting room is modest in scale, lit by a single sash window and entirely north facing. The dull north light was counterbalanced by the decorative scheme of a white, lime-washed ceiling, bright blue walls and dark green door, window surround and skirtings, which would have created a warm, rich atmosphere. The red-brick fireplace (fig. 4.56) has a simple wooden mantelpiece with a chamfered edge, which appears again on a more diminutive scale in the two west-facing bedrooms on the first floor. The reveals are lined with tiles which may originally have been the white, Dutch tin-glazed earthenware blanks specified by Webb in the building contract or tiles designed for the house by Burne-Jones. No records exist of the first tiles, though they have been sympathetically replaced by a Dutch variant of Morris's design *Bough* from the 1870s. This four-square design of foliage in dark and light blue overglaze on a tin-glazed tile was sold by Morris & Co. from about 1877.[88]

In his 1879 lecture 'Making the Best of It', Morris expounded on the subject of the decorative interior and the great importance he placed on fireplaces. With the example of Webb's unadorned red-brick fireplaces in mind, he argued:

Now I think there is nothing about a house in which a contrast is greater between old and new than this piece of architecture [the fireplace]. The old, either delightful in its comfortable simplicity, or decorated with the noblest and most meaning art in the place; the modern, mean, miserable, uncomfortable, and showy, plastered about with wretched sham ornament, trumpery of cast-iron, and brass and polished steel, and what not – offensive to look at, and a nuisance to clean – and the whole thing huddled up with rubbish of ash-pan, and fender, and rug, till surely the hearths which we have been bidden so often to defend (whether there was a chance of their being attacked or not) have now become a mere figure of speech the meaning of which in a short time it will be impossible for learned philologists to find out.

DECORATING AND FURNISHING THE HOUSE

FIG. 4.56
The red-brick fireplace with a hearth of 12-inch red paving tiles specified by Webb. The fire basket and the original tiled reveals have been lost and replaced with a Dutch version of Morris's tile design *Bough*, c.1870s. The copper hood and tiled back blocking the chimney are post-1866 adaptations.

> *I do most seriously advise you to get rid of all this, or as much of it as you can without absolute ruin to your prospects in life; and even if you do not know how to decorate it, at least have a hole in the wall of a convenient shape, faced with such bricks or tiles as will at once bear fire and clean; then some sort of iron basket in it, and out from that a real hearth of cleanable brick or tile ... if you have wooden work about the fireplace, which is often good to have, don't mix up the wood and the tiles together; let the wood-work look like part of the wall-covering, and the tiles like part of the chimney.*[89]

In their discussions on the number, layout and requirements of the various rooms to be included in the house, the need for a small reception room close

to the front door enabling Morris to interview servants, meet potential customers for his art works, as well as tradesmen or possibly even models, must have been voiced. The waiting room would have enabled Morris to conduct a degree of business without admitting potential customers into the family rooms of the house. With his career as a painter in mind, he envisaged the need for a room in which to do business whilst also anticipating his later desire to move the productions of the Firm to the Red House or the locality in 1864.[90]

'BACHELOR'S BEDROOM'

In a house that served almost as a second home for Morris's friends in the early 1860s, as they spent long weekends there as often as time would allow, there must frequently have been the need for extra beds. Delineated on Webb's ground plan as a bedroom, this room has traditionally been assigned the role of accommodating bachelor and male friends visiting without their wives. Amongst others – recorded and unrecorded – these included Webb, Charles Faulkner, Algernon Swinburne, the architect G.F. Bodley, the artists George Price Boyce and Arthur Hughes, and the poet William Allingham. As it was often the case that several friends were staying, Webb placed this bedroom at the furthest point away from the upstairs west-facing bedrooms. Once Jenny was born in 1861, this meant that both baby and guests were least likely to impact on the others' sleep.

It was decorated in the same combination of colours as the waiting room, with bright blue walls and dark green woodwork. Fragments of yellow ochre have been found on the stamped ceiling, suggesting that this had a yellow and white scheme.[91] The red-brick fireplace by Webb with wooden mantelpiece survives, although in altered form. The original tiled inserts have been lost and are unrecorded, though again either white blanks or tiles designed by Burne-Jones would have been found here.[92] Below the mantelpiece is a later painted inscription in gothic-inspired script which matches the lettering of the inscription above the fireplace in the drawing room and is believed to have been introduced in around 1889–1901 by a subsequent owner, Charles Holme.[93] The room is furnished with a corner cupboard designed by Webb, which was painted a deep dark green to match the door, window surrounds and skirting. The current oxide red scheme with two lions rampant and a pennant with an inscription in golden yellow paint is attributed to Charles Holme.[94] This stands in the south-east corner of the room and is fixed to the wall. Webb's ground plan clearly shows a pencil line demarcating this cupboard in the diagonally opposite corner, and the position of this piece may have been altered when it was fixed in the room. Other pencil lines appear to denote

FIG. 4.57
The upper section of Webb's corner cupboard, *c.*1860. Painted wood and iron: 202 x 114.6 cm. It is fitted internally with shelves and was originally painted a deep dark green and does not appear to have had painted patterns or inscriptions.

a large rectangular piece of furniture where the cupboard now stands, and two beds. The appearance of the beds is unknown and the furniture may well have comprised the simple green-stained washstand, dressing (toilet) table and towel horse designed by Ford Madox Brown in 1860 or, from 1862, the bedroom furniture designed by Webb (fig. 4.57). The bedroom is lit by two east-facing sash windows with shutters. The circular leaded window looking in to the Pilgrim's Rest porch was added in about 1926 by a later owner who copied the form of the windows lighting the passage on the first floor.

FIG. 4.58
The drawing room today, with Webb's towering hearth and wall of windows facing north. This room was originally richly-coloured and intricately patterned.

DRAWING ROOM

The drawing room lies at the head of the oak stair. Innovative for the time, the decision to place the principal reception room on the first floor was inspired by the medieval precedent of a great chamber. Any visitor would have the opportunity to experience the volume of the stair tower before entering the rich, glowing interior of the jewel-like drawing room. The ceiling extends up to the roof line, is well lit by three arched windows to the north and an oriel window to the west; when it was built it commanded expansive views in both directions.

Recalling her first stay in the house, Georgiana Burne-Jones recounted that because 'The dining-room was not yet finished, and the drawing room upstairs, whose beautiful ceiling had been painted by Mr. and Mrs. Morris, was being decorated in different ways', Morris's first floor studio was used 'for living in'.[95] The 'different ways' to which she refers conjures up an image of the varied elements planned for the rich interior. She might have added the phrase 'by different hands', to give a fuller suggestion of the collaborative decorative scheme devised and then underway for the room. The drawing room was, in effect, an artist's studio and the art work was the room itself.

This was to be the most ambitiously decorated part of the house, with

flower and foliate patterns on the ceiling, floral decoration above the settle, seven scenes from the poem of *Sir Degrevaunt* to be painted by Burne-Jones at eye level on the walls, banded decoration with flower motifs to be painted around all four walls, the panelled alcove to the bay window to be decorated with gold leaf and repeating foliate patterns, the corresponding section of ceiling to be decorated in a grid of circles within squares and the settle to be enhanced by the addition of a third panel painting by Rossetti, depicting *Dantis Amor* (*Dante's Love*). The resultant interior was complex and densely layered; it exploited the architecture to dramatic effect. Repeating flat patterns abutted figurative wall paintings which were positioned alongside panel paintings depicting scenes from literary texts that held potent meanings for Morris, Burne-Jones and Rossetti. Morris's great chamber was a paean to the constancy of love as expressed in the poetry of Dante, Chaucer and the anonymous poet of the Arthurian poem of *Sir Degrevaunt*. Morris saw his love for Jane mirrored in the works of these great poets.

A strong sense of the passionate enthusiasm with which Burne-Jones and Morris embraced the interiors is evoked by Burne-Jones's recollections:

As we talked of decorating ... plans grew apace. We fixed upon a romance for the drawing room, a great favourite of ours called Sir Degrevaunt. I designed seven pictures from this poem, of which I painted three that summer and autumn in tempera ... The great settle from Red Lion Square, with the three painted shutters above the seat, was put up at the end of the drawing room ... Morris painted in tempera a hanging below the Degrevaunt pictures, of bushy trees and parrots and labels on which he wrote the motto he adopted for his life, 'If I can'. He worked hard at this and the room began to look very beautiful.[96]

In sharp contrast to Burne-Jones's sense of the beauty of the whole was William Bell Scott's astonishment, when he visited in 1861, at the surprising and unexpected character of the decoration. He wrote of the drawing room: 'It had a fixed settle all round the walls, a curious music-gallery entered by a stair outside the room, breaking out high upon the gable ... This vast empty hall was painted coarsely in bands of wild foliage over both wall and ceiling, which was open-timber and lofty. The adornment had a novel, not to say startling character, but if one had been told it was the South Sea Island style of thing one could have easily believed such to be the case so bizarre was the execution.'[97] Bell Scott's response highlights the originality of the decoration and the individual nature of the fixed furniture, which united to form an exotic interior that spoke of Morris's singular vision and imaginative world. Bell Scott's reminiscences continue: 'This eccentricity was very easily understood after a little consideration. Genius always rushes to extremes at first: on leaving the beaten track of everyday no medium is to be preserved.'[98]

FIG. 4.59
William Bell Scott's mural on the stair at Penkill Castle, *c.*1865–8. Tempera on plaster. This scene depicts the opening of the poem *The King's Quair*, attributed to James I of Scotland, and written during his captivity in the 1420s. The uppermost knight is reading Boethius's *The Consolation of Philosophy*, and is believed to be modelled on the co-founder of the Pre-Raphaelite Brotherhood, William Holman Hunt.

DECORATING AND FURNISHING THE HOUSE

On looking back at his first visit to Red House some thirty years later, Bell Scott acknowledged Morris's experimentation and his desire to forge a new visual artistic language for decorating his home. He also appears to have been inspired by what he saw, for in 1861 he visited Penkill Castle, Ayrshire, Scotland (fig. 4.59), and was to begin his own series of ambitious neo-medieval wall paintings and decoration there in 1865, much of which may be seen to respond to Morris's example at Red House.[99]

✣

The earliest known photographs of the room show that by 1887 it had been given an explicitly neo-baronial character, with the addition of battens to suggest a medieval waggon-vault roof, panelling beneath the *Sir Degrevaunt* wall paintings, protective glazing to the paintings, stencilled decoration of coats of arms, fleur de lys to the front of the minstrels' gallery and the painted inscription 'Ars Longa Vita Brevis' ('Life is short, art endures') added to the upper line of brickwork of the fireplace.[100] By the late twentieth century, the appearance of the drawing room was even further removed from its original form. Whilst the settle still survived in situ, the only colour in the room was provided by Burne-Jones's three wall paintings, the mass of Webb's spare but monumental red-brick fireplace, the primary yellow of the patterning on the small section of ceiling to the oriel window and pine battens to the main ceiling. The rest of the room was universally painted in titanium white, leaving the *Sir Degrevaunt* paintings as a vibrant relic of the former highly coloured, richly patterned interior immortalised by the memories of those who had been part of its creation or witnessed it in the early 1860s.

Recent investigations of the physical fabric of the room have been undertaken with the aim of testing the fidelity of the first-hand accounts of this striking interior. To date, a series of discoveries has revealed that extensive parts of the original polychrome decoration have survived; this has enabled the individual elements of the decorative scheme to be pieced together to create a picture of the resplendent ensemble (fig. 4.61).

In the summer of 1860, before Burne-Jones began work on the *Sir Degrevaunt* paintings, William and Jane Morris had decorated the ceiling with a repeating pattern of stylised spiky flower heads on wavy stems, set within a frame of horizontal and vertical bands and repeating geometric fan-shaped motifs in shades of brown, yellow and red over a pale cream lime-wash ground.[101] It is a controlled and confident composition which fills the ceiling with bold forms whilst retaining a sense of lightness and balance.[102] Morris had first explored creating a flowing ceiling pattern, which responded to the architecture of the room and reflected the meaning of the figurative paintings on the walls, in his work on the Oxford Union Debating Hall in 1857 (fig. 2.8). He is said to have completed the 'dark, complicated, mythical'

OVERLEAF
FIG. 4.60
The drawing room today, featuring three wall paintings by Edward Burne-Jones. Much of the rich polychromatic interior has been obscured by later white paint.

PREVIOUS PAGES: **FIG. 4.61**
A digital rendering of the drawing room showing the richly-coloured, highly patterned decoration of the room prior to 1863, when the panel paintings by Rossetti were removed from the settle. John Tredinnick.

FIG. 4.62
Detail of the original ceiling decoration when it was briefly exposed in 1957. The wavy flower stem is incised with fine vertical scratches which appear to be integral to the design and add definition to the stem.

FIG. 4.63
Detail of the partially exposed ceiling decorations today.

design with 'a mass of vegetation' within a day, and this suggests something of his gusto and delight in experimenting with pattern, with which he approached the design of the drawing room ceiling.[103] At Red House, he devised a freer, less dense composition to integrate with and complement the richness of the decoration to be executed on the walls below. The decoration had been papered over by 1897 but was rediscovered and photographed in 1957 before being obscured with white paint and lost from sight and memory until 2004, when the first ghostly vestiges of the richly coloured decoration were revealed (figs 4.62 and 4.63).[104]

As recorded by Burne-Jones, Morris did paint a simulated textile 'hanging below the Degrevaunt pictures', though it does not match his description. Surviving behind the panelling introduced (after 1866 and before 1897) are walls painted in horizontal bands of a salmon-orange, a warm blue-green and dark red. Stylised plants (auricula) with petals of a brighter red, and white and yellow stems and leaves are repeated to give the impression of an embroidered hanging.[105] A scrolling banderole inscribed in French, 'Qui bien aime tard oublie', which translates as 'Who loves well forgets slowly', runs across each flower stem (fig. 4.69). The upper blue-green band has a truncated appearance, for it is partially overpainted by the lower section of Burne-Jones's wall paintings. Having been protected from the light for over a century, the salmon-orange and dark red bands have held true to their

original intensity of colour, but the blue-green band has darkened almost to black. This decoration originally extended around the entire room, rising to the springing of the ceiling on either side of the towering brick fireplace.

The quotation is from a song in Chaucer's fourteenth-century poem *The Parliament of Fowls* in which the narrator watches birds, ranging from eagles to ducks, meet to choose their mates on St Valentine's Day in a lively and disputatious gathering presided over by the goddess Nature.[106] Morris was to use this quotation on a set of embroidered hangings of 1861–2, whose exact provenance is uncertain but which may have been made at Red House.[107] The embroidered hanging comprises a repeated design of fruit trees with a banderole entwining the trunk inscribed with 'Qui bien aime tard oublie' and daisies, flying herons and chameleons (fig. 4.66). The banderole and form of the fruit trees have a very similar layout to the auriculas and banderole on the painted 'hanging' (fig. 4.69). They both derive from wall hangings depicted in 'The King of France and the Duke of Brittany Meeting at Tours' and 'The Dance of the Wodehouses', two illustrations from the fifteenth-century manuscript of Froissart's *Chronicles*, which Morris had studied in the British Museum (figs 4.64 and 4.65).[108]

This decorative scheme is essentially similar in form, but decidedly different in detail, to that recorded by Burne-Jones. Did Burne-Jones misremember the detail of Morris's painting after a passage of time, or even the location of this alternative scheme? The documentary evidence implies that Morris inscribed his motto 'If I can' on a banderole on one of his painted schemes, for Burne-Jones so clearly remembers the ensuing verbal outburst when 'On one of these visits to Red House Rossetti found many of these labels still blank, waiting for the words "If I can", and in his reckless way instantly filled them with another motto, "As I can't". When Morris saw this pleasantry, Edward said, "it would have puzzled the discriminator of words to know which of those two was most eloquent in violent English".'[109] Evidence of this additional painted 'hanging' may yet materialise.

✿

The design of the 'Qui bien aime tard oublie' painted 'hanging' seems likely to have inspired William Burges. He visited the house in 1861, and would have seen this and the wall painting depicting a simulated 'hanging' of Old Testament figures, which was possibly still in execution in the principal bedroom. Did his close friend, the architect and designer E.W. Godwin make an unrecorded visit to the house too? Both Burges and Godwin had much in common with Morris in their shared passion for the medieval and their knowledge accumulated from close study of illuminated manuscripts and historical sources. Burges introduced simulated painted 'hangings' into his decorative scheme for the Vicar's Hall at Wells in Somerset in 1864, whilst

FIG. 4.64
'The King of France and the Duke of Brittany meeting at Tours' from *The Chronicles* by Jean Froissart, *c.*1396. The wall hangings depicted here and in fig.4.64 provided inspiration for the daisy hanging and the the 'Qui bien aime tard oublie' embroidery and banded wall decoration in the drawing room.

FIG. 4.65
'The Dance of the Wodehouses' (detail) from *The Chronicles* by Jean Froissart, *c.*1396. British Library.

FIG. 4.66
Embroidered hanging by William Morris, *c.*1860–2. Wool on a linen ground: 185.5 x 127.5 cm. This may have been made at Red House and may possibly have hung there before being displayed at Penkill Castle, Ayrshire from 1868. The motto 'Qui bien aime tard oublie' also features in the banded decoration which runs around all four drawing room walls. William Morris Gallery.

qui bien aime tard oublie

FIG. 4.67
The Proposed Design by William Burges for the Winter Smoking Room at Cardiff Castle by Axel Haig, *c.*1870
Watercolour on paper: 57 x 52 cm. This depicts Burges's ornate neo-medieval interior, designed for the 3rd Marquess of Bute. The wall to the side of the fireplace is painted with figures in medieval dress harvesting apples and the inscription on the fireplace is taken from Virgil and reads: 'love conquers all; let us yield to love'. National Trust, Knightshayes Court.

Godwin's design for Northampton Town Hall dated 1861–2 included painted textile 'hangings'.[110] Burges's designs for the riotously coloured and richly furnished interiors for Cardiff Castle, Castell Coch, and his own house, Tower House in Kensington, in the 1870s might also be seen to have responded to and transcended Morris's decorative schemes for Red House, exemplified by the drawing room (fig. 4.67).

Sir Degrevaunt

Sir Degrevaunt, the 'great favourite' of Morris and Burne-Jones was one of four anonymous poems, compiled under the heading of *The Thornton Romances* (comprising also *Sir Perceval of Galles*, *Sir Isumbras* and *Sir Eglamour of Artois*), which date from the fifteenth century and survive in manuscript form in the libraries of Lincoln Cathedral and Cambridge University. First published in 1844 by the Camden Society, the stirring romances of knightly endeavour and prowess were made available to a wide audience and stimulated the burgeoning revival of interest in medievalism.[111] Burne-Jones and Morris developed a mutual passion for *Sir Degrevaunt* whilst at Oxford and their decision to illustrate the events of the final verses of the poem in such a prominent position speaks of its importance.[112] The poem recounts the tale of Sir Degrevaunt, a knight of the Round Table. He is both accomplished in warfare and a considerate landowner whose estate is well stocked and whose tenantry are in good heart. Whilst away on crusade, he learns that his lands have been plundered and his people attacked by the earl whose lands adjoin his. On his return, he sends the earl a letter seeking legal redress; the earl scornfully ignores Sir Degrevaunt's request and continues to hunt on his land. Sir Degrevaunt arms his men and lays in wait to ambush the earl on his next foray, and after a bout of fierce fighting the earl flees. The following day, Sir Degrevaunt rides to the earl's castle to confront him but catches sight of his daughter Melidor and is smitten. Consumed by love, Sir Degrevaunt determines to restrict himself to hunting on the earl's land rather than challenging him to fight. That evening, he hides with his squire in the orchard near Melidor's chamber. He waits until she returns from chapel, before approaching her and confessing his love. Melidor's first thought is to call for her father's guards but her maid, who has fallen for the squire, beseeches her mistress to let her spend the evening with him. Sir Degrevaunt's squire and the maid become betrothed and the maid assists Sir Degrevaunt in his pursuit of Melidor. She shows him a secret way into the castle and reveals that there is to be a tournament in Melidor's honour arranged by her suitor, the Duke of Gerle. The duke vows to slay Sir Degrevaunt but is unwittingly unseated by an unknown knight (Sir Degrevaunt in disguise) on both days of the tournament and is spurned by Melidor.

After his success in the tournament, Sir Degrevaunt avails himself of the

secret entrance and visits Melidor in her beautifully decorated chamber. She confesses that she returns his love and they plight their troth, although she is steadfast that she will remain chaste until they are married. Ignoring the threat posed by her father, Sir Degrevaunt secretly visits her every night for nine months until he is spotted by one of the earl's men and ambushed. He successfully fends off his attackers and visits Melidor as usual in her chamber. The following morning, the earl is overcome by anger and confronts Melidor with her treachery. His towering rage is finally assuaged by the countess and he agrees to the marriage of Melidor and Sir Degrevaunt. The happy couple inherit the earl's estates, have seven children and are married for thirty years. They remain devoted until Melidor's death prompts Sir Degrevaunt to return to the crusade, where he is slain in the Holy Land after jousting with a sultan.

The poem has a lively narrative and a dramatic plot with a wealth of description and inventive detail. The love of the chivalric hero and the chaste maiden triumphs in the face of the fierce hostility and marauding behaviour of her father, whose character is diametrically opposed to that of the fair, generous and steadfast Sir Degrevaunt. There are richly descriptive passages which conjure up life in the castle in vivid detail and portray the arresting interior of Melidor's chamber, her fine clothes and beautiful appearance.

Burne-Jones recounts that he 'designed seven pictures from this poem, of which I painted three that summer and autumn [1860] in tempera'. The three executed paintings are *The Wedding Ceremony* (fig. 4.68), *The Wedding Procession* (fig. 4.69) and *The Wedding Feast* (fig. 4.72); each one depicts a scene from the denouement of the poem. In *The Wedding Ceremony*, Sir Degrevaunt and the flame-haired Melidor are both richly attired in sumptuous golden outfits and attended by three maidens dressed in rich red and blue dresses. The marriage is presided over by a cardinal, who chants the royal mass against the backdrop of a suspended golden hanging, patterned with flower motifs. The adjoining picture, *The Wedding Procession*, shows the bride and bridegroom walking through a beautiful rose garden whilst being serenaded by three musicians. In the poem, both Sir Degrevaunt and Melidor share a love of music. The sky is golden, ensuring a fluent line of colour between the two sequential pictures, which meet at an angle in the corner of the room. The golden hue suggests, too, a reinterpretation of the lines

> *gold ...*
> *Welle a thowsand pounde*
> *Lay glyterynge in the gronde*
> *By the way as thei wend!*[113]

Burne-Jones supplants the glittering golden path of the poem with a burnished golden sky. The placement of the musicians has been carefully wrought so that they are depicted immediately to the left of the ladder which leads up to

FIG. 4.68
The Wedding Ceremony by Edward Burne-Jones, 1860. Tempera on plaster: 112 x 88.8 cm.

DECORATING AND FURNISHING THE HOUSE

FIG. 4.70
The Wedding Procession of the Virgin (detail), Giotto, *c*.1305. Fresco. Scrovegni (Arena) Chapel, Padua.

the minstrels' gallery of the settle.

Music making was to be a feature of the drawing room and this juxtaposition accentuates the role of music in the poem and in Morris's life. Morris sang plainsong at Oxford and published his first carol, 'French Noel', in the collection *Ancient Christmas Carols* in 1860.[114] Georgiana Burne-Jones captured the scene when she recalled, 'in the evenings we had music of a simple kind – chiefly the old English songs published by Chapell and the inexhaustible *Echos du Temps Passé*'.[115] Jane Morris learnt to play the piano and Morris's present on her first birthday after their marriage was a copy of William Chappell's *Popular Music of the Olden Time*, inscribed 'Janey Morris October 19th 1859 With W.M.'s love.'[116]

Ruskin's writings on Italian art and architecture, newly published engravings of early works in books and recently acquired pictures – including works by Bellini, Botticelli and Veronese on display in the National Gallery in the 1850s – built up Burne-Jones and Morris's impressions of Italy and the allure of its art. Burne-Jones made his first Italian tour, visiting Milan, Siena, Pisa, Bologna, Verona, Padua, Florence and Venice in the autumn of 1859, filling his sketchbook with studies of pictures and frescoes and revelling in the light, colour and beauty of the works in situ.[117] Giotto's sequence of thirty-

FIG. 4.69
The Wedding Procession by Edward Burne-Jones, 1860. Tempera on plaster: 114 x 112 cm

FIG. 4.71
Study for The Wedding Feast of Sire Degrevaunt by Edward Burne-Jones, c.1860. Pen with brown ink and graphite paper: 29.7 x 35.6 cm. Yale Centre for British Art, Paul Mellon Fund.

nine frescoes in the Scrovegni (Arena) Chapel, Padua were greatly admired by Ruskin and captivated Burne-Jones.[118] Drawn to the comprehensively told narrative of the life of Mary and Jesus by both the realism and striking colour of Giotto's compositions, Burne-Jones appears to have chosen two to serve as direct inspiration for his miniature fresco cycle at Red House.[119]

In *The Wedding Procession*, Burne-Jones's depiction is modelled on Giotto's *The Wedding Procession of the Virgin* (fig. 4.69). The placement of the figures and the appearance of the musicians and their instruments reveals his

FIG. 4.72
The Wedding Feast of Sir Degrevaunt by Edward Burne-Jones (possibly part-executed by William Morris). Tempera on plaster: 115.5 x 104 cm. William and Jane Morris are portrayed as Sir Degrevaunt and Melidor at the centre of the feast whilst a wombat lies asleep underneath a chair. The dress of the seated lady holding a small dog is based on the floral pattern painted on the wall above the settle and the serving maid to her right wears a red dress with patterning copied from the ceiling to the oriel window. Or alternatively, the decorative patterns are based on the precedent of the wall painting. Above the painting, the vestiges of the corresponding verse from the poem are visible.

indebtedness. Burne-Jones translates the procession of Sir Degrevaunt and Melidor to a familiar garden setting. They walk along a flowery path against a backdrop of climbing roses towards the edge of a red-brick building, which signifies Red House.

Five preparatory studies for the three wall paintings are known.[120] Each is revealing of Burne-Jones's creative process and heightens our understanding of the adaptations that he made on site when he painted the scenes directly onto the plaster walls. The watercolour study for *The Wedding Feast of Sire Degrevaunt* shows a seated red-headed figure intently reading an illuminated manuscript (fig. 4.74). This is a portrait of the poet Algernon Swinburne, who was a frequent visitor to Red House in the early 1860s, in the guise of the unknown author of *Sir Degrevaunt*. His flame-coloured hair and laurel wreath are closely allied to Melidor's in *The Wedding Procession*. The fragment of striped decoration is a copy of the wall hanging in Giotto's *Marriage at Cana* (fig. 4.73) and the study of the serving girl is believed to have been posed by Fanny Cornforth, a model who also served as Rossetti's housekeeper (fig. 4.74).[121] In the accompanying pen and ink study, the arrangement of figures is close to the wall painting, although it differs in detail (fig. 4.72). The placement and sex of various figures are altered in the final rendition. The figure of the poet is much closer to the black-clad figure, with a red band to his headdress, who features in the wall painting. Lost in study of the book of stanzas and musical notation on his knee, he is apparently oblivious to the feasting and merrymaking which surrounds him.

The inclusion of the figure of the unknown medieval poet in the painting itself testifies to the esteem in which Burne-Jones held his work. He is personified in art, just as Burne-Jones had reverently included a portrait of Chaucer on the front of *The Prioress's Tale* wardrobe, which stood in the neighbouring bedroom. Burne-Jones's portrait of the anonymous poet also places him alongside Dante, both literally and metaphorically, for Rossetti included a portrait of Dante in almost identical dress in his panel painting of *The Salutation of Beatrice on Earth* on the adjacent settle. Art is inspired by poetry and poetry is inspired by art and the young artists pay homage to their poetic heroes in their works. They also connect their friends with the character of literary figures by including their portraits in the pictures in the drawing room.

In the first two *Sir Degrevaunt* paintings, Burne-Jones portrays the bride and bridegroom as attractive figures; he is handsome and clean shaven, she is pretty with long red hair, yet neither appears to be a direct portrait. In contrast, in *The Wedding Feast*, Sir Degrevaunt and his bride are depicted as William and Jane Morris wearing coronets. Burne-Jones makes a strong visual association between the virtuous love and ensuing happy marriage narrated in *Sir Degrevaunt* and the union of the recently married Morrises. William is characterised as Sir Degrevaunt and Jane becomes Melidor in a

DECORATING AND FURNISHING THE HOUSE

FIG. 4.73
The Marriage at Cana (detail), Giotto, *c.*1305. Fresco. Scrovegni (Arena) Chapel, Padua.

FIG. 4.74
Study for The Wedding Feast of Sire Degrevaunt by Edward Burne-Jones, 1860. Watercolour, gouache and pen and violet ink over graphite on wove paper: 26.2 × 29.5 cm. Inscribed by the artist: EBJ/to/FEHB [unidentified recipient]. The striped fragment is drawn directly from the wall decoration in Giotto's fresco, *The Marriage at Cana*. Lanigan Collection, Saskatoon/National Gallery of Canada.

FIG. 4.75
Ceiling decoration to the oriel window with an uncovered section of original pattern c.1860 set against the 1957 scheme which copied the original in modern paints. The fragment of red shows the original colour of the beams.

symbolic allusion which is amplified by the figurative wall painting with which Morris chose to decorate the principal bedroom as a representation of Melidor's chamber. In the poem, there are fourteen days of feasting and revelry to mark the marriage; with Burne-Jones's decision to place William and Jane in character presiding over the wedding feast, he makes a literal association to the hospitality for which Morris was famed and which became synonymous with Red House.

The wall painting of *The Wedding Feast* incorporates details that tie it to the wider decoration and make a visual joke. The brass pitcher, which must have been owned by Morris, features in Burne-Jones's painting as well as in Morris's *La Belle Iseult* (fig. 2.11). The pattern of circles within a square grid on the red dress worn by the serving maid is recreated from the flat pattern in yellow and cream on the section of ceiling to the oriel window (fig. 4.75). The green patterned dress of the seated guest echoes the floral decoration of the wall above the settle. At first glance, there appears to be a small dog lying asleep under the chair on the left. Closer inspection reveals this to be a wombat, no doubt included to amuse Morris and Rossetti with the thought that a marsupial native to Australia had trespassed into this fifteenth-century scene. Burne-Jones was introduced to wombats by Rossetti, on whom they exerted a powerful fascination. Rossetti had arranged to meet Edward and

Georgiana Burne-Jones 'at the Zool. [Zoological] Gardens – place of meeting, The Wombat's Lair' in July 1860, so this sighting of wombats in Rossetti's company may have sparked Burne-Jones's portrait a month or so later.[122]

Burne-Jones applied himself to the task of painting, spurred on by Morris's energy and ebullience and the overwhelming atmosphere of industry in the house. The men spent the mornings painting, whilst the equally committed women were taken up with embroideries and occasional painting, or woodcuts. Burne-Jones and Morris worked alongside one another in the drawing room, no doubt recalling their first 'jovial campaign' at the Oxford Union Debating Hall and seeing the act of decorating Red House together as the realisation of the artistic brotherhood of which they had first dreamt at Oxford. Georgiana recollects: 'Before we left in October Edward had finished his three pictures, but unfortunately the walls were new and not properly prepared for painting, and, as in the case of the Union, the colour soon faded in patches.'[123] Described as tempera paintings by Burne-Jones, technical analysis of the wall paintings has shown that there was an attempt to 'imitate the appearance of fresco' by building up the layers of colour on a fresh chalk ground and that on *The Wedding Feast* 'the deterioration of the paint surface started almost immediately', due to the technique employed 'of repeatedly under-painting with layers of white chalk' and of using different types of paint for consecutive layers.[124] A marked difference in technique between *The Wedding Procession* and *The Wedding Feast* has prompted the question of whether Burne-Jones chose to experiment with a new approach to the execution of his third painting, *The Wedding Feast*, with the knowledge of the rapid deterioration of the Oxford Union Debating Hall wall paintings uppermost in his mind? Or perhaps the different technique suggests that this picture is the work of another painter? This would be at odds with the Burne-Joneses accounts of his work and requires more detailed analysis and comparative study. However, it raises the possibility that Morris (or another friend) may have painted *The Wedding Feast* to Burne-Jones's design and that there may have been greater collaboration on these art works than has been previously recognised.[125]

The designs, which Burne-Jones mentions for the four unexecuted scenes to complete the proposed sequence of seven, have never been traced and no evidence has been found of preparatory work on the walls of the drawing room. As they were preceding scenes from the poem, they must have been intended to run along the east wall up to the entrance doorway, so that all seven could be read sequentially. One of the scenes may be suggested by the Kelmscott Press edition of *Sire Degrevaunt* that Morris completed in 1896, and which was printed posthumously in 1897.[126] For its frontispiece,

DECORATING AND FURNISHING THE HOUSE

Burne-Jones made a wood engraving depicting Sir Degrevaunt enthralled by Melidor playing a stringed instrument in her chamber (fig. 4.76). The poem still held great resonance for both men years after the poem was chosen as chief subject for the drawing room walls and inspired the decoration of the principal bedroom.[127] Georgiana writes of Edward Burne-Jones, 'For him, whose work was so interwoven with his life, what memories must have risen up when thirty-seven years later he made for the Kelmscott Press another design from this same Romance ... He was often a little hard upon his own early pictures, and did not wish to see them again, but I never remember him quarrel with their subjects.'[128]

Whilst Morris's response to Burne-Jones's wall paintings is unrecorded, a letter from Rossetti suggests that he had seen the works in progress.[129] Writing to William Allingham in September 1860, he emphasises the pull of Red House, noting that Morris, Burne-Jones and Madox Brown are all there and out of his immediate orbit. Madox Brown may have collaborated on the decoration (possibly contributing to the figurative wall painting in the principal bedroom) or may have been there tutoring Morris in painting, which was still his intended occupation. Rossetti relates:

I wish you were in town to see you sometimes for I literally see no one now except Madox Brown pretty often, & even he is gone now to join Morris who is out of reach at Upton and with them is married Jones painting the inner walls of the house that Top [Morris] built. But as for the neighbours, when they see men portrayed by Jones upon the wall, the images of the Chaldeans portrayed (by him!) in extract Vermillion, exceeding all probability in dyed attire upon their heads, after the manner of no Babylonians of any Chaldea, the land of anyone's nativity – as soon as they see them with their eyes, shall not they account him doting, & send messages into Colney Hatch?[130]

This is an extraordinary description, couched in hyperbole for effect. Rossetti makes no mention of Sir Degrevaunt and assigns Burne-Jones's work a biblical basis, for the Chaldeans were a Semitic people mentioned in Genesis. William E. Fredeman notes that he 'is suggesting that the Chaldean magic of E[dward] B[urne-] J[ones]'s imaginative world would qualify him in the public mind for Colney Hatch, an insane asylum near London'.[131] Rossetti's tone is ironic but echoes that of his friend William Bell Scott.

In alluding to the likely response of Morris's neighbours to the wall paintings, he captures the sense of otherness that the decoration embodied. His pronouncement was not misjudged, for Morris's house and his artistic friends were viewed with suspicion. The neighbours were businessmen and

FIG. 4.76
Frontispiece to *Sire Degrevaunt* by Edward Burne-Jones, 1897. Wood engraving for Kelmscott Press edition. Worcester College, Oxford.

farmers, far removed from their literary and artistic milieu. An account recalling Bexleyheath ten years later, in the 1870s, notes: 'the inhabitants ... consisted at that time of middle-aged ladies and gentlemen who had avoided the married state; retired military men who grumbled at everything; and young married people wrapped up in themselves and their children'.[132] This memoir continues:

> *I remember one of the autocrats of the Heath calling and making some extraordinary statements about William Morris who had built a house in the place. His chief offence appeared to be having tea-parties on Sunday ... I can remember well my father's amused smile, which grew into a laugh when the lady asserted that she 'had heard, and felt sure it must be true, that Mrs Morris had been in a circus; no one could ride and manage a horse so beautifully but a performer.' My father explained that this rumour was quite false ... But the autocrat refused to be convinced and said 'That was not the worst. The man was quite a heathen for it was well known that he was married in his drawing room, the ceremony being of a most curious character and afterwards he had it painted upon the wall'.*[133]

Whilst the subject matter was misconstrued, the fame of Burne-Jones's wall paintings had taken on a mythical character in the locality.

※

The removal of later battens on the section of ceiling above *The Wedding Ceremony* has revealed a previously unknown section of wall painting, with inscriptions in a gothicised script in the form of the verses from the poem which narrates the painted scenes (fig. 4.60).[134] Above *The Wedding Ceremony*, three verses run horizontally on a scroll within a frieze of geometric decoration in blue (or possibly a degraded green), red and cream (or yellow), which extends to the springing of the ceiling. Parts of words are legible, notably the 'sse' of 'masse' in the second verse and the 'rych' of 'ryche' in the third.

> *One the Trinite day*
> *Thus in romance herd y say*
> *He toke hyr in Godus lay*
> *Tylle hys lyvys ende*
>
> *Solempnely a cardinal*
> *Revescyd with a pontifical*
> *Sang the masse ryal*
> *And wedded that hend*

DECORATING AND FURNISHING THE HOUSE

FIG. 4.77
Roof decoration with painted king posts, All Saints Church, Middleton Cheney, Northamptonshire, Morris, Marshall, Faulkner & Co., 1864. The floral decoration is allied to the wall decoration above the settle and the design for *Trellis*. Victoria and Albert Museum.

FIG. 4.78
Detail of the wall decoration above the settle which pre-empts Morris's design for *Trellis*.

DECORATING AND FURNISHING THE HOUSE

And the ryche Emperoure
Gaff hyre at the kyrke dore
With worschyp and honoure
As for his owne frend[135]

Both *The Wedding Procession* and *The Wedding Feast* have lost their painted verses, but evidence of two painted scrolls on which the poem was inscribed has been found. The rediscovered text over *The Wedding Ceremony* matches a handwritten extract of the poem found in the photograph album which belonged to Charles Holme, the owner of Red House from 1889–1902. This reveals the full text of the verses above all three pictures and suggests that this section of the wall painting was still on view in 1889 before being obscured by a subsequent decorative scheme prior to 1897.

The wall above the text scrolls to *The Wedding Procession*, *The Wedding Feast* and the settle is painted with a repeating floral and foliate design of pink roses and buds against a rich, dark green background (fig. 4.78). There is a marked similarity between this wall decoration and details of Morris's original design for *Trellis*, his first wallpaper in 1862 (fig. 4.79). The pink roses appear as a flat, stylised precursor to the later *Trellis* roses. The dark green background of the wall decoration was one of the original background colour options for *Trellis*. This wall decoration was executed in the summer of 1860, almost certainly by Morris, who looked to the climbing roses in the garden for inspiration. Moreover, his choice of pink roses picks up on Rossetti's inclusion of pink roses in *The Salutation of Beatrice in Eden* on the settle below, and pre-empts their use by Burne-Jones in *The Wedding Procession*. The repetition of this flower in three different guises across one expanse of wall unites the richly layered decoration. The visual effect of the stylised form of the repeating rose and flower bud pattern complements and reflects the auriculas in the banded decoration at the base of the wall and unites the varied decoration viewed on the same wall. Morris's pink rose reappears in the painted roof decoration executed by the Firm for All Saints Church, Middleton Cheney, Northamptonshire in 1864. This extends the skilful, layered pattern-making devised by Morris for the drawing room and translates it to the king posts and rafters of a fourteenth-century gothic church (fig. 4.77).

FIG. 4.79
Trellis wallpaper designed by William Morris with birds by Philip Webb, 1862. Manufactured as a wallpaper from 1864. Victoria and Albert Museum.

The settle

Mackail records that the 'great painted settle from Red Lion Square was taken and set up in the drawing-room, the top of it being railed in so as to form a small music gallery'.[136] The settle had been designed by Morris in 1856 and made for him by Henry Price in Hatton Garden, whose diary vividly recalls that:

A gentleman who in after years became a noted Socialist, and Poet as is an Art Furnisher called at our shop and got the govner to take some orders for some very old fashioned Furniture in the Mideaval [sic] Style. The guvner knowing that I took great interest in such things put the job into my Hands. Oak, Walnut, Pitch, Pine, Lime Tree and Mahogany all went into the job. A large cabinet about 7ft high and as long, a seat forming a bunk, with arms each end Carv to represent Fishes. Three Cupboards The Doors with fantastic ironwork hinges, representing Birds, fishes and Flowers bolted on, and gilt coloured. The hinges cost 14 pounds. He spent a lot of his leisure in carving the arms and panels.

Pat Kirkham has questioned whether the impressive settle recalled in such distinct detail by Price, with its carved arms and gilded hinges of birds, fishes and flowers, is indeed the piece that survives in the drawing room.[137] Price's ambiguous comment would suggest that elements of the settle were carved by Morris, who is known to have had wood-carving tools and to have made woodcuts. In comparison with the visually dramatic piece that Price's words conjure up, the drawing room settle is determinedly plain, with simple shaped ends to the bench, which are very close in form to Webb's hall settle and with no sign of carving or 'fantastic ironwork hinges'. The accounts by Mackail and Georgiana Burne-Jones indicate that this settle is the one brought from Red Lion Square. It appears that it was dismantled when Morris quit his lodging but was in both his and Webb's minds when the designs for Red House were made. There is a loosely drawn sketch of the settle on Webb's floorplan for the house, dated 1859, which shows the intended form of the minstrels' gallery jutting out above the cupboards of the earlier piece (fig. 3.10).

The position of the settle, centrally placed on the south wall, where it still stands, is also delineated by a pencil sketch on the section of floorplan for the drawing room, indicating that the scale and position of the piece influenced Webb's layout of the room (fig. 3.9). Webb remodelled the settle for its new, pre-eminent position in the drawing room with the addition of a minstrels' gallery and a ladder which lent against the left side and rose to the gallery and to the pair of small doors centrally placed in the wall above. This intriguing juxtaposition draws the eye and tempts the exploration of the hidden inner room. It is a small roof space, which served as a store for the bountiful crop of apples from the garden.[138] The doors were painted an orange-red to match the window seats on the opposite side of the room. Burne-Jones recalls the function of the gallery: 'There at Christmas time it was intended that minstrels should play and sing.'[139] Georgiana Burne-Jones's memory of the settle is equally distinct. She captures the spirit of the playful high jinks and easy camaraderie of the house when she recalls 'in the intervals between work [Charles Faulkner] joined in triangular bear-fights in the drawing room. Once, in the middle of a scrimmage that had surged up the steps into the

FIG. 4.80
Fragments of the original pattern and colours found on the right-hand side of the settle where it abuts the wall. The plain grey plaster is the area behind the settle which remained undecorated.

"Minstrels' Gallery" he suddenly leapt clear over the parapet into the middle of the floor with an astounding noise; another time he stored windfallen apples in the gallery and defended himself against all comers until a too-well delivered apple gave Morris a black eye.'[140]

Surviving patches of red colouring on the inner face of the Minstrels' gallery suggest that part of the settle was painted a shade of deep red, close to that of the dresser in the dining room. Evidence of painted patterns on the sides (which have been covered over by later panelling) in the form of diagonal bands of colour and a repeating circular motif need further research to establish how much of the settle was covered in patterns (fig. 4.80). There would appear to be distinct similarities between the flat patterns found on the hall settle and this piece.

The Salutation of Beatrice on Earth, The Salutation of Beatrice in Eden, and Dantis Amor

Rossetti's father was a Dante scholar and he grew up with an intimate knowledge of the *Divine Comedy* and *Vita Nuova*. Named Gabriel Charles Dante in the poet's honour, from 1849 he expressed his deep-felt affinity with the poet even more strongly by styling himself 'Dante Gabriel Rossetti'. He completed his own translation of Dante's *Vita Nuova* in 1848, which he published in *The Early Italian Poets from Ciullo d'Alcamo to Dante Alighieri* in 1861 and began work on the first of a series of drawings and watercolours that gave pictorial form to Dante's verse and prose narrative of enduring love. The *Vita Nuova* relates the story of Dante's love for Beatrice on earth and remained of critical importance to Rossetti. Throughout the 1850s, he produced watercolours of subjects from the *Vita Nuova*. As Julian Treuherz has emphasised of *Vita Nuova*, 'Its way of transforming autobiography into art, as well as its explorations of questions of artistic meaning and

FIG. 4.81
The Salutation of Beatrice on Earth by Dante Gabriel Rossetti, 1859. Oil on pine panel: 74.9 x 80 cm. National Gallery of Canada.

interpretation, inform all of Rossetti's work in both painting and poetry.' Rossetti identified himself with Dante, and the 'Art, Friendship and Love' which delineated Dante's youth also defined his and that of Morris and Burne-Jones.[141] The enduring love of Dante and Beatrice spoke to all three. In the poem, Beatrice dies on 9 June 1290 and, as Douglas E. Schoenherr has noted, 'that Dante's love for Beatrice was taken very seriously within the Morris circle is indicated by the fact that Georgiana and Edward Burne-Jones became engaged deliberately on 9 June 1856 and married deliberately on 9 June four years later'.[142]

In December 1856, Rossetti wrote of himself, Burne-Jones and Morris, 'we are all three going to cover a cabinet with pictures'.[143] Morris conceived the original design of the settle (the cabinet mentioned by Rossetti) with the

DECORATING AND FURNISHING THE HOUSE

FIG. 4.82
The Salutation of Beatrice in Eden by Dante Gabriel Rossetti, 1859. Oil on pine panel: 74.9 x 80 cm.
National Gallery of Canada.

intention that it should be decorated with figurative painting. He worked on the decoration of the sides and front of the settle, leaving the three cupboard doors for Rossetti to paint. However, it was only after Morris had left Red Lion Square and the settle had been dismantled pending the move to Red House that Rossetti began work on painting the two outer pine cupboard doors. On 22 June 1859, he told Ford Madox Brown, who must have been familiar with the subject and the settle itself, 'I have done a whole picture in a week on one of Topsy's doors.'[144] This was *The Salutation of Beatrice on Earth* dated '15–25 June 1859' (fig. 4.81). The subject is the first meeting in Florence of the poet and Beatrice. It was followed by *The Salutation of Beatrice in Eden*, which depicts their meeting in heaven after her death (fig. 4.82).[145] The two panels are believed to have been Rossetti's wedding present to the Morrises.

149

WILLIAM MORRIS & HIS PALACE OF ART

DECORATING AND FURNISHING THE HOUSE

The Salutation of Beatrice on Earth was exhibited at the Hogarth Club by Rossetti in March 1860.[146]

In *The Salutation of Beatrice on Earth*, Dante is shown enraptured as his attention is caught by Beatrice as he passes her on the opposite side of steps, beyond which the Florentine cityscape rises. Perhaps as a compliment to the bride, he gives Beatrice the features and dark hair of Jane Morris. Her female attendants are modelled on Mary Nicholson (Red Lion Mary), the maid who had looked after Rossetti and then Morris and Burne-Jones in their bachelor lodging, and his later housekeeper and sometime mistress Fanny Cornforth. In *The Salutation of Beatrice in Eden*, the lovers are reunited against a lush backdrop of roses and lilies and a burnished gold sky. Beatrice adjusts her veil so that Dante may see her face, and her two female attendants gaze upon them as they play stringed instruments. Beatrice is shown here not as Jane Morris but as Rossetti's red-headed fiancée Elizabeth Siddal, upon whom many of his earlier representations of Beatrice are modelled. Rossetti appears to be making the artistic statement that both Jane and Elizabeth Siddal embody the fine qualities of Beatrice. The highly accomplished oil and gold-leaf panels are richly coloured, striking compositions designed to enhance and enliven the strong form and scale of the settle.

Rossetti wrote to William Bell Scott, in December 1860, that Siddal was staying at Red House for a few days and that he would 'join her tomorrow but shall probably return before her as I am full of things to do, & could not go there at all but that I have a panel to paint there'.[147] This was *Dantis Amor* (*Dante's Love*), which ostensibly formed the central door of the settle and symbolically portrays Beatrice's death in the intervening scene between her meetings with Dante on earth and in heaven (fig. 4.83). Alastair Grieve has defined the importance of the picture and its symbolic subject matter thus: 'the composition not only symbolises the death of Beatrice and her transition from Earth to Heaven but also what Rossetti took to be the essential truth of both the *Vita Nuova* and the *Divina Comedia*, that love is the generating force of the universe'.[148]

Christ is depicted in the upper left-hand corner, his head set against a golden sun with radiating rays. The inscription *Qui est per omnia secula benedictus* (Who is blessed throughout all ages), from the *Vita Nuova*, is inscribed around his halo. Christ's gaze is directed to the lower right of the picture, where the head of Beatrice is encircled by a crescent moon, and she in turn gazes back at him. The red-winged angel in heaven stands centrally, looking directly out from the picture to the viewer, and holds a bow and heart-tipped arrow and an incomplete sundial, set against a field of dull silver and golden stars.

Rossetti's letter indicates that he is preoccupied with other matters and perhaps this is the reason why he left the painting unfinished. A pen and ink study for *Dantis Amor*, which he had made earlier that year, suggests his

FIG. 4.83
Dantis Amor
by Dante Gabriel Rossetti, 1860.
Oil on mahogany: 74.9 x 81.3 cm.
Tate, London.

intentions for the missing details. This shows the sundial at 9 o'clock in the year 1290, the hour and date of Beatrice's death. The crescent moon bears the inscription *'Quelle beata Beatrice che mira continamente nella facia di colui'* which is read in continuation with the words on Christ's halo, 'that blessed Beatrice who now gazeth continually on His countenance Who is blessed throughout all ages'. The concluding words of Dante's *Divine Comedy*, *'L'amor che muove il sole e l'altre stelle'* (the love which moves the sun and the other stars) is inscribed on the diagonal separating the sun from the stars.

The subsequent history of the panels is intriguing. It is not definitively known why Rossetti had the panels back in his possession by August 1863, when he devised a single frame for the two outer panels and sold them to the art dealer Ernest Gambart. It is surprising that the Morrises would part with both a wedding gift and art works that formed an integral part of the settle and the complex iconography of the drawing room. Various explanations have been suggested, including that Rossetti was given them either as a payment or to raise funds for the recently established firm of Morris, Marshall, Faulkner & Co.[149] Alternatively, it may be that after Siddal's untimely death from a laudanum overdose in 1862, when Rossetti buried the journal containing many of his poems with her, he could not face the prospect of seeing her immortalised as Dante's Beatrice in heaven on the settle doors in the house of his close friend.[150]

Rossetti's sale of the two panels in 1863, coupled with the fact that the central mahogany panel retains no evidence of having fixing points where the iron hinges for the doors were originally attached, has prompted the question of whether the panels were rehung on the settle once painted? Technical analysis undertaken by the National Gallery of Canada, Ottawa, which has owned the diptych of *The Salutation of Beatrice on Earth and in Eden* since 1957, suggests that they were returned to the settle as functioning doors but that Rossetti made various alterations in advance of painting them. The 'fantastic ironwork hinges' were removed and the fixing points plugged and overpainted before he painted the figurative scenes. The two outer cupboard doors originally opened symmetrically, with hinges on the right and left sides respectively. New hinges were added to the right of each of the cupboard doors after they were painted so that they opened in the same way, and two locks were installed when 'the paint on both panels was evidently still soft but not wet'.[151] These findings support the view that *The Salutation of Beatrice on Earth and in Eden* did hang as functioning doors on the settle during the first few years at Red House. The lack of discernible evidence for hinges on the *Dantis Amor* panel does not preclude the possibility that this panel was ingeniously slotted into place as a fixed picture, so that all of Rossetti's works were read together as a powerful triptych on the settle.[152]

As envisaged in 1856, Burne-Jones contributed to the painted decoration of the settle too. He recalled: 'I began a picture from the Niebelungen Lied

DECORATING AND FURNISHING THE HOUSE

on the inside of one of the shutters of this settle'.[153] Georgiana added that the 'Niebelungen Lied design of which Edward speaks was never finished, and if it was begun upon the back of either of the beautiful "Salutations of Beatrice" which Rossetti painted on the outside of the doors of the big settle, it may perhaps still remain there.'[154] A fragment of this incomplete picture survived unrecognised as the work of Burne-Jones until 1964, when it was lost during conservation work to the settle.[155] The *Niebelungenlied* is a thirteenth-century German epic poem in which Siegfried wins the hoard of the Niebelungs by slaying a dragon, marries Kriemhild, a Burgundian princess, assists her brother in securing Brunhild, queen of Issland as his wife but is then slain and ultimately avenged by his wife. The hoard over which they feuded is never recovered.[156]

✿

A recollection of the drawing room in 1863 reveals more of the colours, textures, textiles and furniture with which it was furnished and evokes comfortable and hospitable space. It had 'a dais and window seats covered in golden velvet ... A splendid yellow Turkey carpet lay on the floor, beautiful rugs here and there, quantity of original tables and chairs, and a wide sofa filled with luxuriant cushions. But the great feature of the room was a painted bookcase cabinet.'[157]

May Morris stated that 'the carpet was a fine Marsulipatam one with a yellow ground', which confirms the description of the 'splendid yellow Turkey carpet'. Furniture described as a 'quantity of original tables and chairs' may well have included the oak table (fig. 4.84) and ebonised chair by Webb and the two painted tub chairs Morris had designed whilst at Red Lion Square, alongside the 'wide sofa' of unknown appearance and design.[158]

The 'dais and window seats' were in the panelled alcove that leads to the oriel window, which is tucked away from the main body of the room. Enjoying the best of the afternoon sun, this intimate space strikes a romantic note and seems designed to be the eyrie of a beautiful medieval maiden (or a Pre-Raphaelite 'stunner') lost in reading, stitching, close conversation or her own thoughts. The oriel originally had sash windows, which enabled a view out on all three sides and a place for the perfume of plants trained against the wall to penetrate.[159] The green, red and yellow ochre painted and gilded panelling was covered with flowing foliate patterns, giving it 'a spectacular cloth of gold appearance' enhanced by the 'golden velvet' cushions on the window seat (fig. 4.87).[160] The flowing pattern is very close to the decoration Morris is believed to have added to the sides of *The Prioress's Tale* wardrobe (figs 4.85 and 4.86) and stylistically allied to a simple detail of flowing arcs which has been partially uncovered in the frieze above *The Wedding Ceremony*. The rich panelling abutted the orange-red beams that framed the ceiling decoration

FIG. 4.84
Round table by Philip Webb, c.1860. Oak: 72 x 142.5 cm. The table demonstrates Webb's close observation and fluent refashioning of Gothic sources to create a highly individual and nonetheless medieval-looking piece. His use of stylistic details, including crenellations, notches and pierced panels is characteristic of his Red House furniture. Society of Antiquaries of London, Kelmscott Manor.

FIG. 4.85
Detail of a sketch of a trefoil and arch design by William Morris, c.1859–60. Pencil on paper: 31.4 x 22.9 cm. This pre-figures the decoration found on the side of *The Prioress's Tale* wardrobe and on the panelling to the oriel window in the drawing room. The Huntingdon Library, Art Collections and Botanical Garden.

FIG. 4.86
Detail of decoration attributed to Morris, c.1860 on the side of *The Prioress's Tale* wardrobe, which is closely allied to the oriel panelling. Ashmolean Museum, University of Oxford.

FIG. 4.87
Recreation of a section of the foliate pattern in gold, green, red and gold leaf which originally adorned the oriel panelling. National Trust, Red House.

of yellow circles set within yellow squares on a cream limewash background. The glowing colour of the green and gilded panelling significantly added to the lustrous, jewel-like effect of the room.

In 1866, the room is summarily described in the Sales Particulars; nonetheless, its artistic interior dominates:

Drawing Room, 24ft. by 18ft., well lighted, and most elegantly and artistically decorated with the commencement of a series of Wall Pictures, by an Eminent Artist of the Old Water Colour Society. On the West end is a charming old English Oriel Window, looking North, South, and West.[161]

The all-encompassing decorative scheme Morris created, with critical contributions from Rossetti and Burne-Jones, was one of striking juxtapositions, patterns, colours and textures with a strong narrative of enduring love. The drawing room is an exultation of pattern-making and a fusion of visual art and literature. It exemplifies Morris's artistic prowess and the role decoration played in expressing the close friends' shared feeling. With other hands – including Jane's, Faulkner's and possibly Webb's – involved in the execution, the drawing room epitomises the joy in shared labour that is the heart of Red House.

FIG. 4.88
Old Testament wall painting, attributed to Elizabeth Siddal and William Morris, and potentially Edward Burne-Jones, Dante Gabriel Rossetti and other hands (?), *c.*1860–2. Tempera on plaster: 180 x 400 cm. The wall painting was rediscovered in the principal bedroom. It was designed as a simulated 'hanging' with loose folds in the textile. From left to right, the figures depicted are: Adam, Eve, Noah, Rachel and Jacob from the Old Testament. A tree is positioned between each figure and two scrolls are shown at the base of the painting. The right-hand one, under Noah, Rachel and Jacob, is inscribed with verses from Genesis.

PRINCIPAL BEDROOM & DRESSING ROOM
Jane Morris's bedroom

Whilst the house was still in its design stage, it was envisaged that the influential piece of 'storytelling' furniture designed by Webb and decorated by Burne-Jones with scenes from *The Prioress's Tale* by Chaucer would stand in the principal bedroom. Presented to the Morrises as a joint wedding present in 1859, it was at once at work of art and a functional domestic object, which set a precedent for the form and stylistic details of Webb's furniture elsewhere in the house and for the richly layered decorative scheme of the room itself. May Morris succinctly recorded, 'In my Mother's bedroom, hung with flowered embroideries on a rough blue serge, stood the Chaucer wardrobe that Burne-Jones had been working on in 1858.'[162] Webb's plan simply demarcates this relatively modest, north-facing room and adjoining dressing room as 'bedroom'; it may have been a shared marital bedroom or solely Jane's from the outset. Morris certainly conceived the decoration of the room for Jane and it augmented the visual association between Jane and Melidor already established in the wall painting of *The Wedding Feast* in the neighbouring drawing room. He countered the cool, grey north light by creating a densely layered, intimate room of wall paintings, textile hangings and painted furniture – a romantic response to Melidor's lavishly decorated chamber in the poem of *Sir Degrevaunt*. Morris's intriguing decision to adorn one wall of the bedroom with a wall painting of five Old Testament figures appears to derive from the literary precedent of *Sir Degrevaunt*. It also provides a counterpoint to the miracle of the Virgin, already glorified in paint in *The Prioress's Tale* wardrobe which was placed across the room from the wall painting.

Melidor's chamber stands as a reflection of her fine character and greatly impresses Sir Degrevaunt. Her 'chaumbur of loffe [love]' is architecturally impressive and finely arrayed with wall paintings and sculpture, with complex iconography from the Old and New Testament including the four Doctors of the church, the evangelists, the parables of Solomon and fifty 'red gold' archangels.[163] Alongside these biblical figures are the nine Worthies – three pagan, three Jewish and three Christian, the latter being King Arthur, Charlemagne and Godfrey of Bouillon. There are walls of black marble, floors of crystal and a bed of azure blue hangings decorated with green parrots (or popinjays) and the story of the lovers Ydoyne and Amadas. This gloriously appointed room is a literary concoction rather than a literal description. Yet, it has its root in the highly decorated interiors found in castles and medieval houses, such as the ambitious series of fourteenth-century wall paintings of religious and secular subjects adorning the great chamber of Longthorpe Tower, near Peterborough.[164] The poetic description caught Morris's imagination and he created a version of Melidor's 'chamber of loffe' for Jane.

The paintings are on the south wall of the bedroom, which backs onto the upper passage.[165] Whilst there is no discernible evidence of figurative painting on the other three walls, it is possible that they too were originally intended to be decorated as part of a more ambitious, but unrealised, scheme. The wall painting is a sophisticated composition; a simulated embroidery or tapestry 'hanging', fixed at seven points along the upper part of the wall, which gives the illusion of a loosely festooned textile. The source of the design precedent for the painted 'hanging' might be Morris's study of illuminated manuscripts, or equally well his knowledge of medieval church wall paintings featuring simulated textiles.[166]

The body of the painting comprises five figures standing on a green sward, divided by spindly looking trees against a dark blue backdrop (fig. 4.88). From the left, adjacent to the door to the room, are Adam and Eve standing on a grassy lawn, on either side of the Tree of Life, around which the serpent is twisted. Eve is depicted recoiling from the serpent, with a bowed head and her hands raised. Adam faces the viewer and stands with his right hand on his hip in a classical pose reminiscent of the Farnese Hercules. A deep red scroll with a dull gold border runs beneath the two figures. There is no evidence of a painted inscription on the scroll and it suggests that this element remained incomplete. Separated from Eve by a tree is the figure of Noah, cradling a small ark with an intricately detailed fish-scale roof. Alongside Noah stands another tree and then the figure of Rachel with a doleful expression, then a fourth tree and finally the figure of Jacob with a ladder. Running below Noah, Rachel and Jacob is a reddish-brown scroll inscribed with black lettering that does not appear to run consecutively. This is due to the fact that the illusionistic folds of the 'hanging' extend to the scroll beneath. The text beneath each figure is taken from Genesis and the verses that the scroll reveals (and obscures) are:

And Noah did according unto all that the Lord commanded him
GENESIS 7:5

And Rachel said, God hath judged me, and hath also heard my voice
GENESIS 30:6

And he dreamed, and behold a ladder set upon the earth
GENESIS 28:12

A painted inscription on a tiled fireplace at Sandroyd (fig. 4.91), designed by Webb in 1860 for the artist John Roddam Spencer Stanhope, might suggest the intended verses for the unfinished scroll beneath the figures of Adam and Eve. This inscription in Latin is taken from Genesis and translates as 'So the Lord God took the man and placed him in a Paradise of Pleasure' (Genesis 2:15). Above each figure is a thin scroll, which was probably intended for the

DECORATING AND FURNISHING THE HOUSE

FIG. 4.89
The principal bedroom today.

FIG. 4.90
A digital reconstruction of the appearance of the principal bedroom in 1865. John Tredinnick.

159

individual names of the figures, though all evidence of a painted inscription has been lost. The painted folds give each of the figures of Eve, Noah and Rachel attenuated body shapes and the trees disproportionately small crowns to their trunks.

⁂

When the wall painting was rediscovered in 2013, beneath layers of wallpaper and paint, it proved possible to identify the component figures and the surviving inscriptions from verses in the Book of Genesis.[167] Jacobus de Voragine's *Golden Legend*, a thirteenth-century collection of lives of the saints, was a literary text of great importance to Morris and this was his source for the hagiographies of the Old Testament figures chosen. The *Golden Legend* was an immensely popular medieval 'bestseller' and Morris knew it from William Caxton's English translation of 1483. This folio volume of nearly nine hundred pages has a wonderful array of woodcuts, which feature detailed depictions of medieval domestic interiors, that must have fascinated Morris. He went on to publish a Kelmscott Press edition of Caxton's text of the *Golden Legend* with woodcuts by Burne-Jones in 1892. Morris's decision to adorn the 'chamber of loffe' that he created for his wife with the figures of Adam, Eve, Noah, Rachel and Jacob, reflects the underlying narrative of love and faith in God's purpose inherent to all their lives. The theme of divine love and married love unites all five figures. Adam and Eve trespassed against God and faced expulsion from Eden together, whilst Noah and his wife were saved from the cataclysmic flood by God's love for mankind. Jacob worked for Laban for seven years to prove his worth as a husband for Laban's daughter Rachel. She in turn felt desperation in the face of her infertility and placed her faith in God to hear her voice in her earnest desire to provide Jacob with children.

Whilst Morris is credited with the overall conception and design, the authorship of the wall painting has proved to be a more complex and elusive question to determine.[168] Further technical analysis may yet reveal more conclusive evidence for the execution and authorship of the wall painting. From the analysis of the painting undertaken so far, it is apparent that the execution of the figures varies in competence, suggesting that there were at least two different artists involved and possibly more. Adam and Eve appear to be the work of a single artist, who exhibits greater technical proficiency than that found in the representations of Noah, Rachel and Jacob. It is intriguing that Edward Burne-Jones makes no mention of the wall painting in his notes and it is not recollected by Georgiana in *Memorials*. It is feasible, though, that Burne-Jones and possibly Ford Madox Brown had a hand in the wall painting and that it was this work, rather than the three *Sir Degrevaunt* pictures in the drawing room, to which Rossetti was referring when he related to Allingham in September 1860 that both Madox Brown and Burne-Jones were at Red

DECORATING AND FURNISHING THE HOUSE

FIG. 4.91
The corner fireplace designed by Philip Webb in 1861 for Sandroyd. The tiles of Adam and Eve on either side of the inscription from Genesis are attributed to Morris or Burne-Jones. The four female figure tiles of characters from Chaucer's *Legend of Good Women* are by Burne-Jones, c.1862 and the intervening pomegranate tree with the artist, John Roddam Spencer Stanhope's initials is attributed to Morris. Historic England.

House and that Burne-Jones was painting 'images of the Chaldeans ... in extract Vermillion'.

Although the timing of the letter ties in exactly with the date Burne-Jones was working on the *Sir Degrevaunt* wall paintings, in this extract Rossetti makes no mention of *Sir Degrevaunt* but he does refer to the 'Chaldeans' and the 'Babylonians'. These references have a direct correlation to the Old Testament figures portrayed on the bedroom wall, most importantly to Noah, for the great flood detailed in Genesis is a descendant of earlier flood myths, notably the 700 BCE Babylonian *Epic of Gilgamesh*.

The mention of Madox Brown being at Red House at the same time raises the possibility that he too collaborated on the wall painting. Stained glass commissions of biblical subjects were to be the mainstay of the Firm's work in the 1860s, and Madox Brown's design of Noah for the Firm in 1864 shows the figure with flowing robes and clutching a small ark, in similar vein to the depiction in the wall painting (fig. 4.92). Madox Brown, however, may simply have been there giving Morris painting lessons or may have contributed to other undocumented works in the house. The fragmentary nature of the surviving evidence means that this stands as plausible conjecture, rather than a definitive attribution. A further significant attribution is suggested in a letter sent in July 1861 from Elizabeth Siddal at Red House to Rossetti in London. She asks of him:

Adam　　　　Noah

DECORATING AND FURNISHING THE HOUSE

If you can come down here on Saturday evening, I shall be very glad indeed. I want you to do something to the figure I have been trying to paint on the wall. But I fear it must all come out for I am too blind and sick to see what I am about.[169]

Elizabeth Siddal and Rossetti were married in May 1860, but in May 1861, she suffered the anguish of giving birth to a stillborn daughter. The extract from her letter gives a strong sense of her artistic frustration and her fragile health during her stay at Red House as she invites Rossetti to help her with the execution of the figure that she is struggling to capture. Siddal was an artist of considerable promise, who had garnered the approbation and financial support of Ruskin for her artistic ambitions. No other figurative paintings or fragments have been found at Red House and it is credible to assign, on stylistic grounds, at least one of the Old Testament figures to Siddal with possible input from Rossetti. Her body of work is predominantly of medieval and literary subjects, undertaken on an intimate scale characterised by her individualistic naïve style. The figure of Rachel bears a resemblance in her slightly stiff, awkward pose and medieval dress to Lady Clare in Siddal's *Study for Lady Clare* (fig. 4.94) and her watercolour from around 1854–7 of the same intense scene in an enclosed medieval interior.[170] Both Siddal and Rossetti were familiar with the story of Rachel as retold by Dante in the *Purgatorio*. In about 1855, Siddal had modelled for a pencil sketch of Rachel by Rossetti,[171] which he translated into the watercolour *Dante's Vision of Rachel and Leah*, in which in a dream, the poet sees Rachel and her sister Leah as he enters the Garden of Eden.[172]

One of the Firm's early stained glass commissions offers potential evidence of Rossetti's contribution to the wall painting. His design of Mary Magdalene for the Firm's commission for Bradford Cathedral reveals a distinct similarity of form to Eve with her bowed head, elongated neck and heavy hair (fig. 4.93). The greater level of skill and understanding of anatomy exhibited by the painter of the figures of Adam and Eve suggests Rossetti's potential involvement as a collaborator or sole executor of these two figures.

The composition of the wall painting shares details with Morris's scheme for the dining room and may be read as a painted version of the embroideries of female figures, who are similarly placed in garden settings and divided by trees. There is a strong stylistic link between the serpent wrapped around the trunk of the Tree of Life and the stem of the flowering plant entwined around the trunk of the lemon tree on the St Catherine hanging (fig. 4.35). The wall painting similarly relates to the setting of the four painted female figures, attributed to Morris, which are found on the interior of *The Prioress's*

FIG. 4.92
Adam and Noah designed by Ford Madox Brown for Morris, Marshall, Faulkner & Co., 1864. Detail of panel from the east window of All Saints Church, Middleton Cheney, Northamptonshire.

FIG. 4.93
Mary Magdalene by Dante Gabriel Rossetti for Morris, Marshall, Faukner & Co., 1864. Stained glass. Bradford Cathedral.

FIG. 4.94
Study for Lady Clare by Elizabeth Siddal, c.1854–7. Pen and ink: 14.9 x 11.5 cm. The subject is taken from Tennyson's poem, *Lady Clare*, and depicts the eponymous heroine on the eve of marriage to her cousin after she has just learnt from her anguished nurse that when the real Lady Clare died in infancy, the nurse secretly placed her own daughter in her stead. Siddal's depiction of Lady Clare shares similarities with the figure of Rachel in the wall painting. The Fitzwilliam Museum, Cambridge.

Tale wardrobe. Was Morris responsible for the overall composition – the simulated tapestry, trees, scrolls and lettering? Were his fellow collaborators Elizabeth Siddal, Rossetti, Burne-Jones and Ford Madox Brown or a lesser combination of this talented group of friends? The collaborative nature of the whole makes it difficult to disentangle authorship and be definitive on the point of attribution.

The Prioress's Tale wardrobe

Webb made the design for the wardrobe after Morris's announcement of his engagement in 1858. Constructed of pine and oak, it has a simple hinged door spanning two-thirds of the piece and, to the right, a smaller door which gave a large flat expanse for painted figurative scenes (fig. 4.97). Burne-Jones was working on the painted exterior in 1859, when he wrote to Cormell Price, 'Is Topsy in Oxford? Love to him and everyone – tell him not to come up yet till I've done more to the wardrobe'.[173] Webb later recounted, 'it was finished in a great hurry at the end for exhibition at the Hogarth Club [in 1860] and we all worked getting it done'.[174] The implication of Webb's comment is that he and Morris contributed to the finished piece alongside Burne-Jones. Lethaby's biography of Webb notes that 'The flowers on the sides must have been painted by either Webb or Morris.'[175] No mention is made of the paintings on the interior faces of the doors, where incomplete paintings of four women engaged at their toilette are found. These have been attributed to Morris and their unfinished state suggests that they were executed at Red House.

In the knowledge that Morris would be taken by the pictorial realisation of a Chaucerian tale, Burne-Jones (with Webb's agreement) must have given careful thought to the subject before fixing upon *The Prioress's Tale*. The decision to depict a tale of unprovoked murder and child martyrdom as a wedding gift has been viewed as surprising but, although the tale is marked by violence and hostility, this is ultimately overcome by God's grace in the form of the heavenly intervention of the Virgin Mary. It is the miracle that dominates the pictorial scene on the wardrobe and, in a tribute to Jane, Burne-Jones models the Virgin Mary on her, and associates Morris's future wife with the tenderness and compassion of the Virgin. There is an element of playfulness too, in the word association between Chaucer's description of how the Jews disposed of the boy's body in a 'wardrobe' – 'I seye that in a wardrobe they hym threwe' – which literally translates as a privy.[176] Undoubtedly, the story held great resonance for Burne-Jones and Morris and beautifully fused their shared love of Chaucer, poetry and the medieval period in the late 1850s. Burne-Jones was to return to the subject of *The Prioress's Tale* in his large-scale watercolour, which he worked on sporadically from 1869 to 1898 and in his final collaboration with Morris on the Kelmscott Press edition of *The Works of Geoffrey Chaucer* of 1896.[177]

WILLIAM MORRIS & HIS PALACE OF ART

FIGS 4.95–4.97

The Prioress's Tale wardrobe designed by Philip Webb and decorated by Edward Burne-Jones and William Morris, 1858–60. Painted oak and deal: 219.7 x 157.4 x 53.7 cm. The wardrobe was a wedding present for William and Jane Morris. Ashmolean Museum, University of Oxford.

Above left: the interior of the wardrobe showing the hinged doors and arrangement of the unfinished painted female figures engaged in their toilette, attributed to William Morris, c.1860.

Above right: the left-hand side panel of the wardrobe with decoration by Morris and Webb. The scroll around the orange tree is inscribed with the first line of *The Prioress's Tale* and set against bands of alternating plain gold and black on gold flowing patterns. The orange tree is very similar in form to the lemon tree designed to accompany the embroidered figure of St Catherine in the dining room scheme devised by Morris.

Facing page: The black clad figure of Chaucer, quill and manuscript in hand, is depicted in the lower right corner.

The Prioress narrates the story of a seven-year-old Christian boy who lives with his widowed mother in an Asian city, which is also home to a community of Jews. The boy sings the hymn 'O alma redemptoris mater' ('O loving mother of our redeemer') in honour of the Virgin Mary as he walks to school. One day whilst singing, he is set upon by Jews who cut his throat and throw his body in a pit. He miraculously comes back to life and sings the hymn in the Virgin's praise once again when she places a grain of corn in his mouth. The boy's singing draws his desperate mother to the pit and his body is recovered and placed before the high altar of the abbey, where he reveals the miracle and explains that once the grain of corn is removed, the Virgin will come for his soul.

Burne-Jones depicts the Virgin in heaven on the right, holding the ear of corn, whilst on the left she places the corn in the boy's mouth as he stands in the pit. The whole tale is portrayed. Burne-Jones drew on early Italian painting for inspiration in placing in the background to the principal scene earlier episodes of the boy singing at school before his murder and being seized by his assailants. At the foot of the left panel is a painted page of an illuminated manuscript inscribed with the opening lines of the Prioress's Prologue, in which she addresses God:

O Lord, oure Lorde, thy name how merveillous
Is in this large world ysprad – quodshe –
For noght oonly thy laude precious
Parfourned is by men of dignitee,
But by the mouth of children thy bountee
Parfourned is, for on the brest soukynge
Sometyme shewen they thyn heriynge.[178]

Oh Lord, our Lord, how marvellous thy name
Is spread in this large world – said she –
For not only thy precious praise
Is performed by men of dignity,
But by the mouths of children thy goodness
Is made known, for on the breast sucking
Sometimes they show thy praise.[179]

On the right panel, Burne-Jones pays homage to the great poet by portraying him in the act of composition. He stands against a dark blue embroidered hanging (which prefigures the Daisy hangings) quill in hand, having inscribed the first two lines of *The Prioress's Tale* on a manuscript:

There was in Asie, in a greet cite,
Amonges Cristene folk a Jewerye

*There was in Asia, in a great city,
Among Christian folk a Ghetto*

The Prioress's Tale was Burne-Jones's first oil painting on such an ambitious scale and the wardrobe is Webb's first known piece of furniture. Their combined talents and industry created a highly prized gift and set a precedent for the distinct painted furniture and the fusion of visual art and literature that is the basis of all the decoration at Red House.

The decoration of the side panels to the wardrobe is believed to be the work of Morris, with contributions from Webb. Each side has two distinct painted panels divided by a horizontal band, with crenellated detailing and surmounted by a shaped arch with cusps beneath a short band of seven small ogee arches. On both sides, the lower panel features a repeating stylised flower motif in gold and yellow against a red background. The right-hand side panel features an orange tree in fruit standing on a grassy bank set against a golden hanging with foliate patterns arranged in diagonal bands to represent an embroidered backcloth. Entwined around the trunk of the tree is a ribbon scroll inscribed with line 683 from *The Prioress's Tale*: 'There he is now God leve us for to mete'. The left-hand side panel has a corresponding orange tree standing on a flowery mead set against a golden backdrop of alternating bands of plain gold and a flowing foliate pattern in black on gold (fig. 4.96). An enhanced version of this design is found as a tiny sketch on the back of a drawing by Morris of drapery and the rough plan of Red House from around 1858–9, and it was amplified for the glittering 'cloth of gold' decoration of the panelling to the oriel window in the drawing room (fig. 4.87). The banderole winding round the trunk of the tree is inscribed with the opening line of *The Prioress's Tale*: 'Ther was in Asie in a fair citie'.

༺

On the inner face of the wardrobe doors are four painted panels of women in medieval dress (fig. 4.98). All the panels appear to have been left incomplete; there is the suggestion that two further scenes might have been intended for the blank panels on the upper section of the hinged double door. One of the figures is lacking a face and prompts the question of whether the features were to be added by a different artist? The four women are depicted engaged in their toilette; one is brushing her hair, a second is affixing her girdle, the third raising her skirts to place her foot in a shoe and the fourth is attending to her nails. All are activities allied to the bedroom and the function of the wardrobe. In a surprising juxtaposition, in the light of their activities, each of the figures is depicted in a garden, which may be an attempt to link the outdoor setting of *The Prioress's Tale* and the two side panels of fruit trees with the more intimate and everyday scenes depicted in the interior. Two of

FIG. 4.98
Female figure brushing her hair attributed to William Morris, *c.*1860. This detail shows one of the painted figures inside the wardrobe. The female figure placed in a garden setting is a recurrent theme in Morris's decoration at this time. Ashmolean Museum, University of Oxford.

DECORATING AND FURNISHING THE HOUSE

FIG. 4.99
Four painted panels by William Morris, Edward Burne-Jones or Dante Gabriel Rossetti, c.1860.
Oil on panel: 61 x 41 x 3.2 cm each. Thought to depict the four seasons, these female figures bear a striking resemblance to the panel paintings by Morris on the interior of *The Prioress's Tale* wardrobe.
Victoria and Albert Museum.

the panels show the figures standing against grid-like patterns with squares and circles that are reminiscent of the patterning of circles set within a grid which decorate the sides of the hall settle. The arrangement in these two panels of the women standing to the side of a small tree reflects a closeness in composition to the proposed layout of the dining room embroideries and to the arrangement of figures set alongside trees in the Old Testament wall painting. Stylistically, the figure of the woman with a girdle has the same pose as Morris's *La Belle Iseult* (fig. 2.11), although the painting itself is much more detailed and highly finished. This panel, has been identified as 'a personal gesture of praise to his wife ... and the inscription next to it, a reference to the refrain in Morris's paean to Jane, "Praise of my Lady", published in 1858 as part of his first volume of poems, *The Defence of Guenevere*'.[180] The four wardrobe panels also bear an unmistakeable similarity in subject and setting to the four painted panels attributed to Morris, Burne-Jones and possibly Rossetti of around 1857, which were part of the furnishings of Red Lion Square prior to Red House (fig. 4.99). The uncertainty of the artist of these panels reflects the close collaborative nature of the three men's work at this point, although it has been convincingly argued that Morris and Burne-Jones's work is stylistically much closer than Rossetti's.[181] It is not known where these framed panels were hung in the house and if they adorned a piece of furniture or were treated as pictures on a wall. It is conceivable, though, that if they were separate art works by 1860 then they could have hung in close proximity to the allied wardrobe pictures, possibly in the dressing room. The subject of the panels suggests that they depict the four seasons.

❦

The walls of the room were painted with a deep dark blue which extended the background colour of the Old Testament wall painting around the room. The windows and doors were painted in a richly contrasting shade of orange-red with ceiling beams of orange brown. The canted slope of the ceiling above the wall painting and rising from the east and west walls were painted with a repeating pattern of hatched brownish red shapes resembling a stylised fir cone, above which was a pattern of three circles and short radiating sunburst rays in a soft yellow against a cream ground (fig. 4.102). The flat of the ceiling was stamped with a pattern of simple repeating arcs (which also features in the adjoining passage and studio) in yellow and white.

Morris devised and Jane embroidered a set of dark blue woollen serge hangings that were hung around the walls of the room, continuing the theme of medievalising textiles established by the wall painting.[182] Five lengths of these hangings survive and give a strong sense of the warmth and richness with which they imbued the bedroom (fig. 4.100).[183] Jane recalled that the hangings were the result of a serendipitous discovery of fabric that exactly

DECORATING AND FURNISHING THE HOUSE

FIG. 4.100
Daisy hanging designed by William Morris, 1860 and executed by Jane Morris, *c.*1860. Woollen ground embroidered with wool: 167 x 299 cm. One of five surviving hangings made for the bedroom. Society of Antiquaries of London, Kelmscott Manor.

suited Morris's taste: 'The first stuff I got to embroider on was a piece of indigo dyed blue serge I found by chance in a London shop ... I took it home and he was delighted with it, and set to work at once designing flowers – these were worked in bright colours in a simple rough way – the work went quickly'.[184] Morris modelled his design on the wall hanging visible as a backdrop in 'The Dance of the Wodehouses', an illustration to the fifteenth-century manuscript of Froissart's *Chronicles*, which served as an influential visual source (fig. 4.65). An element of the painted decoration of *The Prioress's Tale* wardrobe suggests a further visual precedent for Morris's design. Burne-Jones depicts Chaucer in front of a dark blue hanging embroidered with flowers, and Morris must have responded to this in his design for the physical hangings. The literary link to Chaucer is further emphasised in his choice of embroidered daisies, tying the hangings in with the depiction of daisies in the embroideries planned for the dining room and Chaucer's prologue to *The Legend of Good Women*, which opens with lines in praise of the daisy.[185]

Webb's drawing of the house's floor plan, has a pencil sketch which appears to denote a bed behind the door to the room but this placement would have obscured the wall paintings, so the bed must have stood opposite the fireplace, with *The Prioress's Tale* wardrobe either alongside it or standing next to the communicating door to the dressing room. It is not clear what the bed hangings were but they might have included lengths of the daisy embroidery. May Morris records a 'Half tester bed hung with rose chintz (the bed Red House)' but unfortunately, the appearance and whereabouts of this bed are unknown. It is uncertain whether the rose chintz hangings were part of the bedroom scheme in 1860 or post-dated Red House.

Other furnishings for the room must have included rugs, window hangings (potentially daisy embroideries) and a chair and a chest or table on which to stand the mirror designed by Webb and the jewel casket believed to have been designed by Webb and decorated by Elizabeth Siddal and Rossetti before 1862 (fig. 4.101).[187] Webb's mirror on stand of around 1862, made under the aegis of the Firm, was of ebonised wood with a band of gilded decoration which reflects the pattern of painted banding on the front of *The Prioress's Tale* wardrobe. This elegant, eminently practical mirror was designed to allow adjustment of the angle of the mirror glass (fig. 4.103).[187] The intricate and delicate jewel casket takes the form of a gothic reliquary with seven painted scenes to the sides and lid. It is made of wood with an iron frame, hinges and clasp and two locks at the apex of the roof. The studded iron bands appear as a diminutive version of the iron banding that Webb incorporated into the two dining tables made for Morris. It has been noted that the 'form of the casket recalls the larger more elaborately decorated St Ursula reliquary in St John's

DECORATING AND FURNISHING THE HOUSE

FIG. 4.101
Jewel casket designed by Philip Webb and decorated by Elizabeth Siddal and Dante Gabriel Rossetti, *c*.1860. Painted wood, with iron frame, hinges and clasp: 17.7 x 29.2 x 17.7 cm. The front lower left panel depicts *The Judgement of Paris*, and the centre panel, shows two lovers meeting by a rose-entwined trellis in a garden enclosed by castle walls. Society of Antiquaries of London, Kelmscott Manor.

FIG. 4.102
Detail of the stylised fir cone and sunburst decoration on the slopes of the canted ceiling attributed to William Morris, 1860.

FIG. 4.103
Mirror on stand designed by Philip Webb, *c*.1862. Ebonised wood with gilt decoration: 90 x 49 x 33 cm. Society of Antiquaries of London, Kelmscott Manor.

Hospital at Bruges which ... Rossetti visited on his trip to the continent with Holman Hunt in 1849'.[188] It is uncertain whether it was made for Elizabeth's own use and given to Jane Morris by Rossetti after Elizabeth's death, or presented to Jane Morris as a wedding present from the Rossettis.[189] Seven of the panels are decorated with miniature scenes of medieval romance, with two panels drawn directly from the Harley manuscript 4431, which Rossetti, Morris and Burne-Jones knew from the British Museum (fig. 4.104).[190–1] This is the largest surviving collected manuscript of the works of Christine de Pizan (1365–c.1431), who was a pre-eminent literary figure in the medieval courts of Europe and France's first female professional writer. De Pizan notably employed a talented female artist to produce the illuminated illustrations to her influential celebration of women, the *Book of the City of Ladies*. Perhaps Siddal was drawn to her work because she was recreating an image created to accompany a pioneering text on women by a woman, and this resonated with her ambition to be a professional artist in her own right.

A communicating door on the east wall to the side of the fireplace gives onto the adjoining narrow dressing room with its red-brick surround (the original tiles have been replaced and no record survives of their design) and a single sash window facing north. It was strongly coloured with a combination or red woodwork and yellow ochre walls. A two-door wardrobe designed by Webb is fixed in position in the corner of the room to the side of the door from the upper passage. A pencil sketch on Webb's floor plan suggesting

FIG. 4.104
From *The Book of the Queen*, Christine de Pizan, c.1410–14. This brilliantly coloured and intricately detailed miniature of lovers meeting in a castle garden was the source for the jewel casket's central painted panel believed to be by Elizabeth Siddal. MS Harley 4431, f.376r. British Library.

that a single bed might be placed in this position was obviously superseded; though it is likely that the room did contain a single bed. The wardrobe has a traditional form, with a simple crenellated detail running along the upper horizontal section and four plain strap hinges. It was painted in a rich red colour and there is no evidence of any additional patterning or painted finish. The walls were painted with a deep yellow ochre (the same colour as the kitchen and scullery walls); the window reveals, frames and door were the same red as the wardrobe. The ceiling is not stamped and was painted with a cream limewash, with brown wall beams.

UPPER PASSAGE

The broad, well-lit passage is dominated by the sense of movement introduced by the run of three round windows, set within wooden recesses with gently curved heads, splayed reveals and deep cills. Aligned west to east, it mirrors the lower passage, and has south-facing views over the well court and distant views to the North Downs through the stained glass quarries.[192] A shallow red-brick, segmental arch supporting an internal valley gutter (which is accessed by a small wooden door just below ceiling level on the east side of the arch) separates the passage from the staircase compartment. The doors to the dressing room and studio face the windows. The stamped ceiling pattern of repeating arches is the same as that in the principal bedroom and studio and was recorded in about 1957 as being a yellow and white scheme and may have been decorated with the scheme of white arcs on a yellow ground found in the adjoining bedroom.[193] Unfortunately, no conclusive evidence of the original colours to the walls, ceiling and joinery elements survives, though the stripped pine woodwork would all have originally been coloured as elsewhere in the house. It is conceivable that the yellow found on the walls of the staircase and landing continued along the adjoining passage, giving a coherent sense of flow to the circulating spaces.

The three circular windows were originally glazed with fifty-two quarries, each of alternating stylised plant designs, with Morris's motto 'si je puis' incorporated into every other one in the form of an inscribed banderole (fig. 4.105). The central window survives intact; the two outer windows appear to have had square opening casements with clear glass inserted after 1866, and only one now retains the outer band of 'si je puis' and stylised plant quarries. The grid of horizontal and vertical quarries are hand-painted in enamel and silver stain, which gives the deep yellow colour, onto a design by Webb or possibly a collaborative work with Morris. The glazing must have been in place for late summer 1860 and James Powell & Sons of Whitefriars were most probably responsible for its execution.

FIG. 4.105
Stained glass quarries designed by Philip Webb and possibly William Morris, c.1859–60. Painted and leaded glass: 74.2 x 74.2 cm. The quarries are arranged in horizontal bands in an alternating sequence of a stylised flowering plant and a plant and banderole with Morris's motto 'si je puis'.

DECORATING AND FURNISHING THE HOUSE

FIG. 4.106
Embroidered hanging by William Morris, 1856–7. Linen ground embroidered with wool: 168.5 x 187 cm.
The *If I Can* hanging is Morris's earliest known textile design which he worked himself in an idiosyncratic style and the earliest use in its English form, of the motto he had appropriated from Jan van Eyck after his visit to the Low Countries in 1856. Society of Antiquaries of London, Kelmscott Manor.

FIG. 4.107
The Studio today, viewed to the east and south with desk and cupboards designed for the room by the architect, Edward Hollamby, who lived in the house from 1952–99. The original colour scheme comprised red walls with dark green joinery, and yellow slopes leading to a stone and cream patterned ceiling.

DECORATING AND FURNISHING THE HOUSE

Morris's studio lies at the far end of the corridor. The end (east) wall, which terminates the long view from the drawing room doorway and the head of the stairs, is ideally suited to the display of a significant work of art. Whilst there is no indication that there were flat patterns or figurative paintings on this wall, there are a host of possible works – pictures and embroidery – that could carry the space and draw the eye, and which are known to have been in Morris's possession, but for which no precise location is recorded in the house. Potential contenders include: Morris's *If I Can* embroidery, which would have comfortably hung alongside the French translation of his motto emblazoned on the stained glass quarries to the three windows (fig. 4.105); his oil painting of Jane as, *La Belle Iseult* (fig. 2.11); or Arthur Hughes's *April Love*, the first oil painting that Morris purchased and the first expression of his personal taste in pictures whilst still living in Oxford (fig. 2.2).

STUDIO (study)

The dining room was not yet finished, and the drawing room upstairs ... was being decorated in different ways, so Morris's studio which was on the same floor, was used for living in and a most cheerful place it was, with windows looking three ways and a little horizontal slip of a window over the door, giving upon the red-tiled roof of the house where we could see birds hopping about all unconscious of our gaze.[194]

Georgiana Burne-Jones's recollection reveals that in late summer 1860, the studio's earliest guise was as a temporary living room. Morris's occupation was recorded in the 1861 census return as 'artist painter B.A.', and Webb designed a studio house with the express purpose of creating an environment for him to work in. In 1860 though, Morris's planned career as a fine artist was on hold whilst he concentrated his energies and talent on the design and execution of the interior decoration.

The studio's first use as living room suggests that it was a habitable space and that it must already have been decorated in contrast to the drawing room and dining room, which were still works in progress. The decorative scheme was richly coloured but decidedly simple in comparison with the principal reception rooms. The flat of the ceiling was stamped with a pattern of simple repeating arcs painted in a buff-stone colour against a cream ground. The slopes of the ceiling were a yellow ochre, the walls a deep and uniform red, the window reveals and ceiling beams a brownish orange and the windows, doors and skirting a rich dark green. A warm atmosphere was created by the strong earth tones.

The variety of windows to the north, east and south, as well as sashes, leaded

FIG. 4.108
Self-portrait at Red Lion Square by Edward Burne-Jones, c.1856. Burne-Jones depicts himself examining the painted back of one of the two chairs – *The Arming of a Knight* and *Glorious Guendolen's Golden Hair* (figs 2.6 and 2.7) – designed by Morris and decorated by Morris and Rossetti. The room has a quantity of furnishings, including easels, a lay figure seated in front of the fire, a suit of armour and a heap of costumes which may have transferred to Morris's studio at Red House. Georgiana Burne-Jones, *Memorials of Edward Burne-Jones*, 1904.

casements and a leaded circular window set high above paired sashes on the east gable wall, and a ceiling that rose to the underside of the roof, ensured that it was a light and airy space. It is a curious omission that constancy of north light, the one overriding criterion of a successful studio room, is not achieved in this space. The studio is flooded with east light in the mornings and subject to shifting light throughout the course of the day. Whilst it may have been an oversight on Webb's part, it seems unlikely, for he was too considered an architect not to have been alive to this fundamental desideratum. There may have been another, unknown, reason for the placement of Morris's studio in this position – and it is interesting to note that it is marked simply as 'Study' on Webb's first-floor contract plan of 1859. Nonetheless, although Morris was to abandon his intention of easel painting once he discovered that his future lay in the decorative arts, it must have been furnished with the painting equipment he had accumulated at Red Lion Square and the pigments and paints supplied by Roberson's for the figurative and decorative schemes (fig. 4.108).[195] This included his easel, a drawing stool, a lay figure (a three-dimensional wooden mannequin with working articulated joints), his brushes, sketchbooks, canvases and a variety of props. Morris had a collection of armour and metalwork, notably the basinet that he had commissioned from an Oxford blacksmith to assist his depiction of an

FIG. 4.109
Photograph c.1889, inscribed 'Bedroom in Mr Charlesworth's time', from Charles Holme's photograph album. The original stamped and painted ceiling decoration is discernible as are the tiles attributed to Burne-Jones in the fireplace. Post-1865 introductions include the bold stencilled pattern on the slope of the ceiling and, in an act of homage to Morris, the Firm's first available wallpaper, Daisy, which has been hung on the walls. National Trust, Red House.

FIG. 4.110
Basinet designed by William Morris, 1857. Iron: 45 x 16 x 25 cm. Morris commissioned this as a prop along with a sword and a (now lost) suit of mail from a blacksmith near Oxford Castle. It is conical, with an adjustable visor and a red-painted neckpiece supporting chainmail gorget. Burne-Jones recorded that he found Morris trapped in the helmet one afternoon in Oxford. William Morris Gallery.

armoured knight in the wall paintings in the Oxford Union Debating Hall, which are likely to have been in his studio (fig. 4.110). Alongside these were his woodworking tools (which he had kept in a white neckcloth at Red Lion Square), his own woodcuts, his illuminated manuscripts and the treasured engravings by Dürer (and possibly also Hans Burgkmair, for engravings from the Triumphal Procession of Emperor Maximilian I were later to hang in his daughter's house) that he had acquired.[196] It seems likely that this room would also be the repository for his purpose-built embroidery frame and his many books. Morris was to become a noted collector of manuscripts and early printed works and he met the bibliophile and bookseller F.S. Ellis in 1864. Two of the known works he had purchased by 1865 are a fifteenth-century copy of the Nuremberg Chronicles with 645 woodcuts and the satire *Stultifera Navis* by Sebastian Brant, with some woodcuts attributed to Dürer.[197]

The room was heated by a red-brick fireplace placed asymmetrically on the north wall, which had tiled reveals, now lost, probably designed by Burne-Jones. They are visible, though the pattern is too indistinct to identify, in the earliest known photograph of the room, which shows it when the house was owned by Mr Charlesworth in 1889 (fig. 4.109).

The 1866 sales particulars noted that the studio was 'a Large and Elegant Room, built as an Artist's Studio, capable of being converted into a Bed Room and Dressing Room'. The sympathetic later owners used it for a variety of purposes, including as a bedroom, a playroom and latterly as an architect's study; fortuitously, none of them chose to interfere with Webb's spacious proportions by dividing up the room.[198]

After 1861 and the founding of the Firm, it seems most likely that Morris continued to use the room as a studio for designing when he was at home.

BEDROOM PASSAGE

A pointed brick arch demarcates the entrance to a passage running north to south from the landing at the second turn of the stair. Two west-facing bedrooms give off the passage before three steps lead down to the water closet reserved for female family members and guests, and a door which separated the family side of the house from the servants' quarters beyond.

The passage is lit by two round windows overlooking the well court. The windows now have clear glass and small square opening casements, which are post-1865 introductions. The windows are likely to have been glazed with leaded quarries in an alternating pattern of flower and bird motifs designed by Webb, possibly in collaboration with Morris, following the pattern of glazing in the lower passage windows. A Red House provenance has been given to three surviving panels of clear and green glass quarries decorated with birds and with a daisy-like plant with three flowers, feathery leaves and four crescent-shaped buds which are now in two museum collections and a private collection.[199] In each instance, the quarries are reputed to have come from the nursery at Red House. Although it is no longer known which was the nursery, one of the two bedrooms off the passage must have been the bedroom for Jenny and May Morris from 1861 and 1862 respectively (figs 4.113 and 4.114). The other bedroom is likely to have been reserved for the steady stream of visitors to the house. Webb's design shows both bedrooms with a pair of sash windows which remain in situ. A likely explanation would appear to be that the quarries came originally from the leaded circular windows in the passage leading to the nursery, rather than from the nursery itself, and that the exact location became confused after they were removed.[200]

DECORATING AND FURNISHING THE HOUSE

FIG. 4.111
View along passage today, looking north to the main stair and shelf demarcated on Webb's floorplan as a 'stand' which was probably used for storing and lighting candles for the first-floor rooms.

FIG. 4.112
The bedroom passage windows are smaller versions of the trio of windows on the upper passage.

FIG. 4.113
Jane Morris holding May Morris, c.1863.
William Morris Gallery.

FIG. 4.114
Jenny Morris aged 4–5, c.1865–6.
William Morris Gallery.

FIG. 4.115
Bedroom (north-west) today, with Webb's fitted wardrobe and simple red-brick hearth and wooden surround. A section of the original blue wall colour has been exposed beneath the later 'Bird and Anemone' wallpaper produced by Morris & Co. from 1882.

BEDROOM (north-west)

The first bedroom reached from the main stair is generously proportioned and well lit by west facing windows. It was decorated with blue walls and a stamped ceiling (now of indeterminate pattern) with a high ceiling rising into the roof with exposed timber bracing articulating the construction.[201] A red-brick hearth with a simple painted wooden surround with a chamfered mantelpiece heated the room (fig. 4.115). The reveals are lined with 'leaves and berries' tiles of around 1860 (fig. 4.116). The tiles are painted in blue and yellow on tin-glazed earthenware Dutch blanks. Each tile is made up of a grid of twenty-five squares, with an intricate detail of leaves and berries running on the diagonal and the pattern flowing onto the adjoining tile. Although Burne-Jones recollected that he had designed tiles for the house, it is believed that these early tiles are the work of Morris or possibly of Webb. Both men are recorded as designers of five-inch patterned tiles at this time, whilst tiles of the early 1860s attributed to Burne-Jones are all of figurative subjects.[202]

Webb's floorplan is marked with pencil lines that appear to demarcate the potential position of furniture, including the fixed pine wardrobe with vertical plank doors and strapwork hinges in the south-west corner. This was designed by Webb with an angled roof that has similarities in design to the hall settle and to *The Prioress's Tale* wardrobe in the arrangement of a narrow door on the right-hand side, which opens to reveal shelves for clothes. Although now stripped of colour and any decorative scheme, it is believed that the wardrobe was originally stained red.

FIG. 4.116
'Leaves and Berries' tiles designed by William Morris or Philip Webb, *c.*1860. This tile design is found set into the fireplace in both of the west-facing bedrooms.

DECORATING AND FURNISHING THE HOUSE

FIG. 4.117
The 'wooden Webb bed' recorded by May Morris, shown after it was altered into two beds, alongside two washstands and a towel horse attributed to Ford Madox Brown c.1862. The mirror is believed to be one of the two ebonised mirrors designed by Webb. Society of Antiquaries of London, Kelmscott Manor.

The room must also have had a bed or, if it served as the nursery, two beds. May Morris recorded various pieces of painted furniture at Kelmscott Manor, with a Red House provenance, which are likely to have furnished this and the neighbouring bedroom. The furniture listed includes a 'wooden Webb bed' identified as the 'stump bedstead painted green' and 'washstand, horse and dressing table' and, in Jenny's Room, a 'small Webb bed' identified as '4 post bedstead painted red'.[203] The green 'stump bedstead' designed by Webb was later altered to form two beds with a solid wooden headboard and uprights at the foot, which are strikingly similar in form to the newel posts on the servants' stair (fig. 4.117).[204] The washstand, dressing table and towel horses are all ascribed to Ford Madox Brown, who is recorded as having designed such items for the Firm from 1861 and for his own use in his London house.[205] All these pieces are painted a deep green, which is a post-Red House decorative scheme, emulating the appearance of the original green stain.

BEDROOM (south-west)

The south-west bedroom is very similar in character to the adjoining room and shares the same plain red-brick hearth with 'leaves and berries' tiles and wooden surround, red clay tile hearth, exposed timber bracing and pair of sash windows overlooking the bowling alley and garden of Aberleigh Lodge beyond (fig. 4.118). The chimney flues of the fireplaces in the two bedrooms are set alongside one another, creating an alcove in the north-west corner into which Webb fitted a vertical plank wardrobe with strapwork hinges and paired doors beneath a crenellated cornice. This wardrobe is made to the same design as the wardrobe in the dressing room. The surviving evidence for the wall decoration suggests a combination of dark green and red walls, possibly painted in deep bands which do not carry through around the entire room.[206] Was the large expanse of wall opposite the fireplace enlivened by the addition of textile hangings? Might Morris's embroidered sunflower hanging c.1860, which is so closely allied in technique to the 'daisy' hangings in the principal bedroom, have formed part of the furnishings to another bedroom (fig. 4.119)?

SERVICE WING

Running on a north–south axis from the back of the hall is the service passage, which led to a cupboard for 'cloaks', stairs down to a wine cellar, the store closet, 'man's pantry' with 'china closet', a 'water closet' (reserved for the use of gentlemen), a stair up to the two servants bedrooms, the kitchen, larder, pantry, scullery and door to an enclosed yard. This comprised a modest single-storey range on the opposite side of the yard, housing the servants' water closet, an area for the cleaning of 'knives and boots' and a coal store. On the first floor, there was a servants' bedroom which was divided by six-foot high partitions into three spaces, which allowed each of the servants a modicum of privacy, and a separate small bedroom for the cook. The dormitory bedroom had the distinction of having a stamped pattern to the ceiling to the dormer window and a small fireplace. The cook's bedroom had no fire.

Webb specified that the plasterer 'twice coloured ... the walls of Kitchen, Kitchen passage, the Pantry, china closet, the two staircases and upper and lower passages' and that the smith provided 'a kitchen range value Twenty pounds' and 'a range and Trivet to the scullery value two pounds', so that the servants were able to ensure the smooth running of the service wing and provide meals and hot water to the Morrises and their guests as soon as they moved in.[207] The walls were painted in the same shade of deep yellow as the staircase and all the woodwork was the rich brown of the front door, with the

DECORATING AND FURNISHING THE HOUSE

FIG. 4.118
Detail of fireplace, wardrobe and substantial bracing to the roof in the south-west bedroom.

FIG. 4.119
Detail of embroidered hanging by William Morris, c.1860. 208 x 134 cm. The 'sunflower' embroidery is believed to be contemporaneous with the 'daisy' hangings in the principal bedroom. Society of Antiquaries of London, Kelmscott Manor.

FIG. 4.120
The kitchen showing the red-brick hearth which housed the range. The floor was originally laid with bricks. The yellow and brown decorative scheme was re-introduced in 2013 and replicates the original colours of 1860.

FIG. 4.121
The narrow stair leading to the two servants' bedrooms and the door giving access to the family's rooms on the first floor. The newel post has the same profile tapered to a blunt point as the bed Webb designed for the house.

FIG. 4.122
The ceiling to the dormer window in the dormitory bedroom had the same stamped pattern as the flat of the staircase ceiling and the hall.

exception of the deal service stair which was left unstained.

With characteristic thoughtfulness for those who worked in the house, Webb placed the kitchen on the ground floor rather than in a basement and ensured that it was provided with good natural light from high windows, though he did not, perhaps, fully anticipate that the west-facing room would be at its hottest in the late afternoon just as the evening meal was being prepared. He also incorporated a serving hatch to the right of the range, through which the food would be taken to the dining room.

There were two water closets for the family and guests but no bathroom. The house was lit by candlelight and heated by fires.

In 1861, four servants are recorded in the Morrises employment, Charlotte Cooper, a cook, Jane Chapman, a housemaid, Elizabeth Reynolds, a nurse and Thomas Reynolds, a groom. The latter two were brother and sister.[208] Elizabeth Reynolds looked after baby Jenny and later May.

5
THE GARDEN

GOLDEN WINGS[1]
*Midways of a walled garden,
In the happy poplar land,
Did an ancient castle stand,
With an old knight for a warden.*

*Many scarlet bricks there were
In its walls, and old grey stone;
Over which red apples shone
At the right time of the year.*

In the first two verses of his poem 'Golden Wings', written in 1856, Morris vividly evokes the walled garden of a romantic castle of 'scarlet bricks' where 'red apples' abound. The scene he envisages stands as a poetic precursor to Red House, just as Burne-Jones's near-contemporary Arthurian scene, *The Knight's Farewell*, portrays many of the elements that were to feature in the garden – a secluded enclosure with fruit trees and a profusion of lilies and daisies surrounded by a wall – the setting for a scene of chivalric romance (fig. 5.3).

The house and garden were designed as complementary parts of a world all of its own. From the moment you stepped inside the gates in Webb's high brick wall, you entered a re-imagining of a *Hortus Conclusus*. Morris would have been aware of the religious meaning with which medieval and Renaissance gardens were invested where the 'close-locked' enclosed garden stood as both a metaphor for virginity (as personified by the Virgin Mary – the new Eve) and the prelapsarian Garden of Eden. The fountain within the garden was symbolic of the source of spiritual life and salvation. Morris's enclosed garden was modelled on his love of illuminated images and imbued with his strong sense of pattern, texture, movement, colour and spirit of place (fig. 5.2).

FIG. 5.1
The west elevation. The rose arbour in the foreground marks the line of the original boundary to the garden.

The sea of blossom in spring, the rich crop of apples, plums and damsons in the autumn and the heady scents of bergamot, jasmine, passion flower and roses provided a rich sensory experience.

Morris's love of nature and gardens was engendered early; he and his siblings each had their own garden plot at Woodford Hall, Essex (his family home from the age of six to thirteen), and it seems likely that he indulged an early passion for growing plants and lying among trees in its pleasure-grounds, orchard and kitchen garden. An avid reader from youth, he recalled, 'ever since I could remember I was a great devourer of books'. One of the earliest volumes he was drawn to was *The Herball* or *Generall Historie of Plantes* by John Gerard, which he found in his parents' library (fig. 5.4).[2] First published in 1597, *The Herball* was a reference book with woodcuts and descriptions of native and foreign plants and anecdotes on the folklore surrounding certain specimens. All this appealed to Morris's inquiring mind and romantic nature. His father nurtured his interest, taking him to see the experimental and exhibition gardens of the Horticultural Society in Chiswick, a place which must have both fascinated and disquieted the young Morris.[3]

In a very similar vein, Webb exhibited an early and abiding interest in botany and nature. His artistic talents were encouraged by his father and he was given drawing lessons as a child by a noted botanical artist, which both honed his natural skill and broadened the knowledge of plants he gained from accompanying his father on his visits to patients in the Oxfordshire countryside and to the Botanic Garden, a short walk from his home.[4]

From the outset, the garden appears to have been a shared artistic and

FIG. 5.2
Illustration from the *Roman de la Rose* by Guillaume de Lorris. The depiction of ladies seated within a herber surrounded by a trellis and enclosed by a crenellated wall is thought to have been known to Morris. MS, Douce 195, fol. 6r. Bodleian Library, University of Oxford.

FIG. 5.3
The Knight's Farewell by Edward Burne-Jones, 1858. Pen and ink on vellum: 15.9 x 19.1 cm. The Arthurian scene of lovers parting is set in an enclosed garden where both the maiden and the young man engrossed in the 'Roman du Quete du Sangrail' are seated on raised seats with brick plinths. This early work was owned by Morris. Ashmolean Museum, University of Oxford.

FIG. 5.4
The Madder plant, from *The Herball* by John Gerard, 1636 edition. Paper: 33.4 x 21.3 cm. Madder was used to make red dye. William Morris Gallery.

creative endeavour, which benefitted from Morris and Webb's combined and distinct talents. Webb's designs for Red House show that the interdependent relationship between the house, its well and the surrounding garden was uppermost in his mind. Morris and Webb searched for the ideal site for Red House together. The attraction of the acre plot carved out of a larger orchard, surrounded by market gardens, sited in an elevated position with long views across the Darenth valley, is evident. Webb recorded, in his notebook, a list of eighty trees on the site and was alive to the possibilities they offered in providing an established and abundant setting for the new house and an overarching framework within which to create a garden. Both Morris and Webb

FIG. 5.5
View north towards the well c.1889–1902, showing the disposition of the original orchard trees on the west side of the garden as they appeared on completion of the house in 1860. The well-court was enclosed with a wattle fence of woven willow or hazel, running from the edge of the Pilgrim's Rest porch on the right to the southern end of the house. National Trust, Red House.

were anxious to retain as many of the trees as possible and the house was designed pragmatically, accepting the constraints and embracing the opportunities that the orchard setting offered.

Webb's notebook lists apple, plum, damson, red and black cherries and hawthorn trees, with apples accounting for nearly half the number and plums and damsons for a quarter. Most of the retained trees were arranged in rows running north to south on the east and west sides of the house, bordering the well-court and the bowling green lawn (fig. 5.5). Burne-Jones captured the essence of the garden in its earliest incarnation in a letter to his father, written during his first visit to the newly completed house in autumn 1860; he relayed 'apples only keep me in good spirits – Topsy's garden is perfectly laden with them'.[5]

Webb's drawing of the west elevation of the house is annotated with a series of plant names and their suggested positions are delineated (fig. 5.6). They include moss roses, climbing roses, white jasmine, passion flowers, bergamot, Aaron's Rod and, to the left and right of the two kitchen windows, eating pears. This drawing also features a small sketch of a hedged enclosure which may be one of several created in the area to the north of the house. Georgiana Burne-Jones attests to the implementation of this or a very similar planting scheme. She recalls that 'many flowering creepers had been planted

FIG. 5.6
West elevation of Red House by Philip Webb, 1859. Webb's drawing (mistakenly labelled east elevation) is inscribed in pencil with plant names. On the left of the sheet is a sketch of an enclosed herber, possibly denoting the one created to the north of the entrance porch. Victoria and Albert Museum.

against the walls of the house from the earliest possible time, so that there was no look of raw newness about it; and the garden, beautified beforehand by the apple-trees, quickly took shape. In front of the house it was spaced formally into four little square gardens making a big square together; each of the smaller squares had a wattled fence round it with an opening by which one entered, and all over the fence roses grew thickly' (figs 5.7 and 5.8).[6]

The design of the garden was undoubtedly highly distinctive. Due to its ephemeral nature, it has altered significantly over time and our understanding of its layout and character is based on the surviving physical features, the evidence of Webb's plans, the 1865 Ordnance Survey map, contemporary accounts and the 1866 sales particulars. The detail of the planting schemes and interrelationship and appearance of the herbers remains elusive. This lack of evidence for the detail of the garden means that the art works and decorative schemes featuring a garden setting that Morris devised for the interior of the house give the most comprehensive comparative source. In addition, his writings on gardens, his own later gardens at Kelmscott Manor, Oxfordshire and Kelmscott House, Hammersmith, and the works that most appealed to him – both contemporary and historical – all hold potential clues to the inspiration for and reality of the garden.

The medieval-inspired garden comprised a sequence of distinct but related elements. A series of herbers lay to the north of the house, bounded by the red-brick wall to Upton Lane and the sweep of the drive and a shallow forecourt in front of the house. Based on medieval precedent, these were intimate enclosed gardens with lawns, paths and flowery meads often with a fountain or water element. Traditionally, they were features of royal and aristocratic households and were known from a variety of manuscript sources, including the *Roman de la Rose*, which Morris had studied in the Bodleian Library, whilst at Exeter College.[7] The drive swung around to the north-east corner of the site, where the stable was located. On the east side was the orchard and, closer to the house, the well was enclosed to make a large herber. Webb recorded in his notebook on 12 November 1859 a payment to Edward Russell 'for the whole of fencing up to Plum Tree opposite Pantry of House' (the pantry lay at the southern end of the east elevation). To the south of the house, Webb identified 'flower gardens' and the kitchen garden probably lay to the south west.[8] The bowling green and beyond this a row of fruit trees running close to the boundary with the neighbouring house, Aberleigh Lodge, were on the west side of the house. Georgiana Burne-Jones recollects that 'the longest line of the building had a sunny frontage of west by south, and beneath its windows stretched a green bowling alley where the men used to play when the work was over'.[9]

THE GARDEN

FACING PAGE: **FIG. 5.7**
Trellis by William Morris, with birds drawn by Philip Webb, 1862. Pencil, ink and watercolour on paper: 66 x 61 cm. Believed to be inspired by the garden at Red House, the original design for *Trellis* shows four different options for the background colour to the wallpaper. William Morris Gallery.

RIGHT: **FIG. 5.8**
Detail from *Madonna in a Bower of Roses* by Martin Schongauer, 1473. Tempera on panel: 200 x 115 cm. This picture of the Virgin and child set against climbing roses supported by a trellis of hazel wands may have been seen by Morris on his six-week wedding tour. St Martin's Church, Colmar, France.

Vallance quotes from the account by the anonymous visitor of 1863 – 'one who used to know the house in the old days' – who remembered that 'The first sight of the Red House in 1863, gave me an astonished pleasure. The deep red colour, the great sloping tiled roofs; the small-paned windows; the low wide porch and massive door; the surrounding garden divided into many squares, hedged by sweetbriar or wild rose, each enclosure with its own particular show of flowers; on this side a green alley with a bowling green, on that orchard walks amid gnarled old fruit-trees; – all struck me as vividly picturesque and uniquely original.'[10] This is a scene of strong but balanced contrasts, the 'deep red' of the bricks and great expanses of tiled roof are anchored by the green sward, the 'gnarled old fruit trees' and the intimate vistas created by the herbers. The garden he recollects tallies with Georgiana Burne-Jones's memory and indicates both the attractiveness and sense of fluency of the whole.

Morris's first published story, *The Story of the Unknown Church*, which appeared in the *Oxford and Cambridge Magazine* in 1856, might be read as encapsulating his abiding plant preferences and reflecting the character he envisaged for Red House's garden with the striking well-head, a miniature turreted tower recalling Kentish oast houses and lychgates, with its spring-fed well replacing the fountain of his story:

in the midst of the cloister was a lawn, and in the midst of that lawn, a fountain of marble, carved round about with flowers and strange beasts; and at the edge of the lawn, near the round arches, were a great many sun-flowers that were all in blossom on that autumn day; and up many of the pillars of the cloister crept passion-flowers and roses. Then farther from the Church

FIGS 5.9–5.10
Detail of the incomplete panel painting on the hall settle (figs 4.18–4.19) by William Morris and possibly Dante Gabriel Rossetti, c.1860. Oil on panel. The figures portrayed, from left to right above, are believed to be Mary Nicholson (Red Lion Mary), William Morris (or possibly Charles Faulkner), Jane Morris and an unknown woman. The garden setting shares many of the features of Red House and may be an accurate depiction.

> ... *a great garden round them, all within the circle of the poplar trees; in the garden were trellises covered over with roses, and convolvulus, and the great-leaved fiery nasturtium; and specially all along by the poplar trees were there trellises, but on these grew nothing but deep crimson roses; the hollyhocks too were all out in blossom at that time, great spires of pink, and orange, and red, and white, with their soft, downy leaves.*[11]

Georgiana Burne-Jones recalls poppies in the garden too; she relates of her husband that 'Poppies also held a fascination for him: Mr. Bodley remembers him at Red House, coming in to breakfast one day with a beautiful drawing of a poppy that he had done in the early morning' and mentions 'special flowers – the lily, the sunflower and the rose, for instance – which at various times Edward studied profoundly and finally knew by heart'.[12] These were favoured plants of Morris too. Her description of the large herber, known

FIG. 5.10
Left to right: two unknown figures, Edward Burne-Jones, Georgiana Burne-Jones and Elizabeth Siddal.

as the 'well-court' enclosing the symbolic architectural feature of the well also has echoes of this story. She recalled the deep porch 'at the back was practically a small garden-room. There was a solid table in it, painted red, and fixed to the wall was a bench where we sat and talked or looked out into the well-court, of which two sides were formed by the house and the other two by a tall rose trellis. This little court with its beautiful high-roofed brick well in the centre summed up the feeling of the whole place.'[13] The cool, sheltered porch overlooking a 'medieval well' recalls the line from Chaucer's *The Merchant's Tale*, which relates 'the beautee of the garden and the welle'; in just such an inviting spot, medieval pilgrims or Morris and his friends imbued with Chaucerian spirit might pause to rest, nourished by the fruits of the garden and the spring water from the well (figs 5.9 and 5.10).[14]

May Morris records a further significant built structure in the garden, made to Webb's design, which, surprisingly, is not mentioned in any other

account. Writing of the sketches and notes contained in her father's pocket notebook, which is 'infused with the personality of Red House'; she relates:

Among other notes is one that is rather affecting in its glimpse of the home-days but dimly recalled by a scarce-yet-conscious member of the circle – the youngest of the two babes [May]: i.e. a sketch for part of the garden with trellises and fruit-trees, and in the midst, a little house that Philip Webb designed for Friend-dog. So you see, Friend-dog was not to be housed anyhow in a dusty corner of the stable-yard, but had his home nicely placed as a comely part of the garden architecture, whence he could watch and ruminate over the doings of all his human companions.[15]

The sketch to which she refers is a series of rapid strokes in which trees and trellis are discernible and where a few pencil lines suggest the 'little house' within what appears to be an enclosed herber. Her words give the impression that the dog lived at the centre of things and its 'little house' could have been situated in the garden at the front of the house or may be the small structure demarcated on the 1865 Ordnance Survey map at the south-west end of the bowling alley. The presence of the dog in the garden and in the Morris household adds another dimension to the Red House days. May's recollection continues and she describes the horse and wagonette that were housed in the stable, adding colour and movement as they travelled along the sweep of the drive. 'Besides the Dog, there was a Horse at Red House. And a Wagonette ... it was like the Dog's house, designed by Webb'.[16]

<center>✿</center>

The sales particulars for the house, dated June 1866, relate that the house was 'on an elevated Position, commanding Extensive Views of the surrounding much-admired scenery ... stands in its own Grounds, approached by a Carriage Sweep ... The Grounds are tastefully disposed, the Flower Garden with Plaisances in character with the House, Bowling Green, Orchard, and Productive Kitchen Garden, the whole containing more than an Acre. There is an abundant supply of Spring Water, which has never failed in the hottest Summer.'[17] This document is at once both enticing and business-like. It conveys a picture of a good, commodious house and garden, with all the necessary adjuncts for modern living, without overwhelming by focusing overtly on the artistic character of the whole. Morris's voice can be heard in the descriptive 'Plaisances in character with the House', denoting the unity of the whole. Plaisances traditionally described a pleasure-ground of shaded walks, trees and plants with statuary or an ornamental feature as a focal point. Here it may be taken to relate to the series of herbers, with their intimate and interconnected quality.

Morris is believed to have begun composing, or to have had the germ of the idea for, his poem 'The Life and Death of Jason', part of *The Earthly Paradise*, which was published to critical and popular acclaim in 1867, whilst living at Red House. Written in Chaucerian metre, it contains passages that – whilst explicitly depicting classical myth – may be read as containing an implicit reference to the garden. In the description of the garden of Circe, Medea finds herself

Unto a sunny space of daisied sward,
From which a strange-wrought silver grate did guard
A lovely pleasance, set with flowers, foursquare,
On three sides ending in a cloister fair
That hid the fair feet of a marble house,
Carved thick with flowers and stories amorous:
And midmost of the slender garden-trees
A gilded shrine stood set with images[18]

Here in poetic form are the plaisances or pleasance of Red House.

Garden settings and plants feature prominently in the decorative schemes that were planned and executed inside the house, contributing to the overall sense of interconnectedness of house and garden. Artistic representations of gardens are found in all the principal rooms and in a variety of artistic media. The embroidered panels devised for the dining room walls incorporated flowery meads and fruit trees, and had they been completed and hung around the room, would have been punctuated by views out into the green of the garden from the windows to the north and east. In the drawing room, Sir Degrevaunt and his bride process along a flowery path to their wedding feast. Alongside this, on the settle, was Rossetti's panel painting depicted Dante and Beatrice reunited in Eden with bluebells and daisies lining the foreground and lilies and climbing roses forming the backdrop. On the walls beneath the Sir Degrevaunt paintings, Morris's banded decoration is enlivened by auriculas. The wall painting in the principal bedroom places Adam and Eve, Noah, Rachel and Jacob in garden settings. They are divided by fruit trees, including the apple tree around which the serpent is entwined in this incarnation of Eden. Standing across the bedroom was Burne-Jones's depiction of *The Prioress's Tale*, featuring poppies, sunflowers and daisies, and lining the walls were the embroidered daisy hangings worked by Jane Morris. The stained glass windows running along the ground and first-floor passages include quarries decorated with stylised plants which filter the view out onto the garden itself.

OVERLEAF
FIG. 5.11
The Orchard or *The Seasons* by William Morris and John Henry Dearle, 1890. Tapestry woven in wool, silk and mohair on a cotton warp: 221 x 472 cm. Victoria and Albert Museum.

THE GARDEN

The most important depiction, though, is found in the incomplete panel painting on the hall settle (figs 5.9 and 5.10). This shows nine figures in medieval dress standing and sitting in a garden in a frieze-like composition. There is a bench seat, a wattle fence, flowers and fruit trees, which are all redolent of the garden outside the front door. This is Morris's rendition of his friends, talking and playing instruments, at ease and enjoying one another's company in his garden. Other interpretations of this scene have been suggested – that Morris translated the friends to an Arthurian setting and that he depicts them in the garden of Lancelot's castle, Joyous Gard, or that the setting may be a recreation of one of the illuminated scenes which resonated so strongly with him. The painting undoubtedly presents an enduring image of crucial aspects of the garden at Red House. It immortalises a convivial gathering in the setting of a beautiful herber and accentuates the role of the garden as a place of rest after work – of conversation, poeticising, bowls, apple-picking, drawing, painting, sewing, looking, writing and thinking.

The remembrance of the garden lived on in Morris's memory and design lexicon long after he left it in 1865. It influences the stylised, repeating patterns of flowers and foliage in the wallpaper and fabric designs which were such a critical and popular product of the Firm and Morris & Co. Nearly twenty-five years later, the orchard setting of the garden appears again, vividly reimagined, as the inspiration for his first figurative tapestry design, entitled *The Orchard* or *The Seasons*, which he drew in the late 1880s, with the tapestry woven in 1890 (fig. 5.11).

In his lecture 'Making the Best of It', delivered in 1879, Morris expressed his strongly held views on town gardens and implicitly recalls his intentions at Red House for the synthesis and visual bond between house and garden:

Large or small, it should look both orderly and rich. It should be well fenced from the outside world. It should by no means imitate the wilfulness or the wildness of Nature, but should look like a thing, never to be seen except near a house. It should, in fact, look like a part of the house.[19]

Whilst Morris must have had periods of industry in the garden at Red House and laid out the plants to please his plan for the colour and pattern of the overall scheme, he was not himself a gardener. As Mackail described in 1899, 'in his knowledge of gardening he did ... with reason pride himself. It is very doubtful whether he was ever seen with a spade in his hands; in later years at Kelmscott [Manor] his manual work in the garden was almost limited to clipping his yew hedges. But of flowers and vegetables and fruit trees he knew all the ways and capabilities.'[20]

THE GARDEN

The garden that Morris created at Red House, with important contributions from Webb, has an autobiographical quality, for it reflected Morris's avowed passions and spoke of his youth, his medievalism, his strong sense of the appropriateness to place and of the need to create in organic form a fitting complement to the carefully considered and wrought house. It was highly individual and distinctly different from the contemporary fashion, which delighted in the artistry of seasonal bedding schemes and strong shows of formal pattern and colour. Morris was not interested in the fruits of the plant hunters or the products of the hothouse and so looked back to find inspiration in the herbs and native plants he knew from his childhood, and which he connected to the literature and visual imagery of the medieval period (fig. 5.12).

The garden exerted a strong influence and has been identified as an important precursor of the Arts and Crafts garden and as a pioneering example of the development of garden rooms. In his biography of Webb, Lethaby identified that the garden stood as the first of 'the modern square-plot and trained hedge type, which is now well-known' and Fiona MacCarthy has suggested that 'one might argue Morris's garden was more influential than his house'.[21]

✿

The design unity of the whole ensemble and of the character of the garden was felt by his contemporaries. In his architectural career, Philip Webb displayed an intuitive and pronounced understanding of the interrelationship between house, garden and wider setting, including the views out from the house and to the house and vistas within the garden itself. This is perhaps best exemplified by Standen, Sussex, which he completed in 1894. The Burne-Joneses moved to The Grange, Fulham in 1867, and one of its many attractions was the garden, which had 'apple-trees enough to justify us in calling part of it an orchard'.[22] Rossetti also took on the lease of a house with a substantial garden of lawns and trees, including mulberry, limes and fruit, which rapidly became home to his extensive menagerie of domestic and exotic animals, among them wombats, armadillos and peacocks. In each instance, whilst the overall aesthetic and planting of Red House may have been both a subliminal and acknowledged influence, they stopped short of adumbrating a radically individual design of their own making.

There were common elements, most notably exhibited in the choice of plants, between Red House and Kelmscott Manor, Morris's country retreat from 1871, and at the garden of his London home from 1878, Kelmscott House. The garden was an important consideration; in an effort to persuade Jane of the charms of Kelmscott House when house-hunting, Morris proposed that 'we might stick up a great high trellis wh:would effectively shut out the

FIGS 5.12
Summer Snow by Edward Burne-Jones, c.1863. Wood engraving: 14.5 x 10.7 cm. Burne-Jones's study may be modelled on Jane Morris reading in the orchard at Red House. William Morris Gallery.

overlookers: on the other side there are other gardens & all is quite pretty'. He subsequently mentions 'a sort of orchard (many good fruit trees in it) with rough grass (gravel walk all round garden)'.[23] Georgiana Burne-Jones was later to recall of Kelmscott House: 'There was also a long garden, of which Morris made the most by dividing it in to separate spaces as he had done at Upton [Red House].'[24] His first garden reappeared in modified form in his last. His intervening move to the upper floors of Red Lion Square in 1865 and the loss of his *Hortus Conclusus* must have been deeply felt.

6

THE FIRM

MORRIS, MARSHALL, FAULKNER AND CO.,
FINE ART WORKMEN IN PAINTING, CARVING,
FURNITURE AND THE METALS
EDWARD BURNE-JONES C.J. FAULKNER
ARTHUR HUGHES FORD MADOX BROWN P.P. MARSHALL
WILLIAM MORRIS D.G. ROSSETTI PHILIP WEBB

The growth of Decorative Arts in this country, owing to the efforts of English Architects, has now reached a point at which it seems desirable that Artists of reputation should devote their time to it. Although no doubt particular instances of success may be cited, still it must generally be felt that attempts of this kind hitherto have been crude and fragmentary. Up to this time, the want of that artistic supervision, which can alone bring about harmony between the various parts of a successful work, has been increased by the necessarily excessive outlay, consequent on taking one individual artist from his pictorial labours.

The Artists whose names appear above hope by association to do away with this difficulty. Having among their number men of varied qualifications, they will be able to undertake any species of decoration, mural or otherwise, from pictures, properly so called, down to the consideration of the smallest work susceptible of art beauty. It is anticipated that by such co-operation, the largest amount of what is essentially the artist's work, along with his constant supervision, will be secured at the smallest possible expense, while the work done must necessarily be of a much more complete order, than if any single artist were incidentally employed in the usual manner.

These Artists having for many years been deeply attached to the study of the Decorative Arts of all times and countries, have felt more than most people the want of some one place, where they could either obtain or get produced work of a genuine and beautiful character. They have therefore

FIG. 6.1
Daisy wallpaper designed by William Morris, 1864. Printed by Jeffrey & Co. for Morris, Marshall, Faulkner & Co., 1864. Block printed in distemper colours: 68.6 x 50 cm. William Morris Gallery.

now established themselves as a firm, for the production, by themselves and under their supervision, of –

- *Mural Decoration, either in pictures or in Pattern Work, or merely in the arrangements of Colours, as applied to dwelling-houses, churches, or public buildings.*
- *Carving generally, as applied to Architecture.*
- *Stained Glass, especially with reference to its harmony with Mural Decoration.*
- *Metal Work in all its branches, including Jewellery.*
- *Furniture, either depending for its beauty on its own design, on the application of materials hitherto overlooked, or on its conjunction with Figure and Pattern Painting. Under this head is included Embroidery of all kinds, Stamped Leather, and ornamental work in other such materials, besides every article necessary for domestic use.*

It is only requisite to state further, that work of all the above classes will be estimated for, and executed in a business-like manner; and it is believed that good decoration, involving rather the luxury of taste than the luxury of costliness, will be found to be much less expensive than is generally supposed.

April 11, 1861[1]

❦

Morris, Marshall, Faulkner & Co. was formally founded in April 1861, with the publication of their eloquent and evocative circular advising potential clients of their purpose, their experience and artistic credentials, their desire to raise the status of the decorative arts, their ability to work collaboratively across the artistic spectrum on domestic, church and public buildings, the competitiveness of their pricing and their dedication to their cause.

The idea of establishing a distinct and collaborative business venture appears to have been first mooted in 1860. It was precipitated by, and naturally flowed on from, the experience of decorating and furnishing Red House, in which at least five (and possibly Madox Brown as a sixth) of the founding partners had been intimately involved. The first few months at Red House were highly productive, heady times charged with creative urgency. The shaping of the interior of Morris's house fuelled the friends' shared sense of what could be achieved by combining their talents in a crusade against the prevailing fashions of their age and in the promulgation of good design through their artistic lead. Morris, emphasising his own youthful determination to overturn the accepted status quo, was to later record: 'we found, I and my friend the architect especially, that all the minor arts were

in a state of complete degradation especially in England, and accordingly with the conceited courage of a young man I set myself to reforming all that and started a sort of firm for producing decorative articles'.[2] He placed Webb firmly at the heart of the enterprise, acknowledging their shared perspective and Webb's crucial role as both designer and expert manager. Webb took on on much of the early coordination and his good-natured pragmatism meant that orders were made and delivered in a timely fashion. The bonds between the partners were critical to the success of the whole; they were, in effect, creating a new artistic brotherhood destined to transform the decorative arts and effect a revolution in taste.

The founding partners alongside Morris and Webb were Peter Paul Marshall, a surveyor, civil engineer and amateur artist who was a friend of Madox Brown; Charles Faulkner, the Oxford mathematician and engineer who became the Firm's part-time book keeper; the emergent artist Edward Burne-Jones; and the artists of considerable reputation Ford Madox Brown and Dante Gabriel Rossetti. Arthur Hughes, a fellow artist who had worked alongside Morris, Rossetti and Burne-Jones on the Arthurian paintings of the Oxford Union Debating Hall was a co-founder but resigned in the early months over difficulties in attending the partners' meetings on Wednesday evenings at Red Lion Square. At least one other man is known to have been considered as a founding partner: the architect George Frederick Bodley. A friend of Webb, Burne-Jones and Morris, and former member with them of the Medieval Society in the late 1850s, Bodley was proposed by Morris in a letter to Madox Brown dated 14 December 1860.[3] Although he was either not offered or refused the opportunity to become a partner, Bodley was to play a vital role by providing the Firm's first and critically important commissions for church decoration and stained glass. The latter was the art form on which the Firm established its reputation, with all the partners except Faulkner contributing designs for stained glass up to 1864 (figs 6.2 and 6.3).[4]

The Firm came in the wake of renewed interest in the economic potential to the nation of raising the status of art manufacture; and the involvement of Henry Cole, later first director of the South Kensington Museums (now the Victoria and Albert Museum) in Summerly's Art Manufactures. This sought to partner artists with manufacturers to their mutual benefit by connecting 'the best Art with familiar objects in daily use'.[5] At the time, other well-established firms, including Clayton & Bell, were already supplying stained glass and ecclesiastical furnishings, and the Firm had competition from the outset. The Firm's partners sought to offer something more, a comprehensive and bespoke approach to every aspect of the interior, which responded to the architecture of the whole and united the artist and the maker. They were

FIG. 6.2
Eve and the Virgin by William Morris, 1864. Sepia wash and pencil on paper: 74.9 x 55.9 cm. Stained glass cartoon for the chancel east window of All Saints, Middleton Cheney in Northamptonshire. This working drawing is annotated with colour references for the Virgin's robe. William Morris Gallery.

FIG. 6.3
King Arthur from the *King Arthur and Sir Lancelot* cartoon for stained glass by Ford Madox Brown and William Morris, 1862. Black and sepia wash and pencil on paper: 63.5 x 70.5 cm. Designed for Harden Grange, Bingley, Yorkshire by Morris, Marshall, Faulkner & Co. The garden setting is drawn from Red House. King Arthur, who is modelled on Morris, stands on a flowery mead in front of a wattle fence with trees beyond. His robe is patterned with a daisy-like flower, possibly an aster or chrysanthemum. William Morris Gallery.

to forge a new course, diametrically opposed to that of fashionable firms of decorators such as J.G. Crace. 'We are not intending to compete with Crace's costly rubbish or anything of that sort' wrote Rossetti in January 1861, 'but to give real good taste at the price if possible of ordinary furniture'.[6]

The Firm took a lease on 8 Red Lion Square in March, drew up their circular, began seeking commissions and designing and making stock for their shop. A kiln for firing glass and tiles was erected in the basement and work began with intent. Morris wrote to his friend and former tutor, the Rev. Frederick Barlow Guy, on 19 April, announcing his new venture: 'By reading the enclosed [the circular] you will see that I have started as a decorator which I have long meant to do when I could get men of reputation to join me, and to this end mainly I have built my fine house'. He makes a direct association between Red House and the genesis of the Firm and, perhaps with the thought of his several changes in intended career over the preceding few years in mind, states that his new role as a 'decorator' is one on which he has been focused for some time. Morris, keen to drum up business, continues with a request for the clergyman's assistance in identifying potential clients:

You see we are, or consider ourselves to be, the only really artistic firm of the kind, the others being only glass painters in point of fact, (like Clayton and Bell) or else that curious nondescript mixture of clerical tailor and decorator that flourishes in Southampton Street, Strand; whereas we shall do – most things. However, what we are most anxious to get at present is wall-decoration, and I want to know if you could be so kind as to send me (without troubling yourself) a list of clergymen and others, to whom it might be any use to send a circular. In about a month we shall have some things to show in these rooms, painted cabinets, embroidery and all the rest of it, and perhaps you could look us up then: I suppose till the holidays you couldn't come down to Red House: I was very much disappointed that you called when I was out before.[7]

With his pattern-making on the walls at Red House still fresh and the interior schemes yet to be completed, he makes a particular point of mentioning to Guy that commissions for 'wall-decoration' are sought. This indicates the importance he placed upon this art form, the skill in this medium possessed by various of the partners, notably himself, and his desire to do more of the designing and painting he so much enjoyed. With the advent of the Firm, Morris had to shift his focus to encompass both the new business enterprise and the ongoing decoration of his own house. What is apparent is that there is a synthesis between the two that is mutually enriching. Many of Red House's design motifs and subjects form the basis for the earliest productions of the Firm and new works executed for the Firm become part of the fabric and domestic furnishings of Red House. For the earliest commissions, Red House

acted as a showroom, a creative work in progress illustrative of what could be achieved by the combined talents of the Firm. It was a powerful expression of an artistic home in which every element spoke of craftsmanship and the connectivity between designer and maker.

Morris was the major investor in the Firm, and he took on the role of business manager with a salary of £150 per annum.[8] Each partner held one £20 share and was paid according to their level of skill and contribution to the various designs. The more limited artistic skills of Morris, Marshall and Faulkner commanded smaller fees than those of the other partners. Morris's father had amassed considerable wealth through his entrepreneurial approach to business and investment and Morris himself possessed a voracious appetite for work as well as having the ability to inspire others. Committed to the success of the enterprise, he threw himself into his new work, which drew him physically and mentally away from his previous preoccupation with Red House. From Easter 1861, Morris spent considerable time commuting daily to Red Lion Square and stayed in town on Wednesday nights after partners' meetings. Whilst the other partners each had their own separate careers, ensuring the Firm's success was Morris's chief occupation. Work on Red House abated and progressed in an episodic fashion. Weekends were still hospitable and jolly but there was a shift in focus from the shared activity of decorating the house to designing for the Firm and building a business.

In 1861, they began work on a unified narrative scheme of stained glass depicting the Creation for Bodley's new church, All Saints, Selsley, Gloucestershire, and worked for him on St Michael's, Brighton and St Martin's, Scarborough from 1862. The Selsley scheme beautifully demonstrates the unique skill of the Firm. Webb made the initial sketches for the complete scheme and 'together with Morris he integrated the individual styles of the figure cartoonists – Rossetti's vigour, Madox Brown's expressiveness, Burne-Jones's fluent elegance and modernity; Morris's own simple narrative directness – into a coherent entity' and contributed all the designs for the lettering, borders, canopy-work and quarries himself.[9] Alongside the stained glass, ecclesiastical embroidery was made and they designed and executed painted decoration. Webb, Morris and Faulkner worked with one another, using skills honed at Red House, on the repeating floral and foliate patterns on the chancel roof of St Michael's. Webb was to note that he spent five days painting the roof.[10]

Their earliest commissions for domestic decoration came through artistic connections. In 1860, Webb designed Sandroyd, Surrey, a studio house for John Roddam Spencer Stanhope, who had been a fellow collaborator on the painting of the Oxford Union Debating Hall. Two surviving photographs of its much-altered interior show details of stained glass and tiles supplied by

the fledgling Firm.[11] The stained glass quarries include Webb's characterful birds and the 'daisy-like' flower that Morris had designed for the lower passage. These quarries were supplemented by three new designs comprising a stylised plant, Spencer Stanhope's coat of arms and his motto on a banderole entwining a tree, dated 1861. The motto is directly adapted from Morris's 'si je puis' design and all three are very much in the Red House style. Perhaps Spencer Stanhope, who knew the house, was specific in his desire for a glass panel closely modelled on and emulating Morris's windows. The architectural form of the corner fireplace that Webb designed for the hall is an amalgam of his earlier designs for the roof of the hall settle and the corner wardrobe in the downstairs bedroom at Red House (fig. 4.91). The fireplace was entirely glazed with tiles, with the main sloping section comprising a combination of a repeating flat pattern, a stylised pomegranate tree standing on a flowery mound, with a monogrammed shield containing the initials 'RSS', and four female figure tiles from Chaucer's *Legend of Good Women*; Alceste, Cleopatra, Philomela and Thisbe. The pomegranate tree is attributed to Morris on stylistic grounds, for it is a reworking of his design for an embroidered tree from his scheme for the Red House dining room. Burne-Jones designed the figure tiles for the Firm and then re-employed both the design and subject in his sketch scheme for Chaucerian embroideries for Ruskin in 1863 (fig. 4.47). On the uppermost section are two further figure tiles of Adam and Eve separated by an inscription in Latin from Genesis: '*Tulit ergo Dominus Deus hominem et posuit eum in Paradisum voluptasis*' (So the Lord God took the man and placed him in a Paradise of pleasure).[12] The figures were originally designed by Burne-Jones for stained glass windows at All Saints, Selsley and are believed to have been adapted by Morris for use on tiles. The inclusion of Adam and Eve in a near-contemporary decorative scheme juxtaposed against Chaucerian heroines has a direct parallel in the iconography of the principal bedroom at Red House.

The Firm received a significant commission for secular stained glass in 1862, from the successful textile manufacturer Walter Dunlop for the Music Room of his house, Harden Grange, Bingley, Yorkshire. The thirteen panels depicting the doomed love of Tristram and Isolde from Malory's *Morte d'Arthur* enabled the partners of the Firm to give expression to one of their favoured Arthurian subjects in a new medium (fig. 6.5). The panels were designed by the partners Burne-Jones, Rossetti, Morris, Madox Brown and associates Arthur Hughes and Valentine Prinsep. This commission was one of several received from patrons in the local area who were introduced to the Firm by John Aldam Heaton, a decorator and watercolourist who was friendly with Rossetti. Through the same network of patrons, the Firm went on to

design stained glass for the nearby church of St Paul's Manningham, for Bradford Parish Church and for Bradford Cathedral in 1864.

The public launch of the 'Fine Art Workmen in Painting, Carving, Furniture and the Metals' came at the International Exhibition held in South Kensington in 1862, the successor exhibition to the Great Exhibition of 1851 (which, as a boy of sixteen, Morris had defiantly refused to enter on a visit with his family). The Firm ambitiously reserved two stands in the Mediaeval Court for their stained glass and decorated furniture. A quantity of tiles, embroidery, table glass, jewellery and domestic items were also displayed, demonstrating the breadth and accessibility of their work. This was their opportunity to show the public and influential critics that they excelled in 'the luxury of taste rather than the luxury of costliness'.[13] Rather belatedly, the Firm only began taking minutes of their meetings on 10 December 1862, which means that it is difficult to be precise about all the objects shown at the International Exhibition. Nonetheless, in 1862 alone, Webb designed an extensive list of furniture, furnishings and jewellery, comprising a chest, dressing table, round table, book case, sideboard, chair (fig. 6.8), cheval glass, looking glass, iron bedstead, washstand, towel horse, long table, wardrobe, two-leaf screen, candlesticks (fig. 6.7), wine glasses, finger glasses, liqueur glasses, tumblers, sugar basin, jam dish, seal, brooch and bracelet. Whilst some pieces were for specific commissions, others were destined for display at the exhibition and as stock for customers visiting the shop (fig. 6.6).

Faulkner recounted that the Firm's early business meetings generally took a lively but circuitous form.

FIG. 6.4
Geoffrey Chaucer tile designed by Edward Burne-Jones, 1863, and believed to be painted by William Morris for Morris, Marshall, Faulkner & Co. Hand-painted on a tin-glazed earthenware Dutch blank: 15.3 x 15.3 cm. The portrait of Chaucer relates to Burne-Jones's earlier depiction of the poet on *The Prioress's Tale* wardrobe and the enduring interest he and Morris shared in the poet and his works. The white rose is closely modelled on the 'Rose in splendour' tile Morris had designed in *c.*1861 for the Pilgrim's Rest porch at Red House, which Morris invested with a Chaucerian spirit. Victoria and Albert Museum.

FIG. 6.5

Sir Tristam is recognized by Isoude the Fair's dog by William Morris, 1862. Stained glass: 68 x 60.5 cm. Window from the Music Room, Harden Grange, Bingley, Yorkshire by Morris, Marshall, Faulkner & Co., 1862. Morris's interest in and understanding of medieval stained glass practice and his own sure sense of the rich deep colour and subtleties of pattern which could be achieved are exemplified by this work. His skilful use of silver stain is revealed in the intricate patterning on Isoude's gown, which is suggestive of a richly embroidered cloth. Bradford Art Galleries and Museums.

OVERLEAF: **FIG. 6.6**

Labours of the Months tile panel designed by Edward Burne-Jones, Ford Madox Brown, William Morris, Dante Gabriel Rossetti and Philip Webb c.1862 for Morris, Marshall, Faulkner & Co. Hand-painted on tin-glazed earthenware tiles: 12.7 x 12.7 cm each tile. Four of the seven partners of the Firm contributed individual designs for the figures depicted, and Webb designed the signs of the zodiac which appear on all but two tiles. Lucy Faulkner, Charles Faulkner's sister, was a skilled artist and painted many of the Firm's early tiles. Her initials, 'LJF' appear on the border of the February tile. On the January tile, Webb's astrological sign of Aquarius depicts a man modelled on Morris. William Morris Gallery.

FIG. 6.7
Pair of copper candlesticks, designed by Philip Webb, c.1860–1. Copper: 26.7 x 17.8 cm diameter. Red House was lit by candlelight and Morris also owned brass candlesticks in the same design. This design was sold by the Firm from 1861. Victoria and Albert Museum.

FIG. 6.8
Armchair designed by Philip Webb and made by Morris, Marshall, Faulkner & Co., 1861–2. Ebonised wood with gilded bands: 99 x 41 x 43 cm. This highly distinctive chair has extended side rails to the seat and diagonal struts with bands of gilding at the back. Webb employed similar banded decoration on his ebonised mirror which was also shown at the International Exhibition. Although the chair was favourably reviewed by the *Illustrated London News*, it was not sold and was kept by Morris at Red House. Society of Antiquaries of London, Kelmscott Manor.

Beginning at 8 or 9p.m. they open with relation of anecdotes which have been culled by members of the firm since the last meeting – this store being exhausted, Topsy [Morris] and Brown will perhaps discuss the relative merits of the art of the thirteenth and fifteenth century, and then perhaps after a few more anecdotes business matters will come up about 10 or 11 o'clock and be furiously discussed till 12, 1, or 2.[14]

Nonetheless, the opportunity offered by the International Exhibition provoked a serious response in the form of a flurry of designing and making with Morris at the helm. Faulkner captures the mood in a letter to Cormell Price in April: 'The getting ready of our things first has cost more tribulation and swearing to Topsy [Morris] than three exhibitions worth.'[15] Rossetti wrote to Charles Eliot Norton: 'I wish you could see a painted cabinet, with the history of St. George, and other furniture of great beauty which we have in hand. We have bespoke space at the Great Exhibition, & and hope to make the best show there that a short notice will permit of.'[16]

The St George cabinet was designed by Webb and painted externally and internally by Morris with figurative scenes and repeating flat patterns (fig. 6.9). Webb's design is formed of a rectangular cupboard with three hinged doors, set on a painted stand. He made the conscious decision to break up the surface, on which Morris was to paint five narrative scenes from the *Legend of St George*, with copper handles and lock plates. Webb's perceived failure to integrate the physical form of the piece and its intended use as a painted surface for a pictorial narrative drew criticism from *The Building News*: 'This studied affectation of truthfulness, in placing ironwork in the middle of a picture, is one of the many sins which have to be purged from the Mediaevalists'.[17] Webb's earlier design for *The Prioress's Tale* wardrobe displayed a similar arrangement and, had Webb wished to, he could readily have corrected any perceived fault in the form of his design.[18] This suggests that there was a medieval precedent to which Webb chose to remain faithful in his designs and which Morris supported. This cabinet is very much in the same spirit as the furniture he designed for Red House. Shared stylistic details are particularly pronounced in the red painted stand, which has columnar legs extending up from a crenellated foot which read as a reworking of the uprights on the dining room dresser.

Morris divided the five scenes unevenly, with two scenes on the left-hand and central door, and one on the right-hand door with vertical patterns of shells and spots framing the end pictures and blank side panels, daisy heads running up the sides of the central panel and a thin wavy line with alternating spots demarcating the division between scenes on the left and middle panels. Further repeating patterns run horizontally along the upper front edge and around the short upstand on the top of the cabinet. Morris seized the opportunity to display his skill in pattern-making with the variety

FIG. 6.9
Cabinet on stand, depicting the Legend of St George, designed by Philip Webb and painted by William Morris. Manufactured by Morris, Marshall, Faulkner & Co., 1861–2. Mahogany, oak and pine, painted and gilded copper handles: 95.9 x 177.7 x 43.2 cm. Victoria and Albert Museum.

of intricate ornamentation he applied. Morris's deep-rooted enthusiasm for romantic stories from medieval literature is shown in his choice of the *Legend of St George* as the pictorial subject. The narrative scenes (running left to right) depict: the king's despair when his daughter (modelled on Jane Morris) is chosen to be sacrificed to the dragon; his daughter being led away in chains by his soldiers; the princess tied to a post in the forest awaiting her fate; St George clasping the swooning princess after killing the dragon; and St George and the princess walking hand in hand at the front of a procession, carrying the carcass of the dragon through the crowded streets.[19] The interior of the cabinet has fitted shelves and decorated drawers with copper handles. Morris achieved his striking decorative effect on the drawers with layers of tinted varnishes on silver leaf, employing a medieval technique described in Theophilus's *De diversis artibus*, a late twelfth-century treatise written by a German monk.[20] William Burges had successfully employed this technique on the Yatman cabinet in 1858 and Morris eagerly emulated the glowing colours used by Burges on the decorative scenes, whilst developing his own style.[21] Morris completed all the decoration in time for the exhibition,

FIG. 6.10
Sleeping Beauty tile overmantel designed by Edward Burne-Jones with Swan pattern border tiles designed by William Morris, 1862. Probably painted by Lucy Faulkner for Morris, Marshall, Faulkner & Co. Hand-painted in various colours on tin-glazed earthenware Dutch blanks: 76.2 x 120.6 cm. Commissioned by Myles Birket Foster for a bedroom fireplace for The Hill, Witley, Surrey. The decorative backdrops to the interior scenes read almost as a miniature rendition of Red House and reveal that Burne-Jones drew on the drawing room's painted flower pattern for the tile sequence. Victoria and Albert Museum.

concentrating his energies on this whilst other more ambitious schemes remained incomplete awaiting his focus at Red House.

Although the cabinet failed to sell for its price of £50 and was still listed as part of the shop stock the following year, the visually arresting painted furniture on the stand exerted both praise and criticism and, crucially, raised the Firm's public profile. In all, they sold over £150-worth of objects and garnered critical acclaim, receiving two medals of commendation from the Exhibition Jury, which acknowledged the 'artistic qualities of colour and design' in its stained glass.[22]

One of the commissions to come after the International Exhibition was the interior decoration and furnishing of the watercolour artist Myles Birket Foster's newly built Hill House in Witley, Surrey. The Firm supplied tiled overmantels, fireplace tiles, stained glass and furniture. The fairytale tile sequences are predominantly the work of Burne-Jones, and were one of his major contributions to the Firm's domestic wares and a development of the penchant for storytelling decoration. Three of the subjects he addressed were *Cinderella*, *Beauty and the Beast* and *Sleeping Beauty* (fig. 6.10). The Hill's bedroom fireplace with the *Cinderella* overmantel had tiled reveals containing tiles of *Fortune* and *Love* designed by Burne-Jones.[23] The latter two designs

FIG. 6.11
Jasmine Trellis designed by William Morris 1868–70, for Morris, Marshall, Faulkner & Co. Block printed cotton: 22.9 x 94 cm. In Morris's first design for a furnishing fabric a stylised delicate Jasmine flower weaves through a trellis.

were then made as stained glass panels and overlain on the stained glass quarries in the ground-floor passage windows at Red House in about 1863 (figs 4.52 and 4.53). Burne-Jones's designs for the decoration of the rooms of the castle in which Sleeping Beauty lives show the influence of Red House on his style too; the miniature walls are depicted with painted and embroidered hangings based on the drawing and dining rooms at Red House.[24] The fairytale narratives were painted by Lucy Faulkner and subsequently sold directly through the Firm's shop.

The Firm's development of flat repeating patterns on wallpapers began with the design of *Trellis* in 1862 (fig. 5.7). Wallpaper was a natural evolution of the labour-intensive, painted pattern-making that Morris had devised for the roof of the Oxford Union Debating Hall and the walls and ceiling of the drawing room at Red House. Rossetti had first commissioned a paper (to be printed on blue and brown paper variants) made to his design from a printer in 1861, and this example is likely to have been a further spur to the production of *Trellis* and *Daisy* (fig. 6.1) from 1864. By transferring patterns onto paper, a similar effect to Red House could be achieved across large expanses of wall. The earliest wallpapers drew on Red House's garden as a source of inspiration. In *Trellis*, Morris was responsible for the overall design of stylised rambling roses weaving through the wooden fence, whilst Webb contributed the flying and perching birds. Looking out of any window at Red House, you

might have glimpsed a parallel image of birds on wattle fences smothered in a riot of roses. *Daisy* takes the detail of the wall hanging from the fifteenth-century 'Dance of the Wodehouses' in Froissart's *Chronicles* (fig. 4.65), which in turn inspired his design for the daisy hangings in the principal bedroom and reimagines it in a more detailed form as a flat, repeating pattern.

Early tile and stained glass designs may also be seen to relate directly to the garden as a visual sourcebook, notably the *Daisy* tile, designed by Morris in around 1862, and Burne-Jones's cartoon for *The Song of Solomon Series*, at St Helen's Darley Dale, Derbyshire in 1862. Although this drawing has traditionally been attributed to Burne-Jones, the concept of the design appears to be Morris's, and the sawn timber trellis bears a very close resemblance to his first design for *Trellis* wallpaper made in the same year.[25] In similar vein, *Jasmine Trellis*, Morris's first printed cotton, designed 1868–70, recalls the west elevation of the house, against which Jasmine was trained (fig. 6.11).

Although Morris was forced to shore up the Firm's finances with additional investments, church and domestic commissions kept it in constant work after 1862. By early 1864, he was faced with a critical decision, for new premises were needed as they had outgrown the accommodation available in Red Lion Square. Morris alighted on the solution offered by Red House and proposed that it be extended to accommodate the Burne-Joneses and that the Firm's works move close by so that he was on hand to supervise. Georgiana Burne-Jones reflected: 'After three years of daily travelling between Upton and London it was no wonder Morris began to feel the journey a waste of time and strength. There was land to be had near Red House where workshops might be built, and if only Edward came to live their also, how much more could be got through together than separately. The idea was timely so far as we were concerned, for our rooms in Great Russell Street were now too small for our needs and we had thought of removing elsewhere.'[26] Morris, thrilled by the prospect of a shared life with his and Burne-Jones's family together, called upon Philip Webb to devise a scheme for Red House's extension.

7

RELINQUISHING RED HOUSE

FIG. 7.1
Fruit or *Pomegranate* wallpaper designed by William Morris c.1866. Printed by Jeffrey & Co. for Morris, Marshall, Faulkner & Co. Block-printed in distemper colours. National Trust, Cragside.

Webb designed Red House as a coherent, stand-alone building whilst, fortuitously, recognising that he might be called upon by Morris to make future additions. With his unrivalled understanding of the site's potential, he set to work on drawing up designs for an extension to accommodate the Burne-Joneses and presented his scheme in spring 1864 (figs 7.2–7.4). In effect, he proposed turning Red House into a semi-detached villa. The new house, which was to be entirely self-contained, with its own front and garden doors, kitchen and service yard, was to extend out from the original building to the east and south, creating a three-sided courtyard around the well. The two families would share the garden and the existing entrance from Upton Lane. Morris's studio was to be given up, with this room and the bedroom below becoming the Burne-Joneses' first-floor drawing room and ground-floor dining room respectively. The ever-generous Morris was happy to forego these rooms to ensure a balanced design which would provide his friends with the accommodation that they needed to live happily alongside his family.

The Burne-Joneses were to have a three-storey house with a deep entrance porch and bay window to the dining room (the former downstairs bedroom) to the north. The design drawings reveal that Webb intended the porch to give onto a long passage, with the staircase, kitchen and domestic offices accommodated on the ground floor and a small wine cellar below the scullery. The double aspect drawing room (the former studio) with views north and south was to be on the first floor, adjacent to Burne-Jones's studio. The remainder of the first floor was to comprise two family bedrooms, a separate bathroom with a bath, and a broad, well-lit passage, with a semi-circular oriel window with views of the well, and stairs to the attic floor. The attics are shown with two bedrooms for servants, a narrow lumber room and a store room lit by a dormer window. It is a well-composed arrangement with no overlooked bedrooms, a cool east-facing kitchen, an attractive drawing

FIGS 7.2–7.3
Unexecuted design for alterations (first arrangement) to Red House by Philip Webb, 1864. Pencil, pen and ink and wash. Inscribed 'Addition to House at Upton near Bexley – Kent – for W. Morris Esq.'. Above: design for the 'Ground Plan (the existing house is outlined in black ink with the extension demarcated by coloured wash). The new house shows the division of Morris's downstairs bedroom and studio from the original house to become the Burne-Joneses' dining room and drawing room. Victoria and Albert Museum.

FIG.7.3
Plan of Roofs, Plan of 1st Floor and Plan of Attics.

room and, all importantly for Burne-Jones, a first-floor studio with both north light and a huge expanse of east-facing windows. Webb amended the original building contract of 1859, with details of the works needed for the extension. He specified stamped ceilings of the studio, two bedrooms, upper and lower passages, and instructed that the same red bricks and clay tiles as at Red House should be used.

Webb's drawings reveal the development of his architectural style in the five years since he made his first designs for the site. His work for the Firm and on buildings as varied as Sandroyd, his terrace of houses and workshops in Worship Street, London and Arisaig House in Inverness-shire, meant that he had garnered significant design experience and become much more certain of his keen sense of appropriateness to place and use of local materials. The elevations of the proposed extension show his greater appreciation of the local Kentish vernacular, with the inclusion of externally expressed timber framing and tile hangings; whilst the semi-circular first-floor oriel may have been suggested by an admired precedent like the stone oriel at Great Chalfield Manor, Wiltshire.

The proposed extension was conceived as a fluent addition to the whole, which would have enhanced the distinctive architectural character of his original house without compromising its setting. Webb's considered design met with the approval of Morris and Burne-Jones but, conscious of his limited income and without the financial reserves that Morris could draw upon, Burne-Jones quickly realised that he would not be able to afford the extension. His sense of regret is evident in his later remembrance of the unrealised scheme. 'A lovely plan was made', he recorded, 'too happy ever to come about. It was that Morris should add to his house, making it a full quadrangle, and Webb made a design for it so beautiful that life seemed to have no more in it to desire – but when the estimates came out it was clear that enthusiasm had outrun our wisdom and modifications had sadly to be made.'[1]

Whilst Morris continued to search for a site locally for the Firm's workshops, Webb revised his initial scheme. He scaled down the internal accommodation and reduced its overall cost by dispensing with the deep porch, bay window, bathroom, lumber room and store room. He inscribed his new design as 'Proposed additions to the house in the way of a separate cottage' and noted that it was 'The second and reduced design to cheapen it' (fig. 7.5).

Georgiana Burne-Jones recalled the pleasure that the friends derived from one another's company at this time and how much they anticipated the happiness promised by the scheme to live together at Red House:

RELINQUISHING RED HOUSE

FIGS 7.4
Unexecuted design for alterations (first arrangement) to Red House by Philip Webb, 1864. Pencil, pen and ink and wash. Inscribed 'Addition to House at Upton near Bexley – Kent – for W. Morris Esq.'. Webb's design for the elevations and sections of the new house for the Burne-Joneses. Victoria and Albert Museum.

FIG. 7.5
'Proposed additions to the house in the way of a separate cottage. The second and reduced design to cheapen it', Philip Webb, 1864. The accommodation follows the same general layout as the earlier scheme extending out from the existing house on the south and north elevations with the distinctive timber-framed detail he proposed for the west elevation facing on to the well-court. It is however, significantly smaller, so as to meet the Burne-Joneses limited funds. Victoria and Albert Museum.

FIG. 7.6
Philip Webb's letter to Morris, dated 18 November 1864, which was discovered in 2005 beneath floorboards. The letter, written during Morris's illness with rheumatic fever and baby Christopher Burne-Jones's fight for life, was folded into three and posted between the floorboards. National Trust, Red House.

> *We looked forward to building in the spring of 1865, and meanwhile, in order to lose no chance of being together, it was arranged that the Morrises, the Faulkners and we should all meet for our autumn holiday at Littlehampton, on the Sussex coast … three most happy September weeks we spent there … the evenings were always merry with Red House jokes revived and amplified: laughs with so little cause, and yet the cause remembered still!*[2]

Sadly, fate intervened and Philip Burne-Jones caught a mild case of scarlet fever and unwittingly passed it on to his pregnant mother, causing Georgiana to suffer the premature birth of Christopher, her second son. Morris, meanwhile, was laid up with rheumatic fever and at a low ebb. As he struggled, incapacitated, to maintain the Firm's workload and finances he was deeply anxious for the wellbeing of Georgiana and baby Christopher.

In 2005, as floorboards were lifted for reservicing works in the south-west bedroom, a remarkable discovery was made; between the joists lay a letter from Webb to Morris (fig. 7.6). It was sent on 18 November 1864 and shows the concern that was felt in their circle for the tribulations of the Burne-Joneses and for Morris's own health. Webb wrote: 'I can only hope that you are not in great pain – and that you manage to keep up your spirits.' He continued, mistakenly under the impression that Christopher Burne-Jones's health had taken a turn for the better:

> *I must say Ned's case has been a striking example of things all coming round after a depth of trouble, and things are never quite so bad as they look. Charlie Faulkner comes up to town again tomorrow. So Campfield and I manage with him to keep things going pretty smoothly at the shop – and it will do some of your brutes of customers good to wait a bit. Some of the Cambridge*

glass goes off tomorrow which has stopped Bodley's mouth.[3] *I've set them going at S. Philip's Bethnal Green with a pattern for the roof and chancel and I am now going to give them wall & dado patterns for the same.*[4] *I am rather pushed in a corner just now with work as I was away in Norfolk for 2 days and a night.*[5]

Morris must have taken heart from Webb's reassurances about the Firm, but his optimism for the baby proved to be misplaced, for after a three-week struggle he died. It seems likely that on receiving news of baby Christopher's death, Morris posted Webb's hopeful letter between the floorboards from his sick bed.

Shattered by their tragedy and unable to contemplate the costs of building even Webb's 'cottage' design, the Burne-Joneses pulled out of the plan and Webb's extension was never built. Burne-Jones wrote to let Morris know that the 'scheme for building and living together at Upton was at an end, as he could undertake no fresh expense of any kind'.[6] His letter has not survived but Georgiana noted that 'it must have been sad and dispirited'.[7] Morris's reply is written from 'Bed, Red House' in uncharacteristically feeble handwriting. His disappointment is tangible as he refers to the abortive scheme as 'our Palace of Art', once again invoking the 'Lordly pleasure house' of Tennyson's poem. Nonetheless, he also looks forward and seeks to give his friend heartfelt and pragmatic support and proposes a new scheme for a shared studio in London:

As to our palace of Art, I confess your letter was a blow to me at first, though hardly an unexpected one – in short I cried; but I have got over it now.

As to our being a miserable lot old chap, speaking for myself I don't know, I refuse to make myself really unhappy for anything short of the loss of friends one can't do without. Suppose in all these troubles you had given us the slip what the devil should I have done? I am sure I shouldn't have had the heart to go on with the firm; all our jolly subjects would have gone to pot – it frightens me to think of, Ned. But now I am only 30 years old, I shan't always have the rheumatism, and we shall have a lot of years of invention and lustre plates together I hope. I need hardly tell you how I suffered for you in the worst of your troubles; on the Saturday I had begun a letter to you but it read so dismal (as indeed I felt little hope) that I burnt it.

I have been resting and thinking of what you are to do: I really think that you must take some sort of house in London – unless indeed you might think of living a little way out and having a studio in town: Stanhope and I might join you in this you know.[8] *I don't see how you can do with chambers, and it would be too like the old way of living – but all this you have probably thought of yourself. There is only one other thing I can think of, which is when you come back from Hastings come and stay with me for a month or*

two, there is plenty of room for everybody and everything: you can do your work quietly and uninterruptedly; I shall have a good horse by then and Georgie and J. will be able to drive about with the kids jollily, meantime you need not be hurried in taking your new crib. Janey is exceedingly anxious that you should come and it is in her opinion the best thing you could do.[9]

The Burne-Joneses were not to take up his various suggestions, and after a period of recuperation in Hastings, they moved to new lodgings in Kensington Square, London (fig. 7.7). The memory of the aborted scheme was to live with Georgiana and she was later to ponder what might have been:

The two sets of plans lie before me now, clean and unused, and it is curious to think how differently our lives would have gone if this scheme had been carried out. We were not to have actually shared the house with the Morrises; there were separate entrances and rooms for the two families; but all was to have been under one roof with the garden in common.[10]

Morris, possessed of great determination and enterprise, recovered from his illness and took stock of his situation, the demands on his family life and the future of the Firm. He came to realise that his long and wearisome commute, and the social isolation Jane must have hoped would be relieved by having their dear friends as neighbours, were taking their toll and that he too needed to contemplate a move for the good of all. In late summer 1865, he took the decision to leave Red House and move his family to town so that he would

FIG. 7.7
The Burne-Jones and Morris families in the garden of the Burne-Joneses house The Grange, North End Road, Fulham by Frederick Hollyer, 1874. Photograph: 15 x 13.6 cm. Had the extension of Red House gone ahead in 1865, the two families would have grown up together. The children are (left to right) Margaret and Philip Burne-Jones and May and Jenny Morris with Burne-Jones's father on the far left. Victoria and Albert Museum.

be better able to balance their happiness and his work. The house itself never failed to sustain him but, as the Firm and his family grew, Red House was no longer the right place to be and it had to be sacrificed for the greater good.

The Burne-Joneses made a last visit in September and Georgiana fondly remembered 'on a lovely afternoon Morris and Janey, and Edward and I, took a farewell drive through some of the beautiful little out-of-the-way places that were still to be found in the neighbourhood. Indoors, the talk of the men was much about the *Earthly Paradise*, which was to be illustrated by two or three hundred woodcuts.'[11] Morris and Burne-Jones reconnected over this significant literary and artistic endeavour. It was to prove a consuming collaborative project – the much-needed antidote to their shared sense of loss. Soon after this visit, Morris took a lease on a large house in 26 Queen Square, Bloomsbury. The Morrises left Red House in November and moved in to the upper floors of the house that became the new headquarters of the Firm. They must have acutely felt the contrast between their old home and the much less extensive accommodation above the Firm's showroom and workshops, which had no garden.[12] William and Jane's feelings are not known but Georgiana stood as witness to events, and recorded:

> *One of the happiest chapters of our life was closed this year by the sale of Red House.*[13] *But it had to go, for Morris, having decided in his unflinching way that he must come up and live at his business in London, could not bear to play landlord to the house he loved so well – it must be sold outright and he would never see it again. Nor did he; but some of us saw it in our dreams for years afterwards as one does a house known in childhood.*[14]

She recognises Morris's pragmatic determination to avoid nostalgia and to make the best of the situation by throwing himself into his work for the Firm and his epic poem, *The Earthly Paradise*. As William, Jane, Jenny and May adjusted to the hurly-burly of the streets and to town life, welcome consolation was offered by the closeness of their friends and a widening of their artistic and social circle. Most notably for Jane, who had emerged from Red House with her own artistic identity. Whilst there she had become a noted embroideress and occasional pattern painter alongside her critical role as her husband's muse. Living in London though, this was soon to be supplanted by her developing closeness to Rossetti and her new role as his favoured muse.

Red House stood unoccupied for several months. In February 1866, Morris was approached by James Heathcote, a retired officer in the Indian Navy, about the rent for the house. This was eventually settled in March at £95 per annum for two years, with the option to purchase the freehold of the house for the sum of £1,800 at the end of this period. Commander Heathcote equivocated and, in June 1866, Mr Marsh, Auctioneer and Land Agent, advertised the house to be sold or let.[15] It was eventually bought by Heathcote in the autumn of 1866 for considerably less than it had cost to build six years earlier.

Mackail related that 'Red House was sold with such portions of its furniture and decorations as were either unremovable or too cumbrous to transfer to a house for which they had not been designed. Among the treasures thus abandoned were the whole of the tempera paintings executed on the walls, the magnificent sideboard which Webb had designed for the dining-room, and both the great painted cupboards.'[16] Although his use of the phrase 'the treasures thus abandoned' acknowledges the artistic value of the work that were left behind, he gives little hint of the difficult emotional decisions Morris must have faced. The question of what to take and what to leave in place cannot have been an easy one to address, for so much of Morris's personal history and of the shared artistic life at Red House was bound up in the furniture and art works brought from Red Lion Square or fashioned together for the house.[17] These pieces formed part of the visual, literary and social narrative of the house and it is perhaps for this reason that Morris ultimately agreed to part with so much. To remove the fixed pieces – the hall settle, the dining room dresser, the drawing room settle, the bedroom wardrobes and cupboards – would have been to divest the house of part of its very essence and would have diminished the whole. Equally, he must have recognised that, divorced from their rightful context, these pieces might have always seemed out of place, standing as relics from another time and place.

Although willing to forego so much that he had created at Red House, Morris was forced to negotiate to keep ownership of The *Prioress's Tale* wardrobe (fig. 7.8). This had been viewed as a fixture by Commander Heathcote and he drove a hard bargain when Morris expressed his desire to take it on completion of the sale. This wardrobe, the joint creation of his friends Webb and Burne-Jones and a wedding gift, was of seminal importance to him. It was the painted piece of storytelling furniture which set the precedent for all that followed at Red House. In exchange, Morris chose to leave five painted chairs: *The Arming of a Knight* and *Glorious Guendolen's Golden Hair* chairs (figs. 2.6 and 2.7), an ebonised and painted chair (fig. 4.9) and two chairs which are now lost. All five chairs are believed to have been made originally for Red Lion Square and to have influenced the medieval inspired character of Red House. Heathcote's daughter Marion, who lived at Red House from 1866 to 1877, gave a valuable account of the arrangement reached between

FIG. 7.8
The Prioress's Tale wardrobe, in a prominent position facing the ebonised settle from the Red House dining room, across the fireplace in the drawing room of Kelmscott House, the Morrises' London home from 1878. Photograph: 23.3 x 29 cm. William Morris Gallery.

Morris and her father: 'When in 1866 my father bought the Red House of William Morris. Its architect [sic], Morris asked leave to remove a painted cupboard which was a fixture because it had been a wedding present ... In its place, he left there two chairs, two semi-circular ones in which I tried to learn my lessons and a very fine one in oak, like a throne with beautifully carved arms.'[18]

The halcyon days of Red House were over, but they lived long in the memory of all who had lived and stayed there and contributed to its unique character. It was a youthful creation which embodied the romantic ideals and combined skills of a circle of immensely talented friends bound by deep ties. It expressed their shared purpose and visual language and shaped their future emotional and artistic lives, and it continued to resonate with them throughout life, as the place of the near-perfect happy days of youth. Georgiana Burne-Jones, in reflective mood, wrote of the shifts that came with 1865, 'But when we turned to look around us something was gone, something had been left behind – and it was our first youth.'[19] For Morris, relinquishing the house and garden he had created as a paean to love and as an expression of his feeling for his wife, must have been charged with poignancy. Nonetheless, he looked ahead and immersed himself in ambitious new projects, and 'never set eyes on it [Red House] again, confessing that the sight of it would be more than he could bear.'[20] Red House was but one critically important chapter in his extraordinary life, as Burne-Jones was to recount in his deft biographical sketch of Morris, made much later in life:

When I first knew Morris nothing would content him but being a monk, and getting to Rome, and then he must be an architect, and apprenticed himself to Street, and worked for two years, but when I came to London and began to paint he threw it all up, and must paint too, and then he must give it up and make poems, and then he must give it up and make window hangings and pretty things, and when he had achieved that, he must be a poet again, and then after two or three years of Earthly Paradise time, he must learn dyeing, and lived in a vat, and learned weaving, and knew all about looms, and then made more books, and learned tapestry, and then wanted to smash everything up and begin the world anew, and now it is printing he cares for, and to make wonderful rich-looking books – and all things he does splendidly – and if he lives the printing will have an end – but not I hope, before Chaucer and the Morte d'Arthur are done; then he'll do I don't know what, but every minute will be alive.[21]

8
RED HOUSE AFTER MORRIS

After miles of horrible, omnibus-infested roads through the southern suburbs of London we ... found the Red House, not without some trouble, set down in the middle of Bexley Heath, with a shady little formal garden on one side and a deep green orchard on the other. The house still bears the impress of Morris's early taste and a good deal of his furniture is left, also some relics of Rossetti's [Burne-Jones's] wall-paintings, so touching because relics of beauty out of a most Philistine era.[1]

In 1872, Charles Eastlake, the architect and influential author, published *A History of the Gothic Revival: An Attempt to Show How the Taste for Mediaeval Architecture Which Lingered in England During the Last Two Centuries Has Since Been Encouraged and Developed*. His work made no mention of Red House, because Philip Webb refused permission for his buildings to be included. The house remained unpublished in the architectural press and, after 1865, was little known beyond Morris's and Webb's immediate circle. It was not until Charles Holme purchased Red House as his family home in 1889 that it once again became the focus of wider artistic and architectural interest. Holme was an entrepreneur with long-standing trading interests in India, China and Japan who had been in partnership with Christopher Dresser, as 'Dresser and Holme' in Farringdon Road, London. He acquired Red House in the knowledge of its important role in Morris's early life and career and took pride in, and celebrated, this artistic association. Holme lived there with his family for thirteen years, during which time he developed an interest in art and publishing. In 1893, he founded, and was later to edit, *The Studio: An Illustrated Magazine of Fine and Applied Arts*. The magazine championed new artists and designers (notably the young Aubrey Beardsley, who designed the first cover) and became the leading art journal of the fin de siècle.[2] Between 1888 and 1889, travelling with his good friends Lasenby and Emma Liberty and the painter Alfred East, Holme spent eight months in Egypt, Ceylon,

FIG. 8.1
Detail of the stamped pattern on the ceiling in the upper passage today. This red and blue colour scheme was introduced c.1960.

Hong Kong and Japan, before returning home to Red House via the United States and Canada.[3] The tour deepened his long-held interest in the culture and artistic traditions of Japan and on their return he and Liberty were two of the founding members of the Japan Society in 1891, which promoted Anglo-Japanese cultural exchange. Holme's enthusiasm for the art and hand-made goods of pre-Industrial Japan is revealed in photographs of the interior of Red House taken during his occupation.[4,5] The synthesis of his eclectic tastes with the elements of Morris's interiors, which he respectfully preserved, is evident. He also purposefully accentuated the perceived medieval character of the house with the addition of heraldic decoration, painted inscriptions and false beams to ceilings, as if further to amplify and mythologise Morris's narrative (fig. 8.2).

Surviving correspondence from Charles Holme to William Morris, dated May 1890, reveals that he applied to Morris for information about the house. Holme went on to request a more detailed account of the painted scene on the hall settle, seeking to establish definitively its authorship. His letter is written from Red House and is illustrated with his own charming and accurate watercolour sketch, which Morris would have undoubtedly recognised (fig. 8.3). Holme wrote:

FIG. 8.2
View of the drawing room, c.1889–1902, during Charles Holme's ownership. National Trust, Red House.

FIG. 8.3
Sketch included in correspondence from Charles Holme to William Morris in May 1890. Holme was keen to learn more about the painted scene on the settle in the hall (fig. 4.19) and hoped it would help prompt recollections from Morris. British Library.

Dear Sir
Many, many thanks for your kind reply to my letter and for the interesting particulars given by you.
The cupboard doors in the hall, about which you do not seem quite certain, are painted with figures in a garden. It has been suggested that the work is Rossetti's. Perhaps this very rough sketch of it will reveal it more clearly to your mind.
The painting is so admirable that it is much to be regretted that it was never finished.
Yours very sincerely
Charles Holme[6]

Alongside the Japan Society, Holme was a member of the Ye Sette of Odd Volumes, a dining club for bibliophiles. Both societies had distinguished memberships of writers, publishers, artists and architects – many of whom were friends of Holme, contributors to *The Studio* and guests at Red House. Holme was a charismatic and generous host and Red House was once again the destination for an artistic circle, and those like Walburga Paget, who sought out the house as part of the growing cult around Morris. The 1890s

WILLIAM MORRIS & HIS PALACE OF ART

also saw a parallel focus of interest in the house as the first work of Philip Webb, as he was hailed by the successive generation of architects as the father of the Arts and Crafts movement.

✿

Many of those who visited Red House at Holme's invitation engraved their names on the glazed screen and doors which separated the hall from the passage to the Pilgrim's Rest porch, turning this functional feature into a 'visitor's book' and a riveting piece of social history (fig 8.4).[7] The roll call of names includes Mackay Hugh Baillie Scott (architect), A.L. Baldry (artist and critic), Wilfrid Ball (artist), Robert Anning Bell (artist), Alfred East (artist), Onslow Ford (sculptor), John Lane (publisher), Arthur Lasenby Liberty (founder of Liberty & Co. in 1875), Richard Le Galienne (poet and essayist), Mortimer Menpes (artist, author and illustrator), Edmund H. New (the illustrator whose drawings of Red House, Kelmscott Manor and Kelmscott House appear in *The Life of William Morris* by J.W. Mackail, 1899), Mary Newill (embroiderer and stained glass designer), Walter Shaw Sparrow (assistant art editor of *The Studio*), E.F. Strange (Keeper of Woodwork at the Victoria and Albert Museum), Charles Harrison Townsend (architect) and Gleeson White (first editor of *The Studio*). Aymer Vallance, who knew Morris,

FIG. 8.4
A pane from the glazed screen with a host of engraved signatures from the 1890s, including at the very top that of Georgiana Burne-Jones, with the dates '1860–1897' recording her first and last visit to the house. At the foot of the pane is May Morris's signature, marking her return in 1897.

250

visited and engraved his name on the screen in 1892. He contributed articles to *The Studio* and his detailed account, 'William Morris His Art His Writings and His Public Life', suggests that he knew the house well.[8]

Within a year of Morris's death in October 1896, both Georgiana Burne-Jones and May Morris made separate visits to the house and added their names to the glazed screen. Georgiana's recollection is brief and rather matter-of-fact, as her appreciation of the constancy of the house's setting is tempered by the threat of imminent construction. She related: 'I had paid a visit to Red House, which I believe none of us had seen since 1865. The immediate neighbourhood was little changed, "Hog's Hole" being quite recognizable and the fields round the garden untouched. The apple blossom was out, and the grass and flowers in as perfect condition as they used to be; but we were told that changes were at hand, and that soon it would be surrounded by fresh buildings.'[9] She gives no indication of what prompted her pilgrimage after thirty years or who she was accompanied by, but the timing implies that it must have been a poignant visit and perhaps one of leave-taking rather than mere curiosity. A few months later, May Morris visited with her friend Mary Newill. She must have felt mixed emotions in returning to a place so redolent with meaning for her father and of which she could still conjure up fragments of 'dream-pictures' from her earliest days.

✿

Writing in 1897, Aymer Vallance was the first to single out Red House in print as an important building which presaged change. He identified that 'It was, for its time, a bold innovation, which cannot be said to have been without extraordinary results for good. Nay, as an experiment on the part of a man who had both the hopefulness and dauntless will necessary to enable him to make a stand against the tyranny of custom, to William Morris is owing the credit of having initiated, with his Red House, a new-era in house building.'[10] His view was reiterated and enlarged upon by Hermann Muthesius, an architect attached to the German Embassy, whose major study of recent English architecture, *Das Englische Haus*, was published in 1904. He wrote of Red House: 'Not only was the interior revolutionary but in its external design too it was unique in its way'.[11] Making no reference to the important antecedents of A.W.N. Pugin's St Marie's Grange (1835–7) or to the intervening brick houses by Street and Butterfield, he continued: 'Built entirely of red brick, it was the first example of the use of this material for a dwelling-house, although William Butterfield had frequently used brick for churches and larger buildings'.[12] Muthesius mistakenly invested Red House with a degree of innovation which belied the Gothic Revival tradition in which Webb was working, and his clear architectural debt to Street and Butterfield. Nonetheless, his view took hold and Red House became famous and much

publicised for its associations with Morris and his intimate circle. It was seen as the precursor of the Arts and Crafts Movement, with a later generation claiming for it a significant influence on the Modern Movement. Red House achieved a mythic and, for some, an iconic status. As Nicholas Cooper has shown, the changing perceptions of the house, its revolutionary role and its influence have led to a rich and complicated historiography.[13]

After Holme, the house had a series of owners in the twentieth century for whom it was a much-loved home, most notably for its final owners Edward and Doris Hollamby, who lived at the house from 1952 until 1999 and 2002 respectively. For their first five years, they shared the house with Richard and Mary Toms. Edward Hollamby and Richard Toms were fellow architects working for the London County Council and were staunch Morrisians, determined to save the house from years of benign neglect and the threat of institutional use. The two families lived alongside one another, with separate rooms, and separate kitchens and bathrooms but with a shared eating room (the former kitchen) and shared use of the garden. They also had a shared outlook and ethos at work and at home and lived out something of the rich, collaborative existence at Red House that Morris had so dearly wanted for his own family and the Burne-Joneses. In 1957, Jean and David Macdonald moved in, taking the Tomses' place. Jean was also an architect, working alongside Edward Hollamby and Richard Toms for the LCC, and David was an accountant and a talented craftsman. These three families were young and energetic and together they slowly gave the house a renewed purpose, treating it with respect, drawing out historical details, painting the interior, fashioning furniture and introducing contemporary pieces from Ercol and Heals. They were confident in their own tastes and were not bound by history, making their own creative interventions. Taking sole ownership of the house in 1964, the Hollambys enjoyed half a century as custodians of the house and did much to further Morris scholarship and understanding of the place through Edward Hollamby's writings and by opening the house to scholars and visitors as the cult of Morris waxed once again.

They also sought a long-term solution to the future of the house, which from the 1930s until their acquisition in the 1950s had been repeatedly under threat from developers. The importance of the house had long been acknowledged and various unsuccessful campaigns had been mounted to secure it for the benefit of the nation. The Hollambys were determined that it should be accessible, so that the wider world had the opportunity to appreciate the very special character of the place and its extraordinary survival.[14]

In January 2003, the National Trust formally took ownership, acknowledging the intrinsic and exceptional significance of Red House and the import-

ance of Morris and Webb as co-founders of the Society for the Protection of Ancient Buildings in 1877, as pioneering conservationists who informed and prompted the Trust's own foundation in 1896. Red House still resonates – prompting visits and pilgrimages – for it speaks of its original owner's youth, exuberance, creativity, passionate medievalism, romanticism, instinctive desire to collaborate, strong bonds of friendship and fellowship, first confident steps in commercial production and zeal to transform the decorative arts and tastes of his age. Red House stands as a vitally significant embodiment of the achievements of Morris and his closest friends and a critical expression of how they chose to live and work, which stayed with them and coloured their future lives. It continues to capture the imagination and remains a powerfully evocative place through Morris's enduring legacy.

Ars Longa Vita Brevis.[15]

Notes

ONE | 'SI JE PUIS': 'IF I CAN'
1. 'Als ik kan' (As I can) is inscribed in Greek letters on the frame of Jan van Eyck's *Portrait of a Man* (Self Portrait?), 1433, in the National Gallery, London. **2**. *The Palace of Art And Other Poems* by Alfred, Lord Tennyson, New York, 1898, lines 57–60, p.13, https://archive.org/stream/palaceofartotherootenn#page/12/mode/2up (accessed 2 March 2017). **3**. Georgiana Burne-Jones, *Memorials of Edward Burne-Jones*, London: Macmillan & Co, 1904, p. 294.

TWO | BEFORE RED HOUSE: OXFORD AND LONDON
1. William Morris, 'The Beauty of Life'. Lecture delivered in to the Birmingham Society of Arts and School of Design, 19 February 1880, in May Morris, ed., *Collected Works*, vol. 22, p. 76. **2**. Burne-Jones, op. cit., p. 568. **3**. Quoted in Fiona MacCarthy, *William Morris: A Life for Our Time*, London: Faber and Faber, 1994, p. 18. **4**. Quoted by Martin Harrison, 'Church Decoration and Stained Glass' in Linda Parry, ed., *William Morris*, exh. cat., Victoria and Albert Museum, London: Philip Wilson Publishers in association with the Victoria and Albert Museum, 1996, p. 107. **5**. Quoted in Linda Parry, ed., William Morris, 1996, p. 25. **6**. Ibid. **7**. See Fiona MacCarthy, *William Morris: A Life for Our Time*, London: Faber and Faber, 1994, p. 83. **8**. William Morris, introduction to the Kelmscott Press edition, 'On the Nature of Gothic', 1892. Quoted in MacCarthy, 1994, p. 69. **9**. Quoted in MacCarthy, 1994, p. 95. **10**. Letter to Emma Shelton Morris, 11 November 1855. Quoted in Gillian Naylor, ed., *William Morris by Himself: Designs and Writings*, London: Time Warner Books, 2004, p. 35. **11**. W.R. Lethaby, *Philip Webb and His Work*, London: Oxford Union Press, 1935, p. 7. **12**. Ibid., p. 11. **13**. Ibid., p. 12. **14**. Sheila Kirk, *Philip Webb: Pioneer of Arts & Crafts Architecture*, Chichester: Wiley Academy, 2005, p. 15. **15**. Clive Wainwright, 'Morris in Context' in Parry, 1996, p. 356. **16**. Street played an important role in the revival of ecclesiastical embroidery, and in 1854 his sister co-founded the influential Ladies Ecclesiastical Embroidery Society. **17**. Burne-Jones, op. cit., p. 99. **18**. Letter to Cormell Price, July 1856. Quoted in MacCarthy, op. cit., p. 115. **19**. Lethaby, op. cit., p. 122. **20**. See Linda Parry, William Morris Textiles, London: V&A Publishing, 2013, p. 17. **21**. John William Mackail, *The Life of William Morris*, London: Longmans Green & Co., 1899, Two volumes bound as one, p. 113. **22**. Burne-Jones, op. cit., p. 147. **23**. Mackail, op. cit., p. 113. **24**. MacCarthy, op. cit., p. 130. **25**. See MacCarthy, pp. 130–4. **26**. Mackail, op. cit., p. 117. **27**. Ibid. **28**. Ibid., p. 119. **29**. Ibid., pp.120–1. **30**. Ibid., p. 120. **31**. See Mackail for extracts from Cormell Price's diary for October 1857. He relates the time he spent 'daubing in black lines on the Union roof for Topsy [Morris]', p. 126. **32**. Lethaby, op. cit., p. 21. **33**. Quoted in MacCarthy, op. cit., p. 133. **34**. Undated letter, written from Queen Square from Morris to Mr J.R. Thursfield, chairman of the Union fresco committee, reproduced in Mackail, op. cit., pp. 124–5. **35**. MacCarthy, op. cit., p. 139. **36**. Burne-Jones, op. cit., pp. 187–8. **37**. Mackail, op. cit., p. 137.

THREE | DESIGNING AND BUILDING RED HOUSE
1. https://www.marxists.org/archive/morris/works/1884/hwl/hwl.htm (accessed 1 July 2017). William Morris, 'How We Live and How We Might Live'. Lecture delivered on November 30th, 1884, and first printed in *Commonweal*, 1887. **2**. Mark Girouard, 'Red House, Bexleyheath, Kent', *Country Life*, 16 June 1960, p. 1383. **3**. Lethaby, op. cit., p. 25. **4**. Georgiana Burne-Jones describes this as Morris's 'cherished scheme of building a house after his own heart', op. cit., p. 196. **5**. Recounted by Sydney Carlyle Cockerell, Morris's secretary at the Kelmscott Press, 1891–6, in his foreword to the collection of letters from Warrington Taylor to Philip Webb, 12 November 1915, Victoria and Albert Museum, National Art Library, 86.ss.57. **6**. Lethaby, op. cit., p. 26. **7**. Burne-Jones, op. cit., p. 196. **8**. The Red House deeds are held by the William Morris Society and were presented to them by Sir Edward Maufe RA in May 1960. His parents bought Red House in 1903 and his mother lived there until 1920. **9**. Aymer Vallance, *William Morris: His Art His Writings and His Public Life*, London: Studio Editions, 1986, p. 43. **10**. 'Building Contract, Dated 16 May 1859, Mr Willm Kent and Wm Morris Esq', p. 6, National Trust Archive, Red House. The building contract is a remarkable survival and is annotated in pencil with a few minor amendments for the execution of details in 1859–60 and more significantly reworked in early 1864 to form the basis for the contract for the proposed extension to the house, designed by Webb for Morris with the intention that the Burne-Jones family would occupy the new accommodation. This scheme and the reasons it remained unexecuted will be discussed in greater detail in Chapter 7. The contract was the property of Philip Webb but was perhaps given by him to Morris when the extension for the Burne-Joneses came to nought, or possibly given to May Morris on Webb's retirement as an architect. It was rediscovered by Robert Coupe, when he purchased it from a book dealer in New York who had acquired it from the estate of Stephani Godwin, who had become a friend of May Morris in her last years. Godwin and her husband were tenants at Kelmscott Manor in the 1940s, before emigrating to the United States. Robert Coupe, a Morris scholar and collector, very generously donated the contract to the National Trust for Red House in 2013. Amendments to the building contract for the proposed extension reveal that the bricks were sourced from Malling, near Maidstone, Kent, ibid. **11**. Letter to Andreas Scheu, 15 September 1883. Quoted in Poulson, ed., *William Morris on Art and Design*, Sheffield: Sheffield Academic Press, 1996, pp. 28–9. **12**. Kirk, op. cit., p. 304. **13**. G.E. Street, 'On

the Future of Art in England', *The Ecclesiologist* 19 (1858), p. 240. Street had published the influential work *Brick and Marble Architecture in the Middle Ages: Notes of Tours in the North of Italy* in 1855. **14**. Nicholas Cooper, *Red House Conservation Plan*, 2007, p. 73. **15**. Michael Hall, 'Butterfield's Houses' in The Victorian Society Studies in Architecture and Design Volume 6: *Butterfield Revisited*, ed. Peter Howell and Andrew Saint, London: The Victorian Society, 2017, pp. 42–3. **16**. Lethaby, op. cit., p. 27. **17**. Burne-Jones, op. cit., p. 196. **18**. Philip Webb to William Kent, 16 June 1859, letter transcribed into Philip Webb's Account Book. Quoted in Kirk, op. cit., p. 20. **19**. Building Contract, op. cit., p. 8. **20**. Ibid., p. 15. **21**. One closely related example to the ceilings at Red House is found at Hill House, Cawthorne, the Yorkshire home of the artist John Roddam Spencer Stanhope from 1860–70. Spencer Stanhope was a friend of Webb, Morris and Burne-Jones and a patron of Webb's architectural practice. The stamped pattern is in the hallway of his house and comprises a grid of 10-inch squares within which running diagonally are three rows forming an arc, a larger curved form bisected by a line of holes and a small circular motif with a central hole (this is now painted white and no evidence of the original colour scheme is known). All three elements bear distinct similarities to the detail of the stamped patterns found on the slope of the staircase and the arcs on the flat ceiling of the Red House hall and it seems likely that Spencer Stanhope visited Red House and saw Webb and Morris's patterned ceilings in situ. Webb may also have specified stamped ceilings for Sandroyd, the studio house he designed for Spencer Stanhope in Surrey in 1860. This building has been substantially altered internally and no stamped ceilings are known but they may have formed part of Webb's design. Sandroyd shared a number of characteristics with Red House, including windows glazed with the bird quarries that Webb had designed for the lower passage at Red House. Morris and Burne-Jones are also believed to have visited Spencer Stanhope at Hill House. I am grateful to Simon Poë for first drawing the ceiling at Hill House to my attention and to Richard Flowerday for very generously sharing his knowledge of the house and a photograph of the ceiling pattern. The ceiling of the Green Dining Room in the South Kensington Museum (now the V&A), which was designed by Webb and Morris in 1867, is reputed to have had a stamped ceiling, although no evidence of the original stamped pattern is now visible in the room. **22**. Building Contract, op. cit., p. 17. **23**. Ibid., p. 22. **24**. Ibid. **25**. Ibid., p. 16. **26**. This has been potentially identified as the firm of J.K. and H. Cooper, listed in the Post Office directory of 1854 as 'Surveyors, builders, brickmakers and lime burners ... at East Street, Maidenhead.' Webb is thought to have known the supplier whilst working for Street at Boyne Hill, Maidenhead. Friends of Red House, THE RED HOUSE BUILDING CONTRACT Notes on research into this important document, 2012, p. 8, http://www.friends-red-house.co.uk/Building_the_Dream.pdf (accessed 12 February 2017). **27**. Building Contract, op. cit., p. 15. **28**. Cooper, op. cit., p. 58. **29**. Although it has been subsequently altered to accommodate more horses, it retains its original loosebox and stall at the north end. The coach house element was dispensed with when a separate coach house was built by 1889. **30**. Burne-Jones, op. cit., p. 212. **31**. May Morris, *William Morris: Artist, Writer, Socialist*, vol. 1, Oxford: Basil Blackwell, 1936, p. 396. **32**. Ibid., p. 395. **33**. MacCarthy, op. cit., p. 154.

FOUR | DECORATING AND FURNISHING THE HOUSE

1. William Morris, 'Some Thoughts on the Ornamented Manuscripts of the Middle Ages', in *The Ideal Book: Essays and Lectures on the Arts of the Book*, William S. Peterson, ed., London: University of California Press, 1982, p. 1. **2**. Mackail, op. cit., pp. 142–3. **3**. Morris first saw the Bayeux Tapestry in 1855. Fiona MacCarthy writes, 'To Morris the mediaeval tapestry was the equivalent of a Chaucer poem, precise in its narrative, human in its range of reference, eloquent, alive ... It was public art, immediately accessible.' MacCarthy, op cit., p. 406. **4**. William Morris, 'The Lesser Arts of Life', 1882. https://www.marxists.org/archive/morris/works/1882/life1.htm (accessed 4 April 2017). **5**. MacCarthy, op. cit., p. 16. **6**. Lethaby, op. cit., p. 45. **7**. First stanza from 'The Blue Closet', published in William Morris, *The Defence of Guenevere*, 1858. https://ebooks.adelaide.edu.au/m/morris/william/defence-of-guenevere/chapter18.html (accessed 20 March 2017). **8**. Rossetti commented that, 'though beautiful in themselves', Morris's poems 'were the result of the pictures, but don't at all tally to any purpose with them' (G.S. Layard, *Tennyson and his Pre-Raphaelite Illustrators*, 1894, p. 55). http://www.tate.org.uk/art/artworks/rossetti-the-blue-closet-n03057 (accessed 20 March 2017). **9**. Parry, op. cit., p. 19. **10**. Letter to William Allingham, 18 December 1856. *The Correspondence of Dante Gabriel Rossetti: The Formative Years 1855–1862*, William Fredeman, ed., Cambridge: D.S. Brewer, 2002, p. 147. **11**. MacCarthy, op. cit., p. 131. **12**. Burne-Jones, op. cit., pp. 209–10. **13**. In retrospect, Georgiana Burne-Jones recorded, 'it is pathetic to think how we women longed to keep pace with the men, and how gladly they kept us with them until their pace quickened and we had to fall behind'. Burne-Jones, op. cit., p. 218. Just as Morris was ultimately called away from the house by the claims of the business, the impact of motherhood was to claim Jane and Georgiana and ultimately Elizabeth Siddal. **14**. Frances Collard notes that the 'influence of William Burges and his furniture, particularly the iconographic and carefully structured cabinets shown in the 1859 Architectural Exhibition and at the International Exhibition of 1862, must be acknowledged. Burges's use of a medieval technique for painting furniture, taken from the twelfth-century manuscript of a monk, Theophilus, was to be copied by Morris on furniture exhibited in 1862.' Collard, 'Furniture' in Parry, ed., op. cit., p. 156. **15**. Burne-Jones, op. cit., p. 213. **16**. Mackail, op. cit., p. 137. Rossetti wrote to Allingham of Morris: 'You know he is a millionaire and buys pictures. He bought Hughes's *April Love*, & lately several water-colours of mine and a landscape by Brown – indeed seems as if he would never stop, as I have 3 or 4 more commissions from him.' Fredeman, op. cit., 56.59, p. 147. In 1864, Rossetti had back five of the watercolours Morris had purchased from him in 1857–8. Several of these were re-worked before being sold to the collector George Rae in 1864. It is not known whether Morris returned them to Rossetti as a gift, for money or in exchange for work done at Red House or for the

Firm. See http://www.rossettiarchive.org/docs/s99.raw.html (accessed 21 March 2017). **17**. Mackail, op. cit., p. 113. **18**. May Morris records in a Memorandum, 17 June 1926 (part of the Will and Testament of Mary Morris), London Probate Department (HM Courts & Tribunals Service), which details her bequest of part of the contents of Kelmscott Manor to the University of Oxford, that there was a 'Half tester bed hung with rose chintz (the bed Red House)' in the passage room at Kelmscott Manor. There is now no record of a half-tester bed at Kelmscott Manor and no half-tester is listed in the 1939 sale, so the whereabouts of the Red House half-tester recorded by May is unknown. Jan Marsh records: 'the elegant Regency four-poster in which Morris and his siblings had been born, which is now at Kelmscott Manor, was sent to Red House by his mother', *William Morris and Red House*, p. 35. This appears to be a misunderstanding, for the four-poster bed at Kelmscott bears a small brass plaque which was most likely made on May Morris's instructions. It reads: 'This bed, upon which William Morris was born 24 March 1834, was given to him by his mother on his coming to Kelmscott Manor. MM [May Morris]'. I am grateful to Kathy Haslam for details of the plaque. **19**. Mackail, op. cit., p. 161. **20**. The two carpets recorded in May Morris's memorandum of 1926 are described as: 'Worn Eastern carpet from Red House' and 'Very worn Turkey carpet from Red House'. These are part of the collection at Kelmscott Manor but are not on display due to their fragility. Morris, op. cit., p. 12. **21**. Mackail, op. cit., p. 158. **22**. Rossetti to Charles Eliot Norton, 9 January 1862. Fredeman, ed., op. cit., 62.3, p. 441. **23**. Extract from Psalm 121, verse 8. This inscription is believed from its gothic-inspired script to date from 1859–60, but it is possible that it might be an addition of c.1889–1903 by Charles Holme. **24**. Burne-Jones, op. cit., p. 208. **25**. A surviving photograph of the hall, c.1910 shows the leaded bottle-glass panels. Jean Macdonald recalls that they 'were made up of rather crude, leaded glass circles unlike any other glass in the house.' Jean Macdonald, 'Red House After Morris', July 2003, typescript, National Trust Archive, Red House, p. 6. They were removed c.1959 and replaced with four coloured mosaic panels depicting the seasons by Anthony Holloway, which remain in place. May Morris records 'tiles for the porches' suggesting that the entrance porch originally had tiled walls. No evidence for the appearance of the tiles has been found. Morris, op. cit., p. 13. **26**. Anonymous visitor recalling a visit made in 1863. Quoted in Vallance, op. cit., p. 49. Jan Marsh has suggested that the unknown visitor may have been George Campfield, the Firm's glass painter. Vallance recorded his memories after a passage of thirty years. **27**. Quoted in MacCarthy, op. cit., p. 159. Dr Furnivall, in discussion following lecture on Morris by F.S. Ellis, *Journal of the Society of Arts*, 27 May 1898. **28**. The Building Contract specifies that all oak should be 'English sound and cut die square free from sap and other defects', op. cit., p. 12. **29**. Girouard, op. cit., pp. 1383–4. **30**. Building Contract, op. cit., p. 8. **31**. Research into the decorative history of the earliest decoration of the hall has been hampered by the significant abrasion caused by later decoration. In 2015, evidence for a green and red floral pattern was found to the side of the front door by Lisa Oestreicher and this suggests the lower walls of the hall had a repeating floral pattern which led to the yellow walls of the stair. Further research may reveal a more detailed understanding of the complete scheme for the hall. In January 2017, there was 'considerable evidence to conclude that there was a red border along the skirting boards and around the edges of the walls. Red vertical lines were also found along the bottom of the walls, which may have been setting out techniques before the application of a more complex scheme, or could have formed part of a decorative scheme themselves'. Tobit Curteis Associates LLP, Investigation for Painted decoration in the Main Entrance Hall and Staircase, Red House, Bexleyheath, January 2017, p. 11. **32**. Burne-Jones, op. cit., p. 209. **33**. The study may alternatively depict *Iseult Boarding the Ship*. **34**. Morris was to publish, in 1867, 'The Life and Death of Jason', his poetic retelling of the search for the Golden Fleece and subjects derived from classical mythology that are also significant to Burne-Jones, notably his unfinished *Troy Triptych (Polyptych)*, which Julia Dudkiewicz has suggested may address the Greek subjects that he had much earlier contemplated for Red House. Julia Dudkiewicz, 'Kelmscott Manor Venus and Morris's Idea for a "House of Love" at Red House', in *Useful and Beautiful*, winter 2016, William Morris Society in the United States, p. 8. See http://www.bmagic.org.uk/objects/1922P178 for further details on Burne-Jones's unfinished *Troy Triptych (Polyptych)* and the location of the known preparatory studies (accessed 1 May 2017). In 1892, Morris planned that William Caxton's *Recuyell of the Historyes of Troy*, the first book to be printed in English, should be reprinted by the Kelmscott Press and developed the Troy type for this work. **35**. British Library, Add MS 45336, facing p. 32 and p. 33. **36**. Mackail, op. cit., vol. I, p. 166. For the text of *Scenes from the Fall of Troy* see http://morrisedition.lib.uiowa.edu/Poetry/EarlyPoems/ScenesTroy/earlypoemsscenestext.html (accessed 1 July 2017). **37**. A.P.M. Wright, Introduction, *Scenes from the Fall of Troy*, Morris Archive http://morrisedition.lib.uiowa.edu/Poetry/EarlyPoems/ScenesTroy/earlypoemsscenesintro.html (accessed 1 July 2017). **38**. The inner face of the front door has a geometric pattern in blues and reds, which Jean Macdonald painted c.1957. She recounts that after some of the patterns on the door, which she believed were by Morris, were revealed, she 'volunteered to paint over the [later] brown in matching colours, following the patterns underneath.' Macdonald, op. cit., p. 6. **39**. This results in the current contrast of deal and oak which Webb would not have countenanced. In 1860, only oak was left unpainted with the exception of the deal service stair. Building Contract, op. cit., p. 11. **40**. Vallance, op. cit., pp. 49–50. **41**. Helen Dowding cogently argues for Rossetti's involvement in the hands and faces of the figures. Dowding, 'An Investigation into the Original Decoration and Possible Treatment of a Painted Settle in William Morris's Red House', postgraduate diploma in the conservation of easel paintings final year project, 2005, pp. 26 and 31, Courtauld Institute of Art. **42**. Ray Watkinson, 'Red House Decorated', *Journal of the William Morris Studies*, spring 1988, p. 14. **43**. W. Minto, ed., *Autobiographical Notes on the Life of William Bell Scott and notices of his artistic and poetic circle of friends 1830–1882*, 2 vols, London 1892, vol. II, p. 61. **44**. May Morris, memorandum attached to her will, June 1926. *The Antiquaries Journal*, XLIII, 1, 1963, p. 112. **45**. Quoted in Mackail, op. cit., p. 160, this is thought to be the recollection of Philip Webb, himself a connoisseur of wine. **46**. Letter from Warrington Taylor, the Firm's manager, to Webb, dated 1866. Quoted by Jennifer Hawkins Opie in Linda Parry, ed.,

op. cit., p. 185. **47**. See Richard and Hilary Myers, *William Morris Tiles*, Shepton Beauchamp: Richard Dennis, 1996, pp. 10 and 138–40; and Jennifer Hawkins Opie, 'Tiles and Tableware', in Parry, ed., op. cit., p. 182. The existing blue and white tiles were probably supplied towards the end of the nineteenth century by Thomas Elsley, a successful tile manufacturer. **48**. This drawing is accurate in the detail of the dresser and the panelling, so there is every reason to suppose that H.P. Clifford faithfully represented the ceiling decoration. Vallance, op. cit., p. 51. **49**. This table is in a private collection in the United Kingdom. **50**. Wilfrid Scawen Blunt's book *Love Lyrics and Songs of Proteus* was published by the Kelmscott Press in 1892. Blunt was part of the wider Morris circle and a former lover of Jane Morris. In his retirement, Webb lived at Caxton's, Worth, Sussex, a cottage on Blunt's estate. **51**. Letter from Philip Webb to Sydney Cockerell, 28 May 1898, National Art Library, Victoria & Albert Museum, 86.TT.14 MSL/1958/688/81 **52**. Sheila Kirk refers to Morris's 'sudden muscular spasms'. Kirk, op. cit., p. 24. This element in his nature combined with his occasionally explosive temper has prompted the view that Morris suffered from a form of epilepsy. His daughter Jenny was diagnosed with epilepsy in her teens. **53**. Quoted in Mackail, op. cit., p. 161. **54**. Diary of Henry Price, pp. 151–2, Islington Central Library. Quoted in Pat Kirkham, 'William Morris's Early Furniture', *Journal of the William Morris Society*, vol. IV, no. 3 (spring 1981) pp. 25–8. **55**. Georgiana Burne-Jones remembers returning early from honeymoon to find Webb's table awaiting them and what a cherished piece it became: 'Our own home-coming was informal, for Russell Place had not expected us so soon and was unprepared to receive us; there were no chairs in our dining-room, nor any other furniture that had been ordered except a table. But what did that matter? If there were no chairs there was the table, a good, firm one of oak, sitting upon which the bride received her first visitors, and as the studio was in its usual condition there was a home at once. The boys at the Boys' Home in Euston Road had made the table from the design of Philip Webb, and were busy with chairs and a sofa, which presently arrived … The chairs have disappeared, for they were smaller articles, vigorously used and much moved about, but the table and sofa have always shared the fortunes of their owners and were never superseded: we ate our last meal together at that table and our grandchildren laugh around it now.' Burne-Jones, op. cit. pp. 205–6. For further detail on Webb's medieval and vernacular sources for his trestle tables see Giles Ellwood, 'Three Tables by Philip Webb', *Furniture History* 32, 1996, pp. 127–39. **56**. See Lethaby, op. cit., pp. 36–7. Webb was to design and build 91–101 Worship Street, Shoreditch, a terrace of six houses with workshops for artisans, for Gillum in 1861–3. **57**. Morris, op. cit., p. 12. Frances Collard notes that the earliest chair design by Webb was 'based on a Regency prototype, a painted chair or armchair, with turned uprights and imitation bamboo frame'. Collard, 'Furniture', Parry, ed., op. cit., p. 169. The Firm went on to train and employ the boys to execute the simpler pieces of furniture they offered in the 1860s including the early examples of Sussex rush-seated chairs which went on to become one of the Firm's most popular and affordable products with designs by Webb, Rossetti and Morris. **58**. Vallance, op. cit., p. 50. **59**. Morris, op. cit., p. 396. **60**. Burne-Jones, op. cit., p. 177. Morris's contemporary poem of the same title, *The Tune of Seven Towers*, although inspired by Rossetti's watercolour, which Morris acquired in 1857, does not focus on the same subject and makes no mention of a chair. His poem was published in 1858, in *The Defence of Guenevere and Other Poems*. **61**. Burne-Jones, op. cit., p. 213. **62**. Quoted in Poulson, ed., op. cit., p. 136. **63**. Jennifer Hawkins Opie, 'Tiles and Tableware' in Parry, ed., op. cit., p. 196. **64**. Mackail, op. cit., p. 143. **65**. Burne-Jones, op. cit., p. 202. **66**. William Morris, 'The Lesser Arts of Life', 1882 **67**. Burne-Jones, op. cit., p. 213. **68**. The term 'tapestries' is used by Jane Morris in this instance to denote embroideries. British Library, Add MS 45341. **69**. This embroidery is recorded as Guenevere, as is the surviving cartoon at Tate Britain, but there has been debate as to whether the figure is Guenevere or Iseult. Linda Parry describes the embroidery as 'Iseult' in *William Morris Textiles*, p. 20 and makes no reference to Guenevere as part of the embroidery scheme. She had previously identified this embroidery as Guenevere in *William Morris*, p. 227. I have continued with the appellation of Guenevere but recognise that there is an equal likelihood that the embroidery depicts Iseult. Morris's painting, *La Belle Iseult*, was reidentified as Iseult after it had been mistakenly labelled Guenevere after Morris's death, and the embroidery of Guenevere is closely modelled on the figure of *La Belle Iseult* (fig. 2.11). **70**. May Morris, ed., *The Collected Works of William Morris*, vol. 9, London: Longmans Green and Company, 1911, p. xiv. Morris's notebook British Library, Add MS 45 336. **71**. Dudkiewicz, op. cit., pp. 3–18. This article considers the role and authorship of the painting of Venus at Kelmscott Manor – which Dudkiewicz argues is a collaborative work of Morris and Burne-Jones – and its relationship to the scheme of embroidered female figures for the dining room. See also Diane Waggoner, *The Beauty of Life William Morris and the Art of Design*, New York: Thames & Hudson, 2003, p. 67, for discussion of the similarity of the figure and face of St Mary Magdalene to Morris's embroidery designs for Red House. **72**. See Parry, ed., op. cit., pp. 236–8, for details of the unexecuted scheme for Ruskin and the scheme for Burne-Jones's house, 1863 and Parry, William Morris *Textiles*, op. cit., pp. 20–1. **73**. Morris, op. cit., p. xxxvii. Mackail, op. cit., p. 159. Parry, *William Morris Textiles*, 2013, p. 19. Jan Marsh, *William Morris and Red House*, London: National Trust Books, 2005, p. 52. **74**. ee Santina M. Levey, The Embroideries of Hardwick Hall: A Catalogue, London: National Trust, 2007. **75**. Watkinson, op.cit., p.12. **76**. A.R. Dufty has suggested one potential direct source: a page from a late thirteenth-century psalter, which Morris may have seen in around 1860, depicting 'the Judgement of Solomon'. The pose and dress of the upper figure is very close to that of Guenevere and has a patterned underdress which bears a marked resemblance to the dress of St Catherine. See Psalter, England, possibly London, late thirteenth-century MS M102 fol. 2r. The Morgan Library & Museum, http://ica.themorgan.org/manuscript/page/2/77025 (accessed 1 April 2017). **77**. Dudkiewicz convincingly argues that all of the female figures identified are united by being 'heroines representing different facets of love from carnal desire through romantic love to religious worship … the story of Penelope illustrates marital loyalty in the face of adversity and attention from multiple suitors, whilst Guenevere represents the weakness of giving in to an extra-marital affair. As

a victim of lust, Lucretia could only save her honour by killing herself following rape, whilst lusting after Helen's beauty brought about the Trojan War and, with it, multiple deaths. Both St Catherine of Alexandria and St Cecilia embody religious devotion, love of God and virginity; the former represents a "religious bride" who experienced a mystical wedding with Christ, whereas the latter was forced into marriage but managed to remain celibate due to her religious vows, and succeeded in converting her spouse to her faith. Mary Magdalene combines the theme of love of God with romantic love; according to apocryphal accounts, her relationship with Jesus had a physical aspect that included kissing, and according to legend she became an "apostle" after his death.' Dudkiewicz, op. cit., p. 7. **78**. Fiona MacCarthy singles out Morris's 'very forceful poetry' when he writes of the moment in which Helen, living in Troy with her new husband, the Trojan prince Deiphobus, is confronted by her first husband Menelaus who has entered Troy concealed in the Trojan horse. Menelaus kills Deiphobus in his bed and Helen is compelled to lie with Menelaus surrounded by the blood of her murdered second husband. MacCarthy describes Morris's Helen as 'ageing, saddening' and identifies that his verse focuses 'powerfully on the negation of desire, the paralysis of love, and the weirdness of the moment when sexual desire turns to violence'. MacCarthy, op. cit., p. 191. The poems on Troy were published by May Morris in the *The Collected Works of William Morris*, 1915, vol. 24. **79**. Lisa Oestreicher, Colour Matching Report, Phase 7, September 2015, p. 8. **80**. Parry, *William Morris Textiles*, op. cit., p. 20. **81**. Burne-Jones, op. cit., p. 210. **82**. British Library, Add MS 45341. **83**. Edward Burne-Jones gives an indication of the time he anticipated his smaller scale embroidery scheme for John Ruskin would demand. In this instance, the embroiderers were to be Georgiana and able schoolgirls from Winnington Hall, Cheshire. He wrote to Ruskin in 1863, 'As far as I can calculate it will take nearly a year to get all the figures ready. They are about fourteen or fifteen in number; but only half the work; for scrolls, roses, daisies and birds will more than double it.' Quoted in Dufty, op. cit., p. 29. This scheme was never realised. **84**. Burne-Jones, op. cit., p. 213. **85**. See Dudkiewicz, op. cit., p. 10, for discussion of the painting of Venus. **86**. Dufty, op. cit., p. 29. **87**. Fredeman, op. cit., p. 342, 61.5. **88**. Myers, op. cit., p. 117. This illustrates the variant of *Bough* found in the waiting room in a Dutch Tile Catalogue *c.*1870–80s. **89**. 'Making the Best of It' in *Hopes and Fears for Art*, a collection of talks given by William Morris towards the end of the 1870s. The talks were first published as a book by Ellis and White in 1882. https://www.marxists.org/archive/morris/works/1882/hopes/chapters/chapter4.htm (accessed 1 March 2017). **90**. Webb was to incorporate a 'Business Room' close to the entrance hall into his design of Standen for James and Margaret Beale. Beale used it for interviewing staff, dealing with his business correspondence and meeting callers who were not invited into the principal reception rooms. **91**. Lisa Oestreicher, Architectural Paint Analysis Report Phase 5, February 2013, p. 48. **92**. The replacement tiles are a late nineteenth-century transfer-printed sunflower design by Mintons. **93**. The inscription, 'Our content is our best having', is from *Henry VIII* by William Shakespeare and John Fletcher. Analysis of the painted surface shows that the inscription is part of the third decorative scheme for the room, which post-dates 1866. The original dark green colour devised by Morris is found beneath the later inscription. **94**. The Latin inscription 'Esto quid esse videris', which translates as 'to be what you seem to be', ties in with the inscription on the mantelpiece and the inscription 'Ars Longa Vita Brevis' found in the drawing room. The evidence of the architectural paint analysis and stylistic similarities with Charles Holme's known introductions to the house, which accentuated its neo-medieval character, have led to the dating of all three painted inscriptions to Holme's ownership of Red House of 1889–1903. **95**. Burne-Jones, op. cit., p. 211. **96**. Burne-Jones, op. cit., p. 209. **97**. Minto (ed.), op. cit., p.61. Bell Scott mistakenly refers to the dining room and the hall, but his recollection is actually of the drawing room and the table from either the hall or dining room. At this point in 1861, Bell Scott was close to completing the major work of his career: a series of ambitious paintings on canvas depicting the history of Northumbria. These were commissioned by Sir Walter Trevelyan for the hall at Wallington, Northumbria, and occupied Bell Scott from 1857–61. **98**. Ibid., p. 62. **99**. See Jan Marsh, 'The Topsaic Tapestries and Penkill Castle', *Journal of the William Morris Society*, spring 2000, pp. 35–40. Penkill was the family home of Alice Boyd, an amateur artist and Bell Scott's long-term companion and was to host summer visits from Rossetti, Morris and others in the wider Pre-Raphaelite circle. The 'Qui bien aime tard oublie' embroidered hangings, known as the 'Topsaic tapestries' designed by Morris and probably worked at Red House, hung at Penkill from 1868 to 1992. **100**. Vallance, op. cit., p. 152. Vallance's book on Morris was published in 1897 and he records of the Sir Degrevaunt pictures: 'These paintings are in a bad position for light, but they are in good hands and well cared for, having been covered with glass to ensure their thorough preservation.' At this point, the house was owned by Charles Holme, a former East-India merchant and influential businessman trading in Japanese and Indian goods and founder of *The Studio: An Illustrated Magazine of Fine and Applied Arts* in 1893. See Tessa Wild, 'More a Poem than a House', *Apollo*, April 2006, Volume CLXIII, no. 530, pp. 32–7. The inscription 'Ars Longa Vita Brevis' makes reference to Chaucer's *The Parliament of Fowls* and may be read as a reworking of Chaucer's opening line 'The lyf so short, the craft so long to lerne'. **101**. At the north end of the west wall there is one area of the slope of the ceiling where there is a break in the pattern of flowerheads and stems. There is evidence of coloured decoration, but further investigation is needed to understand if there is a change in pattern at this point or if this section was left unfinished in 1865. **102**. There is evidence of a stamped pattern applied in advance; although the decorative scheme does not appear to have followed the pattern it provided. **103**. MacCarthy, op. cit., p. 132. It was to be replaced by Morris in the 1870s with the lighter, simple foliate decoration which is still visible. **104**. In 1957, the house was lived in by two families: the Hollambys and the Macdonalds. Each family had their own set of rooms and the drawing room was the Macdonalds' sitting room. Jean Macdonald recalls that 'a few traces of stripes were exposed' when her husband David 'washed the ceiling' before repainting it white. Macdonald, op. cit., p.4. **105**. This panelling was removed to reveal the full extent of the wall painting in 2013. **106**. There are fourteen surviving manuscript versions of the poem and some

include the final roundel (line 675) being sung to the line 'Qui bien aime tard oublie'; see http://www.librarius.com/parliamentfs.htm (accessed 10 April 2017). Chaucer is believed to have composed the poem to mark the marriage of Richard II to Anne of Bohemia in 1382, and perhaps knowledge of this added to Morris's sense of the appositeness of the quotation to the spirit of the drawing room. **107**. This may have been the embroidery displayed by the Firm at the 1862 International Exhibition. Four lengths were at Penkill Castle, Ayrshire, until they were sold in 1992. Two lengths are now in the collection of the William Morris Gallery. See Jan Marsh, 'The Topsaic Tapestries and Penkill Castle', op. cit. **108**. This wall hanging from the illustration in Froissart had earlier been depicted by Morris in painted form as part of the decoration of the bed chamber in his painting *La Belle Iseult*, 1857–8. **109**. Burne-Jones, op. cit., p. 209 (fig 2.11). **110**. Godwin and Burges worked closely together and shared ideas. Godwin's executed scheme at Northampton did not include the painted draped textiles, but he continued to sketch them into town hall designs as late as 1872. See Linda Parry, 'E.W.Godwin and Textile Design', in *E.W.Godwin: Aesthetic Movement Architect and Designer*, Susan Weber Soros, ed., London : Yale University Press for the Bard Graduate Center for studies in the decorative arts, 1999, pp. 263–79. I am grateful to Linda Parry for drawing Godwin's designs for painted textiles to my attention. **111**. The Camden Society was founded in 1838 to promote the publication of the primary text of historic works. **112**. Morris's son-in-law, Henry Halliday Sparling, referred to *The Thornton Romances*, as a 'favourite of [Morris's] youth'. Quoted in Nancy Mason Bradbury, 'The Victorian Afterlife of the Thornton Romances', in *Medieval Romance and Material Culture*, Nicholas Perkins, ed., Cambridge: D.S. Brewer, 2015, p. 266. **113**. Halliwell-Phillips, James Orchard (ed.), The Thornton Romances – The Early English Metrical Romances of Perceval, Isumbras, Eglamour and Degrevant, 1844, p. 253, L. 1837–40. The Camden Society, London. **114**. This was compiled by Edmund Sedding, who, with his brother the architect John Sedding, had worked in G.E. Street's architectural practice. See MacCarthy, op. cit., p. 106. **115**. Burne-Jones, op. cit., p. 212. *Echos du Temps Passé* includes Airs, Rondeaux, Minuets and other compositions from the twelfth to eighteenth centuries. **116**. Jane Morris's book is in the William Morris Gallery. **117**. Giotto's frescoes had been published as woodcuts by the Arundel Society in 1853–60 with a commentary by Ruskin. Burne-Jones travelled to places recommended by Ruskin, with Charles Faulkner and Valentine Prinsep, for six weeks in September and October 1859. A sketchbook from this trip, containing drawings and watercolours, is in the Fitzwilliam Museum. **118**. MacCarthy writes, 'Ruskin viewed these frescos, painted in the early 14th century as prime examples of Christian art. He praised Giotto's painting as possessing an ideal simplicity and dignity, the quality he called "repose". He connected this back to classical sculpture and forward again, in an unbroken line of beauty, to the work of the Pre-Raphaelites', *The Last Pre-Raphaelite: Edward Burne-Jones and the Victorian Imagination*, London: Faber & Faber, 2012, pp. 103–4. **119**. Giotto's sequence is drawn from many sources including *The Golden Legend* by Jacobus de Voraigne, which both Burne-Jones and Morris read and revered in the English translation first printed by William Caxton. Morris's Kelmscott Press published an edition with woodcuts by Burne-Jones in 1892. **120**. There are studies in the collections of Birmingham Museum and Art Gallery, Fitzwilliam Museum, Royal Institute of British Architects, Yale Centre for British Art and a private collection. **121**. Lochnan, Schoenherr, Silver, op. cit., p. 42. **122**. Extract from a letter from Rossetti to Ford Madox Brown, Wednesday 25 July 1860. Fredeman, op. cit., 60.19, p. 303. Rossetti and Burne-Jones had made playful studies of wombats on the whitewashed windows at the Oxford Union Debating Hall in 1857 and both went on to make caricatures and drawings of wombats. In 1869, Rossetti acquired the first of two short-lived wombats, which he named 'Top' in a satirical swipe at Morris, who was familiarly known as 'Topsy', after the character in *Uncle Tom's Cabin* by Harriet Beecher Stowe. Topsy's comment 'Spect I growed' was the basis for the saying 'grew like Topsy' which was initially applied to Morris because of his increasing girth. I am indebted to James Breslin who was the first to identify the sleeping 'dog' as a wombat in 2012. **123**. Burne-Jones, op. cit., p. 213. **124**. Catherine Hassall, The Drawing Room Wall Paintings, report no. B062, March 2013, pp. 1 and 6. **125**. Ibid. Hassall suggests that another painter was involved due to the distinct variation in technique. Vallance, records: 'Morris himself also somewhat contributing to the decorative work, of which, however, the more important share was necessarily that undertaken by Burne-Jones', op. cit., p. 52. **126**. Vallance, ibid., p. 52. **127**. In 1898, Joseph Jacobs recounted that he had heard Burne-Jones 'repeat line after line of such an out of the way book as the *Thornton Romances*'. Quoted Perkins, ed., op. cit., p. 265. **128**. Burne-Jones, op. cit., pp. 213–4. **129**. There is a possibility that Rossetti is referring not to the *Sir Degrevaunt* wall paintings but the wall painting in the principal bedroom. **130**. Fredeman, op. cit., 60.36, p. 315. **131**. Fredeman, op. cit., 60.36, p. 316. **132**. Laura Jane Friswell, 1898, quoted in Malcolm Youngs, ed., *Stories from the Newsletters: William Morris, his family and friends: Other People: The House: The Vicinity*, The Friends of Red House 2015, p. 11. **133**. Ibid. **134**. The first battens were removed in 2012. **135**. Halliwell-Phillips, op. cit, p.253, lines 1825–36. **136**. Mackail, op. cit., p.143. The settle was fitted into position after the wall decoration, including the three *Sir Degrevaunt* pictures had been executed. The wall behind the settle is bare plaster, except for the continuation of a horizontal band of grey paint which marks the upper section of the *Sir Degrevaunt* paintings. Catherine Hassall, The Drawing Room Wall Paintings, report no. BO62, March 2013, p. 2. **137**. Kirkham, op. cit., p. 26. **138**. The 1866 Sales Particular for Red House records that on the first floor 'There is access ... to the High-pitched Roof above the Joists, forming a capital Store Room for Fruit, or could be made into an excellent Lumber Room.' N. Kelvin, ed., vol. I, op. cit., p. 43. **139**. Burne-Jones, op. cit., p. 209. **140**. Burne-Jones, op. cit., p. 210. **141**. ossetti wrote of his own watercolour, *Giotto painting the portrait of Dante*, 1854, that it depicts 'all the influence of Dante's youth – Art, Friendship and Love – with a real incident embodying them'. Fredeman, op. cit., vol. I, p. 224. **142**. Lochnan, Schoenherr, Silver, op. cit., p. 105. **143**. Rossetti to William Allingham, 18 December 1856. Fredeman, op. cit., 56.59, p. 149. **144**. Rossetti to Ford Madox Brown, 22 June 1859. Fredeman, op. cit., p. 259. **145**. The subject and composition of the two panels draws

on a pen and ink study of the two meetings that Rossetti had made in 1849–50. It is in the Harvard Art Museums/ Fogg Museum, Bequest of Grenville L. Winthrop. Rossetti appears to have returned to this drawing in 1863 for inspiration for the carved frame he designed when the two panels were sold as a diptych to the dealer Ernest Gambart. **146**. Lochnan, Schoenherr, Silver, op. cit., p. 104. **147**. Rossetti to William Bell Scott, 7 December 1860. Fredeman, op. cit., p. 335. **148**. Leslie Parris, ed., *The Pre-Raphaelites*, London: Tate Gallery, 1994, p. 179. **149**. Ibid. **150**. Lochnan, Schoenherr, Silver, op. cit., p. 206. **151**. Pers. comm. from Stephen Gritt, Chief Conservator, National Gallery of Canada, 27 February 2017. **152**. More detailed physical analysis is likely to be undertaken of the settle itself and this may reveal evidence of hinge points and earlier fixings. The settle has been subject to subsequent alteration though, with the addition of two replacement doors to the outer cupboards on the upper register, visible in photographs of c.1890–1902, and later repositioned on the lower register in the twentieth century. **153**. Burne-Jones, op. cit., p. 209. **154**. Burne-Jones, op. cit., p. 211. **155**. Pers. comm. from Stephen Gritt, Chief Conservator, National Gallery of Canada, 27 February 2017. **156**. Morris told the tale in his epic poem *The Story in Sigurd the Volsung*, 1876, and it was also the source for Wagner's *Der Ring Des Nibelungen*, which was first performed as a complete cycle in 1876. **157**. Quoted in handwritten manuscript of recollections by an 'Anonymous Visitor, 1863'. The manuscript is contained in Charles Holme's photograph album, c.1889–1902. **158**. There is no corresponding entry for a sofa designed by Webb at this time. **159**. These had been replaced with the present leaded lights by 1897. **160**. Jane Davies Conservation, Red House: Drawing Room, window alcove, uncovering and sample analysis Report, September 2015, p. 2. **161**. N. Kelvin, ed., vol. I, op. cit., p. 43. **162**. Morris, op. cit., p. 12. **163**. *Sir Degrevaunt*, lines 1442 and 1450. **164**. See W.A. Davenport, 'Sir Degrevant and Composite Romance', in Judith Weiss; Jennifer Fellows; Morgan Dickson, *Medieval Insular Romance: Translation and Innovation*, Cambridge: Boydell & Brewer, 2000, pp. 111–34. Longthorpe Tower, Cambridgeshire is in the care of English Heritage. **165**. In 2003, a fragment of wall painting in a degraded state was discovered hidden behind a wardrobe constructed in around 1957. A section of the wardrobe was removed to reveal intriguing male and female figures in medieval costume with a ladder or a sword and a scroll with a largely indecipherable script at the foot of the wall. The few decipherable words suggested a biblical source for the text, but it did not read consecutively. The fragmentary painting was left exposed and shown to visitors framed by the wardrobe doors. In 2013, a comprehensive programme of investigation of the adjoining walls for evidence of painted decoration, revealed that there was a much more extensive wall painting of five figures and four trees which spanned the section of wall from the door frame to the return of the wall. The surviving painting was painstakingly uncovered by specialist conservators, who removed the later layers of wallpaper and paint which overlay the figures of Adam, Eve and Noah. Prior to conservation treatment, the wall painting was in a parlous state, with areas of abrasion from preparation of the walls for subsequent decorative schemes. The abrasion of the paint surface revealed the preparatory layers, giving the painting an unevenness of tone. Originally, the plaster was prepared with a thin greenish wash of carbon black and yellow ochre in most areas and then a wash of lead white with some red lead. Fragments of the underdrawing are visible in areas of damage to the upper paint layer. Overall, the limited number of paint layers suggests that the design was carefully planned and little altered in execution (in contrast to the Sir Degrevaunt wall paintings, where significant alterations were made during the painting of the pictures). Nonetheless, areas of the painting were left in an unfinished state or untidy state, notably the splashes of flesh-coloured paint on the grassy lawn, the long drip of blue paint on the empty red scroll beneath Adam and Eve. The wall painting has been conserved and areas of loss have been touched in with watercolour paints (which are reversible) to enable a clearer reading of the overall effect of the damaged painting. The conservation treatment and uncovering work was undertaken by Tobit Curteis Associates LLP. **166**. Morris may well have known works like the thirteenth-century 'simulated silk hangings' at St Peter, Wickham Bishops, Essex. See Roger Rosewell, *Medieval Wall Paintings*, London: Shire Editions 2014, p. 16. **167**. In the pervading spirit of the house, this was a collaborative effort. I would particularly like to thank James Breslin, former House Manager at Red House and Jan Marsh for the lively discussions and excitement we shared in the discovery. To his credit, James Breslin also pinned down the source of the biblical verses overnight with the help of a Red House Facebook follower in the USA. **168**. I am grateful to Jan Marsh for her suggestions of contemporaneous or later stained glass commissions by the Firm connected to the five figures in the wall painting. **169**. Quoted in Jan Marsh, *The Legend of Elizabeth Siddal*, London: Quartet Books, 2010 (2nd edn.), pp. 114–15. **170**. The watercolour of *Lady Clare* is in a private collection. For more details and an illustration see Barringer, Rosenfeld, Smith, *Pre-Raphaelites Victorian Avant-Garde*, 2012, pp. 73–4. **171**. *Study of Elizabeth Siddal as Rachel*, c.1855, pencil on paper, Dante Gabriel Rossetti, Birmingham Museums and Art Gallery. Julian Treuherz, Elizabeth Prettejohn, Edwin Becker, *Dante Gabriel Rossetti*, London: Thames and Hudson, 2003, pp. 153–4. **172**. Ibid., p. 159. 'Ruskin was encouraging Rossetti at this period to attempt more elevated subjects, with religious or spiritual rather than romantic implications.' *Dante's Vision of Rachel and Leah*, 1855, Dante Gabriel Rossetti, Tate. **173**. Burne-Jones quoted in Parry, op. cit., p. 156. **174**. Webb quoted in Lethaby, op. cit., p. 21. The Hogarth Club was founded by members and followers of the Pre-Raphaelite Brotherhood in 1858, as a place to meet and to exhibit their works. Named after William Hogarth, the club served an important role for like-minded artistic and non-artistic members until it was dissolved in December 1861. Among the artistic members were Holman Hunt, Rossetti, Ford Madox Brown, Burne-Jones, Morris, Webb and Burges; among the non-artistic members were Cormell Price, the collector Thomas Combe and Webb's important early patron, Colonel Gillum, for whom he designed 91–101 Worship Street, London in 1861. See Deborah Cherry, 'The Hogarth Club: 1858–61', *Burlington Magazine*, 122, no. 925 (April 1980), pp. 237–44. **175**. Lethaby, op. cit., p. 21. **176**. Christian has suggested that this word association between the object to be decorated and the text of the poem would have appealed to Burne-Jones. Stephen Wildman and John Christian, *Edward Burne-Jones: Victorian*

Artist-Dreamer, New York: Abrams, 1998, p. 128. **177**. This work is in the Delaware Art Museum (1935–41). **178**. Geoffrey Chaucer, lines 453–9, in Prologue of *The Prioress's Tale*, Larry D. Benson, ed., *The Riverside Chaucer* (3rd edn.), Oxford: Oxford University Press, 1987, p. 209. **179**. *The Prioress's Tale* (lines 453–9), interlinear translation: https://sites.fas.harvard.edu/~chaucer/teachslf/pri-par.htm (accessed 10 April 2017). **180**. Barringer, Rosenfield, Smith, op. cit., p. 79. **181**. Parry, ed., 1996, op. cit., p. 167, cites the close stylistic resemblance to the Ladies and Animals Sideboard, c.1860, by Burne-Jones (V&A, w.10-1953). **182**. May Morris records that a sketch in Morris's notebook, inscribed 'Hangings for best bedroom' are part of the 'jottings of what must be Red House decoration'. May Morris, op. cit., p. 394. The notebook is dated 1862 but was used prior to this date, British Library, Add MS 45336. **183**. These are at Kelmscott Manor, Oxfordshire. **184**. British Library, Add MS 45341, ff. 91–110 Jane Morris, wife of William Morris: Letters to her daughter, May: 1901–1912, n.d. **185**. Parry, ed., op. cit., p. 236. **186**. Jennifer Harris makes the attribution to Webb in 'Jane Morris's Jewellery Casket', *The Antique Collector* 12 (1984), pp. 68–71. **187**. Two examples of this mirror in differing sizes survive in the collection at Kelmscott Manor. One is recorded in May Morris's memorandum of 1936 as being from Red House, but it is not clear which of the two sizes she had identified. Parry, op. cit., p. 174. **188**. Treuherz, Prettejohn and Becker, op. cit., p. 227. The St Ursula Shrine, Hans Memling, 1489, is a carved and gilded wooden reliquary with oil on panel inserts by Memling, depicting the life of the Breton princess and martyr Ursula (as recounted in Jacobus de Voraigne's, *The Golden Legend*). **189**. May Morris's *Memorandum* records that the jewel casket belonged to her mother and was painted by Rossetti and Siddal. **190**. Paul Acker has proposed that Elizabeth Siddal knew a watercolour facsimile of f.376r painted c.1850–60 by the artist Frederick Sandys, on which she based the central panel painting. Sandys's watercolour is entitled 'Scene from a fifteenth century Illuminated Manuscript' and is in Birmingham Museum and Art Gallery. Paul Acker, 'Elizabeth Siddal's Jewelry Box for Jane Morris', William Morris Society in the United States Newsletter, January 2013, pp. 5–6. http://www.academia.edu/13180708/ELIZABETH_SIDDAL_S_JEWELRY_BOX_FOR_JANE_MORRIS (accessed 1 June 2017). **191**. British Library, MS Harley 4431. For the digital facsimile see http://www.bl.uk/manuscripts/Viewer.aspx?ref=harley_ms_4431_f132r (accessed 1 June 2017). **192**. As Sarah Rutherford has observed, the upper floor of the house originally had long views. She writes: 'A further crucial element of the original character of the site which has been lost is the visual connection of the site with the wider landscape, via views over the surrounding country, particularly from the upper storey of the house across the garden … The main remaining view out of the site is a winter glimpse southwards from the upper corridor and Morris's studio across the well-court and east lawn, to the distant North Downs, and this is greatly limited by boundary trees and shrubs.' Sarah Rutherford, *Red House Historic Garden Survey*, April 2004, unpublished report, p. 14. **193**. Macdonald, op. cit., p. 7. **194**. Burne-Jones, op. cit., p. 211. **195**. Morris opened an account with Robersons in 1857. From 1859 onwards, his address is given as Red House, Upton, nr Bexley and he is being supplied with colours, brushes, canvases amongst other equipment. HKI MS 104-1993 Petty Ledger E 1858–62, William Morris fo. 19, Roberson Archive, Hamilton Kerr Institute, Cambridge. **196**. A photograph of the interior of May Morris's house, 8 Hammersmith Terrace, in the collection of the Emery Walker Trust, 7 Hammersmith Terrace, London; shows a set of Burgkmair engravings hanging on a wall. **197**. Lochnan, Schoenherr, Silver, op. cit., p. 264. **198**. Kelvin, op. cit., p. 31. **199**. The three panels of leaded quarries of plants and birds that are reputed to have come from the nursery at Red House are in the Fitzwilliam Museum, the Victoria and Albert Museum and a private collection. For the respective stained glass panel in the V&A see https://collections.vam.ac.uk/item/O8356/panel-webb-philip-speakman/ (accessed 10 June 2017); in the Fitzwilliam Museum see http://webapps.fitzmuseum.cam.ac.uk/explorer/index.php?qu=philip%20webb%20stained%20glass&oid=28089 (accessed 10 June 2017); in a private collection in Ottawa see Lochnan, Schoenherr, Silver, op. cit., pp. 118–9. A single quarry of a bird (possibly a magpie or a jackdaw) with the same reputed Red House origin was in the sale of *The John Scott Collection Architect-Designers From Pugin to Voysey*, The Fine Art Society, volume eight, 2015, p. 91. http://thefineartsociety.com/usr/documents/exhibitions/list_of_works_url/36/architect-designers-catalogue-10mb-file.pdf (accessed 10 June 2017). **200**. A further explanation might be that not all the extant quarries were made for the nursery passage at Red House. A photograph dated 1962, showing the interior of the artist John Roddam Spencer Stanhope's house, Sandroyd, which was designed for him by Webb in 1860 and constructed from 1860–61, depicts six panels each of six quarries. The quarries include Spencer Stanhope's motto (in a very similar form to Morris's 'si je puis'), a coat of arms, birds (a cock, a duck, a hen and chick, a flying duck), and two stylised plant designs, one of which is a daisy-like flower. The house caught fire in the 1950s and has been altered internally, losing its original fittings, so it is possible that some of the extant quarries with a Red House attribution may in fact derive from Sandroyd. For further details on Sandroyd and a picture of the quarries in situ, see Kirk, op. cit., pp. 66–9. The William Morris Society also holds a collection of broken quarries from Sandroyd (twenty-six of the original thirty-six quarries) which were rescued from outside the house during demolition works by Ronald Briggs, then Secretary of the William Morris Society. A panel of six conserved quarries is on display at the William Morris Society, Kelmscott House, Hammersmith. I am grateful to Helen Elletson for details of Ronald Briggs' actions. **201**. The 1927 sales particulars for the house relate that the Oak Room and Blue Room (as the two bedrooms on the west side were known in the 1920s) have ceilings 'decorated in pierced design', the detail of which has been lost. 'Illustrated Particulars and Condition of Sale of the Freehold Property known as Red House, Upton, Bexley Heath', 1927, p. 15, National Trust Archive, Red House. **202**. Myers, op. cit., p. 10. **203**. Morris, *Memorandum*, op. cit. **204**.The Society of Antiquaries copy of Hobbs & Chambers 1939 Inventory of the remaining contents of Kelmscott Manor includes the annotation 'made into two beds', which suggests this was done after the inventory was made in 1939. **205**. See Parry, ed., op. cit., p. 168. **206**. The paint analysis report undertaken by Lisa Oestreicher records that: 'The findings relating to the wall surfaces are complex and at times confusing. The

walls appear to have initially been prepared with a coat of clear varnish. Above this layer, the initial blue-green decoration noted on the chimneybreast was also identified on the east wall immediately above the skirting and the north wall at high level. However, it does not appear on the other wall areas sampled in the room. Instead – on the south wall at low height, the west wall at mid height, the east wall below the door lintel and above the skirting – red paint layers can be seen finished coat of red pigmented varnish.' Red House Architectural Paint Analysis Report, Phase 6, September 2013, pp. 25–6. **207**. Building Contract, op. cit., p. 17 and p. 3. **208**. Youngs, ed., op. cit., p. 10.

FIVE | THE GARDEN

1. William Morris, *Prose and Poetry (1856–1870)*, Oxford: Oxford University Press, 1920, p. 287, verses 1–2. **2**. Quoted in a letter of 15 September 1883 to Andreas Scheu, an Austrian socialist and furniture designer, whom Morris knew through the Democratic Federation. Poulson, ed., op. cit., p. 29. **3**. Quoted in MacCarthy, op. cit., p. 9. The Horticultural Society Gardens, later the Royal Horticultural Society, was founded in 1804 and had a thirty-three acre garden comprising 'hot-house, arboretum, kitchen-garden and orchard departments' on the banks of the River Thames at Chiswick. **4**. For more detail on Webb's early influences, see Kirk, op. cit., p. 10. **5**. Burne-Jones, op. cit., p. 211. **6**. Burne-Jones, op. cit., p. 212. Although Georgiana mentions four square gardens, only three have been identified on the detailed Ordnance Survey map. **7**. Sarah Rutherford, Red House - Historic Garden Survey, unpublished, 2004, p. 28. The Bodleian Library had acquired and catalogued the Douce manuscripts, of which the *Roman de la Rose* was part, in 1840. **8**. 'Flower gardens' are annotated in this position on Webb's sketch plan, c.1859 (V&A, E.58-1916). **8**. Burne-Jones, op. cit., pp. 208–9. **10**. Quoted in Vallance, op. cit., p. 49. Jan Marsh has suggested that the recollection was that of George Campfield, a glass painter who worked for the Firm from 1861. Marsh, op. cit., p. 97. **11**. William Morris, op. cit., 'The Story of the Unknown Church', p. 5. **12**. Burne-Jones, op. cit., pp. 225–6. **13**. Burne-Jones, op. cit., p. 212. **14**. Geoffrey Chaucer, *The Canterbury Tales*, 'The Merchant's Tale', line 2036, in Benson, ed., op cit., p. 163. **15**. May Morris, op. cit., pp. 394–5. The notebook, dated 1862 but used prior to this date, is in the British Library, Add MS 45336. The sketch of the dog kennel to which May Morris refers appears to be the one on p. 12. **16**. May Morris, op. cit., p. 395. **17**. Kelvin, op. cit., p. 31. **18**. http://morrisedition.lib.uiowa.edu/jason-bookxiii.html (accessed 10 January 2017). *The Life and Death of Jason*, William Morris. Book XIII, Medea receives counsel from Circe, lines 125–32. **19**. 'William Morris, 'Making the Best of It' in Poulson, op. cit., pp. 97–8. **20**. Mackail, op. cit., p. 143. **21**. Lethaby, op. cit., p. 28. MacCarthy, op. cit., p. 165. **22**. Burne-Jones, op. cit., p. 307. **23**. Baker, op. cit., p. 58. **24**. Burne-Jones, op. cit., p. 86.

SIX | THE FIRM

1. Poulson, ed., op. cit., pp. 22–3. **2**. Quoted in a letter of 15 September 1883 to Andreas Scheu. Poulson, ed., op. cit., p. 29. **3**. Michael Hall, *George Frederick Bodley and the Later Gothic Revival in Britain and America*, 2014, p. 461, note 106: 'The letter is lost, but its existence is recorded in the notes that J.W. Mackail made for his 1899 biography of Morris, which are in the archive of the William Morris Gallery, Walthamstow: "14 Dec 1860 to Madox Brown – as to Bodley being one of the firm".' **4**. Harrison notes that 'Rossetti and Marshall provided a limited number of designs until 1863, but subsequently figure cartoons were divided between Burne-Jones, Morris and Ford Madox Brown.' Martin Harrison, 'Church Decoration and Stained Glass' in Parry, ed., op. cit., p. 106. **5**. MacCarthy, op. cit., p. 167. **6**. Rossetti to William Allingham, c. 20 January 1861. Fredeman, op. cit., 61.5, p. 25. **7**. Poulson, op. cit., p. 25. **8**. The loan of £100 from his mother is noted in MacCarthy (op. cit., p. 166). The deeds for Red House record that a 'Mortgage for Securing £500 and further advances and interest' was taken out between Morris and his mother, Emma on 28 August 1862. A further undated advance of £300 to Morris is recorded on the same legal document. Red House Deeds, William Morris Society Archive, London. These not inconsiderable sums suggest that Morris was further investing in the Firm in 1862. **9**. Parry, ed., op. cit., p. 106. **10**. Lethaby, op. cit., p. 41. **11**. The main staircase in 1962 with stained glass panel is illustrated in Kirk, op. cit., p. 68. **12**. Quoted in Myers, op. cit., p. 25. **13**. Poulson, ed., op. cit., p. 23. **14**. Quoted in MacCarthy, op. cit., p. 169. **15**. Ibid p. 180. **16**. Rossetti to Charles Eliot Norton, 9 January 1862. Fredeman, op. cit., 62.3, p. 441. **17**. Quoted in Collard, 'Furniture', in Parry, ed., op. cit., p. 172. **18**. Both Webb and Morris were aware of the synthesis William Burges achieved between form and decoration in the Yatman cabinet of 1858. V&A, CIRC.217:1, 2-1961. **19**. Morris's preliminary drawings for the painted scenes are in the Victoria and Albert Museum, E.2787-1927 to E.2790-1927. **20**. Theophilus's text was published in 1847 by John Murray as *An Essay upon Various Arts*. **21**. The Yatman Cabinet, designed by William Burges and made by Harland and Fisher, with painted scenes by Edward Poynter, 1858. **22**. MacCarthy, op. cit., p. 181. **23**. See Myers, op. cit., p. 29, fig. 53, for an illustration of the bedroom fireplace at The Hill, Witley, with figure tiles of Love and Fate/Fortune, c.1863. **24**. In *The Sleeping Beauty* tile panel, the room in which the prince awakens the sleeping princess shows two variants on Red House decoration. See Myers, op. cit., p. 53, fig. 21c, for an illustration of the tile scene in situ at The Hill, Witley. **25**. Martin Harrison makes this dual attribution in 'Church Decoration and Stained Glass', in Parry, ed., op. cit., p. 119: 'In one of the firm's photographic albums an almost identical design is catalogued under Morris; significantly the alternative version is bordered with Morris's 'si je puis' motto. The date of Morris's *Trellis* wallpaper, 1862, corresponds exactly with the trellis background in this design.' **26**. Burne-Jones, op. cit., p. 277.

SEVEN | RELINQUISHING RED HOUSE

1. Burne-Jones, op. cit., p. 277. **2**. Ibid., pp. 277–9. **3**. The Firm was working on stained glass for All Saints, Cambridge for G.F. Bodley. **4**. Webb designed most of the decoration for St Philip's, Bethnal Green, which was undertaken in 1864. **5**. He was working on an extension to Cranmer Hall, Norfolk. Letter from Philip Webb to William Morris, 18 November 1864, National Trust Archive, Red House. **6**. Burne-Jones, op. cit., p. 283. **7**. Ibid. **8**. John Roddam Spencer Stanhope, fellow artist and friend. **9**. Quoted in Burne-Jones, op. cit., pp. 283–4. **10**. Burne-Jones, op. cit., p. 277. **11**. Ibid., p. 294. **12**. Georgiana recorded that the Queen Square house 'had been made to shine with whitewash and white paint, a background that shewed (sic) better than any other the beautiful fabrics with which the house was furnished. Yet nothing ever made it a home like the one they had left.' Ibid, pp. 298–9. **13**. It was not in fact sold until the following year, 1866. **14**. Burne-Jones, op. cit., p. 294. **15**. Fredeman, op. cit., p. 31. **16**. Mackail, op. cit., p. 165. **17**. Interestingly, the only item of fixed furniture that the sales particulars mention is the dining room's 'commodious Cupboard and Cellaret' (Webb's dresser). All the other pieces – from the drawing room settle to the bedroom wardrobes – were ultimately included in the sale. **18**. Marion Heathcote, 1946, quoted in Christie's Sale Catalogue, Auction 29 October 1997, 'The Rossetti Chairs', p. 32. 'The Arming of a Knight' chair and 'Guendolen's Golden Hair' chair remained in her family's ownership until 1997. **19**. Burne-Jones, op. cit., p. 286. **20**. Mackail, op. cit., p. 165. **21**. Quoted in Frances Horner, *Time Remembered*, London: Heineman, 1933, p. 14.

EIGHT | RED HOUSE AFTER MORRIS

1. Quoted in Michael Hall, 'Red House Bexleyheath, London', *Country Life*, July 10, 2003, p 67. Walburga Paget visited Red House in 1903, with her friend Madeline Wyndham, who lived at Clouds, Wiltshire, which Webb had designed for her and her husband, the Hon. Percy Wyndham, in 1877–80. Their journey took the form of an artistic pilgrimage to see Webb's first house and Morris's former home. **2**. See Ann Brothers, *A Studio Portrait: The Marketing of Art and Taste 1893–1918*, Melbourne: University of Melbourne, 1993. **3**. See Toni Huberman, Sonia Ashmore, Yasuko Suga, eds, *The Diary of Charles Holme's 1889 Visit to Japan and North America*, Folkestone: Global Oriental, 2008. **4**. 'The Red House' photograph album collated by Holme was given to the National Trust by the children of Edmund Penning-Rowsell in June 2003. Penning-Rowsell (1913–2002) was a publisher, author and journalist who worked as the wine correspondent of *The Financial Times* for many years. An ardent admirer of Morris, he was one of the founding members of the William Morris Society in 1955. He was given the album by Charles Holme's youngest daughter, Gwendolen, when he was working for Studio Books, an offshoot of *The Studio* magazine in 1962. **5**. See Tessa Wild, 'More a Poem than a House', *Apollo*, April 2006, pp. 32–7, and Sonia Ashmore and Yasuko Suga, 'Red House and Asia: A House and its Heritage', *Journal of William Morris Studies*, winter 2006, pp. 5–26. **6**. British Library, Add MS 45345, vol. VIII (ff. 288), f. 186. Letter from Charles Holme to William Morris, 1890. **7**. See Olive Mercer and Jane Evans, 'The Glazed Screen at Red House', *Journal of William Morris Studies*, summer 2008, pp. 33–51. **8**. For instance, he commented on the glazing which protected the wall paintings in the drawing room from light damage and noted the painted patterns on the inside face of the cupboard doors of the hall settle. **9**. Burne-Jones, op. cit., p. 310. **10**. Vallance, op. cit., p. 44. **11**. Hermann Muthesius, *The English House*, translated by Janet Seligman and Stewart Spencer, London: Frances Lincoln Limited, 2007, vol. 1, p. 106. **12**. Ibid. **13**. Nicholas Cooper, 'Red House: Some Architectural Histories', *Architectural History*, vol. 49 (2006), pp. 207–221. **14**. See Jan Marsh, op. cit., pp. 117–47, for a detailed account of the twentieth-century history of the house. **15**. 'Life is short but art endures', the motto introduced above the fireplace in the drawing room, probably by Charles Holme in fitting homage to Morris.

Select bibliography

ARCHIVES

British Library Add MS 45336, Notebook c.1859–1861, vol. XLII (ff.47). Sketches, drawings, plans, and notes connected to Red House and the designing and artistic work of Morris, Marshall, Faulkner & Co., 1861. Add MS 45341, Notes by Jane Morris; Add MS 45345, vol. VIII (ff.288) f.186 Charles Holme's letter to William Morris, 1890. Add MS 45298–45337, William Morris Literary Manuscripts, the May Morris Bequest.

National Trust, Red House Philip Webb, Building Contract, 1859. Charles Holme, photograph album, c.1889–1902, Containing the handwritten manuscript of the recollections of an 'Anonymous Visitor in 1863'. Jean Macdonald, Typescript 'Red House After Morris', 2003.

Victoria and Albert Museum National Art Library: 86.ss.57, Collection of letters from Warrington Taylor to Philip Webb, 1915. Archive of Art and Design: Philip Webb Records, AAD/2014/5. Prints, Drawings & Paintings Collection: E.58-1916–E.71-1916, Designs for Red House, Upton, Bexleyheath, by Philip Webb, 1859 and for unexecuted extension, 1864.

William Morris Gallery J.W. Mackail Notebooks, vol. I.

William Morris Society Red House Deeds.

PUBLICATIONS

Aplin, John (ed.), *The Letters of Philip Webb*, London: Routledge, 2016, 4 vols. Atterbury, Paul, and Wainwright, Clive, *Pugin: A Gothic Passion*, London: Yale University Press in association with the Victoria & Albert Museum, 1994. Banham, Joanna and Harris, Jennifer (eds.), *William Morris and the Middle Ages*, Manchester: Manchester University Press, 1984. Baker, Derek, *The Flowers of William Morris*, London: Barn Elms Publishing, 1996. Barringer, Tim and Rosenfeld, Jason and Smith, Alison, *Pre-Raphaelites Victorian Avant-Garde*, London: Tate Publishing, 2012. Bennett, Mary, *Ford Madox Brown A Catalogue Raisonné*, New Haven: Yale University Press, 2010, 2 vols. Bennett, Phillippa, *The Last Romances and the Kelmscott Press*, London: William Morris Society, 2009. Benson, Larry D. (ed.), *The Riverside Chaucer* (3rd edition,), Oxford: Oxford University Press, 1987. Bradbury, Nancy Mason, 'The Victorian Afterlife of the Thornton Romances', in *Medieval Romance and Material Culture*, Nicholas Perkins (ed.), Cambridge: D.S. Brewer, 2015. Burne-Jones, Georgiana, Memorials of Edward Burne-Jones, London: Macmillan, 1904. Cherry, Deborah, 'The Hogarth Club: 1858–61', *Burlington Magazine*, 122, no. 925 (April 1980), pp. 237–44. Crook, J. Mordaunt, *William Burges and the High Victorian Dream*, London: revised Frances Lincoln edition, 2013. Dudkiewicz, Julia, 'Kelmscott Manor Venus and Morris's Idea for a "House of Love" at Red House', in *Useful and Beautiful*, William Morris Society in the United States, Winter 2016.1, pp. 3–15. Dufty, A.R., *Morris Embroideries: The Prototypes*, London: Society of Antiquaries, 1985. Ellwood, Giles, 'Three Tables by Philip Webb', *Furniture History* 32, 1996, pp. 127–39. Fredeman, William E. (ed.), *The Correspondence of Dante Gabriel Rossetti*, 9 vols, Woodbridge: D.S. Brewer, 2002–10. Gere, Charlotte, *Nineteenth-century Decoration: the Art of the Interior*, London: Weidenfeld and Nicolson, 1989. Hall, Michael, 'Penkill Castle, Ayrshire', *Country Life*, March 21 1991, pp. 116–121. Hall, Michael, *George Frederick Bodley and the Later Gothic Revival in Britain and America*, London: Yale University Press, 2014. Hall, Michael, 'Butterfield's Houses' in *The Victorian Society Studies in Architecture and Design Volume 6: Butterfield Revisited*, ed. Peter Howell and Andrew Saint, London: The Victorian Society, 2017. Halliwell-Phillips, James Orchard (ed.), *The Thornton Romances – The Early English Metrical Romances of Perceval, Isumbras, Eglamour and Degrevant*, 1844. The Camden Society, London. Helsinger, Elizabeth K., *Poetry and the Pre-Raphaelite Arts: Dante Gabriel Rossetti and William Morris*, New Haven: Yale University Press, 2008. Hollamby, Edward, *Red House : Bexleyheath 1859: Architect: Philip Webb*, London: Architecture Design and Technology Press, 1991. Horner, Frances, *Time Remembered*, London: Heineman, 1933. Kelvin, Norman (ed.), *The Collected Letters of William Morris*, Princeton: Princeton University Press, 1984–1996. Kirk, Sheila, *Philip Webb Pioneer of Arts & Crafts Architecture*, Chichester: Wiley Academy, 2005. Kirkham, Pat, 'William Morris's Early Furniture', *Journal of the William Morris Society*, vol. IV, no. 3 (spring 1981), pp 25–8. Lethaby, W.R., *Philip Webb and His Work*, London: Oxford Union Press, 1935. Levey, Santina M., The Embroideries of Hardwick Hall: A Catalogue, London: National Trust, 2007. Lochnan, Katharine A. and Schoenherr, Douglas E. and Silver, Carole, *The Earthly Paradise, Arts and Crafts by William Morris and his Circle from Canadian Collections*, Toronto: Key Porter Books Limited, 1993. MacCarthy, Fiona, *William Morris: A Life for Our Time*, London: Faber and Faber, 1994. MacCarthy, Fiona, *The Last Pre-Raphaelite: Edward Burne-Jones and the Victorian Imagination*, London: Faber & Faber, 2012. Mackail, John William, *The Life of William Morris*, London: Longmans Green & Co., 1899 (two volumes bound as one). Marsh, Jan, *Jane and May Morris : A Biographical Story, 1839–1938*, London: Pandora,1986. Marsh, Jan, *The Legend of Elizabeth Siddal*, London: Quartet Books, 1989. Marsh, Jan, 'The Topsaic Tapestries and Penkill Castle', *Journal of the William Morris Society*, spring 2000, pp. 35–40. Marsh, Jan, National Portrait Gallery Insights: *The Pre-Raphaelite Circle*, London: National Portrait Gallery Publications, 2005. Marsh, Jan, *William Morris and Red House*, London : National Trust, 2005. Miele, Chris (ed.), *William Morris on Architecture*, Sheffield: Sheffield Academic Press, 1996. Minto, W. (ed.), *Autobiographical Notes on the Life of William Bell Scott and notices of his artistic and poetic circle of friends 1830–1882*, London 1892, vol. II. May Morris

(ed.), *The Collected Works of William Morris*, 24 vols, London: Longmans Green and Company, 1910–15. Morris, May, *William Morris: Artist, Writer Socialist*, vol. 1, Oxford: Basil Blackwell, 1936. Morris, William, *Prose and Poetry (1856–1870)*, Oxford: Oxford University Press, 1920. Muthesius, Hermann, *The English House*, edited by Dennis Sharp; translated by Janet Seligman and Stewart Spencer, first complete English edition, London: Frances Lincoln, 2007. Muthesius, Stefan, *The Poetic Home: Designing the 19th-Century Domestic Interior*, London: Thames & Hudson, 2009. Myers, Richard and Hilary, *William Morris Tiles*, Shepton Beauchamp: Richard Dennis, 1996. Naylor, Gillian (ed.), *William Morris by Himself: Designs and Writings*, London: Time Warner Books, 2004. Oledzka, Eva, *Medieval & Renaissance Interiors in Illuminated Manuscripts*, London: The British Library, 2016. Parris, Leslie (ed.), *The Pre-Raphaelites*, London: Tate Gallery, 1994. Parry, Linda (ed.), *William Morris*, Victoria and Albert Museum, London: Philip Wilson Publishers in association with the Victoria and Albert Museum, 1996. Parry, Linda, 'E.W. Godwin and Textile Design', in *E.W. Godwin: Aesthetic Movement Architect and Designer*, Susan Weber Soros (ed.), London: Yale University Press for the Bard Graduate Center for Studies in the Decorative Arts, 1999. Parry, Linda, *William Morris Textiles*, London: V&A Publishing, 2013. Peterson, William S. (ed.), *The Ideal Book: Essays and Lectures on the Arts of the Book*, London: University of California Press, 1982. Prettejohn, Elizabeth, *The Cambridge Companion to the Pre-Raphaelites*, Cambridge: Cambridge University Press, 2012. Poulson, Christine (ed.), *William Morris on Art and Design*, Sheffield: Sheffield Academic Press, 1996. Poulson, Christine, *The Quest for the Grail: Arthurian Legend in British Art, 1840–1920*, Manchester: Manchester University Press, 1999. Roberts, Leonard, *Arthur Hughes: His Life and Works: A Catalogue Raisonné*, Woodbridge: Antique Collectors Club, 1997. Rosewell, Roger, *Medieval Wall Paintings in English and Welsh Churches*, Woodbridge: Boydell & Brewer, 2008. Rosewell, Roger, *Medieval Wall Paintings*, London: Shire Editions 2014. Sharp, Frank C. and Marsh, Jan, *The Collected Letters of Jane Morris*, Woodbridge: The Boydell Press, 2012. Thirkell, Angela, *Three Houses*, London: Allison & Busby, 2012. Treuherz, Julian and Prettejohn, Elizabeth and Becker, Edwin, *Dante Gabriel Rossetti*, London: Thames and Hudson, 2003. Vallance, Aymer, *William Morris His Art His Writings and His Public Life*, London: Studio Editions, 1986. Waggoner, Diane (ed.), *'The Beauty of Life', William Morris & the Art of Design*, New York: Thames & Hudson, 2003. Watkinson, Ray, 'Red House Decorated', *Journal of the William Morris Studies*, spring 1988, pp. 10–15. Weiss, Judith and Fellows, Jennifer and Dickson, Morgan, *Medieval Insular Romance: Translation and Innovation*, Cambridge: Boydell & Brewer, 2000. Wildman, Stephen and John Christian, *Edward Burne-Jones: Victorian Artist-Dreamer*, New York: Abrams, 1998. Youngs, Malcolm (ed.), *Stories from the Newsletters: William Morris, his family and friends: Other People: The House: The Vicinity*, The Friends of Red House, 2015.

UNPUBLISHED REPORTS

Caroe Architecture Ltd., 'Red House Conservation Management Plan and Gazeteer' (draft), July 2017. Cooper, Nicholas, 'Red House Conservation Plan', 2007. Tobit Curteis Associates, Wall Paintings Conservation Reports, 2005–13. Davies, Jane, 'Red House: Drawing Room, window alcove, uncovering and sample analysis report', September 2015. Dowding, Helen, 'An Investigation into the Original Decoration and Possible Treatment of a Painted Settle in William Morris's Red House' (postgraduate diploma in the conservation of easel paintings final year project), 2005, Courtauld Institute of Art. Hassall, Catherine, 'The Drawing Room Wall Paintings' (report B062), March 2013. Oestreicher, Lisa, 'Red House Architectural Paint Analysis Reports', 2003–15. Oestreicher, Lisa, 'Colour Matching Report' (phase 7), September 2015'. Rutherford, Sarah, 'Red House Historic Garden Survey', April 2004.

Picture credits

Title page, figs 1.1, 3.1, 3.16, 3.19, 3.20, 5.1: National Trust Images/Andrew Butler ⬩ figs 1.2, 3.18, 3.21, 4.92, 4.93: James Breslin ⬩ figs 1.3, 1.6, 2.3, 4.9, 4.12, 4.66, 4.110, 4.113, 4.114, 5.4, 5.7, 5.12, 6.1, 6.2, 6.3, 6.6, 7.8: William Morris Gallery ⬩ figs 1.4, 4.37: Castle Howard Collection (with kind permission from the Howard family) ⬩ figs 1.5, 4.86, 4.95, 4.96, 4.97, 4.98, 5.3: Ashmolean Museum, University of Oxford ⬩ figs 1.7, 1.10: National Portrait Gallery, London ⬩ figs 1.8, 4.94: The Fitzwilliam Museum, Cambridge ⬩ figs 1.9, 1.11, 4.21, 4.27: private collection ⬩ figs 2.1, 4.42, 4.46, 4.85: The Huntington Library, Art Collections and Botanical Garden ⬩ figs 2.2, 2.11, 4.3, 4.5, 4.6, 4.7, 4.8, 4.83: photos © Tate, London 2018 ⬩ fig. 2.4: photo by Hall for Alinari (via Getty Images) ⬩ figs 2.5, 3.7, 3.8, 3.9, 3.10, 3.11, 3.13, 4.28, 4.29, 4.31, 4.44, 4.77, 4.79, 4.99, 5.6, 5.11, 6.4, 6.7, 6.9, 6.10, 6.11, 7.2, 7.3, 7.4, 7.5, 7.7: Victoria and Albert Museum, London ⬩ fig. 2.6: Delaware Art Museum, Wilmington, USA/Doris Wright Anderson Bequest & F.V. Dupont Acquisition Fund/Bridgeman Images ⬩ fig. 2.7: Delaware Art Museum, Wilmington, USA/Bridgeman Images ⬩ figs 2.8, 2.9: The Oxford Union Society ⬩ fig. 2.10: National Trust, Wimpole Hall/Iain Stewart ⬩ figs 3.2, 3.3, 3.22: RIBA British Architectural Library Drawings and Archive Collections, Victoria and Albert Museum ⬩ figs 3.4, 3.5, 3.6: Bexley Local Studies & Archive Centre/Libraries, Heritage and Archive Service ⬩ fig. 3.12: private collection/Bridgeman Images ⬩ fig. 3.14: Gavin Stamp (photograph taken in 2000) ⬩ fig. 3.15: Martin Charles/RIBA Collections ⬩ figs 3.17, 4.39, 4.62, 4.109, 5.5, 7.6, 8.2: National Trust, Red House ⬩ figs 4.1, 4.10, 4.15, 4.16, 4.18, 4.19, 4.22, 4.23, 4.49, 4.54, 4.55, 4.56, 4.57, 4.58, 4.60, 4.63, 4.68, 4.69, 4.72, 4.80, 4.87, 4.89, 4.107, 4.111, 4.112, 4.115, 4.116, 4.118, 4.120, 4.121, 4.122, 5.9, 5.10, 7.1: National Trust Images/Andreas von Einsiedel ⬩ fig. 4.2: Archivist/Alamy Stock Photos ⬩ figs 4.11, 4.50, 4.51, 4.52, 4.53, 4.105, 8.4: National Trust Images/Nadia Mackenzie ⬩ figs 4.4, 4.25, 4.67, 4.75, 4.102, 8.1: National Trust Images/John Hammond ⬩ figs 4.13, 4.24, 4.32, 4.33, 8.3: The British Library Board (add MS 45336f018v), (7857.w.19. p048), (add MS 45336 f023v), (add MS 45336 f024v) (add MS 45345 f52.tif) ⬩ figs 4.14, 4.78, 4.88: Tobit Curteis Associates LLP ⬩ figs 4.17, 4.59: Country Life Picture Library ⬩ fig. 4.20: © The Trustees of the British Museum ⬩ figs 4.26, 4.34, 4.36, 4.101, 4.106: Kelmscott Manor, Oxfordshire/Bridgeman Images ⬩ figs 4.30, 4.47: Birmingham Museums Trust, Birmingham Museum & Art Gallery ⬩ figs 4.35, 4.40, 4.84, 4.100, 4.103, 4.117, 4.119, 6.8: Society of Antiquaries of London, Kelmscott Manor ⬩ fig. 4.38: National Trust Images/Brenda Norrish ⬩ fig. 4.41: Tullie House Museum & Art Gallery, Carlisle, Cumbria/Bridgeman Images ⬩ fig.4.43: National Trust/Charles Thomas ⬩ fig. 4.45: The Morgan Library and Museum (MA 381.44) (purchased by Pierpont Morgan, 1909) ⬩ fig. 4.48, 6.5: Bradford Art Galleries and Museums, West Yorkshire/Bridgeman Images ⬩ figs 4.61, 4.90: John Tredinnick ⬩ fig. 4.64: Florilegius/Alamy Stock Photo ⬩ fig. 4.65: British Library, London, UK © British Library Board; all rights reserved/Bridgeman Images (Harl 4380 fol. 1) ⬩ fig. 4.70: Scrovegni (Arena) Chapel, Padua, Italy/Mondadori Portfolio/Archivio Antonio Quattrone/Antonio Quattrone/Bridgeman Images ⬩ fig. 4.71: Yale Centre for British Art, Paul Mellon Fund ⬩ fig. 4.73: Scrovegni (Arena) Chapel, Padua, Italy/Bridgeman Images ⬩ fig. 4.74: private collection; photo © The Maas Gallery, London/Bridgeman Images ⬩ fig. 4.76: with kind permission of the Provost and Fellows of Worcester College ⬩ figs 4.81, 4.82: Musée des beaux-arts du Canada, Ottawa; photo MBAC ⬩ fig. 4.91: Historic England ⬩ fig. 4.104: British Library, London, UK © British Library Board; all rights reserved/Bridgeman Images ⬩ fig. 4.108: The British Library Board ⬩ fig. 5.2: Bodleian Library, University of Oxford (MS, Douce 195, fol. 6r.) ⬩ fig. 5.8: St. Martin, Colmar, France/Bridgeman Images

A Red House colour chart

This chart shows colour matched samples of the original colours used in the decoration of the interior walls, ceilings and joinery elements of the house from 1860–65. The colours are based on the evidence of the architectural paint analysis undertaken by Lisa Oestreicher from 2003–15 and were recreated in two phases in 2013 and 2015. The rich palette favoured by Morris includes a range of distinctive blues, greens, reds, yellows and browns often set against an off-white or cream ground with every room, including the servants' quarters, having strong colour.

Kitchen
skirting

Dining room
walls/chimneybreast
Bedroom (south-west)
walls

Dressing room
joinery

Studio
walls

Principal bedroom
walls

Bachelor's bedroom
walls
Waiting room
walls

Bedroom (north-west)
walls

Studio
ceiling beams/ window reveals

Bedroom (south-west)
walls

Passage
window reveals

Passage
walls

Passage
door screen mullion return

Kitchen
walls

Studio
patterned ceiling decoration

Staircase
window reveals

Studio
sloping ceiling
Bedroom (south-west)
joinery

Acknowledgements

I had the privilege of becoming curator of Red House at its moment of acquisition by the National Trust in January 2003. At this point, although William Morris had been much studied and analysed and the many wonderful survivals of embroideries, furniture and works of art from the five years he lived in Red House were well known, it was readily apparent that many questions still remained unanswered. So began a thrilling investigative journey to uncover the hidden history that the fabric of the house and garden guarded. This book seeks to disseminate the findings of our investigations and present a richer, more detailed picture of Red House from 1859–1865 than has previously been possible. The research has been a collaborative endeavour, very much in the original Red House spirit, to which many people have contributed. I am indebted to Jean Macdonald, former co-owner of Red House, whose love of the house was contagious.

I am especially grateful to Lisa Oestreicher – who undertook the architectural paint analysis and who resolutely sought out pattern and colour on nearly every surface in the house, to Tobit Curteis and his team – who conserved the wall paintings and painstakingly uncovered the figures of Adam, Eve and Noah from beneath layers of later wallpaper to reveal a lost Pre-Raphaelite painting, to James Breslin – fellow enthusiast and former House Manager for his curiosity and gusto and to Gill Nason for her pragmatic good sense.

David Adshead offered great encouragement and in his role as Head Curator of the National Trust championed the commissioning of this book and later made valuable comments on the text. James Rothwell took a critical interest and generously provided sage advice whenever called upon. Robynn Finney cheerfully responded to a steady stream of queries after I had left Red House. John Tredinnick created striking digital impressions of the former decorative glory of the drawing room and bedroom.

Many others have offered invaluable assistance and insight over the years including Nicholas Cooper, Robert Coupe, Gillian Darley, Victoria Marsland, Katy Lithgow, Edward Diestelkamp, Charles Pugh, Christine Sitwell, Elly Bagnall, Karan King, Andrew Saint, Sheila Kirk, Helen Dowding, Malcolm Youngs, Linda Hubbard, Jane Evans, Sarah Rutherford, Graham Marley, Michael Hall, Toni Huberman, Claudia Fiochetti, the late Giles Waterfield, Simon Poë, Richard Flowerday, Julia Dudkiewicz, the late Gavin Stamp, Paul A. Shutler, Megan Tanner, Zoe Colbeck, Chris and Jane Shaw, Erin Mitchell and Elisabeth Traugott. Suzanne Satow and Susie Thomson each made vital contributions to the genesis and completion of this book and I offer them my sincerest thanks.

I am indebted to the curators of many institutions for sharing information and would particularly like to thank Linda Parry, Stephen Gritt (National Gallery of Canada, Ottawa), Kathy Haslam (Kelmscott Manor), Helen Elletson (William Morris Society), Anna Mason and Rowan Bain (William Morris Gallery), Amy Partridge (Birmingham Museums Trust), Matthew Slocombe (Society for the Protection of Ancient Buildings), Olivia Horsfall Turner (V&A), Iain Stewart (Wimpole Hall), Gary Alen Enstone (Bateman's) and the staff of the Huntington Library, Ashmolean Museum and London Library. Jan Marsh has been generous with her expertise and her work on the Morrises and their circle has greatly informed my thinking. I also extend my thanks to the anonymous owner of the Philip Webb dining table who has kindly shared his knowledge and allowed me to publish details of the table.

The Paul Mellon Centre for Studies in British Art awarded me a mid-career fellowship in 2017 which funded four months of research and writing and I am deeply appreciative of their support, and in particular the encouragement of Mary Peskett Smith. It has been a pleasure to work with Philip Wilson Publishers and I would like to thank Anne Jackson, commissioning editor, Clare Martelli, production editor and David Hawkins, copy editor for their professionalism. Grateful thanks are also due to Claire Forbes, National Trust editor (Specialist Publishing), Susannah Stone, picture researcher, and to the designer, Ian Parfitt, who has demonstrated his creativity to great effect.

To my husband Edward and my family I extend my heartfelt gratitude for their forbearance and unfailing generosity of spirit.

Tessa Wild

Index

Page numbers in *italics* refer to figures or their captions

Aberleigh Lodge *32*, *33*, 53, 190, 201
All Saints Church, Middleton Cheney 87, *143*, 145, *162*
All Saints Church, Selsley, Gloucestershire *218*, 220, 221
architecture 15, 16, 19, 34, 39; gothic architecture 34, 39, *40*, 42; Gothic Revival 17, 20, 247, 251; *see also* 'Red House, the building'; 'Webb, Philip: Red House architecture and design'
Arthur, King 20, 53, *60*, 67, 90, 157, *197*, 210, *218*
Arts and Crafts Movement 10, 211, 250, 252

bedrooms (Red House): 'Bachelor's' bedroom 114–15; bedroom passage 184, *185*, *186*; north-west bedroom *187*, 188–9, *188*; south-west bedroom 190, *191*; *see also* 'principal bedroom'
Bell Scott, William *9*, 57, 73, 117, *118*, 119, 141, 151
Bess of Hardwick 88, *94*
Boyce, George Price *39*
Brown, Ford Madox 86, 115, 141, 160, 161, *162*, 189, *189*, 217, *218*, 220, 221; *The Hayfield* 61, *62*
Browning, Robert *12*, 13, 55
Burden, Elizabeth (Bessie) 90, *91*, *93*, 94, 95, 99–100, *101*, 103
Burges, William 18, 20, 59, 125, *128*, 129, 228
Burne-Jones, Christopher 10, 239, 240
Burne-Jones, Edward 8, *9*, 13, 15–16, 19, 21, 58, 67, 73, *108*, *109*, 110, 133–4, 139, 146, 199, *205*, 245; caricatures of Morris *25*, *82*; the Firm 217, 220, 221, 229; four painted panels *171*, 172; *Geoffrey Chaucer* tile 222; *Grace before meat Disgrace after meat* 76, *77*; *The Knight's Farewell* 195, *197*; Niebelungen Lied 152–3; *Self-portrait at Red Lion Square* 19, *182*; sketch of an embroidery scheme by 87, *102*, 105, 221; *Sleeping Beauty* tile overmantel 229; *Summer Snow* 212; *Venus* 96, 101; *see also* 'the Burne-Joneses'; 'Old Testament wall painting'; 'The Prioress's Tale wardrobe'; 'Sir Degrevaunt paintings'
Burne-Jones, Georgiana 8, 10, 26, 31, 42, 47, 58, 63, 73, 80, 86, 112, 133, 141, 146, 181, 199, 201, 204–205, *205*, 213, 245, 251; embroidery 99–100; Macdonald, Georgiana *9*; *Memorials of Edward Burne-Jones* 160; *see also* 'the Burne-Joneses'
the Burne-Joneses 57, 64, 90, 103, 148, 241, *241*, 242; *Dining Room, The Grange* 80, *81*; The Grange, Fulham 211, *241*; moving to Red House 231, 233, 236, 239, 240–1
Butterfield, William 39, *40*, 251

candlestick 19, 61, 222, *226*
Canterbury Cathedral 13, 32, 88
ceiling decoration 22, *23*, 103, *143*, 145
ceiling decoration (Red House) 45, 46, 59, 69, *69*, 112, 114, 172, 177, 188, *246*; ceiling to the dormer window 190, *192*; dining room 76–7, *79*; drawing room 117, 119, 124, *124*, *138*; principal bedroom 172, *175*; staircase 66, 67, 69, 70–1; Studio 180, 181, *183*
chairs 243, 245; armchair *226*; *The Arming of a Knight*, chair 20, *21*, 61–2, 83, *182*; *Glorious Guendolen's Golden Hair*, chair 20, *21*, 61, 83, *182*; medieval style *63*, 80, 243; Red House 61–2, *63*; tub chair 62, *63*, 153; *see also* 'furniture'
Chappell, William: *Popular Music of the Olden Time* 133
Chaucer, Geoffrey 53, 87–8, 117, 136, 165, *167*, 168, 174, 222; the *Canterbury Tales* 61; *Legend of Good Women* 87, 88, *102*, *161*, 174, 221; *The Merchant's Tale* 205; *The Parliament of Fowls* 125; *The Prioress's Tale* 165, *166*, 168–9; *The Works of Geoffrey Chaucer* 165
Clifford, H.P. 76, 79
coat of arms (Morris family's) 46, 47, 50, *51*, 112
collaborative work 21–2, 25, 216, *224–5*, 242; Red House 8, 20, 25, 57, 58–9, 61, 63, 105, 116, 139, 141, 155, 160, 165, 245
The Collected Works of William Morris 87
Cornforth, Fanny 136, *137*, 151
craftsmanship 17, *30*, 31, 220

Dante Alighieri 117, 136, 147–8, 151, 152, 163;
De Pizan, Christine 176, *176*
Dearle, John Henry 208–209
Debating Hall of the Oxford Union 20–2, *23*, 139; *How Sir Palomydes ...* 22, *24*, 104; Morris, William 22, *23*, 25, 119, 183, 230; Rossetti, Dante Gabriel 20–1, 22, *23*
dining room (Red House) 43, 57, 58, 67, 76–105, *79*; dining table 77, *77*, 79–80; embroidered hangings 76, 86–105, 110; fixed dresser 61, 62, 72, 76, *78*, *79*, 227, 243; settle, 80, *82*, *244*; Webb, Philip 61, 73, 76, 77, 79, 80, *82*, 83, *84–5*; *see also* 'embroidery (Red House)'; 'tableware'
drawing room (Red House) 26, 41–2, 43, 44, 116–55, *116*; ceiling decoration 117, 119, 124, *124*, *138*; decoration 57, 58, 67, 116–17, 119, 153, 155; during Charles Holme's ownership *248*; fireplace *116*, 119; music making 133, 145, 146; oriel panelling 153, *154*, 155; oriel window 116, *138*, 153, 169; polychromy 119, *122–3*, 124; 'Qui bien aime tard oublie' 124, 125, *127*; white paint 120–1, 124; *see also* 'great settle'; 'Sir Degrevaunt paintings'
Dunlop, Walter: Harden Grange *104*, 218, 221, *223*
Dürer, Albrecht 61, 183

Eastlake, Charles: *A History of the Gothic Revival* 247
embroidery (Red House) 18, 57, 58, 139; Aphrodite 86, 87, 94, 95, *96*, 101, *102*, 103; appliqué 88, 94, 95, 100, 101; Artemis 87, 95, *97*; Burne-Jones, Edward 87, *102*, 105, 221; Burne-Jones, Georgiana 99–100; cartoons and sketches 87, 88, 95–9; Daisy hanging 69, 86, *126*, 168, *173*, 174, 190, *191*, 207, 231; dining room 76, 86–105, 110, 207, 221; Guenevere 86, 90, *91*, 103, *104*; Helen of Troy 86, *93*, 94, 95, 101; Hippolyte 86, *93*, 94, 101; *If I Can*, embroidered hanging 19, 26, *60*, 86, 103, *179*, 181; Lucretia 86, 87, 90, *93*, 94–5, 101; Morris, Jane 86, 90, *92*, 95, *96*, 99–100, *100*, 172, *173*, 207, 242; Penelope 86, 90, *92*, 103; 'Qui bien aime tard oublie' embroidered hangings *60*, 124, 125, *126*; simulated painted 'hanging' 124–5, *156*, 158; St Catherine 86, 89–90, *92*, 103, 163; St Mary Magdalene 87, *98*, 99;

sunflower hanging 190, *191*; trees *92*, *98*, *99*, *100*, 103, 105; *see also* 'Burden, Elizabeth'; 'dining room'; 'tapestry'
entrance porch (Red House) 42, 43, *43*, *52*, 64, *65*

Faulkner, Charles
 8, *9*, 22, 58, *59*, 73, 146–7, *204*, 217, 220, 222
Faulkner, Lucy 73, *224–5*, *229*, 230
fireplace (Red House) 44, 46, 61, 64, 67, 112–13, 114, 190, 191, 193; drawing room 116, *119*; hearth 113, *116*, *187*, 188, 190, *191*; red brick 45, 67, 76, 112, 114, *191*; Studio *183*, 184; tiles 58, 61, 67, 112, *113*, 158, *183*, 184, *187*, 188; waiting room 112, *113*
fireplace at Sandroyd 158, *161*, 221
the Firm 11, 103, 112, 152, 215–31, 242;
 1862 International Exhibition 222, 227, 229; Bodley, George Frederick 217, 220; Brown, Ford Madox 217, 220, 221; Burne-Jones, Edward 217, 220, 221, 229; church decoration 217, 220, 221–2, 231; circular 215–16, 219; collaborative work 216, *224–5*; fabric design 210, *230*; Faulkner, Charles 217, 220, 222; foundation of 8, 57, 63, 184, 216; Hughes, Arthur 217, 221; Marshall, Peter Paul 217, 220; Morris, William 216–17, 219–20, 230, 241; moving to Red House or the locality 10, 114, 231, 236; Red House and 216, 219–20, 227, 229, 230–1; Rossetti, Dante Gabriel 217, 220, 221, 230; stained glass 87, 110, 161, 163, 217, *218*, 219, 220, 221–2, *223*, 231; tiles 112, 114, 219, 222, *224–5*, *229*, 231; wallpaper 65, *183*, *187*, 210, *214*, 230–1, *232*; Webb, Philip 216–17, 220–1, 222, *226*, 230, 236, 239–40; workshop 10, 221, 236
floor (Red House): carpet 61, 63, 83, 153; tiles 45, 58, 64, 67; wooden-boarded 45, 58, 83, 239
Foster, Myles Birket 110, 229–30, *229*
France 15–16, 29, *30*, 31, 41–2, 61, 76
Froissart, Jean: *The Chronicles* 125, *126*, 174, 231
Fulford, William 15–16, 29, *30*
furniture 18, 20, 26, 222, *226*; 17 Red Lion Square 59, 61, *63*, 80, 83, 117, 145, 153, *182*, 243; St George cabinet 227–9, *228*; *see also* 'Red House: furnishing'

garden (Red House) 42, 47, 112, *194*, 195–213, *204*, *206*, 251; bowling green lawn 43, 76, 190, 199, 201, 203, 206; herber 76, 201, 203, 204–205, 207, 210; house/garden relationship 11, 103, 195, 198, 201, 207, 210, 211; medieval character 10, 195, 201, 211; Morris, William and 195–6, 198–9, 201, 203–204, 206, 210–11; trees and plants 34, 196, 198–9, *199*, 201, 203–204, 251; Webb, Philip and 196, 198–9, 206, 211; *see also* 'Red House, the site'; 'well'
Gerard, John: *The Herball ...* 196, *198*
Giotto *133*, 134, 136, *137*
great settle 20, 61, 62, 63, 117, 145–7, *147*, 149, 152–3; *Dantis Amor* 117, *150*, 151–2; *The Salutation of Beatrice on Earth 122*, 136, *148*, 149, 151, 152; *The Salutation of Beatrice on Eden 123*, 145, 149, *149*, 151, 152; *see also* 'Rossetti, Dante Gabriel'
Guillaume de Lorris: *Roman de la Rose* 196, 201

Haig, Axel: *Proposed Design ... 128*
hall (Red House) 43, 45, *52*, 57, 64, 67, *65*, 69, *69*; oak table with trestle-like legs 64, 73, 153, *154*; staircase hall 43, *52*, 65

hall settle 58, *65*, 67, 72, *72*, 73, *74–5*, 146, 147, 188, 248–9, *249*; panel painting on 67, 73, *204*, *205*, 210, *249*
Hollamby, Edward *180*, 252
Holme, Charles 114, 145, *183*, 247–51, *248*, *249*, 252; *The Studio* 247, *249*, 250, *251*
Howard, George: *Philip Webb* 9
Hughes, Arthur 15, 21, *23*, 217, 221; *April Love* 14, 22, 61, 181

If I Can (*Si je puis*) 7, 112, 117, 125, 177, 221; embroidered hanging 19, 26, *60*, 86, 103, *179*, 181; stained glass 177, *178*; tile *8*, *110*, 112
illumination 18, 53, 54, 55, 57, 86, 88–9, 125, *126*, 158, 174, 183, 195; *Paracelsus 12*, 55, 89

Jacobus de Voragine: *Golden Legend* 160
Jesus College Chapel, Cambridge 103

Kelmscott House, Hammersmith
 77, 201, 211, 213, *244*, 250
Kelmscott Manor, Oxfordshire
 63, 189, 201, 210, 211, 250
Kelmscott Press 139, *140*, 160, 165
Kent, William 44–5

Lethaby, William 17, 19, 54, 165, 211

Macdonald, Alice *98*, 99
Mackail, J.W. 22, 26, 87, 145, 146, 210, 243, 250
Malory, Thomas, Sir: *Morte d'Arthur* 13, 15, *60*, 73, 221
materials 34, *39*, *40*, *41*, 58, 221, 236; *see also* 'red brick'; 'tile'
Middle Ages 39, 53, 67, 129; chairs, medieval style *63*, 80, 243; garden, medieval character 10, 195, 201, 211; medieval buildings 29, 31, 41–2; Morris, William and 11, 34, 110, 125, 211, 227, 228, 253; Red House, medieval character 20, 34, 41, 42, 48, 64, 67, 69, 73, 86, 116, 157, 248
Morris, Emma (Morris's eldest sister) 50, 88
Morris, Emma (née Shelton, Morris's mother) 16–17, 63
Morris, Jane (Morris's wife) 8, 26, 34, 59, 73, 117, 133, *186*, *204*, 242; *La Belle Iseult* 26, *27*, 61, 90, 104, 138, 172, 181; Burden, Jane *9*, 26; embroidery 86, 90, *92*, 95, 96, 99–100, *100*, 172, *173*, 207, 242; *Jane Morris in medieval costume* 68; marriage 7, 29, 31, 34, 58, 136, 138, 149; Melidor and *135*, 138, 157
Morris, Jenny (Morris's daughter)
 7, 63, *82*, 100, *186*, 189, 193
Morris, Marshall, Faulkner & Co. *see* the Firm
Morris, May (Morris's daughter) 7, 50, *51*, 63, 80, *82*, 83, 87, 100, 153, *186*, 189, 193, 206, 251
Morris, William 7, 8, 15–17, 19, *25*, 76, 77, *82*, *204*, 239, 245, 253; death 251; family 7, 26, 34, *241*, 242; France, trips to 15–16, 29, *30*, 61; friendship 7, *9*, 15, 253; generosity and hospitality 15, 64, 76, 114, 138, 233; lectures by 86, 112, 210; letters by 7, 16–17, 240–1; traditional/minor arts 18, 19, 183, 216–17; *see also the entries below for* Morris, William; 'the Firm'
Morris, William: drawing and painting 19, 21, *25*, 54–5, 104, 182, *182*; *La Belle Iseult* 26, *27*, 61, 90, 104, 138, 172, 181; *Eve and the Virgin* 218; four painted panels *171*, 172; *How Sir Palomydes ...* 22, *24*, 104; *Jane Burden* 9; *Jane Morris in medieval costume* 68; sketch of a seated female figure *101*; *Trellis* 203;

Venus 96, 101; *see also* 'Debating Hall of the Oxford Union'; 'illumination'; '*Old Testament* wall painting'; '*The Prioress's Tale* wardrobe'
Morris, William: ideas and influences 8, 10, 11, 13, 39, 53–4, 211; medievalism/romantic medievalism 11, 34, 110, 125, 211, 227, 228, 253; romanticism 26, 29, 54, 196, 245, 253; socialism 10, 83, 146
Morris, William: writing and music 7, 10 19, 20; *Ancient Christmas Carols* 133; 'The Blue Closet' 55, *56*; *The Defence of Guenevere* 54, *56*, *60*, 172; *The Earthly Paradise* 207, 242, 245; 'Golden Wings' 195; 'The Life and Death of Jason' 207; *News from Nowhere* 83; 'Rapunzel' 61; 'Sir Galahad: A Christmas Mystery' 61; *The Story of the Unknown Church* 203–204; Troy, poems on 67, 95; 'The Tune of Seven Towers' *60*
Morris, William Sr (Morris's father), 47, 112, 220
Muthesius, Hermann, 251–2

National Trust 10–11, 252–3
Nicholson, Mary (Red Lion Mary) 19, 73, 151, *204*

Old Testament wall painting 156, 157–65, *159*, *160*, 172, 207; Brown, Ford Madox 160, *161*; Burne-Jones, Edward *156*, 160–1; Genesis verses 158, 160; human figures *156*, 158, 160, 163; Morris, William *156*, 163, 165; Rossetti, Dante Gabriel *156*, 160–1, 163; Siddal, Elizabeth *156*, 161, 163; simulated painted 'hanging' *156*, 158; *see also* 'principal bedroom'
Oxford 15–16, *16*, 17, 19, 26, 55, 88–9, 129, 133, 181; *see also* Debating Hall of the Oxford Union
The Oxford and Cambridge Magazine 19, 203

passage (Red House) *106*, 107–10; glazed screen *106*, 107, 250–1, *250*
Pilgrim's Rest porch (Red House) 7, 43, 49, *51*, 110, *111*, 205; oak bench *51*, 110, *110*, 112
Powell & Sons, Whitefriars Glassworks 83, *85*, 107, *107*, *108*, *109*, 110, 177
Pre-Raphaelites 19, 39, 50, 53, 54, 95, *118*
Price, Cormell 16, 19, 22
Price, Henry 79–80, 145–6
principal bedroom (Red House) 44, 57, 58, 157–8, *159*, *160*, *172*, 174, *175*; Daisy hanging 69, 86, *126*, 168, *173*, 174, 190, *191*, 207, 231; dressing room 44, 176–7; jewel casket 174, *175*; mirror 174, *175*; *Sir Degrevaunt*, the poem 141, 157; *see also* '*Old Testament* wall painting'; '*The Prioress's Tale* wardrobe'
The Prioress's Tale wardrobe 153, *154*, 165–72, *166*, *167*, 174, 207, 243, *244*; Burne-Jones, Edward 59, *136*, 157, 165, 168–9, 174, 243; Chaucer, Geoffrey 165, *167*, 168, 174; female figures 165, *166*, 168, 169, *170–1*; interior faces of the doors 165, *166*, 169, *170–1*, 172; Morris, William 165, *166*, 169, *170*; *The Prioress's Tale* 165, *166*, 168–9; Webb, Philip 59, 61, 157, 165, 168, 188, 227, 243; a wedding present 157, 243; *see also* 'principal bedroom'
Pugin, A.W.N. 18, 39, 251
Queen Elizabeth's Hunting Lodge 53–4, *54*

red brick 34, *40*, 42, 45, 47, 48, 58, 251; fireplace 45, 67, 76, 112, 114, *191*; *see also* 'materials'
Red House *2–3*, *6*, 141–2, *194*, *199*; collaborative work 8, 20, 25, 57, 58–9, 61, 63, 105, 116, 139, 141, 155, 160, 165, 245; the Firm and 216, 219–20, 227, 229, 230–1; importance of 10, 251–3; medieval character of 20, 34, 41, 42, 48, 64, 67, 69, 73, 86, 116, 157, 248; Morris, William and 8, 220, 229, 251, 253; Morris's friends and 7, 8, 10, 11, 58–9, 114, 139; 'a Palace of Art of my own' 7, 26, 240; romanticism 29, 245, 253; servants at 193; as unified vision of house, contents, decoration and garden 7–8; *see also the entries below for* Red House
Red House, the building 10, 31, 42–3, *43*, 47; bells 46; building contract 34, *35*–8, 44, *44*, 46; construction, completion and price of 44–5, 53; extension 233–9; L-shaped plan 43; landing 44, 69, 177, 184; lighting 193, *226*; nursery 184, 189; a Pre-Raphaelite building 50; roof *40*, *41*, 43, *43*, 47, 48, 181, 203; upper passage 177, 181, *246*; water closet 43, 44, 46, 184, 190, 193; *see also* 'bedrooms'; 'dining room'; 'drawing room'; 'entrance porch'; 'floor'; 'hall'; 'passage'; 'Pilgrim's Rest porch'; 'principal bedroom'; 'service areas'; 'stair tower'; 'staircase'; 'Studio'; 'waiting room'; 'Webb, Philip: Red House architecture and design'; 'window'
Red House: colour 10, 34, *43*, 45–6, *56*, 57, 58, 67, 69, 203, *267*; blue and green 70–1, 114; green *106*, *107*, 189; polychromy 119, *122–3*, 124; Studio *180*, 181; yellow 64, 65, 66, 67, 69, 114, 177, 181, 190, *191*; *see also* 'Red House: decoration'
Red House: decoration 10, 11, 42, 53, 57–8, 119; doors *43*, 67, 69; graffito 59, 72; ironwork 46, 47, 76, 83, 114, 177, 190; love, theme of 57–8, 87, 160; Troy, theme of 67, 86, 90; woodwork 45–6, 72, 114, 177, 190; *see also* 'ceiling decoration (Red House)'; 'drawing room'; 'embroidery (Red House)'; 'fireplace'; 'principal bedroom'; 'Red House: colour'; 'Red House: furnishing'; 'stained glass (Red House)'; 'tile'; 'weathervane'
Red House: furnishing 11, 59, 62–3, 153; bed 63, 115, 174, 189, *189*; chair 61–2, 63; corner cupboard 62, 114–15, *115*; fixed dresser 61, 62, 72, 76, *78*, *79*, 227, 243; fixed wardrobe 62, *187*, 188, 190, *191*; fixed wardrobe (dressing room) 62, 176, 177, 190; functionality 61, 62–3, 72, *74*, 157; mirror 174, *175*, *189*; Webb, Philip 59, 61, 62, 73, *74*, 76, 77, 79, 80, 82, 83, 146, *154*, 174, *175*, 188, 189, *189*; *see also* 'chairs'; 'great settle'; 'hall settle'; '*The Prioress's Tale* wardrobe'; 'Red House: decoration'; 'table'
Red House, the site 10, 31–2, 198; countryside/rural setting 10, 31, 32, 43, 48, 59; entrance gates 34, *35*, 42; orchards and fields 31, *32*, 34, 80, 198; stable 10, 34, 47, 48, 201; wall 10, 34, 42, 201; *see also* 'garden'; 'well'
Red House after William Morris 247–53; 1865: Morris left Red House 10, 210, 213, 241–2, 245; Charlesworth, Mr *183*, 184; Heathcote, James 243; Heathcote, Marion 243, 245; later owners 115, 184, 252; sale of Red House 242–3; *see also* 'Hollamby, Edward'; 'Holme, Charles'; 'National Trust'
Red Lion Square (17) 19, 26, 59, 61; furniture at 59, 61, 63, 80, 83, 117, 145, 153, *182*, 243; *see also* 'chairs'
Rooke, Thomas Matthews: *Dining Room ...* 80, *81*
Rossetti, Dante Gabriel 8, *9*, 19, 20–1, *21*, 55, 57, 95, 125, 138–9, 147, 174, *175*, 176, 242; *Algernon Charles Swinburne* *9*; *The Blue Closet* *56*, 61; *The Chapel before the Lists* *60*, 61; *The Damsel of the Sanct Grael* *60*, 61; Dante Alighieri and 147–8, 151–2, 163; *The Death of Breuse Sans Pitie* 61; *Elizabeth Siddal* *9*; the Firm 217, 220, 221, 230; four painted panels *171*, 172; Red House and 58, 64, 73, 105, 117, 141; Siddal, Elizabeth, and 152, 163; stained glass 163, *164*;

The Tune of Seven Towers 60, 61, 80; wallpaper *101*, 105; *see also* 'Debating Hall of the Oxford Union'; 'great settle'; 'hall settle'; '*Old Testament* wall painting'
Ruskin, John 9, 13, 15–16, *15*, 55, 86, 101, 133, 163

Sales Particulars (Red House) 155, 184, 201, 206
Scott, Walter 13, 54
service areas (Red House) 43, 47–8, 190, 193; ceiling to the dormer window 190, *192*; cellar *37*, 43, 76; kitchen 43, 46, 190, *191*, 193, 233; servants' quarters 44, 47, 62, 184; service yard 43, 47–8, 233; single-storey service range 47, 190; stair up to the two servants' bedrooms 190, *191*; wine cellar 43, 190
Siddal, Elizabeth 8, 58, 73, *60*, 151, 152, 163, 174, *175*, 176, *205*; *Elizabeth Siddal 9*; *Study for Lady Clare* 163, *164*; *see also* '*Old Testament* wall painting'
Sir Degrevaunt paintings 67, 117, 119, 124, 129–45, 207; Burne-Jones, Edward 117, *120–3*, 124, 130, 134, 136; painted verses 142, 145; *Sir Degrevaunt*, the poem 129–30, 138, 141; *Study for The Wedding Feast of Sire Degrevaunt 134*, 136, *137*; *The Wedding Ceremony* 130, *131*, 153; *The Wedding Feast* 26, 130, *135*, 136, 138–9, *157*; *The Wedding Procession* 130, *132*, 134, 136, 139, 145; *see also* 'drawing room'
Sire Degrevaunt, Kelmscott Press edition 139, *140*, 141
Society for the Protection of Ancient Buildings 253
South Kensington Museum (Victoria and Albert Museum) 83, 217
stained glass 53, 103; All Saints Church 87, *162*; Bradford Cathedral 163, *164*, 222; Brown, Ford Madox 161, *162*, 218; embroidery designs and 103, *104*, 163; the Firm 87, 110, 161, 163, 217, *218*, 219, 220, 221–2, *223*, 231; Morris, William *104*, *218*, *223*; Rossetti, Dante Gabriel 163, *164*
stained glass (Red House) 58, *107*, 207, 210; Burne-Jones, Edward *108*, *109*, 110; passage 107–10; Webb, Philip *107*, 177, *178*
stair tower (Red House) 42, 46, 69, 72, 116; structural timbers 69, *70–1*, 72, *72*
staircase (Red House) 31, 43, 59; oak stair 43, 44, *52*, 65, 66, 67, 116; staircase hall 43, *52*, 65; stamped ceiling 66, 67, 69, *70–1*
Stanhope, John Roddam Spencer 21, *23*, 220, 240; Sandroyd 158, *161*, 220–1, 236
Street, George Edmund 17–18, 39, 41, 55; Laverstoke Parsonage, Hampshire, 41, *41*; Morris, William and 17–19, 22, 39; table designed by *18*; Webb, Philip and 17–19, 34, 39, 41, 61, 251
Studio ('Study', Red House) 43, 44, *180*, 181–4, 233; books 183; ceiling decoration *180*, 181, *183*; fireplace *183*, 184; painting and woodworking tools 182, *182*, 183
Swinburne, Algernon Charles 8, 58; *Algernon Charles Swinburne 9*, 136, *137*

table *18*, 73; dining table 77, *77*, 79–80; round oak table with trestle-like legs 64, 73, 153, *154*; Webb, Philip 61, 73, 77, 79, 80; *see also* 'Red House: furnishing'

tableware 53, 83, *84*, *85*, 86; *see also* 'dining room'
tapestry 158, 165, 245; Bayeux Tapestry 53; *The Orchard* or *The Seasons* tapestry 103, *208–209*, 210; *see also* 'embroidery'
Tattershall Castle, Lincolnshire *28*, 42
Tennyson, Alfred 7, 13, *164*, 240
The Thornton Romances 129
tile (Red House) 110, 188; coat of arms 51; fireplace 58, 61, 67, 112, *113*, 158, *183*, 184, *187*, 188; the Firm 112, 114, 219, *222*, *224–5*, 229, *229*, 231; floor 45, 58, 64, 67; *Geoffrey Chaucer* tile *222*; *If I Can* 8, *110*, 112; *Labours of the Months* tile panel *224–5*; 'Leaves and Berries' tiles 188, *188*, 190; Morris's design *Bough* 112, *113*; oak bench, Pilgrim's Rest porch 51, 110, *110*, 112; pitched tile roof *40*, 47, 48, 181, 203; *Sleeping Beauty* tile overmantel *229*, 230
Toms, Mary 252
Toms, Richar 252
Trellis 143, 230, 231; *Trellis* wallpaper *144*, 145, *202*, 230

Upton 31–2, *33*, 47

Vallance, Aymer 73, *74*, 77, 80, 203, 250–1
Van Eyck, Jan 7, *179*

waggonette 47, 48, 50, *51*, 206
waiting room (Red House) 43, 67, 112–14
wallpaper 10, *101*, 105, 124, 160; 'Bird and Anemone' wallpaper *187*; *Daisy* wallpaper *183*, *214*, 230–1; the Firm 65, *183*, *187*, 210, *214*, 230–1, *232*; *Fruit or Pomegranate* wallpaper *232*; *Trellis* wallpaper *144*, 145, *202*, 230
weathervane (Red House) 46, 47, 50, 112
Webb, Philip 8, 17, 31, *31*, 77, 222, *226*, 236; the Firm 216–17, 220–1, 222, *226*, 230, 236, 239–40; France and 15–16, 29, *30*, 41–2, 76; letter to Morris 239–40, *239*; *Philip Webb 9*; Sandroyd 158, *161*, 220–1, 236; sketches by *30*, *39*, *40*, *44*, *45*, *48*, *51*, *76*, *84*, *85*; Street, George Edmund and 17–19, 34, 39, 41, 61, 251
Webb, Philip: Red House architecture and design 7, 10, 20, 31, 34, 41–3, 44–5, 174, 188, 199, *200*, 247, 250, 251; alterations of original design 47, 48, 107, 114–15, 176–7; cellar, ground and first floor plans *36–7*, 182; contract drawings *35–8*, 44, 48, 146; dining room 61, 73, 76, 77, 79, 80, 83, *83*, *84–5*; extension 231, 233, *234–5*, 236, *237*, *238*; furniture 59, 61, 62, 73, *74*, 76, 77, 79, 80, *82*, 83, 146, *154*, 174, *175*, 188, 189, *189*; garden 196, 198–9, 206, 211; stained glass *107*, 177, *178*; well 34, *38*; *see also* 'hall settle'; '*The Prioress's Tale* wardrobe'
well (Red House) 10, 34, *38*, 48, 49, 199, *199*, 205, 210; well-court 43, 199, *199*, 204–205; *see also* 'garden'; 'Red House, the site'
window 41–2, *43*, 49; arched windows 116, *116*; circular window 115, 177, 182, 184, *186*; dormer window *40*, 47, 190, *192*, 233; oriel window 41, 116, *138*, 153, 169; sash window 42, 112, 115, 176, 181–2, 184, 190
Woodford Hall, Essex 196